ANOTHER AESTHETICS IS POSSIBLE

DISSIDENT ACTS *A series edited by*
Macarena Gómez-Barris and Diana Taylor

ANOTHER AESTHETICS IS POSSIBLE

JENNIFER PONCE DE LEÓN

ARTS OF REBELLION IN THE FOURTH WORLD WAR

DUKE UNIVERSITY PRESS DURHAM AND LONDON 2021

© 2021 Duke University Press
All rights reserved
Printed in the United States of America on acid-free paper ∞
Designed by Aimee Harrison
Typeset in Garamond Premier Pro and Montserrat
by Westchester Publishing Services

Library of Congress Cataloging-in-Publication Data
Names: Ponce de León, Jennifer, [date] author.
Title: Another aesthetics is possible : arts of rebellion in the Fourth World War / Jennifer
Ponce de León.
Other titles: Dissident acts.
Description: Durham : Duke University Press, 2021. | Series: Dissident acts | Includes
bibliographical references and index.
Identifiers: LCCN 2020027258 (print)
LCCN 2020027259 (ebook)
ISBN 9781478010203 (hardcover)
ISBN 9781478011255 (paperback)
ISBN 9781478012788 (ebook)
Subjects: LCSH: Art and society—Argentina. | Art and society—Mexico. | Art and
society—United States. | Social movements in art. | Art—Political aspects. | Aesthetics—
Political aspects. | Aesthetics—Social aspects.
Classification: LCC N72.S6 P663 2021 (print) | LCC N72.S6 (ebook) |
DDC 701/.03—dc23
LC record available at https://lccn.loc.gov/2020027258
LC ebook record available at https://lccn.loc.gov/2020027259

Duke University Press gratefully acknowledges the School of Arts
and Sciences at the University of Pennsylvania, which provided funds
toward the publication of this book.

Cover art: Francisco Papas Fritas (Francisco Tapia Salinas), painting from the series
Folklor insurrecto, 2017. Acrylic paint on canvas, 110 × 90 cm. Courtesy of the artist.

to Gabriel

CONTENTS

ACKNOWLEDGMENTS

THE PROCESS OF WRITING THIS BOOK gave me a new level of appreciation for the social and collective nature of knowledge production. Many more people than I can name here made this project possible.

I am deeply indebted to the artists whose work I discuss in this book for opening new worlds to me and for the enormous generosity they have shown me over many years. Thanks to Pablo Ares, Lorena Bossi, Ricardo A. Bracho, Checha, Sandra de la Loza, Ariel Devincenzo, Cristián Forte, Nancy Garín, Loreto Garín Guzmán, Fran Ilich, Yolanda López, and Federico Zukerfeld. I am also grateful to all of them for letting me reproduce images of their work.

My ideas about art, politics, and aesthetics have been informed by conversations and interviews with many people. I want to give special thanks to the following individuals, whose own work taught me so much: Rodrigo Araujo, Ericka Beckman, María Fernanda Cartagena, Sakarit Chakaew, Teddy Cruz, Julián D'Angiolillo, Marcelo Expósito, Steve Fagin, Harry Gamboa Jr., Santiago García Navarro, Patricia Gherovici, Felipe Teixera Gonçalves, Marcial González, Virginia Grise, Karina Granieri, Gronk, Pablo Helguera, Samuel Ibarra Covarrubias, Magdalena Jitrik, Bill Kelley Jr., Grant Kester, Suzanne Lacy, Robert Legorreta, Florencia Levy, Daniel Lima, Eduardo Molinari,

Peetssa, Steven Powers, Gonzalo Rabanal, Dont Rhine, Boots Riley, Julia Risler, John Patrick Schultz, Túlio Tavares, and Dani Zelko.

Mary Louise Pratt, Gabriel Giorgi, and Gayatri Gopinath provided me with crucial feedback on this project in its early stages. Arlene Dávila, Ana Dopico, Randy Martin, Andrew Ross, and Diana Taylor also helped me develop ideas found in this book. I am grateful to Chon A. Noriega not only for his comments on this manuscript, but also for the countless ways he has inspired me with his work and supported my research and writing over the past two decades. María Josefina Saldaña-Portillo has had an enormous impact on my thinking, and she helped shape this project from its beginnings. I am thankful to have learned so much from someone whose scholarship I so deeply admire.

The process of curating exhibitions and public art events helped me develop ideas in this book. I want to thank Aaron Levy and the Slought Foundation for making possible *Resurgent Pasts, Insurgent Futures* (2017) and for maintaining such an engaging intellectual and artistic space in Philadelphia. I am grateful to Grant Kester and the University Art Gallery and Visual Arts Department at the University of California, San Diego, for supporting *Arrhythmias of Counter-Production: Engaged Art in Argentina, 1995–2011* (2011). I learned so much from *Público Transitorio* (2007) and am thankful to all of those who were involved.

My research for this book was supported by grants from the Office of the Vice Provost of Research and the Graduate School of Arts and Sciences at the University of Pennsylvania, the Department of Social and Cultural Analysis at New York University, UCLA's Graduate Division and Latin American Institute, the Radcliffe Institute and the David Rockefeller Center for Latin American Studies at Harvard University, and by a George Peabody Gardner Fellowship from Harvard University. A grant from the Graduate School of Arts and Sciences at the University of Pennsylvania made possible the inclusion of color plates in this book. A Ford Postdoctoral Fellowship gave me time to complete revisions. I was honored to be a Visiting Scholar at UCLA's Chicano Studies Research Center during my fellowship, as it was a kind of home for me when I lived in L.A.; I, like so many others, have benefited enormously from the resources it has created. Ivanna Berrios and Melody Kulaprathazhe provided me with invaluable research assistance with support from the Undergraduate Research Mentorship program at the University of Pennsylvania.

Earlier versions of parts of chapters 1 and 3 were previously published in *American Quarterly* and *ASAP/Journal*, respectively. I am grateful to the

journals' editors and to the articles' anonymous readers. With thanks to Juan Eduardo Navarrete Pajarito and Alonso Cedillo for allowing me to reproduce their photographs of *Raiders of the Lost Crown*.

I received excellent feedback on early chapter drafts at the Tepoztlán Institute for the Transnational History of the Americas and the Newberry Seminar in Borderlands and Latino/a Studies, and am grateful to the respondents, participants, and organizers. The Critical Theory Workshop/ Atelier de Théorie Critique has provided a wonderfully engaging space of intellectual exchange that has shaped my own thinking. The Escuelita Zapatista was an unparalleled learning experience, and my intellectual debt to the Zapatista movement cannot be overstated.

I feel lucky to have such brilliant colleagues at the University of Pennsylvania. I especially want to thank David Kazanjian, who has been a wonderfully generous and kind mentor and friend. Tulia Falleti, Cathy Bartch, and the Latin American and Latinx studies program gave me opportunities to present my work and bring artists to campus. Thanks to Rita Barnard, Margo Crawford, Jed Esty, Andy Lamas, Rahul Mukherjee, Jean-Michel Rabaté, Paul Saint-Amour, and Dagwami Woubshet for their support and engagement with my work.

David Eng, Leandro Martínez Depietri, Santiago García Navarro, Michael Hanchard, Suvir Kaul, Ania Loomba, Raúl Villa, Brian Whitener, and Chi-ming Yang gave me detailed feedback on chapters of this book. I am so thankful for their insightfulness and friendship. Debra Castillo, Michael Denning, and Macarena Gómez-Barris commented on the entire manuscript, giving me excellent suggestions that helped me improve it. Ken Wissoker gave me crucial advice and encouragement. Ken, Nina Foster, Lisa Lawley, and the staff at Duke University Press were wonderful to work with. The anonymous readers who reviewed the manuscript gave me very helpful feedback on it.

Two brilliant writers, Randall Williams and Ricardo A. Bracho, read and edited the entire manuscript and gave me key suggestions at every stage of this project. I have learned so much from them and cherish their friendship. A special thanks to the inimitable Fran Ilich, who influenced my thinking in profound ways. With his unparalleled wit, wisdom, and kindness, Andrews Little accompanied me in the entire process of researching and writing this book. My father, Ed Sternad, taught me to find excitement in books and ideas, and has given me unconditional love. My mother, Lyndee Flores Sternad—a former art teacher and lifelong artist of the everyday— taught me to love art and to see that it is everywhere.

Gabriel Rockhill improved every aspect of this book with astute suggestions, insight that helped me clarify and expand my arguments, and careful editing of every sentence. His exhilarating and demanding love of ideas, and the extraordinary joy he has brought me, shaped this book in so many ways, as they are inseparable from living and writing at his side. I cannot imagine a more inspiring and enthralling interlocutor.

IN 2002, in the wake of a financial crisis and massive popular uprising that rocked Argentina, the artists of Etcétera ... brought a proposal to a popular assembly that met weekly in a park in Buenos Aires: "Now that we have nothing, we should give back to the politicians the only thing we have left: our shit!" With the help of the assemblies and independent news media, they organized a collective performance that realized this proposal in the most literal way, directly in front of the National Congress.

In Los Angeles, California, a few months later, the Pocho Research Society of Erased and Invisible History inaugurated its practice of direct action public history. They installed seemingly official historical plaques on city monuments, adding occluded histories of working-class Latinas/os/xs and Mexican and Central American immigrants. In the hands of these guerrilla historians, a city monument's nationalist mystification of L.A.'s history was challenged by histories of Mexican and Central American migration to the city and a critique of US imperialism, and an official monument to the Southern Pacific Railroad was altered to honor the taggers who turned boxcars into canvases.

Back in Buenos Aires, Grupo de Arte Callejero (GAC; Street Art Group) was also mimicking state signage in guerrilla interventions that brought

histories suppressed by the state into public view. With what appeared to be traffic signs, they directed people to the homes of former military and police officers and priests. These signs functioned within exposure protests (*escraches*) that the Argentine human rights movement organizes to publicly denounce individuals who were involved in state terrorism during the country's most recent dictatorship, realizing a form of popular justice not dependent upon complicit state institutions. GAC's work in the human rights movement moved beyond a focus on state terrorism under dictatorship to address state violence in the present, as well as the ubiquitous discourse of "security" that is used to legitimate it.

In 2000 Etcétera... created a heterodox version of the human rights movement's exposure protests in front of Argentina's National Fine Arts Museum. It denounced the museum and one of its trustees, who is a powerful art collector and majority shareholder of an enormous agribusiness. With flaming sugar footprints and sticky traces, this *SUR*realist protest-performance exposed a history of corporate complicity in state terrorism in the 1970s and linked it to the same corporation's exploitation and poisoning of agroindustrial workers in the present, while challenging the bourgeois myths of high art's autonomy and the beneficence of cultural philanthropy.

A museum was also the focus of a public denunciation by the Diego de la Vega Cooperative Media Conglomerate, whose founder and CEO, Fran Ilich, is an artist and activist who has long been active in the social movement constellated around the EZLN (Ejército Zapatista de Liberación Nacional; Zapatista Army of National Liberation). Ilich penned a petition that called on Austria's World Museum to return the most famous object in its collections: an ancient Mexica (Aztec) headdress, "war booty... obtained in the midst of the American holocaust" in the sixteenth century.[1] This petition publicly launched an alternate reality game that was played out across multiple on- and offline platforms, from epistolary and economic exchanges to faux souvenirs and a pop-up coffee shop that materially supported Zapatista communities.

When George W. Bush, the self-proclaimed leader of the so-called War on Terror, came to Argentina in 2005, the Internacional Errorista (International Errorist) went public. After they appeared on streets and beaches bearing their "poetic arms," reports in the news media variously described them as actors playing terrorists, activists dressed as Palestinians, antiglobalization protestors, and vandals, while the police squadron that pulled up on the Erroristas said they had been reported as armed *piqueteros*—that is, members of Argentina's unemployed workers' movement. These police unwittingly

became actors in an errorist film about manufactured perceptions of criminality and security and the confluences among hemispheric antiterrorism politics, U.S. imperialism, and the criminalization of working-class people and dissident movements.

These practices and productions, among others discussed in this book, were created by artists whose omnivorous and politicized experimentalism has led them across and beyond the arts. They fuse artistic production with practices considered extraneous to disciplinary understandings of fine art and literature, such as direct action tactics, public history, gaming, cartography, and solidarity economies. This contradisciplinary experimentalism, as well as the largely extra-institutional character of their work, is bound up with the politics of their practice and its relationship to movements, as well as their heterodox understanding of what "art" is and what it can do.

Their art is articulated—in different ways, and always in specific contexts—with ongoing antisystemic movements and social struggles rooted in different parts of the Americas.[2] These include the anticapitalist and anticolonial movement constellated around the EZLN, which is led by indigenous peasants in southern Mexico; the 2001–2 Argentine uprising and urban social movements in Buenos Aires, including the human rights movement; struggles against the criminalization, policing, and displacement of racialized working-class people in Los Angeles; and the international movements against neoliberal "free trade" regimes and against U.S.-led wars. While these struggles have important local inscriptions and national determinations, they are all part of the global movement against capitalism and the oppression on which it depends. By analyzing art practices that are articulated with different collective struggles, this book elucidates the vitality and creativity of a contemporary anticapitalist cultural Left whose praxis is enmeshed with grassroots movements across the Americas.

AN OTHER AESTHETICS

The looking-glass school is the most democratic of educational institutions. There are no admissions exams, no registration fees, and courses are offered free to everyone everywhere on earth as well as in heaven. It's not for nothing that this school is the child of the first system in history to rule the world. . . . The looking-glass school teaches us to suffer reality, not change it; to forget the past, not learn from it; to accept the future, not invent it. In its halls of criminal learning, impotence, amnesia, and resignation are required courses. Yet perhaps—who can say—there can be no disgrace without grace, no sign without a countersign, and no school that does not beget

its counterschool.—Eduardo Galeano, Upside Down: A Primer for the Looking-Glass World *(2000)*

This book's title cites the imperative affirmation by the EZLN and its base communities that "another world is possible." Within the Zapatistas' theory and practice, this is an assertion that *los de abajo y a la izquierda* (those from below and on the Left) can create a world in which justice, real democracy, and freedom are accorded to all, which necessarily must be a world beyond capitalism.[3] Aesthetics—here understood in its broad sense as the socially forged sensory composition of a world—constitutes a crucial site of struggle in this effort. Because aesthetic practices and productions shape how we perceive and understand the world, they can and do participate in the multidimensional and collective labor of creating and defending another social reality. In this sense, an *other aesthetics* refers to the forging of worldviews that support the collective struggle to make and defend this other possible world.

An *other aesthetics* also refers to a materialist understanding of aesthetics that is not based upon the presumed specificity of what is socially designated as "art" and pertains, instead, to the composition of a sensorium, which is both mental and perceptual. It is based on the recognition, central to Marxist thought, that subjects' experienced lifeworlds are produced, reproduced, and transformed through social practice. As Marx writes, human individuals' existence "*is* social activity," as we make ourselves "for society and with the consciousness of [ourselves as] social being[s]."[4] All aspects of humans' "relations to the world—seeing, hearing, smelling, tasting, feeling, thinking, being aware, sensing, wanting, acting, loving"—are eminently social and historical.[5] Following the work of Marx, Frantz Fanon, Sylvia Wynter, and others, I reject the ontological division of biological and social life (and, by extension, of materiality and consciousness), maintaining instead that humans' consciousness is based in our actual life-process and does not exist apart from it.[6] Human cognition and sensuous perception are bound together and are the product of historical processes. As such, human activity and experience should be understood in all of their material sensuousness.

Aesthetics, which derives from *aisthánomai,* "to perceive, feel, or sense," allows us to discuss intellectual "sense" and material "sense" as inseparable, and the Marxist theory of aesthetics I have adumbrated references the sociocultural formatting of human cognition and perception, understood as co-constitutive. Jacques Rancière has contributed to this theory with his concept of the *distribution of the sensible,* a "primary aesthetics" that orders sensuous perception and thereby "produces a system of self-evident facts of

perception based on the set horizons and modalities of what is visible and audible, as well as what can be said, thought, made or done."[7] Yet Rancière's writings on aesthetics jettison fundamental Marxist insights about the objective bases of social organization and the determinations these exercise upon this primary aesthetics, as well as upon art.[8] I argue, instead, that the production of experienced lifeworlds via material practices operates within a complex social totality that is overdetermined by the social relations of production.

My heterodox use of the concept of aesthetics derives from my understanding that "ideology operates as an all-encompassing sensorium that emerges from the actual life-processes of Homo faber. It composes an entire universe through the collective and historical production of a shared world of sense that is at one and the same time physical *and* mental."[9] It is based on Marxist theories of ideology that posit that subjects' consciousness of themselves and their relationship to the world are constituted via ideology, which is produced and transformed through material practices.[10] These theories guide my analysis of the ways that social relations of production and reproduction relate to aesthetics and to aesthetic practices. I use the concept of *aesthetics* in order to specifically draw attention to the ways ideology structures our perception. While reductionist conceptions of ideology collapse it into mental representations or discourse, I want to emphasize that its reality-producing effects shape our entire world of experience, including through the modeling of perceptions, feelings, habits, actions, memories, and desire, as well as through ideas and language.

I am also interested in aesthetics because of its simultaneous proximity to and difference from art. In this book, "art" refers to literary and performing arts, as well as visual art. The history of art offers a rich repository of concepts, techniques, and methods for both analyzing and mobilizing the power of aesthetics, as defined earlier. However, theories of aesthetics that exclusively refer to those practices and productions that are identified as art easily ignore the social force aesthetics exercises through other social practices. When such approaches are based on claims that artworks have essential and particular aesthetic qualities and/or elicit a unique aesthetic experience, they obscure the historical constitution of art forms as socio-cultural categories and the racial and gendered class relations (including colonial class relations) in which this history is embedded.[11] The artistic practices I analyze certainly draw on the history of art, and on the conventions and techniques that the historical codification of art as a specific type of labor and object of analysis has produced. However, they are equally

informed by and respond to histories and types of cultural practice generally considered extraneous to art when it is treated as a self-contained discourse or practice. For these reasons, I have developed a conceptual vocabulary that allows me to discuss how social practices of all types work to shape perceptions of and ideas about the world. This approach is also necessarily opposed to mimetic conceptions of art—that is, the idea that art represents reality. Rather, I am interested in how aesthetic practices are *constructive* of social reality.

When analyzing the place of the arts in the international communist movement, Antonio Gramsci wrote: "To fight for a new art would mean to fight to create individual artists, which is absurd since artists cannot be created artificially. One must speak of a struggle for a new culture, that is, for a new moral life that cannot but be intimately connected to a new intuition of life, until it becomes a new way of feeling and seeing reality and, therefore, a world intimately ingrained in 'possible artists' and 'possible works of art.'"[12] Gramsci re-framed debates about the politics of art that were taking place in the international Left by arguing that they should begin with the understanding that the arts are subordinate to and shaped by a far broader cultural and ideological struggle. For Gramsci, the cultural and ideological dimensions of class struggles are intrinsic to the exercise of hegemony. Hegemony names a social relation in which a dominant class or fraction of a class gains the "active consent" of subordinate or allied classes by exercising "cultural, moral, and ideological" leadership over them.[13] It is based on the economic power of dominant groups, and it is enforced by their exercise of domination through force as well, as succinctly captured in Gramsci's description of hegemony as consensus protected by an "armour of coercion."[14] Thus, the importance Gramsci and others accord to culture and ideology should not be taken to mean that their refashioning is sufficient for producing needed social change, or even that it is possible to bring about the cultural revolution Gramsci called for without transforming the economic and political structures upon which elites' power to shape culture and ideology rests.

Another Aesthetics Is Possible examines struggles over ways of "feeling and seeing reality" as they are intrinsic to contemporary class struggles. It analyses specific art practices as they shed light on ideological struggles and, specifically, as they advance cultural struggles of the Left. I describe as counterhegemonic those practices and forces that militate against the manufacture of consensual class domination. These work to dismantle the worldviews imposed by the powerful and replace these with an alternate critical and

coherent sense of reality through which people can grasp social contradictions. When Gramsci described this as replacing "common sense" (*senso comune*) with "good sense" (*buon senso*), his vocabulary underscored the fact that he was referring not only to the transformation of theoretical knowledge, but also to perception and practical knowledge.[15]

Because antisystemic movements are, among other things, powerful counterhegemonic forces, I have sought to understand how art practices have been influenced by and articulated with them. I have been inspired, in this regard, by the work of other scholars who have theorized art as part of movement cultures and analyzed how movements have produced counterhegemonic ideologies about culture and art.[16] Moreover, because artistic practices articulated with movements contribute to the latter's archives and repertoires, analyzing them also offers insight into the history and legacies of particular antisystemic struggles.

This book examines a variety of relationships art practices have to specific movements. Artists I discuss take up knowledge, discourses, and tactics that movements have produced, elaborate upon them, and translate them into new aesthetic forms. In some instances, they produce more speculative or utopian elaborations of worldviews movements have produced. Some artists fuse their art production with movements' forms of social action—be these direct action or economic resistance. They also engage in ideological struggles taking place *within* movements to amplify more radical tendencies.

As Luis Tapia argues, movements have the potential to act in every arena of social life.[17] In addition to mobilizing and organizing people and resources and transforming political systems, institutions, and forms of social organization, they also produce knowledge and shape culture and subjectivity. This has been amply theorized by intellectuals organic to socialist, anticolonial, and liberation movements, including those successful in taking state power, who have argued that collective projects of social transformation must also transform culture and produce new types of subjects.[18] Scholars have also shown how movements produce counterhegemonic knowledges and epistemologies, including alternative ways of conceiving of territory, nature, production, and justice.[19] For Suely Rolnik and Félix Guattari, antisystemic movements enable dominated groups to reappropriate the production of subjectivity by developing their own values and practical and theoretical referents beyond those imposed by dominant capitalist cultures.[20]

The multifaceted agency of movements challenges the distinctions between culture and politics that liberal ideology upholds.[21] As Tapia writes,

they "displace politics from its institutionalized spaces [within liberal states] and politicize social sites that had been depoliticized and, as such, legitimated in their function for organizing inequalities."[22] In so doing, movements often make political culture—that is, the practical knowledge and norms that shape how political processes are understood—an explicit grounds of contestation.[23]

Radical movements reveal elements of the "other possible world" to which the EZLN's revolutionary discourse refers—that is, of a "new society with which old collapsing bourgeois society itself is pregnant."[24] Arguing against messianic and programmatic conceptions of social transformation, Raúl Zibechi insists that this "other possible world" is not a "program to be realized"; rather, it is *already* being built in the interstices of the dominant capitalist order. For Zibechi, antisystemic movements are bearers of a "real and possible new world" that is "woven into the base of new social relations" these movements organize, and our task, then, is to defend, strengthen, affirm, and expand it.[25]

This world-in-the-making is largely invisible within the aesthetic-ideological coordinates the dominant social order imposes. That is, it is *aesthetically* rendered invisible, impossible, or forever deferred. Aesthetic practices aligned with movements can work to affirm and defend this other world by producing conditions that allow others to perceive it *as a real world.* This is, of course, precisely what hegemonic aesthetic practices do for dominant capitalist and colonial social orders: they make these seem natural, desirable, or, at least, like the only possible, or even imaginable, reality.

To capture the sense in which the entire experienced lifeworlds of subjects are shaped to naturalize colonial-capitalist social orders, Eduardo Galeano uses the extended metaphor of a "looking-glass world," evoking Lewis Carroll's novel as well as Marx and Engels's metaphor of the camera obscura of ideology. In this "looking-glass world," Galeano writes, where "price determines the value of things, of people, and of countries," "model citizens live reality as fatality."[26] In order to contend with this foreclosure of alternatives, counterhegemonic aesthetic practices create perceptual-epistemological openings that make it possible to perceive another reality whose very existence is obscured within dominant ideology. This does not mean that one's worldview can be entirely transformed all at once. Nor does it mean that such transformation can be an individual endeavor or one confined to the realm of ideas. On the contrary, Galeano's metaphors of a looking-glass school and its counterschool fittingly represent the composition and re-composition of

people's perceptions and understanding of reality as a collective and ongoing process that is grounded in material practice.

THE FOURTH WORLD WAR

The artists and writers addressed in this book were all born in the late 1960s or 1970s, and they became involved in art-making and grassroots politics in the late 1980s or 1990s. They are keenly aware of their generational formation as Leftists who came of age in the midst of antisystemic movements that differ significantly (in their theories, forms of organization, and social action) from the national revolutionary and liberationist movements of the 1960s and 1970s that were the experiential touchstones for their older kin, as well as an inspirational reference point for the artists themselves. Ilich spoke about this in one of my interviews with him, saying:

> My generation is the generation of rupture. My generation wanted international socialism; we had to make do with Zapatismo. It's a different thing, no? We wanted the romantic moment with Che's guerrilla, and Lenin, and later the state, production, space travel, socialism, the distribution of wealth in social forms, socialization of life, recreation, healthy food, electricity for everyone. And the Zapatista Indians brought another thing, which are ideas of autonomy, diversity, organization, right? They are against the state, so they absolutely changed our paradigm. Fortunately, I feel like I adapted to these times.[27]

Similarly, artists from Etcétera . . . describe themselves as belonging to a generation that is a "hinge"[28] between the world-historical conjuncture of the 1960s and early 1970s, in which revolutionary socialism was the horizon for antisystemic movements across Latin America, and the 1990s, when neoliberal capitalism was globally hegemonic, the institutional Left was liberal-reformist, and radical Left movements were not, generally speaking, immediately oriented toward taking state power. As a *hinge,* they connect the ideals of movements of their parents' generation to those in which they are involved, while contending with the transformation of antisystemic politics that has occurred in the intervening years.

The rupture in Left politics their generation straddles was accomplished through a ruling-class counteroffensive against labor and the Left, which I describe later. For the artists I write about, this is an unavoidable history, and, indeed, the political import of *how* it is historicized is of central concern to the Chilean and Argentine artists of Etcétera . . . and Grupo de Arte

Callejero. Their work demonstrates that an engagement with this history need not operate in melancholic or cynical modalities that fixate on the Left's defeat or claim that its youthful adventurism brought this about,[29] nor through idioms of nostalgia or funereal memorialization, which also bury radical politics in an inaccessible past. While readily learning from the histories that preceded them, these artists emphasize the vitality and urgency of Left movements in the present and demonstrate their full assumption of their own potential to make history in circumstances they did not choose.

These artists have honed the arts of rebellion within the world-historical context of the Fourth World War. This is the name the Zapatistas have given to the contemporary war of accumulation globalized capital is waging against "all of humanity, against the entire planet,"[30] in which "everything which opposes the logic of the market, ... everything that prevents a human being from turning into a producing and purchasing machine is an enemy, and it must be destroyed."[31] While the accumulation of capital has denoted social warfare from its beginnings, the "Fourth World War" specifically refers to the form this has taken since the late twentieth century, in the context of globalization and globally hegemonic neoliberalism, as capitalist classes have managed to go further than ever before in "tearing down all nonmarket structures that have in the past placed limits on the accumulation—and the dictatorship—of capital."[32]

In the Zapatistas' periodization, the Fourth World War follows the Third. The "Third World War" refers to the period otherwise known as the Cold War (1945–90), during which time covert wars and wars of "intervention" waged in the Third World by the global superpowers and their surrogates killed an estimated 21 million persons and rendered more than a hundred million others refugees.[33] The inauguration of the Fourth World War in the 1990s indexes the end of the age of "three worlds," when First World Keynesian capitalism, Second World socialism, and Third World decolonization and capitalist developmentalism coexisted, and refers to the contemporary period of capitalist globalization in which "every country and much of humanity [is integrated] into a new globalized system of production, finance, and services."[34] As "globalization" refers to the spread of capitalist production relations around the world and the concomitant destruction of other forms of social organization, it is a continuation of the process that began with European colonialism and the consolidation of the capitalist world-system in the fifteenth century.[35] But "globalization" also refers to a transformation of global capitalism that began in the 1970s. Its salient feature is the

globalization of production processes, which has been enabled by neoliberal restructuring.[36]

Globalization and neoliberal restructuring constituted a counterrevolution led by the capitalist class and its political representatives and ideologues.[37] Coming in the wake of the World Revolution of 1968 and a structural crisis of accumulation, globalization was a means for capital to "break free of the class compromises and concessions" that the working and popular classes had won through decades of struggle, as well as to overcome limits nation-state–based corporate capitalism had placed on accumulation.[38] This reorganization of the accumulation process operated through the imposition of neoliberal social and economic policies on societies throughout the world.[39] These include social austerity, economic deregulation, trade liberalization, cuts to public employment and services, regressive taxation, and the privatization of commonly held social goods.[40] Neoliberalization has subordinated national economies to global economies and has opened up new territories for capitalist profiteering (i.e., outlets for excess accumulated capital).[41] It has also given capital more power to exploit and discipline labor, including through the latter's deregulation and flexibilization.[42] Neoliberalization has transformed capitalist social welfare states into states that more aggressively subordinate the needs of the working class to the demands of capitalist accumulation, while relying ever more regularly on coercive means to ensure obedience to this order.[43] While neoliberal policies are often a more ready target of critique than the capitalist system itself, it is imperative to remember that, as Samir Amin writes, "the savage neoliberal offensive only reveals the true face of capitalism and imperialism."[44]

The transformation of global capitalism since the 1970s has entailed a new round of primitive accumulation, entailing the expansion of capitalist social relations into formerly noncapitalist strata and the concomitant annihilation of the latter's forms of production and social organization, and the separation of millions of people from the means of production.[45] As theorized in Marxist thought, primitive accumulation is a permanent feature of capitalist accumulation and class war that grows from capital's constant need to form new markets and re-create labor supplies.[46] The expansion of capitalist relations operates both extensively and intensively, spreading into new territories and commodifying ever more aspects of social and biological life. It regularly operates through colonial conquest and plundering, war, dispossession, proletarianization and pauperization, and the transfer into private ownership of means of production that had been held in common, including the productive powers of the natural world.[47] While the Midnight Notes

Collective influentially theorized the latest round of intensified primitive accumulation that has occurred around the world since the 1970s as the "new enclosures," in reference to the process of enclosure that occurred in England in the late 1400s that helped give birth to capitalism, spokespersons for the EZLN use the vocabulary of "war" and "conquest" to theorize this phenomenon, thereby underscoring colonialism's foundational and ongoing role in capitalist accumulation.[48]

Latin America has been described as a "laboratory for neoliberal policies,"[49] in reference to their early and experimental imposition in the region. The process of neoliberalization was launched in the Southern Cone (Chile, Argentina, Uruguay) in the 1970s by civil-military dictatorships backed by national and transnational capitalist classes and the U.S. state apparatus.[50] These regimes used authoritarian governance and terrorism, including an internationally coordinated political assassination program (Operation Condor), to create political conditions that allowed them to impose anti-worker policies and attempt to eradicate socialist and communist ideologies and organizations of social solidarity.[51] This violent counterrevolution was also a reaction to the post–World War II advance of the Left across Latin America, which included the triumph of the Cuban Revolution (1959), the spread of Left guerrilla movements, and the rise of a socialist government in Chile (1970–73) and of Left-leaning nationalist governments elsewhere.[52] As Right-wing, pro-capital dictatorships took power across the region, they overthrew these governments through military coups, decimated the armed Left, and attacked workers' movements.

The United States' ruling class and state managers abetted these attacks on labor, the Left, and democratic institutions, and aided in the authoritarian imposition of neoliberal policies across Latin America and other parts of the Third World.[53] Their imposition of neoliberalism within the United States involved a greater "construction of political consent" via a powerful ideological crusade and the capture of political parties.[54] Yet it also entailed union-busting, strike-breaking, and intensification of the state's "domestic war-making," including the "secret, systematic, and sometimes savage use of force and fraud, by all levels of government, to sabotage progressive political activity."[55] The massive expansion of the Unites States' "industrialized punishment system," which made it the largest incarcerator in the world, was also a constitutive feature of neoliberal social and economic restructuring, serving multiple functions: to discipline labor and neutralize potentially rebellious persons who had been expelled from formal labor markets by restructuring, and also as a site of capitalist profiteering in itself (i.e., an outlet for excess accumulated capital).[56]

In the 1980s and the beginning of the 1990s, the neoliberalization process launched by dictatorships in Latin America was legitimized by the constitutional and nominally "democratic" regimes that succeeded them, whose "form of elite rule performs the function of legitimating existing inequalities . . . more effectively than authoritarianism" by offering a simulacrum of democratic participation in the form of tightly controlled elections.[57] While the 1980s saw an upsurge of Left movements in Central America, by the 1990s, following the defeat of the Sandinistas, neoliberal hegemony had spread across the Americas.[58]

While the U.S. state promoted neoliberalization and globalization across the hemisphere through economic coercion, propaganda, and military force, this should not be understood simply as a matter of its national ruling class promoting its imperial interests. Rather, as William Robinson argues, the U.S. state apparatus acts on behalf of the interests of a *transnational* capitalist class and uses its power to defend, expand, and stabilize the global capitalist system.[59] The underlying thrust of Robinson's argument is that a nation-state–based understanding of sociospatial relations obscures the dynamics of class struggle since globalization. He argues that the international division of labor that was created by modern colonialism has been reconfigured by the "transnational disbursal of the full range of world production processes" and the unprecedented transnational mobility of workers and the formation of a truly global labor pool.[60] A materialist analysis of how "groups exercise social power— through institutions—to control value production, to appropriate surpluses, and to reproduce these arrangements" reveals that global society has become "increasingly stratified less along national and territorial lines than along transnational social and class lines."[61] This is evident, for example, in the presence of conditions associated with peripheral social formations within the territory of core countries, including the United States, as well as capital's increasing use of immigrant labor pools and of the citizen/noncitizen divide to organize inequality and exploitation *within* a given state's territory.[62]

A transnational "*social* cartography"[63] not formatted by the sociospatial imaginary of the nation-state also brings into view the transnational contours of antisystemic struggles of recent decades. Michael Denning provides such a map in his historicization of the global antisystemic tendency that emerged in the 1970s. This antiglobalization movement (or movement of movements) has been constituted by heterogenous forms of struggle from below, from popular uprisings to organized movements and new forms of labor militancy.[64]

Latin America has been an epicenter of this antisystemic movement. Its status as a "laboratory for neoliberalism" also reflects the fierce resistance

working and popular classes have mounted to the neoliberal model, which prevented it from achieving stable hegemony in the region. The continental indigenous movement has been a leading force for mobilizing the popular classes in resistance to the predations of transnational capital.[65] As I discuss in chapter 1, the Zapatista uprising in 1994 galvanized the global Left, making clear that armed struggle was not a relic of the past, as liberal ideologues claimed. The Zapatistas have since redefined revolutionary praxis through their pursuit of autonomy and indigenous liberation and their powerful critique of the liberal colonial state.

A few years after the Zapatista uprising, workers in Argentina's provinces who had been thrown out of the formal labor sector by a wave of privatizations organized autonomously in what became known as the *piquetero* (picketer) movement. As I discuss in chapter 3, the *piqueteros* and the human rights movement were among those collective forces from below that set the stage for a massive popular uprising in Argentina (2001–2) that ousted the president and his entire cabinet and opened up an extraordinary context for social solidarity and mobilization.

The Zapatista and Argentine uprisings are among a constellation of popular uprisings that have taken place across the Americas in which the popular classes have collectively enacted their repudiation of capital's dictatorship and the political and repressive institutions that enforce it. These have also included the Caracazo (1989), which forms part of the genealogy of the Bolivarian Revolution; the Los Angeles Rebellion/Rodney King Riots (1992), which was led by the city's "multicultural and transnational working poor who had suffered most from economic restructuring";[66] multiple uprisings led by the indigenous movement in Ecuador throughout the 1990s and early 2000s; the Cochabamba Water Wars (2000); and many others. Antisystemic politics has also taken the forms of labor militancy and mass movements of peasants, women, environmentalists, students, and the urban poor, who have organized themselves outside of the institutions of the state. These movements brought progressive governments to power across South America is what is known as the "Pink Tide" (although, as I discuss in chapter 4, the relationships progressive liberal governments have had to popular movements are complex and oftentimes antagonistic). Latin American immigrants within the United States have also been protagonists of antisystemic movements, as evidenced, for example, in the new labor movement that emerged in L.A. in the 1990s and the immigrant rights movement that mobilized millions of people and organized massive strikes in the mid-2000s.

As Denning notes, while the many movements that comprise the global antisystemic tendency "share a common foe, even a common struggle, they don't always share the same analysis, strategy, or even name for that foe."[67] This is understandable. When conflicts arising from capitalism's contradictions confront political actors in particular social-cultural formations, "how these actors respond is 'mediated' by a host of concrete particulars," writes Colin Barker. For this reason, social movements should be understood as "*mediated* expressions of class struggle," he argues.[68] Moreover, because "historically, capitalism has expanded not only by 'economic' means" but also through "colonial subjugation of whole peoples, slavery and forced labour, coerced breaking up of older systems of social reproduction, immensely destructive wars along with the promotion of racist, sexual, religious and other oppressions," struggles against these numerous forms of oppression and violence are not distinct from class struggle, but "are mutually interdependent parts of the social movement against capitalism as a totality."[69] This book examines concrete instances of political and aesthetic struggle that form part of this global movement.

My purpose in composing a constellation of connected histories from distinct sociocultural formations is to show how contemporary movements and uprisings and their allied artistic practices form part of an antisystemic tendency that is rooted in transnational class struggles. Dominant ideologies—those that compose the "looking-glass world" so poignantly diagnosed by Galeano—attempt to obscure the scope and ferocity of anticapitalist struggle by representing resistance to exploitation and oppression, which is constant, multiform, and global, as so many isolated, purely local, and short-term adventures. Acting as a counterinsurgent force, the "looking-glass school" also teaches us that antisystemic movements are purely reactive, foreclosing apprehension of the other worlds they defend and create. As I hope this book will contribute to the counterschool Galeano invokes, I have sought to uncover connections across time and space that are so often effaced, to analyze the capacious and multiform capacities of movements from below, and to insist on their world-making ambitions and very real capacities—and to show how these are (though not exclusively) aesthetic endeavors.

AGAINST REPRESENTATION

Across the Americas, antisystemic movements have brought about legitimacy crises for neoliberal states. They have put into sharper relief the contradiction between these states' hegemonic function and class function—that

is, the extent to which their mandate to facilitate capitalist profiteering undermines the material basis for their ability to govern through the manufacturing of consent.[70] These legitimacy crises are also described as "crises of representation." I understand this to mean a crisis in the *ideology* of political representation,[71] which plays a central role in liberal states' hegemonic modes of domination.

Illustrating Gramsci's famous dictum that hegemony is "protected by an armour of coercion," neoliberal states in the Americas use violence to manage social conflict and repress antisystemic movements and uprisings.[72] Chapter 4 addresses this phenomenon in Argentina, examining the ways hegemonic and coercive modes of domination are related, as well as the ways they are differentially applied to persons belonging to different social classes. As the U.S. state has led a remilitarization of Latin America in recent decades, it has worked to arm and enlarge Latin American security forces and orient them toward the repression of those designated "internal enemies," including antisystemic movements.[73] It has also increasingly militarized its own territory, treating domestic policing as urban counterinsurgency operations akin to its neocolonial warfare abroad.[74] The explosive growth of the prison- and immigrant detention–industrial complex and the expansion of policing powers in the United States have served as a means of domestic social control in the face of a weakened material basis for hegemonic governance, while profiting from repression has become ever more central to circuits of accumulation.[75]

The artists discussed in this book have amplified the legitimacy crises collective movements have brought to neoliberal states by using their art to publicly critique ideologies of political representation and national identification through which these states exercise hegemony. This is evident in the artists' trenchant criticisms of bourgeois nationalisms' functionality for class domination, ongoing colonial conquest, state terrorism, and ideological obfuscation. For example, the Pocho Research Society's guerrilla interventions on state monuments show how nationalist aesthetics shape perceptions of history, territory, and human collectivities in ways that erase histories of imperialist conquest and naturalize racialized divisions of the global working class.

The artists also critique liberal political ideologies that operate through other modes of recognition. Ilich builds on the EZLN's fierce criticisms of the Mexican state as he satirizes and deconstructs its discourses of *indigenismo,* which operate as a form of multiculturalist representational politics that bolsters the domination of indigenous Mexicans by the (neo)colonial ruling class. The heterodox and radical reading of human rights politics put forth

by Etcétera... is a pointed challenge to liberal human rights politics that channel people's desires for justice toward institutions of bourgeois states that enforce systematic injustice. Works by Grupo de Arte Callejero and the Internacional Errorista reveal how security discourse interpellates subjects as citizens while justifying violence on behalf of capital's class war.

These artists all offer nuanced analyses of the ways in which the naturalization of representation as the ideological basis of hegemonic governance under liberalism is, among other things, an aesthetic endeavor—that is, one that marshals myriad aesthetic practices to capture people's imaginations, channel their desires, and shape their entire worldviews. Their work shows how ideologies of representation are promulgated by cultural productions and institutions whose political function in this regard is typically obscured. From Ilich's critique of museums and de la Loza's interrogation of historical productions, to Etcétera...'s examination of memory sites and sports spectacles, GAC's critical mimicry of touristic and nationalist signage, and the Erroristas' parodies of corporate media—these artists offer a broad view of ways in which culture is regularly used to bolster the hegemony of the ruling class.

Marxist analyses of the social role of intellectuals vis-à-vis the social relations of production illuminate the political agency exercised by those who engage in intellectual and communicational labor to shape public consciousness.[76] The hegemonic function of cultural productions to form citizen-consumer-subjects and enforce dominant ideologies operates not only through what they represent but also through their formal qualities and the modalities of reception they solicit. For example, as I discuss in chapter 3, artist-theorists have argued that the formal qualities of bourgeois theater serve its function as an instrument of class domination, as they naturalize the logic of political representation (i.e., delegation) and encourage a passive disposition in subjects.[77]

David Lloyd and Paul Thomas have shown how discourses on aesthetics and "high culture" that represent these as constituting an extra-economic and extrapolitical space of freedom and self-development actually work to bolster the exercise of hegemony. The (presumably ethical) "disposition of disinterested reflection" they solicit is a "formal or representative disposition" of the subject that annuls concrete particularity and questions of material differences among individuals. This disposition naturalizes the ideology of representation central to hegemonic governance under liberal "democracies," as it primes subjects for a form of political participation that offers only a "purely formal expression of equality."[78]

These theorists argue what is also amply demonstrated by the history of ruling classes' uses of culture as a tool of domination: (1) the cultural apparatus performs a hegemonic function; (2) ideologies about aesthetics and culture that deny this bolster this hegemonic function; and (3) cultural productions' ideological force operates through aesthetic form, the social relations cultural production and reception organize, and the formatting of reception, as well as on symbolic registers. Knowing this, it is only by assuming the *political* nature of our social role that we can mobilize our intellectual and communicational labor toward emancipatory and egalitarian ends.[79] Lloyd suggests that challenging the ideology of representation as it manifests in the "self-evidence of the state–civil society formation" is a crucial task for thusly committed intellectuals, given that our ascribed social function vis-à-vis liberal governance is precisely to naturalize this ideology.[80]

As counterhegemonic intellectuals, the artists discussed in this book use their work to amplify crises of hegemony that have erupted out of the longer-term and collective labor of antisystemic movements, while also shining a light on the constructive and creative character of these movements—that is, their capacities as "bearers of other worlds." The artists' critique of representational ideologies of liberal states operates in tandem with their efforts to convoke, defend, and bring into view other types of collectivities that exist both below and beyond liberal-colonial states and the categories of affiliation they impose. They do this not only through representations they put forth but also in terms of how, with whom, and for whom they produce, and the counterpublics and co-conspirators they seek or organize in the process. These relationships are manifested in multiple, often nested scales: from engagement with local social struggles to participation in movements of national and transnational dimensions.

PRODUCTION

The politics of artistic practices, and specifically the ways in which they are articulated with collective struggles, is manifested not only in the characteristics of individual works but also, fundamentally, in the social relations inscribed in these works' production, circulation, and reception.[81] This has been demonstrated by theorists and artists who critically interrogate the social relations of cultural production in class society and seek to transform them. Bertolt Brecht and Walter Benjamin theorized this endeavor in the 1930s in seminal texts on socialist art in which they argued that the social relations of cultural production are themselves a site and stake of class

struggle.[82] They asserted that the politics of a committed intellectual's or artist's practice lies not only in the political ideas represented in the works they produce but also in their work *on the forms and instruments of production.* The artist or intellectual should work to "alienate the apparatus of production from the ruling class" and transform it "to the maximum extent possible in the direction of socialism," Benjamin wrote, drawing on Brecht's concept of functional transformation. This is necessary, he added, because the "bourgeois apparatus of production and publication can assimilate an astonishing number of revolutionary themes without seriously placing its own existence or the existence of the class that possesses them into question." [83]

Countless artists have treated their work on the "forms and instruments" of cultural production and circulation as intrinsic to the politics of their practice—from Cine Liberación's revolutionary reconception of cinema and Augusto Boal's Theater of the Oppressed to anti-authoritarian protest art, arts of the Black and Chicano liberation movements in the United States, *testimonio* literature, and tactical media, to name just a few examples.[84] The artists I discuss in this book contribute to this tradition. They have forged alternative modes of producing and circulating art that move well beyond traditional *dispositifs* of exhibition and publishing. These enable their participation in collective movements and also afford them greater freedom from ruling-class institutions' functionalization of artistic labor. For example, Ilich disseminates literature via email lists, online petitions, and the sale of coffee, and he organizes the production of his artwork so that it supports Zapatista cooperatives' solidarity economies. Etcétera... and GAC combine their art with direct-action tactics to contribute to the Argentine human rights movement. The Pocho Research Society enacts direct-action public history by installing their own unauthorized historical markers in public spaces. Moreover, these artists have all created autonomous cultural infrastructure, from cultural and activist spaces (be they in storefronts, garages, or squats) to zines, independent presses, and platforms for collaboration. They use the production and circulation of their work to convoke communities of co-conspirators—be it through collective artistic production, the formation of translocal networks of activists and fellow travelers, or by creating work with and for the counterpublics organized by the movements of which they are part.

I am not suggesting that the artists and practices I examine are wholly disconnected from official cultural institutions or their symbolic and financial economies, nor do I want to deploy a strict or implicitly moralized inside/outside dichotomy as a means for understanding how artistic labor is related

to institutions and markets. After all, the "outside" of the cultural institution is still within capitalist social relations, and these artists face the unyielding economic demand of having to sell their labor power. Moreover, they generally seek to have expansive and varied audiences for their work. They have each figured out different ways of doing this: whether this means having both guerrilla and institutional art practices, subsidizing their art practice by selling their labor in other ways, and/or funneling institutional resources into their political communities. Without suggesting that a space of freedom for artistic labor lies just beyond the commercial art gallery or publishing house, I want to show how people shape the conditions in which they can produce and circulate their art in order to prioritize the *political use-value* of their practice over and against the system of values ruling-class institutions and markets impose upon art. Moreover, I will argue that this is *itself* a creative, world-making practice.

EXPERIMENTALISM

Recognizing that aesthetics is politicized across all dimensions of social life, these artists employ an omnivorous experimentalism that allows them to engage in aesthetic struggles in multiple sites and through myriad forms—including those considered extraneous to fine art and literature. While the performing, visual, and literary arts serve as a "historic reservoir" of techniques and "material, conceptual, and symbolic strategies" for their practices, these practices are not only artistic.[85] I describe them as *paradisciplinary* because they operate beyond the normative parameters of disciplinary understandings of art and literature, while some also exist as heterodox versions of other disciplinary practices.[86]

Within art historical discourse and aesthetic theory, artists' forays beyond their specialized fields is often celebrated as a consummate avant-garde gesture when it constitutes a renegotiation of what can be institutionally recognized as art, or when it is interpreted as a dissolution of distinctions between "art" and "life."[87] Yet the former interpretation accepts elite institutions' monopoly on the ratification of artistic value, while the latter implicitly relies on the ideology of art's autonomy.[88] When experimentalism is analyzed principally in terms of difference or innovation vis-à-vis a canonized history of forms (i.e., those already recognized as *art* from the perspective of ruling-class ideology), "newness" frequently functions as an unquestioned value unto itself. This is an expression of the market logics that suffuse contemporary culture industries and complicit progressivist ideologies of

cultural history. As association with newness translates into symbolic and financial capital, producers are encouraged to see themselves as individuals competing to differentiate their products from others', rather than as participants in collective projects organized around values other than the capitalist valorization of boutique products or services for elite consumption.

I am interested, instead, in elucidating artistic experimentalism that is rooted in an antisystemic politics—where the willingness to inhabit or create new forms and to combine art-making with other kinds of practices serves to bolster the counterhegemonic politics of this practice and/or connect it more effectively to collective movements. In doing this, I have been inspired by Brecht's theorization of the importance of experimentation in socialist art practice. In contraposition to other Marxist theorists' attempts to codify "correct" formal qualities for socialist literature, Brecht conceived of the politics of art in terms of its political and ideological *ends*.[89] He argued that socialist art should be *popular* in the sense that it should be for the people, the working masses, noting, "We have a people in mind who make history, change the world and themselves. We have in mind a fighting people and therefore an aggressive concept of what is *popular*." Socialist art should also be "realistic" insofar as it should render apprehensible the "causal complexes of society," exposing ideologies that obscure these as "views imposed by the powerful," while "making possible the concrete and making possible abstraction from it."[90] In order to do this, Brecht argued, artists would need to be radically experimental, because they are operating in a dynamic social reality that is continually transformed by class struggle:

> With the people struggling and changing reality before our eyes, we must not cling to "tried" rules of narrative, venerable literary models, eternal aesthetic laws. . . . But we should use every means, old and new, tried and untried, derived from art and derived from other sources, to render reality to men in a form they can master. . . . Methods become exhausted; stimuli no longer work. New problems appear and demand new methods. Reality changes; in order to represent it, modes of representation must also change. . . . The oppressors do not work the same way in every epoch. . . . To turn the hunter into the quarry is something that demands invention.[91]

Brecht makes a *political* argument for artistic experimentation and formal innovation. This includes the practice of what I am calling paradisciplinarity, as he suggests that artists should draw on all types of forms and techniques, including those derived from sources other than the fine arts.[92] By arguing for an anti-idealist, historical, and situational analysis of art's potential to

support the socialist movement, Brecht suggests that the most effective aesthetic strategies will be developed through attention to the ways that class struggle is manifested in a historically specific social formation. I consider the experimentalism of the art practices discussed in this book in this fashion, and I analyze how artists' readiness to devise new forms and modes of making and circulating their art—or to utilize forms and techniques from other types of social practice—is meaningful to the politics of their practice and its articulation with collective struggles.

ART BEYOND ART

A great deal of writing on the relationship between politics and art treats these as historically transcendent categories with discernible essential qualities in order to argue that there is a unique relationship between them (i.e., between *art* and *politics* understood as decontextualized abstractions).[93] As Gabriel Rockhill argues, this obscures the fact that these sociocultural categories not only are constructed but are sites of struggle. Because such an approach brackets the complex social relations involved in specific aesthetic and political practices, it lends itself to an analysis of isolated artworks as if they were "talisman-like" in their magical ability to produce political effects all on their own, or to fail in doing so.[94] For these reasons, I do not make claims about the "politics of art" in an abstract sense. Instead, I examine specific artistic practices, ideologies, and movements in order to understand how political struggles manifest in struggles over aesthetics.

Rockhill's observations are of special relevance to this book, given that the art practices I examine are enmeshed in movements that actively displace the sites and meanings of politics, and given that they are not *only* "art" practices. Because they do not conform to forms and modes of circulation typically associated with fine art and literature, these practices have often been perceived as being something other than art or literature—be it activism, commerce, solidarity work, or vandalism. Their legibility as art, or as something else, is dynamic and situational. Taking seriously their variegated modes of circulation and reception means rejecting the notion that they must be *one* kind of production or practice in some essential sense.

The social life of these practices stands as a rejoinder not only to the ideology of art's autonomy from other aspects of social life but also to the idea that the aesthetic experience proffered by those creative practices socially designated as art is essentially different from other aesthetic experiences.[95] They make evident the need for an anti-essentialist understanding of art that

recognizes it as a sociocultural category that pertains to a historically and culturally specific social organization of labor, including reception.[96] The very perception of *art* that flows from this organization of labor is overdetermined by the social relations of production in general and by colonial, racial, and gender ideologics.[97] That is, there is an *immanently constituted* social understanding of what art is in particular contexts, which is shaped by institutions and markets and, ultimately, by the class relations to which these respond. Ideologies that affect how people perceive different kinds of creative labor, including ideologies about aesthetics and art, are themselves products of class struggle.

The artists I write about (like many artists) understand this perfectly well and intervene at *this* level. They knowingly manipulate the "signal systems"[98] that socially identify certain kinds of productions and practices as artistic, as this allows their work to circulate and be interpreted in ways that are not always preformatted by its identification as art or literature. In some cases, this allows them to interrogate the aesthetic-ideological dimensions of other types of practices or productions—such as historical markers, commercial exchanges, petitions, policing, news reports, and museum souvenirs. Avoiding identification of their practice as art in certain contexts also allows them to maximize its political use-value. As Stephen Wright argues, some activist artists do this in order to avoid the overwriting of their works' use-value by the abstract, homogenizing symbolic value that is associated with—in fact, defines—*works of art*.[99] By intentionally suppressing the social identification of their practice *as art,* he suggests, artists can encourage modes of reception in which the political use-values of their productions can predominate.[100] This evinces artists' engagement with aesthetics in the more capacious sense that I propose, as they understand that the very perception of art is an aesthetic phenomenon produced by social practices, and is therefore a site of potential intervention.

ABOUT THIS BOOK

My transdisciplinary research methodology is based on my understanding that artistic production is fundamentally a social practice. I have aimed to provide a complex account of the social worlds from which specific artistic and political practices have emerged and in which they have their effects. To do this, I bring together sociological and cultural analysis, history, ethnography, and formal analysis of artworks. As I analyze cultural productions and the social conflicts in which they are embedded, I show how these have

emerged from historical processes that unfold at multiple sociospatial scales. I thereby demonstrate how various local, national, and regional histories are interrelated and how these express structural dynamics that define the capitalist world-system. To develop this historically grounded and multiscalar transnational framework of analysis, I have drawn on Marxist social theory and scholarship from across the humanities and social sciences. I have been especially influenced by scholarship that analyzes Latina/o/x and Latin American history and culture through transnational, international, or global frameworks and whose challenges to nation-state–based paradigms in knowledge production are rooted in an internationalist politics.[101]

Since I began researching articulations between artistic practices and antisystemic movements in 2001, I have regularly interviewed artists about their practices and how these relate to political ideologies they embrace, movements they are part of, and histories that have influenced them. This book draws on many interviews carried out between 2002 and 2018, as well as the kind of knowledge that is gained through informal conversations and shared experience. I have known all of the artists I write about here for fifteen to twenty years, and I have spent a good deal of time with most of them. In this time, I have learned not only about their art but also about other things they do and the preoccupations and commitments that drive them. Knowing these things encouraged me to write about their work together. That is, I wanted to write about artists who bring their anticapitalist and antiracist politics into their artistic praxis. The intellectual questions and political preoccupations that drive my own research made this a determinant framing for this book—more than, say, artists' shared national origin, identities, or work in specific mediums or genres.

In many ways, my research for this book has been deeply intertwined with my seeking out and finding interlocutors, comrades, friends, and collaborators. I do not position myself as a disinterested critic, nor do I have a purely scholarly interest in the practices I write about here. Rather, I see them as part of a collective project that has fundamentally shaped how I see the world and to which I hope my own work can contribute.

This book begins with a study of a radically experimental transdisciplinary art practice that is aligned with Zapatismo. Chapter 1 examines work by Ilich that proffers an anticolonial and anticapitalist worldview while making metropolitan art production materially useful to Zapatista communities. It principally focuses on *Raiders of the Lost Crown* (2013), a heterodox alternate reality game whose players were charged with recapturing a legendary Mexica (Aztec) headdress from the Austrian museum that owns it. As the

game unfolded through epistolary exchanges, petitions, guerrilla interventions, and the operations of a pop-up coffee shop, it became clear that the mission to obtain the headdress was actually a plot device within an interactive narrative that ultimately articulated a far more capacious critique of contemporary colonialism and imperialism, tracing their dynamics from museums to capitalist regimes of debt and property, extractivism, NAFTA, indigenous dispossession, and Mexican nationalism and *indigenismo.*

As chapter 1 demonstrates how contemporary colonialism and imperialism marshal the power of aesthetics to naturalize their predations, it introduces two concepts I use throughout this book. First, I propose a *stereoscopic aesthetics* as one that enables the apprehension of multiple realities and the relation between them—specifically, a dominant "reality" and the counterhegemonic worldview(s) it attempts to foreclose from perception. Stereoscopic aesthetics provides a social depth of perception insofar as it enables an apprehension of epistemological-perceptual difference *and* throws light on the relations of power through which this difference is managed, negated, or obscured. Second, I consider aesthetic strategies that demonstrate the mutual imbrication of colonial, neocolonial, and neo-imperial time-space formations. Specifically, I show how *Raiders* enables a perception of *palimpsestic time* (a term I borrow from M. Jacqui Alexander) as it highlights the colonial character of contemporary modes of capitalist accumulation and liberal governance as they operate in the Fourth World War.

Chapter 2 deepens this book's inquiry into ways aesthetic practices situate subjects in particular time-space formations. It examines the guerrilla art practice—that is also direct action public history—of the Pocho Research Society of Erased and Invisible History. This collaborative platform in Los Angeles is a creation of Sandra de la Loza. The ephemeral countermonuments the Research Society installed throughout L.A. from 2002 to 2008 memorialized erased histories of working-class Latinas/os/xs and Latin Americans and illuminated forms of territorial displacement to which these groups are regularly subjected. Through a discussion of several of these works, I posit the concepts of *aesthetics of history* and *aesthetics of space* as heuristic devices that can illuminate particular facets in the social framework of sense-making. I use these concepts to analyze ways in which the social construction of collective pasts and the production of space are intertwined as they operate as tools of power and sites of struggle. I argue that the Pocho Research Society's guerrilla art models a counterhegemonic practice of historical sense-making that reconfigures underlying epistemological frameworks, practices, and social relations that shape historical production, specifically, as

it is manifested in public monuments and memorials. This chapter's discussion of counterhistory as a historical methodology that attends to the ways historical processes are distributed across multiple social strata, spatial scales, and temporalities illuminates the Pocho Research Society's heterodox practice of public history, while also elucidating (albeit indirectly) aspects of my own methodology in this book—specifically my focus on popular politics and its tension with bourgeois politics and the way I move between local, national, and transnational scales of analysis.

Chapter 3 also considers the political stakes of the aesthetics of history, particularly as this pertains to how perceptions of violence and forms of governance are forged. Specifically, it examines how competing historical representations of Argentina's most recent dictatorship and its political violence offer radically different perspectives on the postdictatorship neoliberal social order, the relationship between authoritarianism and political liberalism, and the history and possible futures of revolutionary anticapitalist politics. Two Buenos Aires–based art groups are the focus of this chapter: Grupo de Arte Callejero, known as GAC, and Etcétera. . . . Both groups have used their art to contribute to the Argentine human rights movement since the late 1990s, combining their art production with exposure protests (escraches) the movement uses to publicly denounce persons responsible for state terrorism. I argue that GAC's urban interventions and Etcétera . . .'s surrealist street theater express a minor and more radical tendency within the human rights movement, as they channel the movement's condemnation of state terrorism during Argentina's last dictatorship toward a critique of the multiform violence inherent in class domination, including the violence of the postdictatorship neoliberal state.

GAC and Etcétera . . .'s work from the late 1990s and early 2000s also expresses a repudiation of the ideology of political representation promulgated by the (neo)liberal state. This repudiation became increasingly generalized in Argentina during this time, as the working class's discontent with the effects of neoliberal policies mounted and popular movements organized themselves at a distance from state institutions and traditional unions. A popular uprising and crisis of state hegemony in 2001–2 created conditions for autonomous movements to flourish and cross-pollinate. GAC's and Etcétera . . .'s work in this context reflects the insurrectionary, collectivist, and anticapitalist ethos of the uprising and the urban movements it constellated.

Chapter 4 examines work GAC, Etcétera . . . , and the Internacional Errorista created in Argentina from 2002 to 2005 that evinces a counter-counterinsurgent aesthetics. Their interventions critique the multiform

tactics of pacification that were used to neutralize and fragment antisystemic movements and reconsolidate state hegemony in the wake of the 2001–2 uprising, from the consuming spectacle of electoral politics to the incorporation of popular organizations into the state apparatus, the criminalization of the poor and of dissident movements, and the intensification of an antiplebian security discourse. When a new progressive and populist government took power in Argentina in 2003 and vied to control the meanings and possibilities of politics, the terrain for antisystemic politics shifted considerably, as did the work of the artists I discuss. By tracking this shift in their practice, I employ a method of cultural analysis that registers conjunctural dynamics of sociopolitical struggles and the way expressive practices are situated in them.

With their bawdy street theater, Etcétera . . . infiltrated and parodied public spectacles to reveal their function as forms of statecraft—including a solemn ceremony that showcased an alliance between human rights organizations and the state. Interventionist works by GAC and the Internacional Errorista that examine police power and security discourse interrogate how the work of repression abets capitalist accumulation, while also showing how policing functions in hegemonic rule—that is, by maintaining class stratification and, ultimately, producing subjects who accept the liberal social order and the violence used to maintain it. The Internacional Errorista, which styles itself as a sendup of a surrealist terrorist cell, addresses, at once, the criminalization of working-class movements and Left activists in Argentina and the antiterrorism discourses and laws that were imposed across the Americas as part of the so-called Global War on Terror. In so doing, their work reveals the imbrication of spatial scales at which pacification and securitization operate and the traffic among different figures of criminality constructed by the transnational policing apparatus.

Through an
Anticolonial
Looking Glass

VIENNA'S WORLD MUSEUM (Weltmuseum Wien) holds in its collection a rare and storied *quetzalapanecáyotl*—an adornment made of quetzal feathers—known as the Ancient Mexican Feather Headdress, the Penacho de Moctezuma (Moctezuma's Headdress), and the Copilli Quetzalli (Precious Crown). Though its provenance is disputed, it is said to have belonged to Moctezuma Xocoyotzin, the penultimate ruler of the Triple Alliance, commonly known as the Mexica or Aztec Empire. In the early sixteenth century Hernán Cortés led the invasion and conquest of the Alliance's capitol, Tenochtitlán, for the Spanish crown. The Spanish razed Tenochtitlán and built a colonial city on its ruins that would become the seat of the viceroyalty of New Spain and of Mexico's Catholic archdiocese. Meanwhile Cortés brought the quetzalapanecáyotl back to Europe as part of the war booty stolen in the conquest. He gave it to Charles V, the ruler of the Holy Roman Empire and the Kingdom of Castile and Aragon. The Penacho has remained in European collections ever since.

A facsimile of the Penacho is exhibited in Mexico's National Museum of Anthropology, where it forms part of a monumental display of ancient Mexica artifacts. Mexican state officials have appealed unsuccessfully to

Austria for the return of the real headdress, and Mexican activists have led international petition campaigns and protests demanding its restitution.[1] An employee of the World Museum even suggested that the international controversy surrounding the ownership and display of the "notorious *penacho* of Moctezuma" is more well-known than the World Museum itself.[2]

In 2013 the Diego de la Vega Cooperative Media Conglomerate disseminated a letter and petition online, in Spanish and English, asking for support in its efforts to repatriate the headdress. These were authored by Diego de la Vega's founder and CEO, Fran Ilich. Ilich is an artist, writer, and activist who works in narrative media, social art, and long-term collective projects that experiment with alternative forms of economic organization and autonomous cultural production. Diego de la Vega is both a collective entity and a meta-artwork[3] by Ilich that functions as a platform for activist and artistic endeavors. Ilich's letter announced that the cooperative was gathering signatures to petition for the "[repatriation] of Moctezuma's feather crown to Mexico-Tenochtitlán." It summarized the history of the Spanish conquest and the headdress's transfer to Europe and concluded with an appeal to the moral reputation of the Austrian people and state: "We believe that the Austrian people and their democratic government don't want to stain their name and reputation more by keeping a war booty, which obviously was obtained in the midst of the American holocaust, a colonial process that exterminated people, languages, religions, and cultures, at a scale unknown to history ever since. For this and other reasons we think that the feather crown must come to the Americas."[4] Ilich's letter provided a link to the online petition, published on Change.org, which was addressed to the presidents of the Austrian and Mexican republics, as well as the World Museum. The petition featured the iconic photograph of the Penacho, whose copyright is owned by the World Museum, and included the following text, in both Spanish and English, beneath it: "Emperor Motecuhzoma's crown was brought to Europe by the bloody Spanish mass murderer Hernán Cortés in 1521, who gave it to the Emperor Karl V of the House of Habsburg as a war trophy. It has been almost 500 years since Quetzalapanecáyotl (the crown) became a prisoner of war. It is time to return home."[5] Over six hundred people signed the petition during the next few months. Yet, when I asked Ilich in an interview if he ever delivered the petition to its addressees, he replied, "Of course not. I don't believe in petitions. Especially not when they are addressed to Europeans."[6]

The petition Ilich penned and distributed online was not the activist instrument it appeared to be. Rather, it was anticolonial critique as literature and the means by which Ilich launched his alternate reality game *Raiders*

of the Lost Crown. *Raiders* was a live and participatory act of storytelling that took place over the course of five months, in both virtual and real-world spaces. Its transmedial narrative unfolded across multiple platforms, including the aforementioned petition, on- and off-line epistolary exchanges, a guerrilla intervention at the World Museum, meetings and conversations, invisible theater, and the activities of a pop-up coffee shop that sold and traded for Zapatista coffee. Although Ilich initially framed *Raiders'* gameplay as a campaign to restitute the Penacho, this "mission" was never the principal subject of its story.

With mordant wit and calculated deception, *Raiders* puts on display the colonial character of museums, neoliberal economic regimes, Mexican state politics, and the geopolitical determinations that define debt and property. It ironizes and provincializes Eurocentric histories and moral economies and, in a speculative and utopic register, invokes a possible future beyond colonial modernity. I examine *Raiders* as an example of experimental artistic-literary production that puts forth a unique anticolonial optic, one that brings together the material reality of colonial practices and their systemic disavowal into a single field of vision, while tracing historical connections between (neo)colonial and (neo)imperial formations across time and space.

Raiders is an avant-garde and especially literary rendition of an alternate reality game (ARG). As Brian Schrank describes them, "ARGs are collective, participatory narratives played by scalable, networked communities across new and old media platforms."[7] While the genre emerged in the 2000s, it draws on genealogies of avant-garde literature, visual art, and gaming.[8] ARGs are characterized by their use of interactive transmedial narratives composed across multiple mediums and platforms.[9] Typically, players form networks online and work together to solve mysteries or puzzles designed by the ARG's creator(s). While ARGs use computer networks to facilitate collective gameplay, they differ from video or computer games insofar as they are played in both real-world and virtual spaces, thereby "fram[ing] the entire world as their media platform."[10] They also erase metalanguage that would frame them as a representational space apart from the real world. According to Patrick Jagoda, this integrates ARGs into players' everyday lives and suggests to them "that the shared experience into which they are entering is not a designed ludic fiction but instead an aspect of the real world."[11] In keeping with this convention of the genre, *Raiders* did not represent itself as a game; nor did it have any rules to follow.

Raiders' use of the conventions of ARGs blurs the boundaries between the real world and its own narrative, as well as the market and aesthetic

demarcations between the popular art form of ARGs and avant-garde art and literature. *Raiders* is a politicized and literary intervention within the genre of ARGs that is interlaced with Ilich's experimental and transdisciplinary artistic praxis. It can be situated within a history of artistic practice Mary Flanagan has identified in which artists use games "as a means for creative expression, as instruments for conceptual thinking, or as tools to help examine or work through social issues."[12] While ARGs are typically associated with collective puzzle solving and scavenger hunts, *Raiders* centered on epistolary and economic exchanges and the production of artworks and protest actions that directly addressed historical and ongoing colonial and imperial relations, as well as actual and possible resistance to these.

Raiders took place as an ARG over the first five months of 2013. While this was a live and ephemeral phenomenon, *Raiders* also continues to exist in the archive it produced (plate 1). Ilich introduced this project into the public sphere through the aforementioned letter and petition, which he emailed to thousands of people. These emails, as well as a website Ilich created for the game, invited readers to contact him if they wanted to join the Penacho Support Network to help Diego de la Vega in its efforts to bring the Penacho de Moctezuma back to Mexico. Joining the Network effectively meant taking up a role within the game. As the game unfolded, Network members received emails and postal mail from Ilich, debated positions and strategies in relation to the game's mission, and produced media, artworks, and protest actions related to it. Support Network members were rewarded for these efforts with payments in Digital Material Sunflowers, a virtual currency of Ilich's design, and these financial operations were managed by Spacebank, a virtual community investment bank he also created.

Ilich and Network members principally communicated via the Penacho email list. This bilingual virtual space connected players across the Americas and Europe; it also organized an international readership for *Raiders*, as the emails sent among Ilich and Support Network members were also received by hundreds of other individuals Ilich placed on the email list.

The texts circulated on the Penacho email list, most of which were authored by Ilich, provided the narrative through-line for *Raiders*. These are all literary works—or, more precisely, components of the literary work that is *Raiders*—though they regularly inhabit linguistic forms that are not typically framed as literature, such as petitions, communiqués, and meeting minutes. Ilich's use of online letters and communiqués as *Raiders*' principal literary form cites the use of these forms by the EZLN's leadership in its public discourse, while both Ilich and the EZLN take up the epistolary literary

forms of the colonial encounter in utopic and sardonic efforts to negate five hundred years of negation.

Raiders' networked and interactive narrative was coproduced by its various participants, along with Ilich. Ilich directed the work's composition, but did so in a way that included the contributions of the players and unexpected changes in the plot these entailed. In one of our interviews about *Raiders,* Ilich described its production as a generative negotiation between the story he planned to tell and the new material that was constantly introduced into it by the players. He designed the game's parameters and its main performative events based on his original idea for *Raiders'* narrative. As the project progressed, he "would change the flow depending on the reactions, to new outcomes and possibilities" that arose from players' actions and their and others' contributions to the open-ended, multiply authored text developed on the Penacho email list.[13] While epistolary exchanges on the email list forms the bulk of *Raiders'* archive and hold together its principal narrative, the game also included performances, protests, and artworks players realized in their own hometowns, as well as texts and audio and visual artworks they shared via the email list (figure 1.1).

In its final two weeks *Raiders* took on a centralized physical setting, in addition to its virtual networked dimension, when Ilich and other network members gathered in Krems, Austria, at the Donau Festival of music and performance, which had commissioned the creation of *Raiders*. Ilich created a pop-up coffee shop within the festival called Café Penacho. The café served as the meeting place for Network members, as a kind of stage set for the game, and as a space where audiences could encounter and participate in the world of *Raiders*. Audience members' interactions within the café's commercial and social spheres were performative manifestations of *Raiders'* cross-genre and multilevel strategy. They could become clients of Spacebank, view its Museum of Revolutionary Currency, and exchange their euros for Digital Material Sunflowers. (Ilich designed and minted coins of this principally digital currency for the occasion.) *Patolli* boards were provided, so visitors could play a game that originated in pre-Conquest Mesoamerican culture. They could read and sign the aforementioned petition, as well as purchase postcards and temporary tattoos of Ilich's design, which condensed *Raiders'* indictment of colonial looting and demand for repatriating the headdress. Ilich's *Anticolonial Tattoo* cheekily communicated this message with transcultural pop-cultural symbolism. It featured a skull and crossbones (an iconic symbol of piracy) wearing the feathered headdress above the caption "Colonial Looters: Payback!" (figure 1.2).

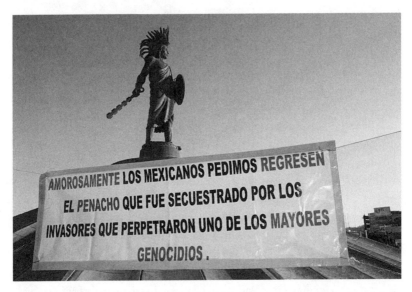

1.1 Documentation of Festival de Quetzalapanecáyotl, organized by Colectivo Shakti and Agatha Kin Producciones in collaboration with *Raiders of the Lost Crown*, April 19–21, 2013, Tijuana, Mexico. (Translation of text: "We Mexicans lovingly request the return of the Penacho that was kidnapped by invaders who committed one of the largest genocides.") Photograph by Juan Eduardo Navarrete Pajarito.

Most important, Café Penacho served coffee and provided a space of encounter and conversation typical of café culture. Ilich and other Network members worked as baristas, serving espressos brewed from beans produced and sold by cooperatives in Chiapas, Mexico, whose members are part of the support base of the EZLN. In this way, the commerce Ilich organized through the café participated in a transnational solidarity market that supports Zapatista communities' autonomy and economic resistance. Café Penacho also served as a space of encounter and conversation, as well as for spontaneous programming and collaborations that arose during the course of the festival. In our interview, Ilich described the café:

> It was a living space for conspiring and also the stage set … [for] a live theater work in which there were some activists who had a café in Austria that sold coffee, or gave you coffee and requested your signature, showed the bills from Spacebank's financial museum, and other things. … There weren't dramatic activities or actors dressed up as anything. The important thing was that people entered into this world and chatted and we

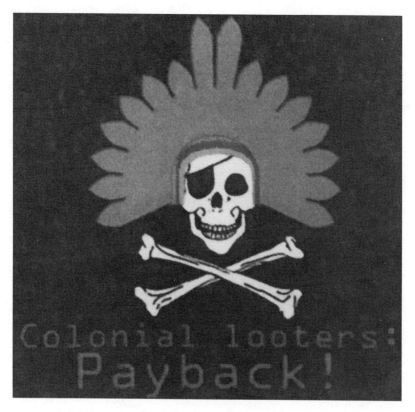

1.2 Fran Ilich for the Diego de la Vega Cooperative Media Conglomerate, *Anticolonial Tattoo*, 2013, temporary tattoo design. Digital design courtesy of Fran Ilich.

inserted ourselves in their conversations. They were inspired by the Zapatista coffee, there was a music festival, a lot of things happened. I mean, ask yourself: What occurs in Denny's at three or five in the morning every night, right? Well, a lot of magic things; that is part of the culture of cafés.[14]

As Ilich notes, *Raiders* melded its character as a live act of theater that was composed as such with the unmediated and spontaneous character of unscripted encounters and conversations.

Raiders also operated at another register, principally for its online and international audience: while it was based at the Donau Festival, Ilich regularly sent emails to the Penacho email list that reported on the Support Network's activities and the goings-on at Café Penacho. These texts fostered the illusion

that they were reports on real events that had happened at the café, depicting Ilich and other actual Network members in their narratives. Yet they were actually semi- or wholly fictional narratives that introduced fictional characters and new conflicts and plot twists into the *Raiders* narrative. As I will show, the narrative that unfolded through these texts and in the live actions in Austria complicated and questioned what had appeared to be the game's original mission of repatriating the famed feathered crown.

STEREOSCOPIC AESTHETICS

Raiders deploys the aesthetic affordances of ARGs to compose a multidimensional anticolonial critique and engage players and audiences in a collective exercise of speculative decolonial imagination. In particular, *Raiders* uses ARGs' capacity to produce a "layered" or "alternate" reality through the way their gameplay is integrated into the real world and the everyday lives of their players. Jane McGonigal argues that this form of immersion encourages participants to develop "a kind of stereoscopic vision" wherein they perceive reality and the game structure in "a single, but layered and dynamic world view."[15] Whereas typical ARGs integrate a fictional narrative into real-world settings, *Raiders*' story is, at base, organized around actual histories, material practices, and institutions (though it does have fictionalized elements). Its representation of reality as multilayered, and the stereoscopic vision this invites, forms an aesthetic dialectic that accounts for the historical persistence of colonial domination and dispossession *and* the ideologies and representational practices that attempt to naturalize these relations. In other words, *Raiders*' anticolonial critique takes the form of a stereoscopic apprehension that holds together in a single field of vision the materiality of colonial practices *and* their systemic disavowal. It thereby puts into relief the ways in which colonialism is also a comprehensive aesthetic and epistemic project that proliferates worldviews organized around systemic misapprehensions and effacements. In the remainder of this chapter, I examine the stereoptics that *Raiders* marshals against the imperial-colonial-capitalist Hydra as it reimagines the protocols of museums, gaming, and petitions to advance an internationalist, anticolonial, and anti-imperialist political imaginary and solidarity with indigenous liberation struggle.

Raiders' anticolonial critique emerges most forcefully through its capacity to make visible the "heterotemporality" of colonial forms of domination and anticolonial resistance in the Americas.[16] The multiple temporalities in which social reality is lived are illuminated by M. Jacqui Alexander's con-

ceptualization of "palimpsestic time" as grounds for understanding relations among modern state forms within a stratified global field. Alexander draws on Johannes Fabian's critique of the hierarchical dualism tradition/modernity that governs modern ideologies of time, placing social formations considered to belong to "tradition" in an *other* time, noncontemporaneous with Western modernity. Alexander notes that the linear and hierarchical conception of time that undergirds the tradition/modernity dualism props up "the political and psychic economies of capitalism, which ground modernization and provide the conditions in which it thrives," while also producing ideologies of distance that separate the modern West from its "others."[17] She argues that ideologies of linear time separate histories that are, in fact, simultaneous and blind us to the presentness of colonialism and the coevalness and mutual imbrication of colonial, neocolonial, and neo-imperial time-space formations. Working against a developmentalist conception of state forms, with its implicit hierarchies, Alexander posits colonial, neocolonial, and neo-imperial social formations as contemporaneous if not coterminous, arguing for the methodological importance of tracing traffic and proximity among these formations. She writes, "Since both neocolonial and neo-imperial states work, albeit asymmetrically, through colonial time and simultaneously through Christian neoliberal financial time . . . it is our task to move practices of neocolonialism within the ambit of modernity, and to move those of colonialism into neo-imperialism, reckoning, in other words, with palimpsestic time."[18] *Raiders'* narrative does precisely this. It uses representations of colonial-era plunder and genocide to highlight the colonial character of current modes of capitalist accumulation as this is evidenced in territorial dispossession, relations of debt and credit, and intellectual property regimes. As it traces continuities of colonial processes in those social formations that constitute modernity within a transnational scope, *Raiders* also highlights the ideological traffic among colonial, neocolonial, and neo-imperial social formations of Europe and the Americas.

This discursive approach is fundamentally enabled by contemporary indigenous liberation struggle rooted in Mexico. Specifically, the Zapatista movement and its political ideology serve as a prioritized historical example and praxeological lesson for *Raiders'* representation of practices and worldviews that operate in resistance to contemporary forms of colonial domination and dispossession. The EZLN's public discourse has always narrated the history of class and caste domination in Mexico as a war that has been ongoing for more than five hundred years, with changing configurations, such that its colonial, neocolonial, and neoliberal/neo-imperial manifestations are

understood as deeply interrelated and ongoing.[19] Moreover, *Raiders'* analysis of the predatory and colonial character of contemporary regimes of accumulation, as well as its critique of the Mexican state and its nationalist ideologies, is especially indebted to the history of the Zapatista movement and the knowledge produced therein.

In its stereoscopic apprehension of contemporary colonialism and imperialism, *Raiders* juxtaposes state representations of indigeneity that work to both manage and efface the social realities of living Indians with knowledge produced by the Zapatistas and other indigenous liberation struggles that belie such representations and radically reconfigure ideas about the nation and modernity. *Raiders* transmits and translates an anticapitalist and anticolonial worldview that identifies as its source Zapatista struggle and knowledge production to the networked, urban communities of Latin America and the Global North in which Ilich lives and works. As we explore the multiple dimensions of *Raiders*, I also discuss how Ilich used the conditions of its production and reception to make material his solidarity with Zapatismo.

A "POCHO FROM THE WRONG SIDE OF THE BORDER"

Ilich's artistic practice is distinguished by its voracious experimentalism and the way that it regularly intermixes literary and visual media, English and Spanish, and a sensibility to popular and mass culture with an avant-garde ethos. Ilich has gained international recognition as a writer, media artist, and social artist; his corpus includes novels, essays, digital cinema and television, plays for radio and theater, electronic literature, and long-term social art projects that involve experimental approaches to organizing social and economic relations. The transmedial and participatory form of *Raiders*, enabled by the use of digital media, expresses long-standing tendencies in his work: namely, his use of digital technologies for storytelling, his work in interactive narrative, and his omnivorous embrace of varied media platforms to compose stories, including those not generally associated with the arts.

Ilich is, fundamentally, a producer and theorist of narrative who understands narrative in its most capacious sense. In his monograph on narrative and ideology, *Otra narrativa es posible (La Imaginación política en la era del internet)* (Another Narrative Is Possible [Political Imagination in the Internet Era]), he theorizes narrative as a material practice through which humans collectively shape their experienced lifeworlds. Therefore it is intimately related to the production and disarticulation of ideologies. He writes, "Narrative is much more than writing, images, audio, code,

fictions and non-fictions. It is the combination of actions that, taken together, produce the dominant ideology. Or that disarticulate it through narrative bombs, dreams, desires that aspire to become actions, ideological prophecies, meteorological predictions, scientific analysis, gossip, rumors."[20] Like other materialist theories of ideology, Ilich's theory of narrative, wherein narrative consists in "actions," refuses the false distinction between representation and "real" social practice. This sheds light on the way in which his narrative practice extends beyond those compositions that are generally perceived as narrative devices (e.g., literature, theater, etc.) to also include things like acts of economic exchange and petitions. This understanding can guide our reading of his artistic production, which consists not only in the composition of texts, performances, and audiovisual media but also in the organization of social and economic relations.

Ilich's work is also characterized by a historico-political optic that fluidly moves across different spatial scales to connect localized phenomena with transnational flows of capital, people, and ideas. This reflects his college education in Latin American studies; his self-education in history, political economy, and social theory; and a long-standing participation in international networks of intellectual exchange spanning the Americas and Europe. It also reflects the early political education he had through his family and a geopolitical consciousness shaped by growing up in the border city of Tijuana, a space where the localized effects of transnational socioeconomic phenomena are evidenced in particularly stark contours, as they shape the economy, built environment, and socially stratified regimes of mobility.

Born in 1975 as Fran Ilich Morales Muñoz, Ilich would take his middle name, which is an homage to Lenin, as his principal moniker. He grew up in a home and kinship network shaped by his parents' socialism and immersion in the arts. His father, Francisco Morales, is a poet who has worked across various genres, including the production of proletarian testimonios with mining communities from his hometown in Cananea. Lilia Muñoz, Ilich's mother, started the branch of the Instituto de Cultura de Baja California in Playas de Rosarito, worked as a teacher and organizer with the national teachers' union, and is a feminist writer. Ilich's younger sister, Sol Ho, is an activist artist specializing in dance and theater, and was an artistic collaborator of Ilich's throughout the 1990s and early 2000s. Ilich's family life provided him with an early immersion in Marxist and anarchist thought and literature of the Americas and Europe. The socialist worldview his parents brought to their home life, as well as to their political militancy, gave him a formative education about the ways in which the organization of daily life

is an important site for social transformation. It also shaped the critique of nationalism that runs through all of his work. As he told me, "I heard different versions of this from the beginning: nationalism is bad, the Mexican flag is bad. I grew up with this."[21]

Ilich describes himself as a "pocho from the wrong side of the border," using a slang term typically used to denigrate U.S. Americans of Mexican descent for having assimilated to hegemonic U.S. culture and losing contact with Mexican culture and language. Ilich's self-identification as "pocho" signals his identification with Chicana/o/x culture and concepts, and reflects his understanding of himself as a border subject in the sense that his social positionality (his imagined relation to his structurally determined social location)[22] is one that is marginal to hegemonic national cultures. Indeed, he grew up experiencing the transborder territoriality of the Tijuana–San Diego metropolis and in intimate contact with U.S. culture, including Southern Californian Chicana/o/x culture and arts. He also grew up with the influence of Anglophone and U.S. American literary production, though he notes that he also has "something of a Germanophile" in him as well.

Living in Tijuana until 2000, when he moved to Mexico City, Ilich experienced the transformation of his hometown during the 1980s and 1990s. During that time, Tijuana saw a massive influx of migrants, breakneck urbanization, and the growth of a "free trade" zone along a border that was intensively militarized by the United States. Much of Ilich's early work addresses the urban youth counterculture of San Diego–Tijuana and examines the political and cultural significance of the U.S.–Mexico border.

Ilich's art production and cultural activism began in the late 1980s, when he cofounded the multidisciplinary arts collective Contra-Cultura (menor). The collective was a protagonist in Tijuana's zine movement, and it created visual art, literature, and performances and founded an independent cultural space. Their practice entailed an iconoclastic rejection of the city's literary and arts establishment, while it modeled an alternative to institutionalized circuits of exhibition and publication, as well as to state financing of artistic production.[23]

In the 1990s, Ilich produced pioneering narratives about Tijuana and its dynamic countercultures, which also addressed the neocolonial political relations, militarization, and racism that are seen in the city and region. He wrote three novels during that decade. The publication of the first of these, *Metro-Pop* (1997), gave him national prominence as a writer and publicly situated him within Mexico's literary Generation X. Paul Fallon argues that border writers of this generation, including Ilich, are distinguished by their

treatment of "literary and multimedia expressions as complementary," and by the ways they "react to and develop the changing temporalities afforded by new media."[24] Ilich began producing narrative works in cinema and new media in the 1990s, and he has produced an extensive and varied corpus of audiovisual narrative works, including electronic literature, films in both analog and digital mediums, a video game, and serialized internet-based productions that reimagined popular genres like telenovelas, reality television, and sitcoms.

Raiders' participatory narrative composition, as well as its networked production that decenters Ilich's sole authorship, also has precedent in his earlier work in digital media. For example, in the 2000s Ilich created interactive web-based films and telenovelas, such as *Modem Drama* (2002) and *La Actriz Interactiva* (2007), and cocreated *Story Streams* (2003), a work of live cinema that was collaboratively produced by multiple authors via digital networks. As Scott Baugh notes, Ilich coined the phrase "democratic net.film" to describe these films whose "storylines, characters' actions, and even formal-textual characteristics are subject to viewers' options, exchanged like votes via the internet."[25] These films, like *Raiders,* as well as Ilich's social artworks, exhibit a tendency of critical importance to the politics of his art practice: the way he works to transform the means of cultural production in order to (to paraphrase Walter Benjamin) lead consumers of culture to become producers, "making co-workers out of readers or spectators."[26] In doing this, Ilich self-consciously contributes to a tradition of Marxist aesthetic practice famously theorized by Benjamin, Bertolt Brecht, and Augusto Boal, all of whom are major referents for him.

Ilich was a pioneering producer of cyberculture and electronic media in Latin America. He founded the cyberculture zine *Cinematík* and produced the Cinematík and Borderhack festivals in Tijuana between 1998 and 2005. The Borderhack festivals, which he staged on the Mexican side of the border wall, brought together hacktivists and other cultural activists from across the Americas and Europe to stage creative protests of capitalist border politics.

As a form of cultural activism that investigates and critiques the geo- and sociopolitical relations and ideologies that have produced the contemporary border regime, borderhacking has taken many different forms in Ilich's work, including media interventions, electronic civil disobedience, online exhibitions, a video game about border crossing, and interventionist literature disguised as journalism.[27] Some of this work evinces qualities I highlight in *Raiders,* such as Ilich's tactical use of deception of his audiences as a means of social critique and his provocative destabilization of categories

and reading practices that divide fictional from purportedly veridical representations. For example, Ilich's work on the United States' militarization of the U.S.–Mexico border, narcoculture, and security discourse has included fictional works disguised as documentaries, press releases, and journalistic reportage. Nonetheless, Ilich pointedly avoids those discourses that would confuse the material reality of the border or treat it as a metaphor. As he has said, "When it comes to talking about the necro-economic border that separates Mexico from the USA I prefer to speak about the wall and not about metaphors, nor saying that the border is everywhere. . . . What is everywhere is neoliberalism and that's another story, where, of course, the wall serves as a sorry example."[28]

THE FOURTH WORLD WAR AND THE NEW CONQUEST

It seems that Mexico's powerful men are bothered by the fact that Indians now go to die in the cities and stain their streets, which up till now were only littered with wrappers from imported products. They would rather they continue to die in the mountains, far from good consciences and tourists. . . . They have had previous opportunities to turn around and do something about the nation's historic injustice against its original inhabitants, but they saw them as nothing more than anthropological objects, touristic curiosities, or part of a 'jurassic park' (is that how you spell it?) that fortunately would disappear with a North American Free Trade Agreement that did not include them, except as disposable elements.
—Subcomandante Insurgente Marcos, letter sent to national and local newspapers in Mexico, January 13, 1994, reprinted in Zapatistas: Documents of the New Mexican Revolution

As an intellectual influenced by and aligned with the social movement constellated around the EZLN, Ilich has been engaging Zapatista political thought with his artistic and activist practices since the mid-1990s, after the Zapatistas declared war on the Mexican state on January 1, 1994. The EZLN clandestinely organized during the previous decade, combining Marxist revolutionary and indigenous communalist praxis. Its base comprises Tzotzil, Tzetzal, Tojolobal, Mam, Chol, Zoque, and mestizo subsistence farmers and landless workers. It emerged as a national revolutionary movement with a broad democratic and socialist program that centered long-standing demands by indigenous communities for land and political and administrative autonomy on a regional scale.[29] After finding the colonial Mexican state recalcitrant to meaningful reforms, the movement pursued local autonomy as

a revolutionary praxis, while asserting an internationalist and anticapitalist horizon for antisystemic movements in and beyond Mexico.[30]

Zapatismo is an anticolonial movement insofar as it explicitly struggles to end the conditions of internal colonialism in which indigenous Mexicans, and indigenous people elsewhere, live. As defined by Pablo González Casanova, "internal colonialism" describes an intranational form of economic, political, administrative, military, and cultural domination of a population that is produced and maintained by policies pertaining to the expansion of markets and frontiers of accumulation, as well as to various aspects of governance. Its specific structure inheres in cultural heterogeneity that has been historically produced by the conquest of the dominated group, and as such, it accentuates the ascriptive character of colonial society.[31]

The EZLN's anticolonialism is distinct from Indianist movements, as it has politicized Indian rebellion in universalist terms.[32] It has historical connections to that of other Marxist-Maoist guerrilla movements that emerged in Mexico and Central America in the 1960s–1980s and is also part of the history of popular movements and uprisings in Latin America in which indigenous and peasant communities have asserted themselves as protagonists of sociopolitical transformation.[33]

The EZLN's rise responds to Mexico's neoliberalization and the ways it intensified colonial and neocolonial dynamics of exploitation and dispossession. In the wake of a major debt crisis in 1982, and facing pressure from the International Monetary Fund, the World Bank, and sectors of the national bourgeoisie, the Mexican state abandoned the model of protectionist state-led development that had been in place since the 1930s and transformed the country into a supplier of cheap labor and natural resources for transnational capital. Neoliberal reforms implemented in the 1980s and 1990s opened Mexican markets to foreign imports, deregulated most sectors of the economy, dismantled and privatized hundreds of state-run firms, eliminated most state subsidies, and gave foreign capital greater access to and control over Mexican territory.[34]

In what Armado Bartra describes as a process of "genocidal restructuring," the Mexican state and private capital used a variety of tactics to separate millions of people from their land and concentrate landownership in the hands of transnational corporations. These included counterreforms that ended redistribution of land to peasants and encouraged the privatization of communal *ejido* land and communal farms, the use of devaluation as "shock therapy," the end of food subsidies, and the liberalization of transnational trade.[35] The North American Free Trade Agreement (NAFTA)

was particularly devastating for small agricultural producers, as it catalyzed the flooding of Mexican markets with agricultural commodities from highly capitalized and state-subsidized industries in the United States.[36] All of these measures created conditions that trapped peasants in cycles of debt and poverty and forced them to leave their land, while paving the way for massive transfers of land from indigenous communities to transnational corporations.[37]

Displaced farmers were forced to join a growing reserve army of labor and migrate. Workers were also forced to leave cities, as neoliberal restructuring led to Mexico's deindustrialization and a decline in manufacturing jobs, as well as to a major decline in wages for Mexican workers.[38] As millions of people were expelled from their means of subsistence or of earning a wage, Mexico became the "number one labor-exporting country in the world proportional to its population," with mass migration affecting nearly all of the regions in Mexico.[39] As millions of workers migrated to the United States, that country's Mexican-born population doubled in the 1990s.[40]

The socioeconomic processes I have described as effects of Mexico's neoliberalization—including the dispossession and proletarianization of peasants, the extension of capitalist markets into noncapitalist strata and concomitant annihilation of the latter's forms of production and social organization, and the transfer into private ownership of resources and means of production that had been held in common are all features of primitive accumulation. Some scholars have theorized the round of intensified primitive accumulation that has occurred around the world since the 1970s as "new enclosures" or "new imperialism."[41] Subcomandante Insurgente Marcos, who was a military leader and spokesperson of the EZLN, theorizes these processes as constitutive of the Fourth World War. He suggests that, for indigenous people, they amount to a "New Conquest," underscoring their colonial character and historical relationship to earlier iterations of pillage inflicted on indigenous people.[42] Noting that capital's conquest and fragmentation of territories are central features of its contemporary war of accumulation, he describes how this has effectively made indigenous subsistence farmers into an enemy of capital and the Mexican state:

> Financial power wants to build a new shopping center which will have tourism and natural resources in Chiapas, Belize and Guatemala. Apart from being full of oil and uranium, the problem is that it is full of indigenous [people]. And the indigenous ... are neither consumers nor producers. They are superfluous. And everything that is superfluous is expendable. But they do not want to go, and they do not want to stop being

indigenous.... They even rose up in arms. This is why—we say—that the Mexican government does not want to make peace: it is because they want to do away with this enemy and turn this land to desert, afterwards reorganizing it and setting it to operate as a huge shopping center, a Mall in the Mexican Southeast.[43]

The EZLN declared war on the Mexican state on January 1, 1994, on the date NAFTA went into effect. They seized four towns in Chiapas and publicly issued a declaration that called on the Mexican people to join them in their struggle to secure "work, land, housing, food, health care, education, independence, freedom, democracy, justice and peace" for all Mexicans.[44] Upon entering into a process of peace negotiations with the government, the EZLN carried out extensive consultations with indigenous and nonindigenous communities from across Mexico. This included holding a National Democratic Convention in liberated Zapatista territory, organizing a nationwide *consulta*, or referendum, about the negotiations, and calling for a National Indigenous Forum, which was organized by members of civil society and consulted by the EZLN during the negotiation process.[45] As María Josefina Saldaña-Portillo argues, this process demonstrated the EZLN's power to summon Mexican citizens "to participate in the project of theorizing the formation of a new Mexican state, one capable of encompassing autonomy within it."[46]

Based on these consultations, the EZLN put forward a set of demands for federal and state reforms that would guarantee the collective rights of Indians pertaining to land, autonomy, political representation, and culture. These included reforms that would allow for the establishment of autonomous municipalities and regions, self-governed by indigenous communities; protections for indigenous communities' land; the preferential treatment of indigenous communities in granting concessions for obtaining benefits from natural resources; the guarantee of access to media for indigenous people; and recognition of the nation's pluricultural makeup in legislative contexts.[47] These were formalized in the San Andrés Accords on Indigenous Rights and Culture, which were ratified by the EZLN's communities. But the Mexican state and Right-wing paramilitaries continued a low-intensity war on the Zapatista communities and those that supported them and refused to honor the Accords. The EZLN eventually suspended its negotiations with the government and focused their efforts instead on building the autonomy of their own territories and institutions and strengthening and expanding their ties with grassroots movements and organizations in and

beyond Mexico that also enact their politics *"desde abajo y a la izquierda"* (from below and to the Left).

As Zibechi notes, Zapatista praxis has demonstrated the inseparability of political autonomy (self-government) and material autonomy, and the dependence of both on the control of territory, which provides the basis from which indigenous people can collectively defend their culture and lifeways.[48] Since 1994 the Zapatistas have governed their own autonomous municipalities. These provide the territorial basis from which they have transformed production and the reproduction of everyday life.[49] They have created their own multilingual educational system, production cooperatives, banks, markets and systems of distribution, hospitals, and workforce of health workers who practice both allopathic and traditional forms of medicine.[50] Their system of democratic self-governance is grounded in the ethos of *mandar obedeciendo* (leading by obeying) and is inured to the formation of a political class and expropriation of social decisions by professional politicians.[51]

The EZLN opened a new political horizon in Latin America and globally, emerging as an armed revolutionary movement precisely in a moment when liberalism's cheerleaders wanted to declare revolutionary movements (and socialism tout court) relics of the past. Acting "like the armed matchmakers of a new international movement against globalization,"[52] they have promoted a nonsectarian anticapitalist internationalism not mediated by political parties and have modeled a nonhegemonic form of articulation among antisystemic struggles that seeks to "[multiply] the subject of social transformation."[53] The Zapatistas have enlivened and complexified understandings of contemporary revolutionary praxis with their melding of socialism and indigenous communalism, their critique of developmentalism, rejection of vanguardism, and situational theorization and practice of autonomy.

The prolific and virtuosic communication of the Zapatistas and their allies has allowed them to disseminate the EZLN's revolutionary vision internationally. They have done so in every form and medium one can imagine, from communiqués, epistolary narratives, testimonios, essays, and political allegories published online and in print to documentary videos, theater, music, and visual art, as well as the many gatherings the EZLN leadership has organized that bring people to their territories, including the La Escuelita Zapatista (Little School).[54] The movement's public discourse has asserted an incisive critique of capitalist development, showing that is has brought dispossession, political domination, and cultural genocide to indigenous people and peasants and has produced massive ecological destruction.[55] In their analyses, the EZLN insists that development and modernization are colonial endeavors

that have produced punishing conditions for the majority of people, thereby refuting the historical ideologies that typically cast the indigenous, peasants, and poor outside of and in need of modernization and development.[56]

AN OTHER CULTURE

In our interviews, as well as in his own writing, Ilich describes the EZLN's publication of the *Sexta Declaración de la Selva Lacondona* (Sixth Declaration of the Lacandon Jungle) and their launching of the Otra Campaña (Other Campaign) in 2005 as having a particularly important impact on his life and work. The *Sexta Declaración* asserted the EZLN's intention to continue as a political and military force in Mexico and to continue to create international alliances to strengthen the global struggle against imperialist capitalism.[57] It outlined their plan to engage in direct dialogue with the Mexican people—without mediation by the political system—in order to articulate grassroots struggles taking place across the country and develop a national campaign that would work to create a new constitution for Mexico. The Otra Campaña put this plan into action. It consisted of a "listening tour," in which the EZLN leadership traveled around Mexico to meet with organizations "from below and on the Left" to learn about their local struggles. This form of "plebian politics" was a counterproposal to the paternalistic, hierarchical, mediated, and exclusionary character of liberal representational politics and its parties.[58] It also served as a counterweight to the Rightward drift of Mexico's institutional Left (represented by the Party of the Democratic Revolution) and to the disorganization of Left social movements across the hemisphere that had occurred through their co-optation by the state apparatus and party system.[59] Rather than channel people's desires for change toward the institutions of a capitalist state, such as its official parties, the EZLN's Other Campaign worked to articulate grassroots struggles and networks of solidarity with the aim of building a broad movement against capitalism.[60]

While the Other Campaign was taking place, Ilich and his collaborators "decided that we need an Other culture, an Other production." An Other culture, he explains, "can be thought of in terms of its functionality within the low-intensity war being fought within Mexico against the oligarchy and state, or from the perspective of building a more grassroots and less vertical culture than the one promoted by the national government."[61] In his 2007 essay, "Otra cultura es posible: no imposible" (Another Culture Is Possible: Not Impossible), Ilich suggests that the ambitions of the Other Campaign

require the construction of an other way of perceiving reality. He writes, "There is no other culture without an other aesthetics, that is to say: an other way of seeing."[62] Here, Ilich is referring to aesthetics in the broad sense with which I am also using it in this book, that is, as the socially forged sensory composition of a world. He argues that the ambitious political project of the Other Campaign requires a cultural-aesthetic-ideological transformation that would take place across all areas of social life. Cultural production can contribute to this to the degree that it calls for and founds an "Other way of seeing" and works toward organizing social relations in ways that align with Zapatismo's ideals.

Ilich's efforts to foment an Other Culture have entailed many different types of projects that express an alignment with the EZLN's political ideology and its economic initiatives. His work with the EZLN's autonomous government in Chiapas has included hosting their website on his internet server, organizing cultural activities with and for them, and being an invited speaker at public events they have organized, as well as a student in La Escuelita Zapatista. He has also participated in solidarity economies that benefit Zapatista communities as part of his art practice since the early 2000s. In addition to these activities, Ilich's artistic contributions to fomenting an Other Culture have taken the form of long-term attempts at organizing human, technological, artifactual, and agricultural communities and entities in ways that are congruent with Zapatismo's autonomist, anticolonial, and anticapitalist politics. These include Ilich's creation of a cooperative internet server, Possible Worlds (2005–ongoing), which, he says, grew out of an effort to "practice another internet politics" that would distance itself from "all the excesses of new media arts and [try] to get into providing infrastructure in order to join the Zapatistas in their struggle."[63] Possible Worlds has hosted Zapatista and other websites associated with Left political and cultural activism. In 2005 Ilich created Spacebank, a virtual community bank that also functions to organize the economic basis for the productions he and his collaborators undertake.

In 2010 Ilich created the Diego de la Vega Cooperative, which has been a platform for a variety of projects of Ilich's design that share a common interest in narrative and experimental approaches toward social organization and cultural production. Diego de la Vega's namesake is a fictional character, the nineteenth-century Californio aristocrat better known by his nom de guerre, Zorro. The pulp novels and films that have immortalized him depict Don Diego de la Vega as effeminate and ineffectual, while, as his secret alter ego Zorro, he is a valiant vigilante who defends workers and indigenous

people. Ilich's reference to a character with this double identity suggests a self-deprecating humor about his small-scale experiments perhaps seeming inconsequential or eccentric. It also speaks to the tactical uses of a double identity—particularly for those persons challenging authoritarian colonial structures. One way this doubling works for Ilich is in his tactical use of the social identification of his practice as art. He makes use of the social latitude and resources this affords him so that he can pursue social experiments and relationships of material solidarity that operate in other arenas that are indifferent to contemporary art discourse and institutions. Finally, reference to the masked vigilante is also an homage to the real and contemporary masked revolutionaries that most directly inspire Ilich: the Zapatistas. In this context, Don Diego de la Vega's relationship to Zorro is recast as one of political identification and admiration, which is nonetheless aware that the relationship between such apparently different social identities may often pass unperceived.

In addition to *Raiders,* Diego de la Vega's projects have included the Tijuana Media Lab, which Ilich created in the garage of his family's home; a community newspaper in Tijuana called *El Zorro*; an internet radio production cooperative named Radio Latina FM; Fiction Department, a press and platform for narrative research; and Collective Intelligence Agency, a research-based art project conceived as a transnational Leftist think-tank (in which I participated). In 2011, Ilich created the Digital Material Sunflower (formerly the Digital Maoist Sunflower), a virtual currency used by Spacebank and its clients. This alternate currency helped Ilich create a system for assigning value to labor and its products that is not dependent upon national currencies. Soon thereafter, Ilich created the Brooklyn Stock Exchange, which brought financial instruments to manage exchanges and valorization within Diego de la Vega's alternate economy, including by selling futures in its projects in order to fund them.[64] Ilich has participated in the solidarity markets of Zapatista coffee through several of these projects (including *Raiders*), and since 2014 he and his collaborators have sold coffee produced by Zapatista production cooperatives in activist and cultural events in New York City under the aegis of the Diego de la Vega Coffee Co-op.[65]

All of the long-term projects Ilich has undertaken since 2005 are conceptualist social artworks and utopian experiments in social organization. They are concerned with the labor of independent and Leftist cultural production, its economic basis and sustainability, and the possibilities for creating economic models, including with the use of financial instruments, to give cultural producers and other workers greater autonomy over their conditions

of production. They also work to create financial flows that allow cultural producers to be connected in material relations of solidarity and exchange with agricultural producers. *Raiders* articulates several of these projects, including Spacebank and its Digital Material Sunflowers and participation in Zapatista coffee markets. When he was invited by the curator Gabrielle Cram (who was a client of Spacebank) to create *Raiders* for the Donau Festival, Ilich saw it as "the big opportunity to have access to a budget so that all of these little projects that were around the Diego de la Vega Cooperative Media Conglomerate could be made visible and become a game."[66]

Ilich does not claim that his activism or art has consequence for the Zapatistas' movement in their autonomous municipalities. Rather, his work participates in the international social movement that is aligned with the political ideologies of the *Sexta Declaración*. It evinces Ilich's efforts to apply Zapatista political ideology to cultural production and other social practices that take place within the urban communities of Mexico and the Global North in which he lives and works, which is in keeping with the Zapatista militants' charge to their urban allies that we apply lessons learned from the movement to our own fraught contexts.[67] Ilich has talked about his relationship to the movement in my interviews with him. In reference to the Zapatismo of the EZLN's autonomous municipalities, he said:

> My work very likely doesn't exist in the sphere of Zapatismo. I feel like a super outsider. It doesn't bother me. I feel that the Zapatistas inspire my life, so I feel I'm also inspiring or dialoguing with other people who have also gathered around these ideas, and taking very seriously the work of [the Zapatistas] as a point of departure for new forms of life. And if we can have a kind of spiritual relation with them that is financial, economic, political, then all the better. They're already our muses and the example to follow, no?[68]

In a 2017 interview he reflected in greater depth upon the specificity of the type of art he has produced in alignment with the *Sexta Declaración*:

> I don't know if deciding to work in this type of production of the Other Culture is mistaken or correct, but I feel that it is very honest. It is part of a search of mine and of people that are around me with whom I'm interested in working where we are navigating between what has been media art, tactical media, or things that are formal, structural, narrative, and aligning them with the values of this Zapatista Other Culture. The problem is that we didn't end up leaving the city or our specializations in order to enter in

the field of insurgency or the living popular movement. Therefore, [what we produce] doesn't become a flag, it doesn't become a song that inspires the people, right? And this is bad, but it is also good, because a song generates that devotion, the momentary inspiration, that catharsis, but really, what does it generate after the song? So, for me, what matters is to create infrastructure, material gains, questions, and inspire the struggle.[69]

Ilich differentiates his mode of political art practice from those that can have a broader popular audience, as well as from community-based practices embedded in movement communities. While he admires the political efficacy of more popular Leftist art, he himself tires of certain aesthetic formulae it often deploys: "It may not be revolutionizing the form, and probably it's copying what was done in Chile in the dictatorship 100,000 times and the movement of the Mothers of the Plaza de Mayo over and over . . . but it adds things, no?"[70] He also differentiates his mode of practice from the forms of community-based art he has observed around Zapatismo that are based on urban artists working with rural communities. In one of our interviews he suggested that these practices end up creating social relationships that are, in fact, quite distanced and scripted into performances of civility. "I'm not interested in that kind of relation. I'm not a humanist," he said. Though he added that he has respect for this kind of work, he himself prefers to do art that is like "acupressure, so the blood and pus come out." His comments speak to the ways his art corrodes consensual discourses to bring to the surface the conflicts they have hidden, operating through precise and provocative interventions rather than processes of identification, empathy, or dialogue.

When he describes his relationship to indigenous liberation struggles in Mexico, Ilich expresses his political agency not through a cultural identification with indigenous communities or a melancholic desire for this. In our interviews, he reflected on his own distance from indigenous lifeways, given that he occupies a social position produced through the processes of de-Indianization and proletarianization to which his great-grandparents and subsequent generations were subjected. He insists on historicizing this social position rather than naturalizing it. For this reason, he does not describe himself with the racialized epithet "mestizo," which can obfuscate processes of de-Indianization by hypostatizing its outcome as a social identity. Refusing identitarian framings of his person and politics, Ilich describes his relationship to Zapatismo as one expressed by his commitment to its anticolonial and anticapitalist political struggle. "I play for their football team,

we could say," he stated. This metaphor suggests a political collectivity that is forged out of a shared political struggle.

As he spoke about how he understands his relationship to indigenous liberation struggles in Mexico, Ilich also offered another metaphor that drew on the history of the pre-Conquest Mexica society in which the Penacho originated: "At one time [the Mexicas] had the *pochtecas*, who were merchants or diplomats that were in other cultures to negotiate the things that went to the city. The image of the pochteca helps me. . . . In another logic, my job, in a certain sense, is to be like a pochteca, like a support network, but a support network of ideas and concepts—more intangible."[71] With this metaphor Ilich offers an understanding of how shared political struggles unfold across different social positions and geographic locations and through different forms of labor. By noting that the hegemony of the Mexicas was enabled by the pochtecas, he also implies that the expansion of Zapatismo's political project could also include labor, like his, that entails communicating, translating, and advancing commerce across cultural differences and geographic distance. While he does materially contribute to Zapatista communities through his participation in their solidarity markets, he notes that his labor is more consequential in its ideological interventions—or, as I would suggest, in the ways it foments an Other aesthetics that aligns with Zapatismo's political project.

Raiders is an attempt at producing oppositional and generative art, literature, and performance of the Other cultural sort. It specifically attempts this within a professional art world context in which Ilich is embedded and in light of the conditions for the production and consumption of culture that this context in the transnational flow of capital entails. It is an attempt to use art to help create an "Other way of seeing" and to produce this art with and for a networked, transnational urban intelligentsia, while using resources and infrastructure of cultural institutions that function as state apparatuses. Ilich and the Support Network use an array of tactics to de-familiarize contemporary colonial ideologies and practices. In so doing, *Raiders* rearticulates the museum, Austria, and Europe as both tangential to and parasitic upon the indigenous struggles for liberation that continue unabated in America.

POP VANGUARDISM AND AN ANTICOLONIAL TREASURE HUNT

Although Ilich initially framed *Raiders'* gameplay as a campaign to restitute the feathered crown, this "mission" was never the principal subject of its story. Nor does *Raiders* purport to offer its audiences veridical or authentic

representations of Mesoamerican Indian culture. Rather, Ilich used the history of the Mexica Penacho and the controversy surrounding its ownership as a plot device within a semifictional anticolonial narrative modeled after the well-known fantasy and adventure subgenre of treasure hunt narratives. In addition to its citation of this genre, *Raiders* amalgamates other popular cultural forms: epistolary fiction, temporary tattoos, souvenir postcards, and ARGs. This use of popular genres has a tactical logic, as it allowed *Raiders* to mobilize their popular appeal and thus proliferate its anticolonial optic more broadly and through varied channels. Ilich also suggested that telling his story in the form of a game allowed for a more open-minded reception of it, given that *Raiders*' anticolonial treatment of colonial histories of genocide and plunder could be taken as a cause for defensive or dismissive reception by some. As he said, "It's interesting how these kinds of games can expose the wound of something so painful, and make it more playable, more participatory, and you can save yourself from simply being in the seat of the accused."[72]

Raiders reflects Ilich's belief that fictional narratives and popular culture play important roles in ideological struggle. In an interview I conducted with him in 2009 he said:

> Fiction and language are some of the most important weapons of any political system. . . . The Left has wasted a lot of time in creating an academic or intellectual artistic class and it has often failed at establishing a relationship with what is known as the popular class—I mean, people who watch mass media. Why aren't they into a Leftist emancipatory kind of narrative? Maybe because they don't have access to it. That is something we have to change. We have to invest more in different kinds of fiction, including legends and rumors. The Right wing is very good at rumors, like the CIA kind of rumor, and those become real once they are seeded in people's imaginations. Fiction is about the heart, not the mind. So much of the Left's discourse is lost in rationalities.[73]

Ilich argues that fiction's appeal to people's imaginations and feelings can be tactically useful in winning their hearts for emancipatory struggles. His vindication of the way legends and rumors can take root in people's imaginations can help to guide a reading of *Raiders of the Lost Crown*. The way this work makes it difficult to distinguish between fiction and nonfiction, or whether a narrative composition documents or dictates reality, reflects Ilich's aspiration for his work to take shape in his audience's minds, if not as an actuality, then certainly as a possibility, for *this* world, not a fictional one.

When Ilich suggests that the Left should produce art for the popular classes, he engages with an important tradition within Marxist aesthetic thought and Leftist artistic production. He is following Brecht and Benjamin, who argue that cultural producers should use or invent any medium or form necessary to produce art that is relevant to the social reality of popular audiences, necessarily rejecting the hierarchization and siloing of different cultural forms.[74] In this regard, Ilich can be situated within a rich genealogy of Latin American Leftist writers who have turned to popular cultural forms, as evidenced in the telenovela scripts of Gabriel García Marquez, the detective novels of Paco Ignacio Taibo II, Claribel Alegría and Darwin Flakoll's use of the thriller's conventions in their nonfiction account of the assassination of Nicaraguan dictator Anastasio Somoza, and Subcomandante Marcos's pedagogical folktales and authorship of a children's book. As a cultural producer born under the influence of mass media, the rise of the internet, and networked gaming, it is no surprise, then, that Ilich creates his political art as an ARG that riffs on a subgenre popularized by video games and Hollywood movies. Moreover, the way he tells a story of colonial holocaust and anticolonial resistance in semifictional and even speculative narrative modes reflects his interest in fiction and popular genres as effective tools in ideological struggle.

Raiders' inhabitation of popular genres and digital platforms supports Ilich's effort to popularize the history, themes, and figures the game addresses. For him, this popularization offers the possibility of defying elites' control over the production and consumption of knowledge about Mexican indigenous history. In our interviews, he suggested that one of the ways the ruling classes of Europe and Mexico exercise control over knowledge about indigenous Mexicans is by treating it as a specialized field that is the province of experts alone, thereby separating this knowledge from the masses of people and preventing its socialization. He said, "When the Europeans came to America they took the crowns and didn't even investigate what they were or for what they were used. They took them and then destroyed the system of thought and the significant religious associations. And now, to recuperate this past, they demand that we have postdoctorates."[75] In this statement, the "they" to which Ilich refers encompasses not only Europeans but also the neocolonial Mexican ruling class and the state institutions they control.

Ilich specifically criticized Mexican institutions' professionalization of knowledge production about indigenous civilizations: "It is a professionalization that doesn't lead to liberation, popularization, dissemination. It's like a specialized police system whose function is to separate you from this

knowledge so that a few can have a monopoly over it and have the jobs, and they can be the experts, the ones who are authorized, and so those temples continue being museums."[76] Ilich argues that the ideological state apparatuses of the museum and university work to make indigenous people's history and material culture into objects controlled by Mexico's ruling class. Ultimately, he suggests that museumization and the professionalization and specialization of knowledge operate vis-à-vis indigenous history and culture as modes of colonial dispossession and sociocide. As I discuss later, this dispossession works in tandem with the proliferation of representations of indigenous cultures and people that, in fact, obfuscate the social reality of Indians in the modern Mexican body politic. For Ilich, representing the themes and figures of *Raiders'* plot within popular genres (including fictional ones) and proliferating these through multiple media platforms are means to contest the mummification and social isolation imposed by elite forms of producing and disseminating knowledge. At the same time, he is aware of his own lack of access to the culture industries and other institutions that would enable a much broader popularization of this knowledge. After noting that *Raiders* was an effort at popularization, he added, laughing, "Unfortunately, I'm not so well equipped to do this. But I can lean on the pop vanguard. Or communicate with or inspire other people so they popularize it."

Ilich suggested that introducing *Raiders'* narrative through a plot line that cited the familiar treasure hunt genre was a way of drawing readers and potential players into the story. He said that, because it is so difficult to bring the American holocaust into discussions, "[he] needed people to suspend disbelief and enter this with a sort of playful mind": "That's why I used all the fantasy literary tropes I could think of, so they would relate it to their *Zelda* games or *Indiana Jones* games—not that Mesoamerican culture is lacking in far more interesting forms."[77] Yet *Raiders* deploys the conventions of treasure hunt narratives in order to subvert them and thus refute long-held beliefs in the moral good of museums, cultural preservation, and the cultured supremacy of Europe. As they appear in countless Hollywood films, video games, television shows, novels, and comics, treasure hunt narratives usually consist of colonialist fantasia that follow Western protagonists as they travel to exotic Third World locales to seek and gain possession of storied artifacts and other treasure. (The myriad products of the *Indiana Jones* franchise, to which *Raiders of the Lost Crown* alludes with its title, are a prime example of this.)[78] By organizing a plot to capture the feathered crown *from* a European museum, *Raiders* defamiliarizes the imperialist ideologies that suffuse the treasure hunt subgenre, revealing their plots as apologias for colonial plunder.

For Ilich, Moctezuma's Headdress served as a particularly compelling "treasure" within a game he created to be presented in Austria because it could be easily assimilated to a Eurocentric worldview. When I asked him why he chose to use that particular artifact, he answered, "Because my dialogue was with the Austrians or with the Europeans, and they value Merlin's sword, Perseus's shield, no? They value those kinds of things." He added, "If we tell them that each penacho is actually a connection to the heavens, will they understand it? Or will they think we are stupid? They think in terms of a crown. In fact, for them a crown of feathers is worth less than one of gold— and why? Because they're dumb and because they don't have gold in their countries and the only gold they could get was by killing a ton of people and taking gold across oceans."[79] Ilich was counting on the misrecognition of the Penacho's meaning and purpose to engage the Eurocentric imagination of his European audience. He makes clear that he is not purporting to offer veridical or authentic representations of Mesoamerican Indian culture. Doing so is not necessary for the anticolonial critique he is making, and moreover, he is not interested in offering representations of Mesoamerican cosmology to a Eurocentric gaze that would likely perceive them as folkloric oddities. Instead, *Raiders* reframes colonialist representations of Mesoamerican culture—like the museum display of the Penacho—to slyly defamiliarize, provincialize, and mock Eurocolonial presumptions.

A HOLOCAUST SOUVENIR

Ilich hijacked the World Museum's proprietary photograph of the Penacho and used it in a postcard that reframes the display, as well as the photograph itself, as an object lesson in the ways modern cultural institutions reproduce colonial ideologies and practices. The postcard featured the official photograph of the headdress that appears in the World Museum's publicity materials and gift shop offerings. However, it is differentiated from the museum's souvenirs by the caption overlaid atop the image: "SOUVENIR OF THE AMERICAN HOLOCAUST Mexico-Tenochtitlan, 1519–Vienna, 2013" (plate 2). This tactic of critical mimicry in which existing cultural forms are reworked and imbued with antagonistic meanings is known as *détournement* (rerouting or hijacking). Initially theorized by the Letterist International and Situationist International, it was re-elaborated by practitioners and theorists of tactical media.[80] Official logos of Vienna's World Museum and Mexico's National Institute of Anthropology and History (Instituto Nacional de Antropología e Historía) appeared on the back of *Souvenir of the*

American Holocaust, thereby creating the impression that it was produced by these institutions. Ilich produced hundreds of these postcards. He planted some at the World Museum's gift shop and information stands, distributed others at Café Penacho, and has since continued to exhibit and distribute the postcards through his other projects (plate 3). The World Museum's anxious and aggressive response to this intervention led to threats that both he and Gabrielle Cram, the curator who selected his project, might be kicked out of the festival.

Souvenir uses an economy of means: a precisely worded phrase overlaid upon an appropriated photograph. This combination evokes the potency and brevity of political poster art that combines text and image to bring its message into view. It specifically recalls, for instance, the incisive anticolonial critique that appears in some Chicana/o/x poster art, such as Yolanda López's *Who's the Illegal Alien, Pilgrim?* (1978), a lithograph that confronts the racist and colonial representation of immigrants to the United States as "illegal aliens" by underscoring the invasion constituted by Anglo settler colonization in the Americas (figure 1.3). Moreover, the fact that *Souvenir* was massively reproduced and broadly circulated aligns it with the politics of production and circulation seen in political graphics.

Souvenir of the American Holocaust exemplifies how the precise deployment of language in *Raiders'* texts is crucial to the game's anticolonial critique. The photo's caption startles and resituates the headdress from its terminal museumization while ironizing Eurocentric morality as it pertains to the recognition and representation of genocide. The use of the term "American holocaust" participates in a tradition of thusly naming the genocide of Native Americans, which asserts the world-historical and moral significance of a history that is regularly made invisible.[81] The implicit invocation of the Nazi Holocaust throws light on the very different ways in which these genocides have been historicized and regarded by states and in international law, evoking Aimé Césaire's assertion that representations of Nazism as an exceptional barbarism exemplify racist pseudo-humanism in their implicit disavowal of the genocides and violence Europeans unleashed on those they colonized.[82]

In fact, the *defense* of colonial violence, on the part of the U.S. government in particular, impeded international efforts around genocide prevention undertaken in the wake of the Nazi Holocaust. When the United Nations created the Convention on the Prevention and Punishment of Genocide, the United States led an effort to restrict its original definition of genocide, which would have offered legal protections against "policies

1.3 Yolanda López, *Who's the Illegal Alien, Pilgrim?*, 1978. Offset lithograph, 22 × 17½ inches. © Yolanda López. Courtesy of the artist and the UCLA Chicano Studies Research Center.

devoted to bringing about the 'planned disintegration of the political, social, or economic structure of a group or nation'" and against activities constituting cultural genocide, in additional to protections against biological genocide and physical annihilation.[83] A U.S.-led committee drastically restricted these provisions, eliminating all protections against cultural genocide, and still refused to ratify the convention for decades.[84] As Ward Churchill argues, this reflected an awareness among U.S. politicians that U.S. state-sanctioned policies toward American Indians, African Americans, and Puerto Ricans, such as compulsory boarding schools for American Indians and forced sterilization programs to which all of these groups were subjected, would still fall under the far more restricted definition of genocide on which the United States had insisted.[85] As a reader of Churchill's work, Ilich was aware of this history when creating *Raiders*. In fact, when he was asked to select a scholar to participate in the Donau Festival in conjunction with his project, Ilich suggested Churchill, though festival organizers denied his request.

Raiders' reference to the American holocaust is given additional heft and texture by the fact that its gameplay and audiences span Europe and the Americas. By invoking the American holocaust in Austria, the birthplace of Adolf Hitler, and creating the impression through the use of official logos and images that this is being done by national institutions, the postcard mimics and inverts a rhetorical strategy common to U.S. nationalist discourse, one that uses representations of the Nazi Holocaust to shore up the myth that the United States has historically been radically opposed to and unsullied by fascist and racist ideologies and practices of genocidal violence.[86] This disavowal misrepresents the actual history of the United States, including the U.S. state's post–World War II collaborations with Nazis and other European fascists, and with neofascist, genocidal, and authoritarian regimes across the Third World.[87] It also misrepresents the transnational traffic of genocidal politics, including Hitler's open admiration for the U.S. state's organization on "principles of race and the acquisition of territory for a racially define *Volk*," and for its genocide of Native Americans in particular.[88] Thus *Raiders* uses Austria's museum and haunting cultural associations with twentieth-century fascism to frame its indictment of the barbaric practices of American colonial states, their conspicuous impunity, and the hypocrisy of the very delimited cultural politics of holocaust memorialization.

Raiders' implicit critique of discourses of exceptionalism pertaining to the Nazi Holocaust is not intended to downplay its significance. Rather, it mobilizes the moral repugnance that is associated with it

against the semblance of neutrality, worldliness, and enlightenment that is regularly given to the museumization of objects obtained through colonial plundering. The phrase "souvenir of the American holocaust" posits a concept that immediately strikes one as obscene: the very proposition of a "holocaust souvenir" is clearly a calculated affront to a contemporary European moral sensibility. Yet insofar as the phrase signifies in tandem with the image of the headdress over which it is printed, it also refers to an actual object obtained in the Conquest, a famous museum display, and even the copyrighted image Ilich hijacked. Far from being seen as obscene, the headdress's display is, in fact, exemplary of broadly naturalized practices of Western ethnological and anthropological museums, which Diana Taylor succinctly describes as follows: "taking the cultural other out of context and isolating it, reducing the live performance of cultural practice into a dead object behind glass. . . . Enact[ing] the knower/known relationship [and] emphasiz[ing] the discrepancy in power between the society which can contain all others, and those represented only by remains, the shards and fragments salvaged in miniature displays."[89] Thus the juxtaposition the postcard stages between the obscene concept and reference to a typical practice pinpoints the blindness that colonial ideologies produce and the hypocrisy of a Eurocentric moral sensibility that is offended by a concept, once delivered in sufficiently relatable language, yet tacitly accepts the existence of the practice to which it refers. The museum's function as colonial space and its reduction of the headdress to artifactual objecthood are handily undone by Ilich's postcard, whose shocking juxtaposition of language suggests that discursive systems must be violently undone to examine colonial violence and to instantiate another worldview.

Souvenir recalls earlier interventionist performances that critique the colonial character of museums' representations of indigenous peoples and their culture, such as *Artifact Piece* (1986) by James Luna. In the performance, Luna created an installation in the style of an ethnographic display within the San Diego Museum of Man's exhibition on Ipai Indians. Luna, who was Ipai, Payómkawichum, and Mexican American, lay motionless within the exhibition case, dressed in a loincloth. In so doing, he performed the transformation museums ideologically enact with their representational practices—that is, the transformation of living cultures into isolated, lifeless artifacts. Luna used the presence of his living body to denaturalize the ways in which museums attempt to relegate a living people to the past. In a similar manner, *Souvenir* parodies ethnographic museums' naturalized representational practices in order to assert that these are part and parcel of the history and practice of colonial genocide.

The layered meanings produced by *Souvenir* work to disarticulate the mythos of historical time that would put colonial formations in a past distant from the present. In the phrase "souvenir of the American holocaust," "souvenir" can refer to the headdress itself, thus underscoring the history of genocide that inheres in the object's provenance; it can also refer to the postcard, which mimics a souvenir produced by the World Museum. Thus, in suggesting that colonial museums' use of indigenous peoples' material culture consists in treating it as so many "holocaust souvenirs," the postcard not only refers to the colonial violence that was the condition for the headdress's transfer to Europe; it also critiques how the museum, as state apparatus and legitimating institution of Euro-colonial modernity, reproduces imperialist relations and ideologies in the present. Moreover, in the frequent references to the American holocaust made by characters appearing in Ilich's reports to the Penacho email list, the holocaust is represented as an ongoing phenomenon. For example, in one of Ilich's reports, he narrates the following intervention, attributed to an unnamed member of the Network:

> "And speaking of the Holocaust," he added, "[Subcomandante] Marcos has always made it clear that he sees it as something still going on. And of course, that becomes terribly obvious if one just looks at the practices of the Guatemalan police or the official institutional programs of sexual reproduction aimed at the so called 'native' populations. Can anyone do the math? We shouldn't forget the system of reservations in the U.S.A. Or the recent boom of the oil industries in Inuit territory in lands the white men know as 'Canada.'"[90]

In this and other texts circulated on the email list, Ilich represents the American holocaust as a phenomenon whose colonial time-space coordinates span the Americas and include state programs of indigenous dispossession and genocide in the nineteenth and twentieth centuries, and dispossession via extractivism and intellectual property regimes in the twenty-first. By reckoning with palimpsestic time, *Raiders* traces connections among these shifting strategies of colonial genocide and appropriation.

Ilich produced his decoy museum souvenir by making unauthorized use of a photograph whose copyright is owned by the Austrian World Museum (which charges fees for use of the image). Moreover, he explicitly appropriated the photograph *as* intellectual property by printing "Copyright Diego de la Vega, 2013" on the postcard's back. Thus the postcard and its maker disavow multiple colonial property regimes in which the image participates: the transformation of the pillaged Penacho into property of the museum and

the Austrian state, as well as the museum's use of this artifact to generate and commercialize intellectual property. This highlights the colonial and neo-imperial character of intellectual property regimes as they function in contemporary modes of accumulation, again underscoring the heterotemporality of colonial plundering.[91]

ANTIHUMANIST THEATER AND SOLIDARITY MARKETS

In its final two weeks *Raiders* took on a centralized physical setting, in addition to its virtual networked dimension, when Ilich created Café Penacho at the Donau Festival. The café provided the physical staging for crucial elements of *Raiders'* performative realization: it was the space where Network members gathered, played, and plotted; it organized an audience for *Raiders* among the festival's other artists and attendees, who could enter into the world of *Raiders* by coming into the café; and, most important, it provided the infrastructure for Ilich to sell and trade for Zapatista coffee. Café Penacho was also the backdrop for most of the fictionalized narratives Ilich penned about the Support Network's activities in Austria. In the first letter he sent to the Network about his arrival in Krems and preparation for the Network's gathering, Ilich described the café as follows:

> In a basement near Stadtpark in Krems, Austria, a coffee-shop managed by the cooperative media conglomerate Diego de la Vega is just a couple of days away of opening to the public. However, its real activities already started. Below the surface of what seems like an ordinary coffee-shop in the basement of Parkhotel Krems, the space is managed by convinced militants of the Penacho Support Network that made a pilgrimage to be close to the Copilli Quetzalli as it is called. During 3 weeks they'll work on Operation Raiders of the Lost Crown.

Ilich's description plays on the transnational history and cultural imagination of coffee shops as spaces for dissident political plotting,[92] by describing a space that is physically divided to serve two distinct functions: one part is an "ordinary coffee-shop," while the other is a clandestine meeting space where "convinced militants" plot. He casts the latter as a literal and figural underground operation, calling up images of urban guerrillas. However, Café Penacho was most crucial to *Raiders'* narrative in its actual function as a coffee shop within the Donau Festival. With part of the production budget the festival accorded *Raiders*, Ilich purchased one hundred kilograms of coffee produced by cooperatives in Chiapas whose members are part of the

support base of the EZLN, and he used this to brew the espressos he served at the café.

Zapatista coffee cooperatives were created in the wake of Mexico's coffee crisis of the late 1980s and 1990s, when privatization and deregulation of the coffee industry in Mexico and liberalization of the international coffee market allowed for an oligopoly of transnational corporations to dominate coffee production in Mexico and push out small producers.[93] The transformation of Mexico's coffee industry is one example of the ways that the liberalization of trade and counterreform of Mexico's agricultural system carried out in these decades constituted an engineered assault on peasant, collective, and small-scale agricultural production.[94] The Zapatista coffee cooperatives and their solidarity economy are a form of economic resistance to forms of agricultural production mandated by transnational capital and a means by which Zapatista communities maintain their autonomy. They function in resistance to the engineered displacement of indigenous farmers from their land and produce surplus that is invested in autonomous municipalities' infrastructure and institutions.[95]

Raiders enacts solidarity with Zapatismo in both symbolic and material registers by articulating its own narrative and gameplay with the solidarity market for Zapatista coffee. By incorporating the purchase and consumption of coffee into the game, Ilich explicitly treats the material conditions of *Raiders'* production, including its institutional sponsorship and the social relations it organizes through its reception, as elements intrinsic to the work and its politics. Ilich's communiqués explained that purchasing the coffee supported the EZLN's anticolonial resistance: "Every sip you take means a few euros of poetic justice will go to the Zapatista National Liberation Army, a mayan [*sic*] army that still fights within the logic of the 500 years. . . ."[96] In contraposition to folkloric representations of indigenous Mexicans, *Raiders'* framing of the Zapatista cooperatives represents indigenous peasants as modern and progressive economic agents who produce a commodity that circulates transnationally but that is not reduced to its total commodification. Moreover, by discursively commingling representations of contemporary indigenous resistance to dispossession with the earlier history of colonial plundering that is condensed around the story of the Penacho, Ilich affirms the heterotemporal character of colonialism suggested in Subcomandante Marcos's conceptualization of the "New Conquest."

Ilich also used the sale of Zapatista coffee in a performance that decentered a politics of representation through which imperialism's beneficiaries could claim moral self-satisfaction. Visitors to Café Penacho could either

buy an espresso drink made with Zapatista coffee for one euro or obtain it at no monetary charge if they signed the petition that requested the repatriation of the Penacho. Yet Ilich and the Support Network never actually cashed in on the moral capital represented by the more than six hundred signatures they gathered. Just days after launching the petition, Ilich announced in a communiqué to the Penacho email list that the Network would abandon the petition as a political strategy and instead explore other ways to obtain the crown.[97] The petition actually functioned as a kind of decoy. Its mimicry of an activist instrument served to interpolate its signatories into a performance of which they were unaware. I read this performance as a kind of antihumanist invisible theater played out through the acts of exchange Ilich orchestrated at Café Penacho.[98] In comparison to the technique of invisible theater as theorized by Augusto Boal, which serves as a method of consciousness-raising for its unwitting spectators-cum-participants, the antihumanist invisible theater Ilich staged in Café Penacho pointedly assigned a marginal position to the consciousness of its participants.

As a speech act, a petition attempts to leverage the moral authority and indignation of its signatories to issue an entreaty to a person or institution with power. The signatories of Ilich's petition, many of whom were members of a European art audience, enacted their own imagined authority as moral subjects (and, for many, as European citizens) by signing the petition addressed to the presidents of the Austrian and Mexican republics and director of the World Museum. Ilich assigned an exchange value to these signatures by trading them for an espresso. Through this exchange, the signatories were inserted into a different set of relations: they became secondary consumers within a solidarity economy that materially supported Zapatista coffee producers and their communities' autonomy. The fact that this material relation was indifferent to the beliefs or moral authority of the coffee drinkers is underscored by the fact that their thoughts concerning the Zapatistas or their cooperatives were not solicited. The marginalization of their role as moral subjects vis-à-vis the anticolonial politics represented in the performance was completed when Ilich declared the petition defunct, thus annulling the use-value that their signatures supposedly had and symbolically "crashing" the conceptual market that had initially accorded exchange value to the act of signing the petition.

Ilich understands that petitions hail their potential signatories, where "hailing" is understood in an Althusserian sense as a social process of address, inscribed in material practices, through which individuals are enjoined to identify with a subject in ideology.[99] In an interview I did with him in

2017, he said that this was his reason for using a petition to publicly introduce *Raiders*: "How could I insert people into the game? Well, I thought, through a petition on Change.org, because people are very naïve and think that signatures can change something. If you think that something is going to magically occur because you sign or you vote, then you're completely imprisoned within the logic of consumerism and customer service, thinking that things really are changed that way."[100] The gesture of discarding the petition negates the politics of representation and supplication in which it traffics, which appeals to the moral sensibility of powerful state figureheads to "do the right thing." It also negates the drama of moral consciousness that is represented by the petition's appeal to the moral authority of its potential signatories—who are likely beneficiaries of imperialism—to right the wrongs of colonial plundering. Through this negation, *Raiders* interrupts a logic of liberal-colonial ideology wherein beneficiaries of imperialism can imagine themselves as would-be rescuers of those collectivities that are oppressed and dispossessed by it.

These negations clear the stage, so to speak, so that the solidarity economy of Zapatista coffee can emerge in the scene as a distinct form of anticolonial politics, one that entails a labor practice protagonized by indigenous collectivities and a labor practice of transnational solidarity materially useful to such efforts. The latter is made all the more visible *as labor* because Ilich intermingles his role as an art worker for the Donau Festival with his performance as a barista and waiter within the café. While the conceptual marketplace-cum-performance of Café Penacho initially appeared to propose an equivalence between the value of symbolic solidarity with the petition and the value of an espresso brewed with Zapatista coffee, it then dismantles this correlation and insists on the dissimilarity and nonequivalence in value of the liberal representational politics exemplified by the petition and the material politics expressed by the coffee economy.

The way Café Penacho's market-as-performance decenters European art viewers' moral consciousness within anticolonial struggle is one example of Ilich's calculated negotiation of *Raiders*' presentation at a curated, state-sponsored Austrian music and art festival. In such a context, the presentation of an explicitly Zapatista-aligned art project, authored by a Latin American artist and activist, could easily be consumed as a spectacle of "radical politics" imported from a distant locale to offer multicultural literacy or moral self-satisfaction to its metropolitan audiences (via an illusion of solidarity forged by the consumption of art), while shoring up a self-image of the metropole's progressive cosmopolitanism. As Ilich suggested in a 2016 interview,

the critical mimicry and deception he deployed throughout *Raiders* allowed him to deflect such interpellations and interpretations that would falsify and diminish his work:

> The Austrian activists, of course, hoped that I would be an autonomist and that I'd bring the Molotov cocktail and wear a ski mask and scream in Náhuatl or something. But, on the contrary, I came speaking their hypocritical European language of human rights, of "we want to make a petition," speaking all of their humanist languages of diversity and the French and Austrian universalist languages they use. Thus, that way I wasn't like a "simple Indian" with no future who came to make art, but rather, they realized that I was a Latino disguised as an Indian who is like them, but who is making fun of them, but saying, "I'm not making fun of you, I'm in character."[101]

Here, Ilich describes his desire to deflect the colonial gaze that would fix his person and work into the image of Latin American agitation imagined and desired by Austrian audiences, which includes a folklorizing fetishization of certain cultural signifiers and the casting of ethnic reclamation as political subjectivity. His solution was to use *Raiders* as an anticolonial looking glass that he could turn on his metropolitan audience to provincialize and critique *their* colonial worldview.

SPECULATIVE ECONOMICS

When Ilich recommended that the Network "forget any sort of political action (whether lobbying, signature petitions, or protest rallies: as none of that would have any real effect)," he proposed alternative strategies to obtain the Penacho. First, he posited the possibility of stealing it, but later reported that "the Diego de la Vega cooperative media conglomerate won't pursue the option of theft or robbery." Instead, he proposed that the Network collect money and attempt to buy the headdress, adding, "Everything is for sale, if the amount is right, isn't it?"[102] In a subsequent missive, he relays a specific proposal to this end: "Let's try to buy the Penacho in the amount originally valued by the museum. We don't adjust to today's prices, but pay in gold, but also don't charge them for interest or commercial use of 150 years."[103]

Several Network members objected to the proposal of buying the crown on ideological grounds. For example, the artist Alicia Herrero wrote to the Network from Buenos Aires, "I understand the poetic and political significance that the restitution of an object of indigenous culture could have for

the desire to become neo-post-neoliberal. But are we truly that interested in the object? I don't think so. I think the most relevant thing would be to find the form to produce an exit from the rules that govern this impunity. Wouldn't buying it be a form of legitimizing the original criminal act?"[104] Ilich responded in a letter to the Network:

> [Alicia] doesn't agree that we try to buy the artifact, because we would be validating the whole criminal system.... And while I understand and agree with the idea, I think the whole system is more than validated and perhaps we have to start to speak not with humanist ideas, but actually discuss money. Look at the french humanists, they just had a big art auction (in, was it Sothebys?) of work previous to the european-engineered genocide in the Americas, which of course was looted. So as CEO of Diego de la Vega I suggest let's talk business.[105]

In his reports, Ilich also noted the disagreement of other Network members who were in Krems with him. He wrote, "The representative of Nimda Corp reminded the group that there are some members in the Penacho Support Network that oppose giving more gold to Europe considering all that Europe already took from the Americas."[106] Ilich also narrated the dissent of Dr. Kruna, a character Ilich invented. Within the game's fiction, Dr. Kruna (whose name means "crown") was an exiled Croatian who traveled from his home in Buenos Aires to join the Support Network. He regularly used references to the dominant historico-moral imaginary surrounding the Nazi Holocaust to criticize the historical effacement and moral indifference with which the American holocaust is treated. As reported in Ilich's email, Kruna responded to the proposal to buy the crown by saying, "I don't see why you have to pay anything to Europe for a Crown that shouldn't be here in the first place. It's almost like charging Anna Frank for not paying the rent while she was a squatter. It is they who owe you reparations, they destroyed your cultures and religions so they could take over the resources."[107] Despite these objections, Ilich pushed forward the plan to purchase the Penacho and solicited Network members to contribute to the fund to purchase it, writing, "Hopefully you will also chip in some pesos, dollars, euros, pounds, gold ounces, cacao seeds, digital material sunflowers or bitcoins to buy the penacho and bring it back."[108]

The epistolary exchange about buying the Penacho is an allegory about uneven geographies of accumulation and an exercise in speculative imagination that juxtaposes hegemonic and anti-imperialist representations of accumulation, debt, and credit. Ilich's suggestion that the Network calculate the

Penacho's exchange value vis-à-vis the value of gold, specifically, signifies on different aspects of gold's history as a commodity within the capitalist world system. For instance, it makes use of gold's modern function of commensuration (its ability to represent exchange value as such), which was historically used to anchor a global money system. On one register, the absurdity of the suggestion that the "original value" of the headdress could be expressed in monetary terms (how would one calculate the value of a sacred object as exchange value?) points to the particularity of capitalist conceptualizations of value and their limitations for reckoning with the scope of colonialism's effects. On another register, Ilich's proposal can be read as an assertion of the rationality, justness, and plausibility of colonial reparations. As the headdress functions as a metonym for wealth taken from the Americas and its inhabitants, then the proposal that this could be represented as exchange value is also a call to account, as it asserts that the transfer of wealth enabled by colonialism should be legible—and payable—within the ledgers and logics of today's financialized global economy.

Ilich's proposal—and Nimda Corp.'s objection to it—also make reference to the history of Europeans' massive extraction of metals from the Americas since first colonizing the continent. Europeans' lust for gold and other precious metals was a driving force in the conquest of Tenochtitlán and the rest of the continental Americas—although, by then, Europeans had already looted gold from the Antilles, exterminating the indigenous population in the process through a brutal regime of forced labor.[109] By the mid-1500s, the Spanish colonists were mining silver in Guanajuato, Zacatecas, and Potosí.[110] Their conquest of the Incas gave them access to Potosí's immense reserves of silver, and they pressed an estimated eight million indigenous people and thirty thousand imported Africans into the work of silver extraction through a forced labor system that would destroy indigenous forms of collective farming.[111]

Europeans' colonial conquest, plundering, and slaving constituted a process of primitive accumulation that transformed the global economy and enabled Europe's capitalist development. Marx emphasized the violence of capitalism's colonial origins, writing, "The discovery of gold and silver in America, the extirpation, enslavement and entombment in mines of the aboriginal population, the beginning of the conquest and looting of the East Indies, the turning of Africa into a warren for the commercial hunting of black-skins, signalized the rosy dawn of the era of capitalist production."[112] While departing from the stadialist view of history that holds that it has been organized by distinct, successive modes of production, Andre Gunder

Frank has shown how the growth of the European economy, and its eventual rise to global hegemony in the eighteenth century, depended on the colonial extraction of metals and labor from the Americas. As he writes, the plundered silver and gold that flowed into European coffers "provided Europeans with their one competitive advantage among their Asian competitors," allowing them to "muscle in on the intra-Asian trade," in which their goods were not competitive.[113] The colonization of the Americas was also essential to European capitalist development in that it provided an important market for European goods and Asian goods Europeans re-exported. Moreover, the supply of goods Europeans obtained from American colonies, as well as imports they were able to obtain from Asia (on account of American metals), freed up land and labor in Europe to be oriented toward development.[114]

The discussion within the Penacho Support Network about paying Austria in gold for the looted Penacho magnifies the contradictions upon which colonial capitalism was built. This is the source of the irony of Ilich's proposal. By calling up the history of Europeans' colonial metallic extraction, his proposal points out that what is at stake in addressing the history of accumulation to which the Penacho's plunder pertains is not only the question of who owns certain artifacts. It is also a matter of recognizing the fundamental role of the colonial extraction of resources and labor from the Americas for producing modern Europe, and producing the modern capitalist world-system in which everything, even what is sacred, can be treated as a commodity.[115] At the same time, Ilich's comments also recognize that the historical centrality of colonial plundering to the modern world economy has little moral or epistemological purchase on dominant conceptions of property and debt. As he says, because the "whole [criminal] system is more than validated," the Network must negotiate using the concepts and property regimes the criminal system has imposed.

Ilich's reference to metallic extraction from the Americas as a feature of primitive accumulation is not only about a colonial *past*. It also functions within *Raiders'* palimpsestic representation of time to assert the continuity of these processes into the present and underscore the imperialist and colonial character of contemporary capitalist extractivism in the Americas, and mining in particular. Processes of primitive accumulation abetted by neoliberal restructuring are central to the pattern of accumulation that has been organized around extractive industries in recent decades.[116] This "new extractivism" is "based on the overexploitation of generally nonrenewable natural resources, as well as the expansion of capital's frontiers toward territories previously considered nonproductive." The accumulation of profit

is "predicated not so much on the extraction of surplus value (the exploitation of labor) as on the appropriation of extraordinary profits in the form of monopoly ground rent."[117] In Latin America, contemporary extractivism is characterized by the dominance of large-scale, capital-intensive (and oftentimes not labor-intensive) enterprises that occupy massive tracts of land and are oriented toward the export of primary commodities, such as fossil and biofuels, minerals, and agrofood products, with the Global North and China as the primary consumers.[118] These industries operate as engines of primitive accumulation, furthering the enclosure of the global commons, separating direct producers from their means of production or livelihood, and furthering the colonization of life by capital.[119] These processes operate through the privatization and commodification of natural resources, landgrabbing, and the degradation of habitats and ecosystems, which destroys livelihoods and ways of life, particularly those of rural, indigenous, and Afro-descendent populations.[120] As these forms of dispossession are often not linked to proletarianization, they also produce what Subcomandante Marcos describes as "expendable" populations.[121]

The rise of extractivism in Latin America is linked to the reprimarization of the region's economies—that is, their orientation toward the export of primary commodities with little added value.[122] Though it was intensified with the commodities boom of the early twenty-first century, reprimarization began in the 1990s, when Latin American governments implemented neoliberal reforms that encouraged the exploitation of "natural resources to increase exports and thus generate the foreign exchange and additional fiscal revenues" to service foreign debt.[123] In addition to causing massive ecological destruction and displacing rural communities, extractivism in Latin America produces familiar patterns of imperialist accumulation and dependency. It has increased Latin American countries' dependence on foreign capital, inhibited domestic capital formation, and fostered the development of enclave economies.[124]

While some social democratic and populist governments in Latin America have used rents from extractivist industries to redistribute wealth to working classes and expand state services, extractivism in Mexico has followed a neoliberal model and has been decidedly neocolonial. Large-scale metal mining in the country exemplifies this. Reforms made under the government of neoliberal crusader Carlos Salinas de Gortari (1988–94) paved the way for the current situation in which nearly a third of the national territory is held by foreign capital in private concessions.[125] While the Mexican state subsidizes these industries, it receives no royalties on their profits, and the

payments the state receives in taxes sometimes do not even cover the wealth it expended to attract foreign capital in the first place.[126] As nonrenewable resources are siphoned out of the country, transnational capital externalizes the costs of extraction in the form of environmental destruction and displacement of rural populations. As precious metals are the vast majority of those mined in Mexico, "Mexico's environment is being destroyed and the health and livelihoods of the rural poor are being sacrificed mostly to produce jewelry and decorative items for the rich and to provide safe haven for speculative capital."[127]

Through its pointed references to gold and colonial pillage, *Raiders* offers a palimpsestic perspective on the extraction of metallic wealth from the Americas, where we can perceive the traffic between colonial primitive accumulation led by imperialist mercantilists, monarchies, and the Catholic Church and present-day plunder by transnational firms enabled by neocolonial, neoliberal states. This perspective—with its attention to mining in particular—also adds greater nuance to *Raiders'* analysis of imperialist pillage, as it makes clear that Europeans are not its only agents. After all, most of the mining firms that are occupying Mexico's territory are based in Canada, while firms based in the United States and China are also leading extraction throughout the hemisphere.[128] The palimpsestic historical perspective *Raiders* offers helps us perceive the dynamic and ongoing character of primitive accumulation, or what Mark Neocleous refers to as "the permanence of systematic colonisation, at the heart of which is the accumulation of capital and not merely one powerful 'imperial' state."[129] *Raiders* assiduously situates indigenous dispossession as constitutive of these processes as it allegorically analyzes capitalist accumulation through the story of the Penacho.

The financialist framing Ilich gives to his speculative valuations of the Penacho adds greater irony to his counterhegemonic representation of imperialist accumulation and its systematic disavowal. His suggestion that Austria could be charged interest for its "commercial use" of the headdress-turned-property can be read as a metonym for an even more comprehensive accounting of imperialist accumulation, one that reckons with the *totality* of capitalist accumulation that has been enabled by colonial and imperial dispossession—that is, not only what has been taken by plundering and enclosure but also wealth generated by the "commercial uses" to which this wealth is put, such as through expanded reproduction, rents, and interest.[130]

As an exercise in speculative economics, Ilich's proposal leads us to imagine an alternate global economic reality wherein colonial property regimes are rejected, imperialist accumulation is conceptualized as outstanding debt,

and imperialized peoples become creditors poised to collect. Set against this utopian financial calculus, Ilich's suggestion that the Network must resort to paying a historically imperialist European state *even more* gold for looted cultural patrimony can be read as a brutally realist send-up of the way the *actual* global economy operates. Whereas Ilich envisages financial instruments being used for an anti-imperialist balancing of accounts, in reality they are among the most powerful forces that late global capital uses to extend the domination, dispossession, and exploitation of colonized and imperialized peoples.[131] This is illustrated by the history of the neoliberalization and financialization of Mexico's economy, which has entailed an increase in the power that foreign capital exercises over the country, the immiseration of millions, and sweeping privatizations and land grabs that exemplify the conquest of new territories to which Subcomandante Marcos refers in his indictment of neoliberal accumulation.[132] By bringing this historical reality into the same discursive frame as the narrative about the Penacho (which, we are told, cannot be restituted, but perhaps only purchased), *Raiders* highlights the ways that forms of dispossession are continually redeployed through the traffic between colonial, neocolonial, and neo-imperial relations.

Raiders' ability to bring into view the heterotemporality of colonial and imperialist plundering militates against what Peter Hitchcock describes as the "complex and highly developed amnesia" enabled by the temporality of accumulation under finance capital.[133] But it also shows how this amnesia is inextricable from a more fundamental effacement: the disavowal of colonial and imperialist forms of dispossession that both enable and operate through finance capital's predations. This is not only a matter of historical representation; also at stake is the constitution of the modern economy as an epistemological object. By bringing into one field of apprehension competing representations of accumulation, value, and debt, *Raiders'* alternate reality frames representations of the global economy as a space of struggle,[134] in which liberal-colonial paradigms overdetermine foundational concepts, relations, and spatiotemporal coordinates. This is another example of how the stereoscopic vision *Raiders* affords further deepens its critique of colonial capitalism as a material, ideological, and aesthetic endeavor, as Ilich's project brings into view practices of dispossession *and* the systems of representation that sanction their systemic disavowal.

As a tongue-in-cheek "business proposal," Ilich's discussion of buying the Penacho echoes another great politico-literary exercise in anticolonial irony. In 1969, eighty-nine American Indians occupied Alcatraz Island, holding it for seven months. Part of the Red Power movement, the occupation became a

powerful symbol within the struggle for Indian self-determination.[135] One of its goals was the establishment of multiple Native American educational and cultural centers on the island.[136] Calling themselves "Indians of all Tribes," the activists issued a proclamation that began, "We, the native Americans, reclaim the land known as Alcatraz Island in the name of all American Indians *by right of discovery.*" "Wish[ing] to be fair and honorable in [their] dealings with the Caucasian inhabitants of this land," they offered a "treaty: We will purchase said island for 24 dollars ($24) in glass beads and red cloth, a precedent set by the white man's purchase of a similar island about 300 years ago." They also promised to give current inhabitants of the island a portion of it "to be held in trust by the American Indian Government . . . to be administered by the Bureau of Caucasian Affairs (BCA)."[137] Like Ilich's proposal for the Penacho, the proclamation slyly inhabits established discursive codes pertaining to the transaction of property. It plays up the claims to universality, neutrality, and civility made by capitalist concepts of value, property, and exchange by deploying them—with exaggerated "civility"—toward an anticolonial settling of accounts. Also like Ilich's proposal, the biting irony of the proclamation issues from the *actual* history of these concepts' use by colonial powers in their systematic pillaging and enforced unequal exchange.

DISMANTLING INDIGENISMO

I have shown how *Raiders* uses Moctezuma's Headdress as material record and symbol of colonial conquest to address ongoing processes of colonial and imperialist dispossession. It pointedly critiques the Mexican state's role in these processes by engaging a symbolic valence the headdress has within expressions of Mexican nationalism, that is, the way the state's representations of the artifact exemplify ideologies and practices of indigenismo, which have long been used to enable and naturalize the domination and ethnocide of Indians.

As summarized by Héctor Díaz Polanco, Latin American indigenismo entails practices and theories formulated by nonindigenous people to address what is defined by the ruling class as the "indigenous problem."[138] Representations of the headdress specifically exemplify the nationalist and integrationist indigenismo of the postrevolutionary Mexican state, which celebrates *ancient* indigenous culture as a source and tradition for the Mexican nation while pursuing the de-Indianization[139] of living Indians. As Saldaña-Portillo has shown, in postrevolutionary Mexican nationalist thought, Indians are represented as a "beginning point of development," while the urban mestizo

proletarian, imagined as the felicitous outcome of the intermixing of European and indigenous cultures, is the paradigmatic subject of the modern nation. This casting of cultural heterogeneity into an evolutionary schema ideologically justifies the targeting of Indians as the object of reform.[140]

Mexico's ideological state apparatuses, including the National Anthropology Museum and the press, promote this colonial ideology by representing indigenous peoples (and particularly the ancient Mexicas) as being a source of Mexican identity who are nonetheless confined to a nonmodern past. For example, while the museum monumentalizes pre-Conquest indigenous cultures, it represents them as belonging to a "dead world" that is separate from the modern world, including the contemporary history of indigenous Mexicans.[141] The way that indigenismo allows for a circumscribed incorporation of indigenous culture into representations of the Mexican nation, while also justifying the domination of Indians, is perfectly exemplified in the fact that state functionaries and intellectuals who publicly clamored for the headdress's repatriation and claimed it to be a symbol of Mexican national identity have also been fiercely antagonistic to the political struggles of living indigenous communities.[142]

A revitalization of indigenismo accompanied Mexico's neoliberalization. Following the highly visible critiques of the state's assimilationist policies made by the EZLN and other indigenous movements, the neoliberal Mexican state deployed indigenismo as a form of multiculturalist politics that vaunts the recognition of cultural pluralism.[143] This amounted to a solely culturalist approach to indigenous rights—a cynical attempt to lend "the neoliberal state an aura of multicultural tolerance," as that same state imposes economic policies that destroy the material conditions for indigenous peasants to reproduce their forms of life and escalates the repression of indigenous communities.[144]

Raiders' use of the discourse surrounding the Penacho as the material for its anticolonial narrative works to expose the Mexican state's strategic use of indigenous culture as evidence of its colonial character. In Ilich's initial missive for *Raiders*, in which he disseminated the petition, he also questioned the Mexican state's claim on the indigenous artifact: "It is true that the Aztec Triple Alliance no longer exists, and that most Nahua people were converted to christianism with the help of the sword, and also that a nation state was born which extended itself all the way past Chichimeca lands to the Pacific Ocean (and whose idea of a Triple Alliance is the North American Free Trade Agreement, together with Canada and the USA)."[145] This text highlights the paradox of repatriating the headdress to Mexico, given that

the headdress originated in an indigenous civilization fundamentally differ-ent from the Mexican state that would claim ownership of it as national pat-rimony. By calling NAFTA the Mexican state's "idea of a Triple Alliance," Ilich emphasizes through irony the antagonistic relationship the Mexican state has with the country's indigenous people. Within indigenist ideologies, the Mexica Triple Alliance is revered as a source of Mexican national identity. NAFTA is evidence and symbol of the colonial and neocolonial character of contemporary Mexico's ruling class. It exemplifies the neoliberal economic policies that have subordinated Mexico's working classes to the needs of transnational capital, and it constituted an especially brutal assault on rural Indians. By comparing the Triple Alliance to the Mexican state's alliances via NAFTA, Ilich ironically deploys the nationalist mythification of the Triple Alliance to unmask the incongruity between the ideals of Mexican national-ism and the machinations of Mexico's neocolonial ruling class. Moreover, as this passage of Ilich's letter braids references to colonial conquest with references to Mexico's economic neoliberalization, it calls attention to the colonial character of neoliberal policies, as these facilitate the further dispos-session of indigenous peoples.

As *Raiders'* narrative unfolds, Ilich marks ever more emphatically and dramatically the antagonism between the Mexican state's use of signifi-ers of Indian identity and the liberation struggle of Indians in Mexico. He warns of "the bad things which could happen" if the Penacho were returned to Mexico, "like falling in the wrong hands or being instrumentalized for things unrelated to giving sovereignty and cultural freedoms to the indig-enous people," thereby critiquing the Mexican state's indigenismo for its stra-tegic use of indigenous culture that is indifferent to the political demands of indigenous people. In another missive he asks, "What if on the boat home we were to cut all the feathers and blow it away one by one into the wind and the sea . . . ?,"[146] suggesting, perhaps, that dismembering the headdress and casting it into the sea would be preferable to delivering it to the Mexican state and its museums.

In clear contraposition to nationalist uses of ancient indigenous culture, in *Raiders* the Penacho becomes a symbol of a contradiction at the heart of Mexican nationalist ideologies: a disavowed and ongoing genocide di-rected at a civilization that is the base of Mexican society but whose domi-nation is the condition for modern Mexican identity.[147] The Mexican state has attempted to mask this contradiction with indigenista ideologies that accord a place to indigenous civilization in the foundational myth of the Mexican nation in order to jettison indigeneity into a past cordoned off

from modernity. *Raiders* counters this maneuver through its representations of a symbol paradigmatically deployed by state indigenismo: a glorious ancient Mexica artifact. Rather than depict the headdress as a vestige of a premodern past or symbol of biologized origins of the Mexican nation, as is typically done in nationalist uses of indigenous culture, *Raiders* uses the headdress to tell a story about the heterotemporality of colonial formations and organized resistance to them, which it not only situates within globalized modernity but also represents as *the* urgent struggle of the present. While the game exploits the mythos associated with the headdress, bestowed on it in no small part by its use in nationalist discourses, *Raiders* promulgates representations of Indians unassimilable to state indigenist ideologies. The Indians in *Raiders'* narrative world are protagonists and theorists of anticolonial struggle against the Mexican state and of globalized struggle against capitalism, as well as progressive economic agents who exercise control over their forms of production and their participation in transnational markets.

Raiders evinces a Zapatista tactic of discursive intervention through its appropriation of symbols of Indian culture that are regularly deployed in state nationalist discourse. Saldaña-Portillo argues that, in its function of hegemonic articulation, Mexican mestizo nationalist discourse deploys representations of Indian difference that essentially make Indian difference into an empty signifier, unmoored from reference to actual indigenous people.[148] Through her analysis of the Zapatistas' discourse and performances of participatory democracy, she argues that the Zapatistas "have seized the empty signifier of Indian difference and its function in Mexican culture" and filled "its 'empty' content with Indian specificity."[149] In so doing, they have politicized indigenous resistance in universalist terms in order to unite resistance to the predations of Mexico's ruling class and articulate heterogeneous struggles of those from below and on the Left.[150] Official nationalist representations of the Penacho exemplify the symbolic deployment of Indian difference as an abstraction detached from any reference to living indigenous people in Mexico. *Raiders* resignifies the headdress within an anticolonial narrative that addresses the concrete specificity of contemporary indigenous liberation struggles in Mexico, while convoking a network of resistance attuned to the global scale and multiple fronts of contemporary anticolonial and anticapitalist struggle. What I want to point out is that not only is the cultural politics of *Raiders* aligned with Zapatista political thought; the form of its aesthetic intervention also expresses the unmistakable influence of Zapatista discourse and performance.

While the Zapatistas' reworking of signifiers of Mexican revolutionary nationalist discourse has enabled their articulation of a new politics for the Mexican nation-state,[151] they have also convoked an international network of collectivities defined below or beyond the modern colonial nation-state and joined by resistance to globalized capital and its attendant structures of (racialized, patriarchal, colonial) oppression. This latter conception of a political collectivity is echoed by the figure of the Penacho Support Network as a translocal network conjoined in solidarity with anticolonial and anti-imperialist struggles of a global scope.

AN AZTEC CHAPEL IN VIENNA

Or will the idea of "'world museum" be one closer to the House of Habsburg conception of world? Will a pope again come and say what belongs to who and split the world between Portugal and Spain?—Fran Ilich, email to Penacho email list, April 16, 2013

The upside-down world created by colonialism will return to its feet as history only if it can defeat those who are determined to preserve the past with its burden of ill-gotten privileges.—Silvia Rivera Cusicanqui, "Ch'ixinakax utxiwa: A Reflection on the Practices and Discourses of Decolonization"

The final message Ilich sent to the Penacho email list narrates a crisis among the Network members, who finally seem unable to decide how to proceed with their "mission." Finally, one member offers an altogether different proposal as to what is to be done:

> What we should probably contemplate is the possibility that the Penacho will stay forever in Vienna, either because their democratic government won't want to give it back or because it's too old and frail to embark on a transatlantic voyage. So ... I think there is a possibility for alchemy, the strategy of destroying temples to put other temples on top can be reversed. How about asking Austria to continue taking care of Moctezuma's Feathercrown in a special space outside of the museum, where it is currently surrounded by dead objects. Perhaps instead Vienna could create a chapel like the one the Mexicans built in Querétaro for the Emperors Maximilian and Carlota. But in this one, they could give the Aztec religion an opportunity to restart and co-exist alongside Catholicism. Of course, not only the Aztec religion, all indigenous religions deserve respect. Half a millennium has passed, Catholicism can't possibly still be in that phase where it either converts or kills, right? ... Why not allow an

almost destroyed religion like the Aztec one to bloom out of the Vienna World Museum? This would certainly demonstrate that the word "world" in its name is much more than just a marketing scheme.[152]

Suggesting that the World Museum could do justice to its name only by creating space for a living Nahua cultural practice is a cheeky way of calling the bluff on the institution's humanist discourse and claims to knowledge on a global scale. Yet the proposal this text makes goes beyond irony and negation, as it conceives of a radically different function for the ideological apparatus that is an ethnographic museum. Suggesting that the World Museum remove the headdress from the abstraction and privatization to which it has long been consigned and instead use it to foment indigenous American cultural practice in Vienna implies dismantling the very structure of representation that characterizes ethnographic displays, including the ideologies of distance and anachronism their representational structure reproduces. *Raiders* reimagines the museum as an apparatus that could assail the universalist claims of Christian ideology and organize material conditions for the exercise of practices and the assertion of worldviews this ideology has long dominated—in the middle of the European metropole, no less. Through this proposition, *Raiders* asserts a utopian vision of a world in which such radical reconfigurations could be possible.

Read literally, the proposal to try to "re-start" the "Aztec religion" may evoke the folkloric fetishization of pre-Columbian religious practice and the obfuscation of the continuity of Nahua religious practices, including in altered forms. But the text should be read as utopic speculation that signifies on a figurative register, as this is more consistent with the allegorical character of *Raiders*, as well as with the politics that animates the work. *Raiders'* narrative continually underscores ways in which capitalist modernity, Eurocentric bourgeois humanism, and European colonialism have been historically co-constituted (thereby contributing to crucial insights from anti-imperialist intellectual traditions).[153] Thus it is fitting that the utopian proposal with which *Raiders'* narrative closes is the decolonization of an institution and set of practices exemplary of Eurocentric bourgeois humanism. The utopic scenario the text invokes, wherein the ethnographic museum's function is fundamentally transformed and Nahua religious practice lays claim to space in Vienna, is a metonym for a far-reaching transformation of social relations and imaginaries.

The proposal evokes the EZLN's assertion that the horizon of struggle is to create a "world in which many worlds fit."[154] By proposing an alternate worlding of the Penacho, *Raiders* imagines indigenous American culture,

worldviews, and practices coexisting on an equal footing alongside modern Christian European culture, *including* within the geographic and cultural heart of European modernity. The proposal to create a new architectural space in Vienna suggests that a pluricultural future intrinsically requires material, spatial, and cultural transformation at a transnational scale— including the transformation of European metropoles. Crucially, *Raiders'* narrative, the theory of the EZLN it references, and the history of colonial capitalism all make abundantly clear that a "world in which many worlds fit" can be sustained only if capitalism is destroyed.[155]

As its narrative unfolds, *Raiders* moves ever further beyond the specific controversy about the ownership of the Penacho to make clear that questions of colonial plunder implicate the entirety of the global economy: from the historical origins of global capitalism to the contemporary dynamics of capitalist accumulation and the epistemological-perceptual ordering of the social world and moral frameworks that flow from this. Its narrative also dismantles claims that recuperation and representation are viable anticolonial strategies when these offer only culturalist responses to colonial social structures or serve to give a sheen of moral rectitude to liberal-colonial institutions. *Raiders'* poetic and utopian conclusion asserts that the horizon of contemporary anticolonial struggle must be a comprehensive and global social transformation that would allow for the survival and equality of those worlds and life-forms capitalism intrinsically destroys. In a shrewd retort to those who suggest that anticolonial struggles are oriented toward recuperating a past, *Raiders* asserts that, in fact, it is those who would obstruct decolonization who are committed to preserving the past—that is, to preserving their colonial pillage (be it held in museums or banks) and preserving socioeconomic relations founded on conquest and dependent upon its perpetuation.[156]

Historiographers of the Invisible

In L.A., Mexican history is so integral to this place, yet it's not recognized. . . . So, our memory has survived in very guerrilla-like ways.—Sandra de la Loza, interview with author, *Latinart* (2004)

IN THE LEAD-UP TO CINCO DE MAYO IN 2002, a Los Angeles–based research society installed historical plaques in and around downtown Los Angeles to commemorate histories pertaining to Mexicans and Central Americans. Within just five hours of its installation, one of these plaques was removed. It had been installed in the El Pueblo de Los Ángeles Historical Monument at the site of an invisible mural. The plaque commemorated both the painting and the whitewashing of *América Tropical* (1932), an anti-imperialist mural by the Mexican artist and communist militant David Alfaro Siqueiros.[1] In a May 5 press release the research society noted the quick removal of their historic marker, wryly suggesting that "apparently it did not conform to the city's vision of a Cinco de Mayo celebration."[2] This was an apt observation, as the corporate multiculturalism that dominates many official and commercial Cinco de Mayo celebrations leaves little space for histories pertaining to Mexicans' militancy against U.S. imperialism or to the U.S. state's whitewashing of history. It is ironic, of course, that a plaque memorializing the whitewashing of a Mexican's artwork about history would

be subject to such hasty erasure—and, moreover, that this would occur in a historic district. Yet it is consistent with the research society's perspective on history, which they cannily summarized in the press release: "What is history but a battleground of the present."[3]

In this same press release, titled "Guerrilla Historians Hit L.A. with (un) Official Historical Markers," the Pocho Research Society of Erased and Invisible History publicly announced its objective: to address "erased moments in Los Angeles History."[4] The Society's guerrilla historians would continue to install unofficial historical markers in and around Northeast and downtown L.A. over the next five years. These commemorated histories of immigration, of radical Left organizing and youth culture, and histories of the city's working-class immigrant, Latinx, and queer collectivities. The Pocho Research Society never seeks permission or permits to install its markers, which are consistently removed (be it in a matter of hours, days, or months). But their removal reinforces the very critique the Research Society is making about the systematic erasure of subaltern histories and about the ways that both historical and spatial production are sites of social struggle.

The Pocho Research Society of Erased and Invisible History (PRS) is a semifictionalized and wholly unofficial historical society that was created in 2002 by Sandra de la Loza (figure 2.1). It is a meta-artwork of hers that also functions as a platform through which she has collaborated with other artists and writers, though de la Loza always conceptualizes and leads these projects. The PRS's work moves between and combines visual art, public history, and literary production—where art and literature are confined neither to the white box nor page but happen throughout the urban landscape, from public plazas to storefronts and bars.

In the spirit of Situationist *détournement*, the PRS appropriates formal conventions of official historical repositories, such as monuments, museums, and state-commissioned memorials, to create its own unofficial, often poetic versions of these. It also surreptitiously augments official monuments in order to critique the hegemonic conceptions of history and space these promote, and to assert alternative histories of the same sites the monuments mark. The PRS's use of this tactic of critical mimicry serves to denaturalize the ideological function of official repositories of history and challenge their poses of neutrality and claims to universality.

Indeed, the PRS's own name is a kind of détournement. By identifying their guerrilla practice of historical production as that of an unlikely sounding historical society, the PRS ironizes the authority such institutions wield in producing historical representations. Yet this is not only a gesture of

2.1 Untitled digital photograph (portrait of Sandra de la Loza), 2002. Courtesy of Sandra de la Loza.

critique. The PRS's mimicry of forms that official historical productions take, and of the name of a historical society, also asserts the PRS *as a producer of history*. It does this while marking the difference in the position the PRS occupies within social relations of historical production as compared to those agents whose productions are officially sanctioned and therefore, most likely, permanent, widely circulated, and financially remunerated.

By calling itself "Pocho," the PRS situates its practice within Chicana/o/x culture and history and, with playful belligerence, lays claim to a marginal and denigrated position vis-à-vis the hegemonic national cultures of the United States and Mexico. Pocha/o/x identity is a contested site over which competing discourses about U.S. and Mexican national identities contend as they are used to identify subjects whose social positioning has been shaped by the United States' imperialist relationship to Mexico, the territorial displacement of Mexicans, and the racism Mexicans and Chicanas/os/xs face in the United States, including pressures to assimilate.[5] With this in mind, a *pocho research society* can be understood as a collective that knowingly contends with these historical forces in its research practice while rejecting nationalist or ethnonationalist notions of cultural authenticity.

Much of the PRS's work has consisted of guerrilla interventions in public spaces with what appear to be official historical markers: bronze-colored metal plaques screen-printed with neat black text. While visually mimicking official historical markers, these countermonuments contest the social relations of production and the typical social function of official historical monuments.[6] They model a direct-action approach to producing public history, and specifically commemorate histories that have been erased by hegemonic history.

The aforementioned plaque about the painting and whitewashing of *América Tropical* was part of the PRS's first series of interventions, entitled *Operation Invisible Monument* (2002). The other three works in the series were dialogic countermonuments[7] in which the PRS added their own plaques to existing historic monuments, thereby juxtaposing to the state's historical representations alternate narratives about the same sites. The histories of working-class people set forth in the PRS's plaques challenged the state plaques' progress narratives about capitalist development, colonial conquest, and nation-building. For example, on a city monument commemorating the construction of Dodger Stadium, the PRS installed its own plaque titled *The Displacement of the Displaced* (plate 4). It named the same site "View of the former site of the Chavez Ravine community" and recounted the city government's forceful displacement of a working-class Mexican

community so that the land on which they had lived could be offered to the owner of the Dodgers.[8] In *The Triumph of the Tagger*, the PRS augmented a city monument that marks the southern terminus of the Southern Pacific Railroad. The plaque the PRS installed on the monument commemorated the "invisible army" that, in the late 1980s, "assaulted the city with spray cans transforming bland concrete walls into canvases filled with an explosive language of hard-edged urban forms, radiating color, and an abstract, coded lexicon." It noted in particular the prolificacy of "the Boyle Heights tagger known as Chaka," who "single-handedly inflicted $30,000 worth of damage to the Southern Pacific Railroad."[9]

In their next series, *October Surprise* (2004), the PRS affixed its plaques to the façades of buildings in Northeast L.A. to commemorate the grassroots youth counterculture and activist spaces that had formerly operated in them. De la Loza has described this project as a response to the gentrification of neighborhoods in L.A. that had been home to working-class Chicanas/os/xs and immigrants. As these communities are pushed out of their neighborhoods, the "radical and political cultural histories" they had created in them are consigned to oblivion, she suggests.[10] The PRS's plaques commemorated grassroots spaces that had created possibilities for political organizing, radical education, and expressive culture in the 1980s and 1990s. One plaque recounted the history of the Vex, a club that "originally gave Eastside bands who didn't have access to Hollywood clubs the opportunity to play with groups from different parts of the city." Another memorialized Decenter, "founded by [a] collective of young anarchists . . . that sought to create a meeting space that could push forward political change beyond electoral politics in a post-riot [1992 L.A. Rebellion] landscape." A third plaque marked the former site of the Popular Resource Center and recounted its history as a space that "created political, cultural, and economic networks that extended the words and actions of the Zapatista uprising in Chiapas to a working-class urban barrio in Los Angeles."[11]

The PRS's next series, *Echoes in the Echo* (2006–7), commemorated lifeworlds of queer working-class Latinas/os/xs, while showing how these have been assaulted by forces of gentrification and displacement. De la Loza collaborated with queer Latina/o/x writers to produce poetic plaques that marked the former sites of queer bars and nightclubs in and near downtown L.A. that had been shuttered as they, along with their working-class clientele, had been pushed out of these neighborhoods.

In the PRS's work, *invisibility* and *erasure* not only designate conditions of representation; they also refer to the territorial displacement of people

and the destruction of spaces. More precisely, the PRS's countermonuments highlight the dialectic of place-making and displacement that characterizes the relationship working-class Latinas/os/xs have to the production of social space in Los Angeles.[12] They conceptualize displacement as it manifests in different forms and at multiple geographic scales—be it the displacement of Mexicans and indigenous people by U.S. Anglo colonization of the West, the transnational displacement of war refugees from Latin America, or the ways working-class communities are displaced and placed in Los Angeles by urban development. As de la Loza has said, the PRS's work examines how displacement "impacts [people] not only as a physical and economic condition, but also as a cultural condition or a cultural experience."[13] The counternarratives the PRS puts forth do this by showing the significance of places and quotidian sociospatial practices for various working-class communities—be this in immigrants' use of a public plaza or nightlife at queer bars. They show how places these communities create, even when fragile or ephemeral, are essential to their social fabric, and also create possibilities for collective self-determination and, in some cases, for counterhegemonic political practices to take root and extend across time and space.

AESTHETICS OF HISTORY AND OF SPACE

The PRS's work does not simply represent histories erased in dominant historical narratives; it reconceptualizes both the practice of historical production and the object of the past with which it is concerned. It is through its more fundamental reconfigurations of how history is perceived and produced that the PRS brings into view social agents, practices, and historical forces that are regularly rendered invisible in official histories.

The PRS's work proffers a counterhegemonic aesthetics of history and of space. I use the concept of the *aesthetics of history* in order to examine how individual and collective subjects perceive, think, and feel history and their relationship to it, where history is understood as a socially constructed past. It names a vector of subjectivation, or a facet in the social framework of sense-making, which is only heuristically distinct from others. I specifically refer to an *aesthetics* of history to emphasize that history shapes perception and formats subjects through an aesthetic apparatus that operates through, but also exceeds, representation and discourse. It situates subjects in time—not only in a past but also in the present and potential futures. Indeed, it produces the very categories of past, present, and future, and shapes the ways these are sensed and understood in relation to each other. This works to

consign some things to oblivion or render them apparently anachronistic, while others are made to seem natural or inevitable. By producing shared pasts, historical aesthetics works to produce identities and social collectivities. In so doing, it can make imagined communities and particular forms of sociospatial organization seem natural or predestined.[14] It also entails the distribution of representativeness, such that some things are seen as capable of representing broad or universal conditions, while others are consigned to their specificity.

With this in mind, we can think of historical productions as sense-making apparatuses that shape subjects' sense of reality in myriad ways, which include, but certainly are not limited to, perceptions and knowledge of and attitudes about collective pasts. By "historical productions" I am not referring exclusively to disciplinary history. Rather, I include the many sites and agents involved in producing shared understandings of the past—from monuments and mass media to public spectacles and cultural productions of all sorts.[15] This does not mean, of course, that a school play and a textbook are understood as equally credible sources of historical knowledge—or, for that matter, that an official monument and an artist's guerrilla intervention on it are received in the same manner. The differentiated reception, valuation, and circulation of different kinds of historical productions, which include their recognition as such, is part of the (always historical and contingent) formation of a dominant aesthetics of history. In other words, an aesthetics of history is itself shaped in profound ways by the social organization of historical production and its circulation and reception. All of these aspects are implicated when we understand history as a site of social struggle.

Time and space being inseparable, an aesthetics of history is necessarily bound up with an aesthetics of space. I use *aesthetics of space* as a heuristic concept to foreground how perceptions of space are socially and historically constructed. Following Henri Lefebvre, I understand space to be "permeated with social relations." As he writes, space "is not only supported by social relations, but it also is producing and produced by social relations," and it is a "political instrument of primary importance" for the state.[16] Hegemonic aesthetics of space tend to naturalize or otherwise render imperceptible the ways in which space is socially produced, often by making social space seem to be simply given and extrahistorical, as if it were an empty and neutral container for social practices.

The aesthetics of history and of space are entwined as they operate as tools of power and as sites of struggle. Historical productions regularly naturalize the spatial production of the powerful while rendering invisible the

social conflict this entails. This is exemplified by representations of colonized peoples' territories as terra nullius[17] and by contemporary discourses of urban blight and renewal that naturalize capitalist urban development. In both instances, ideologies about historical progress are marshaled to valorize sociospatial practices that enable capitalist accumulation and to cast those that do not as roadblocks to be eliminated or reformed.

As Nicos Poulantzas argues, the modern capitalist state regulates relationships between territory and representations of history. The nation-state creates national unity as the "historicity of a territory and territorialization of a history."[18] It works to eradicate the histories, traditions, and memories of nations it conquers or dominates in the process of consolidating or expanding its territorial projection.[19] Importantly, Poulantzas reminds us that *the State is not the subject of real history*: for this is a process without a subject, the process of class struggle." He is pointing to the power states exercise in the "material organization of capitalist historicity," which includes unifying time by establishing it as an instrument of power, homogenizing "the people-nation by forging or eliminating national pasts," and segmenting "the history of the international proletariat" into "histories of national working classes."[20]

Official public monuments, historical markers, and memorials regularly function to promulgate hegemonic—and often nationalist—aesthetics of space and of history. They seek to naturalize a particular historical narrative and the spatial relations to which it corresponds.[21] This operates not only through representation but also through feelings and perception.[22] Site-specific historical markers marshal humans' powerful mnemonic attachments to and sensory experiences of place as they shape a specific aesthetics of history.[23] As they construct a shared past, they anchor it in a sense of place, which may produce perceptions of a shared territory.[24] States regularly mobilize these capacities to shore up their own hegemony, using historical monuments to produce the fiction of national identity, promote mythologized representations of a "national" past, and manage perceptions of social conflict.[25] When monuments project an image of social unity, they conceal the social and spatial conflicts inherent in class society, ideologically disassociating class conflict from the vision of civic life they project.[26]

In its work, the PRS elaborates counterhegemonic aesthetics of history and of space. Their work makes visible social conflicts that attend the production, occupation, and control of space and explores the many ways in which the forging of perceptions of collective pasts is a crucial battlefield in these struggles. Their interventions denaturalize spatial orders that are otherwise made to appear neutral or given—be that of a state's territory or the

current configuration of property in a given locale. They do this in various ways. They bring to light sociospatial conflicts that are suppressed in dominant histories by unearthing otherwise invisible histories of specific sites. They also reframe official historical productions in ways that reveal their function as ideological-aesthetic components of (neo)colonial conquest, colonial state-building, and capitalist urban development. In some cases, their work shows how the histories of a place—and thus, in a sense, the place itself—is distributed across various scales, such that, for example, a local site is revealed as forming part of a transnational history and geography. Other works aim to shift basic perceptions of what constitutes the materiality of a place, revealing otherwise invisible landscapes of practices and sensations within the city.

COUNTERHISTORY

The PRS's interventions do not simply model a more inclusive history. Rather, their counterhegemonic historical sense-making is rooted in a praxical reconfiguration of underlying epistemological frameworks, practices, and social relations that shape modern historical production and, specifically, its manifestation in public monuments and memorials. The concept of a *logic of history* or *historical order* brings into focus these underlying frameworks. As theorized by Gabriel Rockhill, it describes a historically constituted conceptual, perceptual, and practical *dispositif* (apparatus of power-knowledge) that determines what history is and how it functions in a specific social formation. Though logics of history are historically and socially forged, they are deeply naturalized, so that they come to constitute a practical knowledge, or the "unquestioned givens," of how history is practiced and understood. Foundational epistemological and ontological frameworks that shape knowledge production within a given historical and cultural context are implicated in this definition, but Rockhill emphasizes that a historical order is not purely epistemological or conceptual, as it is always produced by specific practices.[27] This emphasis on practice indicates that the very historical constitution of history—what it is understood to be—is fundamentally shaped by the social relations of its production.

Michel-Rolph Trouillot argues that power is exercised through history in its most determinant ways through the underlying structures that organize the conditions of production of specific historical narratives (what Rockhill would call logics of history). These include historically and culturally specific conceptualizations of temporality, the definition of what constitutes facts, what is or is not considered a significant object of research, the creation and

control of archives, and the naturalization of narrative structures that are based on specific ontological orders.[28]

Rockhill, Trouillot, and others have demonstrated the powerful social force historical orders exercise for shaping how people understand reality in ways that operate through, but profoundly exceed, ideas about history as such. For example, a specific historical order often produces for people a deeply felt sense of what constitutes "the present" or "the past" as fallaciously universalized realities, thereby obfuscating vastly different realities of socially stratified groups (as well as the relations between them).[29] Historical orders can condition the production of history such that it systematically effaces the agency of entire classes or groups of people.[30] They can even make certain practices unthinkable for the producer of history, even when evidence of these practices forms part of the historical record.[31]

Recognizing the historical constitution of historical orders shows that it is possible to reconfigure them. Rockhill denominates the practice of doing this "counterhistory." Counterhistory does not simply propose other narratives; it challenges the "historical constitution of the unquestioned givens of certain ways of doing history" and puts forth alternative logics and practices for the production of history.[32] For example, the practice of counterhistory accounts for the ways that sociohistorical processes are distributed across multiple and interrelated social strata and spatial dimensions and operate through multiple temporalities.[33] I also want to argue that counterhistory can entail the transformation of the apparatus of historical production and, therefore, of the social relations its production entails (again, with consideration of the many sites and agents of historical production).

The Pocho Research Society's autonomous direct-action approach to historical production and historiography demonstrates that these practices need not be the exclusive domain of credentialed experts or dependent upon gatekeeping institutions. Ultimately the PRS performs and encourages the socialization of historical production and historiography. It seeks to mobilize both the production of history and the analysis of historical productions toward a counterhegemonic politics by *transforming the social relations* that organize these practices.

The removal of the PRS's plaques puts into even sharper relief the fact that access to the means of historical production is uneven and tightly controlled. Indeed, the PRS anticipates this erasure and notes the removals in its documentation and press releases, thereby incorporating this history into its artwork. This aspect of the work performatively reiterates the critiques the PRS makes about the way the erasure of subaltern histories is constitutive of

hegemonic history. While the PRS's plaques countered a past erasure, their removal shows how this erasure is continually reproduced and therefore operates in the present and future as well. Moreover, insofar as the removal of the plaques clearly involves the policing of public and quasi-public spaces, it serves as a performative metaphor for the ways that historical productions are themselves objects of state control as states engage in class struggle on behalf of capital. But the PRS's guerrilla practice also moves beyond metaphor. It defies the state and corporate control over urban space, of which official monuments are an expression.

State and corporate regulation of space not only conditions the production and preservation of officially sanctioned public artworks, including monuments; these artworks are also often used to expand state control over urban spaces.[34] The way some mural art programs are used to support the criminalization of graffiti is but one example of this. While the enlargement of state control over public spaces is often ideologically framed by discourses about beauty, civic-mindedness, security, and utility, it operates in conjunction with the expansion of the carceral state and the surveillance and criminalization of poor and racialized groups.[35] By adopting a guerrilla art practice, de la Loza wanted to contest this larger system, specifically the "ways the policing of public space [is] used to gain support for the expansion of the prison industrial complex."[36] The PRS's guerrilla plaques provoke the system of control over space, which is often invisibilized, to expose itself with the removal of the plaques.

I have argued that the PRS takes a materialist and anti-idealist approach that interrogates how historical production works, not what history essentially *is*. Ultimately, their work shows that, if history is a battlefield, power operates most fundamentally through it by defining the coordinates of this field and the rules of engagement. The PRS eschews these protocols and instead mounts guerrilla interventions that seek to redefine the battlefield— that is, historical production—itself.

A PARALLAX VIEW ON HISTORY AND SPACE

The PRS's first series of urban interventions, *Operation Invisible Monument* (2002), demonstrates the power of historical logics for shaping perceptions of social reality, including conceptualizations of territory, agency, and human collectivities. Three of the works in the series consisted in the détournement of city monuments that juxtaposed official historical narratives about places in downtown L.A. with the PRS's counterhistories about the same physical

sites. These ultimately juxtaposed different historical orders (i.e., different epistemological and practical frameworks of historical production), which themselves produce irreducibly different aesthetics of history and of space. Here, I focus on *El Otro Ellis* (The Other Ellis), the first countermonument the PRS created in this series, to show how it denaturalized the colonial, nationalist, and elitist historical and spatial aesthetics promulgated by a city monument's representation of L.A.'s history.

The PRS installed this guerrilla countermonument in the El Pueblo de Los Angeles Historical Monument, a historic district in downtown L.A. constructed around the site where a Spanish colonial mission and pueblo were established in the eighteenth century. This site has been used since the early twentieth century for the staging of pseudohistorical cultural representations of Los Angeles's Spanish colonial history that have the ideological function of situating California's Mexican culture firmly in the past and erasing the history of Mexican resistance to Anglo colonization.[37] While the district now contains multiple historical museums, historical productions within it also include cultural performances, monuments, and pseudohistorical commercial attractions that embed interpretations of L.A.'s past within the street-level and quotidian experiences of urban space. The bilingual historic plaques that adorn the park assert sanitized interpretations of Spain's colonization of the region, while bronze statues pay homage to protagonists of colonization and genocide. A tourist-oriented streetscape, designed as a folkloricized representation of a Mexican marketplace, is packed with easily consumable signs of multicultural difference. This street-level history works through varied mediums and aesthetic modalities, from the authority projected by stately bronze statues that lionize colonizers to the sense of authenticity created by the historical preservationist aesthetics that consecrate the mission buildings to the folkloric aesthetics in which "Mexican culture" is packaged for consumption. What they share is a colonial framework that either effaces the histories of L.A.'s Mexican and indigenous people completely or represents them as noncontemporaneous with the contemporary city. As it pertains to Mexicans, this ideological maneuver seems especially anxious and aggressive, given that it is staged in a city that is home to one of the largest Mexican populations in the world, and at a site that has long been a vital part of Mexican Angelenos' social life.[38]

To create *El Otro Ellis*, the PRS hijacked the city's Bicentennial Historical Monument, which is prominently situated in the historic district across from its central plaza. This city monument consists of two large bronze plaques, one with English text and one with Spanish, set atop a wide and

solid brick pedestal. The text engraved on them states that the plaques were dedicated to the city of Los Angeles in 1981 by its mayor, congressman, and city engineer to commemorate the following history:

> On September 4, 1781 eleven families of pobladores [settlers] arrived at this place from the Gulf of California to establish a pueblo which was to become the city of Los Angeles. This colonization, ordered by King Carlos III of Spain, was carried out under the direction of Governor Felipe de Neve. Not until 77 years later were the boundaries of the four square leagues of the original pueblo formally established and confirmed to the city by the U.S. land commission. Notes of U.S. Deputy Surveyor Henry Hancock record the "survey commenced September 13, 1858, at the center of the plaza in front of the Catholic church . . . , at which point I set a post marked C.L.A. (City of Los Angeles).

This narrative could easily seem like a relatively anodyne historical representation. Its flat prose and omniscient voice give it a sense of objectivity and authority, as does its plethora of seemingly neutral data (dates, measurements, names). Yet this apparent objectivity, as well as other formal qualities of the plaques' text and of the physical monument itself, works to naturalize a colonial aesthetics of history and space.

The plaque's prose recapitulates the providential and teleological vision of history that undergirded the colonial and racist doctrine of Manifest Destiny.[39] Its narrative exemplifies a unilinear and progressivist ideological representation of history, which itself is a product of what Poulantzas refers to as the capitalist temporal matrix.[40] The plaque's teleological narrative makes colonial conquest appear natural and inevitable. Colonial settlement by the Spanish state marks the beginning of the site's history, while the contemporary U.S. city of Los Angeles appears as its telos. Its anticipatory rhetoric gives a providential cast to the founding of the city: "a pueblo *which was to become* the city of Los Angeles," and later, "*Not until* 77 years later were the boundaries of the . . . original pueblo formally established and confirmed to the city" (my italics). While representations of colonization as historical progress characterize colonialist representations of history quite broadly, this text proffers an especially nationalist U.S. Anglo colonial version of this, as it enfolds the prior history of Spanish colonization into a narrative about the U.S.'s territorial conquest.

The colonial character of the monument is perhaps most palpable in what its text renders invisible. The history of the land's indigenous inhabitants and their resistance to European colonization is entirely absent from its story,

as is Mexican resistance to subsequent Anglo-American colonization.[41] Although the claiming of the land by the U.S. government is clearly the text's telos, it never mentions the U.S. conquest of Mexico's northwestern territory, which made this possible. A chronological representation of time's passage is used to perform this erasure, as a reference to "77 years" substitutes for any mention of the Mexican state or people, or of the U.S. government's war on them. Although the plaque's narrative essentially follows successive and imbricated processes of colonization, the war, genocide, and territorial dispossession this entailed go unremarked in its bloodless narrative, which represents conquest as if it were simply a matter of history's forward march (represented as the passage of time) and, at most, so many bureaucratic procedures.

The Bicentennial Monument neatly demonstrates how hegemonic aesthetics of history and space mutually reinforce each other, and how both are bolstered by the site-specific medium of the monument. Its text's providential representation of the site as having always been destined to be the birthplace of a U.S. city is reinforced by the monument's siting on land whose belonging to U.S. territory is everywhere made to seem self-apparent and natural (distinct from its being understood as occupied Mexican territory or colonized Gabrieleño or Tongva land, as counterhegemonic geographic imaginaries might have it). In other words, the physical objecthood and site-specificity of the monument marshals the pervasive ideological understanding of space as "given" toward naturalizing a colonial understanding of history, just as the historical representation of the site works to naturalize a colonial sociospatial order. The monument's formal qualities reinforce this spatiohistoric naturalization, as its solid brick pedestal and thick bronze plaques project an image of permanence and stability that supports the providential history its text asserts.

To create *El Otro Ellis*, the Pocho Research Society added its own historic plaque to the Bicentennial Monument, placing it neatly beneath the original bronze plaques (plate 5). Given the conspicuous historical elisions and distortions in the Bicentennial Monument's historical narrative, one might expect the PRS to directly contest these. Instead, its plaque historicized the same site with a wholly different narrative—one that, as I will show, emerged from a different historical logic. *El Otro Ellis* exemplifies the fact that the PRS does not simply represent minor histories in an effort to "repair" their erasure in hegemonic history. Instead, it stages a confrontation between profoundly different practices of historical sense-making as a means to interrogate the practical and epistemological roots of such erasures.

El Otro Ellis recounted the history of the plaza the Bicentennial Monument faces as follows:

LA PLACITA OLVERA

An important entry point for migrants of the Americas. From 1910–1930 over a million Mexicans crossed into the US as a result of economic and military upheaval.

During the 1980s, over 200,000 Central American immigrants flowed in as a result of heavy political repression and bloody civil wars in their home countries. Father Luis Olivares declared the La Placita a sanctuary for refugees fleeing the violence exasperated by U.S. backed death squads and paramilitaries.

La Placita continues to be a gathering place for families and workers; a place where transplanted people gather with compatriots and share information to alleviate the difficulty of entry into a hostile culture. The plaza area reflects the vitality of the hybrid cultural forms that Latino immigrants create as they struggle to plant roots from a place of dislocation.

El Otro Ellis, Declared Invisible Monument #1
By the Pocho Research Society of Erased and Invisible History

The PRS's détournement of the Bicentennial Monument is both a historical and a literary intervention. It prompts passersby to read the PRS's text in relation to the state plaques and, in so doing, to engage with the layered history of this particular location, as well as with the relationship between dominant and subaltern histories more generally. Because of its relatively diminutive size and its placement in the lower margin of the monument's pedestal, the PRS's plaque appears as if it could be a footnote to the larger official plaques. This formally reiterates the minoritarian status of the history the PRS plaque asserts vis-à-vis the state's historical narrative, as well as the marginal position of the PRS as a producer of history in relation to ideological state apparatuses like state monuments and historic parks. Yet, if *El Otro Ellis* operates as a footnote to the bicentennial plaques, it should be situated in a tradition of writing wherein footnotes are not ancillary to the main text but form an integral part of a multilayered narrative, reframing the main text and/or putting it in relationship to another discourse (exemplified in work by Manuel Puig, Junot Díaz, Vladimir Nabokov, Jacques Derrida, and others). Ultimately, the PRS marshals the marginal positionality of its own intervention upon the Bicentennial Monument in order to comment upon the emergence of hegemonic history.

Although the Bicentennial Monument's original text and that of the PRS's plaque ostensibly refer to the same site, their juxtaposition shows that when its past is constructed from within an alternative logic of history, the apparent historical reality is radically transformed. The aesthetic effect this produces is akin to the optical phenomenon known as parallax, wherein the position of an object changes when viewed from different positions. Similar to the way that a parallax demonstrates how the perception of an object is fundamentally constituted by one's sightline on it, the juxtaposition *El Otro Ellis* composes suggests that historical reality itself is constituted by the historical logic that produces and presents it *qua* "reality." This demonstrates, then, how powerfully the aesthetics of history shapes and modulates social reality, and how it does so in ways that go far beyond ideas about the past.

Importantly, the parallax view *El Otro Ellis* creates does not suggest that the state's narrative and the PRS's simply offer different perspectives. While, on one level, the state historical narrative is a particular perspective, in its function as a dominant ideology, it is imposed as *the* perspective, which must eradicate all others. Or more precisely, it is not imposed as a perspective at all, but naturalized so as to appear as unquestionable common sense. *El Otro Ellis* makes a twofold intervention. First, it reveals the particularity of the state narrative and, concomitantly, the nontotalization of the logics upon which it is based; second, it highlights the character of the state narrative as a master discourse that has a *constitutive* relationship to subaltern histories (represented by the PRS plaque), as that which it must render invisible—while also erasing the traces of this erasure. It is for this reason that, rather than attempt to overwrite the state's historical narrative, the PRS inserts subaltern history alongside it—or, rather, from beneath, as its placement suggests—to demonstrate the practice of overwriting the state narrative performs.

The eventual (and anticipated) removal of the PRS's plaque further refines this metaphor for the erasure of subaltern histories. It suggests that, ultimately, there is no room for the "inclusion" of subaltern histories within dominant histories, as their invisibilization is the very condition for the latter's claims to universalized knowledge. Thus, *El Otro Ellis*'s parallax effect can be considered another manifestation of the stereoscopic aesthetics I discussed in chapter 1. It holds together in a single work two different worldviews, while showing that the social relationship between them is an expression of class and colonial social relations.

The different forms of historical sense-making *El Otro Ellis* juxtaposes proffer very different—and largely incompatible—conceptions of space,

territory, historical agency, and the nation. To begin with, the PRS's intervention attests to history's social stratification and, concomitantly, represents historical agency in a very different manner than the Bicentennial Monument's elite- and state-centric narrative. While the latter suggests that history is driven by the actions of state institutions and their functionaries, the PRS's plaque emphasizes the historical agency of working-class immigrants (whom it represents not as individuals but as agents who occupy a historically forged social position). This alternate historical logic is bound up with a counterhegemonic perspective on the present-day city. Situated on a city monument that claims to represent L.A.'s historical origin, the PRS's plaque asserts that Latina/o/x immigrants, who are regularly invisibilized in hegemonic representations of L.A., are protagonists of the city's historical formation.

The parallax view El Otro Ellis offers also juxtaposes different aesthetics of space as these pertain to the Los Angeles plaza. The text on the Bicentennial Monument represents the historical significance of the site it marks strictly in terms of the conquest, settlement, and ownership of land by colonizing forces. By contrast, the PRS's plaque asserts that the historical significance of the same place lies in social practices of Mexican and Central American immigrants, as well as in practices of solidarity with them. This shift in perspective can be understood in light of the distinction Michel de Certeau makes between purely "theoretical" representations of space and the spatiality constituted by everyday practices. For de Certeau, the former are fictions that project a "God's-eye" view of the city, while putting under erasure the everyday spatial practices that are, in fact, largely unacknowledged structuring forces of social life.[42] While theoretical representations of space work to make it appear to be an object of ownership and (state) administration, an alternate spatial aesthetics apprehends social space as a production of working people's everyday practices. As a result, immigrants' collective production of a common space of association, communication, and cultural expression is understood as a material force in the construction of the social-spatial form of the city, and as a practice of historical significance. Thus El Otro Ellis asserts the nontotalization of capitalist and state-centric conceptions of territory, while it also models an understanding of territory as the sociospatial materialization of working-class people's collective social organization and as a crucial ground for communities' survival.

El Otro Ellis's parallax view shows how two different historical orders reckon with transnational historical processes. In so doing, it calls attention to the ideological force exercised by the sociospatial imaginary of the nation-state for structuring historical productions like the Bicentennial Monument.

The way the monument's text enfolds a history of Spanish colonization into a providential narrative about the founding of a U.S. city, while entirely erasing Mexico and Mexicans, demonstrates that it is so thoroughly structured by nationalist-imperialist historical logics that it expunges histories that would attest to the conflictual and contingent forging of the U.S.'s territory. The PRS's plaque, by contrast, moves in the opposite direction: it shows that the history of an apparently hyperlocal site, Placita Olvera, is distributed across a geography that extends across the hemisphere and that it can be understood only by accounting for sociopolitical processes that operate at a transnational scale. By displacing the nationalist historical logic that structures the state's narrative, *El Otro Ellis* challenges the very idea that there can be an exclusively *national* history and, by extension, a national identity.

El Otro Ellis's transnational historicization of La Placita enables its accounting for *causes* of Mexicans' and Central Americans' migration to the United States, including the U.S. government's imperialist violence. It represents U.S. imperialism in Latin America as a historical force that has shaped sociopolitical processes in other countries as well as locally, in Los Angeles. Its text also subtly highlights and editorializes upon the United States' covert wars in Central America by naming the "violence *exasperated* by U.S. backed death squads and paramilitaries" (my italics). In what appears to be a sly substitution or meaningful error, the expected "exacerbated" is replaced by "exasperated" as an expression of rage that slips into the text's otherwise sober account of the U.S. state's role in creating war refugees.

As I have argued, counterhistory does more than offer a different narrative about the past. It also counters the particular schematization of reality that dominant historical orders impose.[43] It is for this reason that *El Otro Ellis* constitutes an intervention into the ways that more recent Latin American migration to the United States is understood, even though this is not the explicit subject of its narrative. The PRS created *El Otro Ellis* in a historical context in which the repression of immigrants and anti-immigrant racism toward Mexicans and other Latin Americans were taking on newly virulent forms in the United States. To be sure, criminalization, mass deportations, racist state and parastate violence, and the denial of civil liberties have been permanent features in the racial and class construction of Mexican labor within the United States since the nineteenth century.[44] With the onset of globalization and neoliberalization, U.S. immigration policy was given a markedly repressive character, and the United States increasingly militarized its border with Mexico. At the same time, the transnational capitalist class and U.S. state managers advanced policies that created conditions

for emigration from Mexico and Central America and that stoked the demand among U.S. firms for low-wage "flexible" labor (that is, workers who can be easily fired and relocated and to whom states and firms have little responsibility).[45]

I discussed in chapter 1 how the imposition of neoliberal economic policies in Mexico pushed peasants off their lands and workers out of formal employment, forcing millions of people into a swelling transnational reserve army of labor. In Central America, U.S.-backed state and parastate terrorism, debt, trade liberalization, and modernization of agriculture also served as means of primitive accumulation, forcing peasants off their land and causing massive emigration.[46] When the counterrevolutionary violence that made millions of people into refugees diminished, neoliberal restructuring and globalization continued to immiserate workers, forcing them to emigrate.[47]

As dispossessed people migrate, borders and migration regimes politicize "the elemental human freedom of movement by subjecting human mobilities to state power," so that states can "legally and politically produce and mediate the social and spatial differences that capital may then capitalise upon and exploit."[48] They divide the global working class and thereby weaken its power vis-à-vis capital. They make migrants into especially vulnerable and controllable workers by, among other things, maintaining their "condition of deportability."[49] In the context of neoliberal capitalism, the illegalization of immigrant workers is one of the means by which the U.S. state has expanded "slave-like" labor conditions, with prison labor and workfare being two other growing labor regimes in which workers have no right to organize or negotiate their wages.[50] Making immigrant workers highly "controlled, disenfranchised, and legally vulnerable—and therefore atomized"—renders their labor superexploitable, and the superexploitation of this segment of the global working class is leveraged to extract more profit from *all* workers.[51] Additionally, the illegalization of immigrants enables profiteering from the repression, incapacitation, and caging of migrants, and it has worked to expand the "immigrant military-prison-industrial-detention complex" as a site of capitalist accumulation.[52]

As Justin Akers Chacón notes, successive U.S. administrations have instated increasingly repressive policies against immigrants "in harmonious succession since the administration of Jimmy Carter."[53] In the 1980s, the U.S. state adopted a national security doctrine that cast illegal immigration as a major threat to national security.[54] The 1990s saw a bipartisan attack on both new immigrants and legal permanent residents. Border militarization weaponized deserts, amplified anti-immigrant sentiment, and created conditions

for later crackdowns, while creating new markets for defense industries.[55] In California, state laws stripped immigrants of access to social services, while local state managers and the corporate media intensified the criminalization of Latinas/os/xs through a "brown peril" discourse that became the "moral equivalent of the obsolete red menace."[56]

Federal laws put in place in the 1990s "laid the foundation for the vast criminalization of immigration infractions and for the sharp increase in the annual number of detentions and deportations," while curtailing "judicial review and due process in immigration cases."[57] They made immigrants imprisoned for unlawful re-entry into the fastest-growing sector of the U.S. prison population.[58] Immigrant detention became a "booming business for private, for-profit prison companies" after the federal government rescued this industry under the Clinton administration.[59] The war on immigrants has been immensely profitable for these and other corporations that profit from the caging, surveillance, and deportation of immigrants, and they, in turn, have lobbied policymakers to push for laws that further criminalize immigrants and expand immigration detention.[60]

The racist repression and criminalization of immigrants took on new dimensions with the advent of the so-called War on Terror in 2001. In addition to being used to rationalize endless imperialist war-making, the U.S. state's twenty-first-century antiterrorism politics have provided cover for a persistent and systematic "authoritarian hardening of the state across its areas of activity."[61] Domestically, immigrants have been prime targets of the War on Terror, especially since the creation of the Department of Homeland Security in 2001 linked the policing of immigrants with counterterrorism politics.[62] As Akers Chacón writes, "The concept of 'permanent war' against an invisible and internal enemy [provided by the War on Terror] has dovetailed with the interests of the well-funded anti-immigrant movement that has been striving to keep immigrant workers disenfranchised."[63] Terrorism discourse has also helped to proliferate "Brown Peril" discourses. The manufactured phantom of domestic terrorism "has been refracted through the border phobic imagery of 'invading hordes,'" and the framing of the United States' border with Mexico as a security vulnerability has fomented racism and xenophobia against Latin American immigrants, as well as U.S. Latinas/os/xs.[64]

El Otro Ellis contests the racist criminalization of immigrants in state policy and popular ideology. While it does not directly address the discursive construction of a "brown peril," it challenges the historical and spatial logics upon which the criminalization and subhumanization of immigrants

are based. I have shown how *El Otro Ellis* displaces nationalist, colonialist, and elite- and state-centric historical logics, as well as the aesthetics of space these imply by (1) addressing the multiple, imbricated spatial scales at which historical processes operate, (2) emphasizing the agency of working-class transnational migrants, and (3) prioritizing an understanding of space as it is used by these communities for their survival and maintenance of their social fabric. The political stakes of this counterhistorical intervention come into sharper relief when we consider how social reality is typically schematized through nationalist and state-centric historical frameworks.

Nationalist historico-spatial imaginaries naturalize global apartheid and are antithetical to movements that seek justice for all people. They naturalize states' illegalization of immigrants and thereby normalize the superexploitation and repression of them. In the United States, nationalist historical logics are also used to efface the history of U.S. imperialism and its role in causing migration. This sets the stage for claims that immigrants are simply drawn to the United States by the attractive economic opportunities on offer, which, in turn, bolster portrayals of immigrants as competitors for dwindling jobs (whose dwindling is actually owed to capitalists' relocation of production in search of greater profits).

By contrast, *El Otro Ellis* models a transnational historicization of migration that elucidates the punishing conditions that cause people to move, including those created by U.S. imperialism. Its text is not a call for humanitarian empathy with distant victims. Rather, it is a challenge to the very historico-spatial imaginary that casts other inhabitants of the Americas as exterior to a U.S. "nation" in the first place (and therefore as potential interlopers within it). It asserts the inseparability of apparently "national" histories and peoples by highlighting the long-standing presence of Latin American communities in L.A. and the imperialist machinations of the U.S. state in Latin America.

El Otro Ellis also contests the ideological foundations of illegality by proffering a history of transnational migration that completely sidelines state borders and laws. Its title implicitly compares La Placita Olvera to Ellis Island, framing both as historic arrival points for immigrants, even though La Placita never housed a border checkpoint or detention center like Ellis Island. While suggesting that twentieth- and twenty-first-century Latin American immigration to the Southwest is of historical significance equal to that of earlier European immigration, *El Otro Ellis* models a historical logic in which the representations of people's movement and their efforts to seek better lives need not be formatted by ideologies of law and citizenship. This is a necessary

perspective for any effort to understand or represent contemporary dynamics of social reproduction that does not simply accept global apartheid and the racialization and criminalization of immigrants.

Like the PRS's other works, *El Otro Ellis* illuminates a condition of displacement at the same time that it addresses ways that working-class people exercise their agency in space, be it through creating a place of social intercourse in a public plaza or by actively refusing to stay in one place and migrating elsewhere. At stake in recognizing the agency of migrants—and the agency exercised through migration itself—is nothing less than understanding the capacities of the globalized working class and the contours of contemporary class struggle.[65]

SANDRA DE LA LOZA AND HER HISTORICAL SOCIETY

While many of the Pocho Research Society's works are collaborative, the Society itself is a meta-artwork of Sandra de la Loza, and she conceptualizes and leads all of its projects. I have known de la Loza since 2002. In addition to the countless informal conversations we have had over the years, I have also conducted studio visits with her and have interviewed her multiple times about her art practice and her political-ideological and artistic formation. When discussing these things with me, she has described a constellation of influences that attest to the prolific traffic of artistic and political ideas and communities across national borders.

Born in 1968, de la Loza grew up in East Los Angeles in a working-class and predominantly Chicana/o/x neighborhood. In interviews I conducted with her in 2002 and 2015, she discussed the way the Chicano movement impacted her life and her ideas about art. This social movement organized working-class Mexicans and Mexican Americans to struggle against the economic exploitation, political domination, and institutionalized racism to which they are subjected in the United States. It built political power for Chicanas/os/xs and connected their struggles to other liberation struggles, both within the United States and in other parts of the world.[66] Art of all types was an integral aspect of the Chicano movement. Artists used literary, theatrical, and visual art forms to contribute to its counterhegemonic struggle on an ideological front, and even to participate directly in political organizing. Moreover, movement artists created alternative modes of producing and circulating art, which included founding arts institutions for working-class Chicana/o/x communities in the United States and participating in internationalist movements that used art as a weapon in anti-imperialist struggles.[67]

De la Loza has extensively researched the visual art of the movement and has used this research in her own art, teaching, and writing.[68] Although she was a child in the 1970s, she "was the youngest of six kids and . . . grew up with older brothers who were in their twenties during the Chicano movement of the seventies," so she "definitely got a whiff of seventies-era culture and Chicano movement politics." She emphasizes the influence of her older brother Ernesto de la Loza, who was a muralist in the movement. "I think what I learned from my brother was art not as a profession but more so as a lifestyle, as a way of being," she told me. Describing how Ernesto took her all over L.A. while she was young, she said, "[He] taught me how to cruise, look at the city, look at people, reflect, . . . and not to have to care about social norms or values or definitions." When I asked her about the impact of the movement on her art practice, she replied, "The Chicano movement made it possible for me; I am a product of the movement. I wouldn't have had an education if it wasn't for the Chicano movement. I think the questions I ask, and even the content of my work builds from what has been the history that comes before me."[69]

De la Loza's way of situating herself in relationship to the Chicano movement offers a nuanced counterpoint to the way contemporary art discourse often represents the relationship between de la Loza's generation and the culture of the movement in agonistic, polarizing terms. It often celebrates artists of de la Loza's generation for breaking with legacies of movement-era art, and many artists adopt this narrative structure in their own self-representation.[70] This historical narrative readily marshals revisionist, oversimplified, and even reactionary representations of the political ideologies of the movement and the cultural production that emerged from it, wherein movement politics are monolithically cast as ethnonationalist, heterosexist, and identitarian, and movement art is represented as content-driven and lacking in formal complexity.[71] In short, attention to the ideological breadth of the movement (including the self-critique within it) and the stylistic breadth and complexity of its art are both sacrificed to a progressivist historical narrative keyed to art discourse's fetish for novelty and rupture. In contradistinction to this narrative and the marketplace-ready temporality it encodes, de la Loza valorizes the Chicano art movement for its rootedness in a working-class social movement and for the way it helped to construct counterhegemonic worldviews: "I think early Chicano art wanted to undo the racism of dominant American culture and change a Chicano subject's perception of him or herself, and it did that by creating other narratives, other mythologies, creating new cosmologies, other non-racist . . . notions of self. . . . I think

Chicano art is important because it was a very grass-roots development . . . that truly sprung up outside of [the art] world, and because of its working-class roots."[72] De la Loza also describes the ideological-aesthetic project of the movement as an intergenerational undertaking that she carries forward in her own practice:

> I feel that my work is part of a larger conversation, one that started with earlier generations of Chicano artists. I don't rehash what earlier generations have done, but I think that some of the initial questions raised are still relevant and we are just beginning to explore them. I also understand the significance of what was done in a historical context. I definitely have benefited from the work of that first generation. It has given me a certain freedom; I am able to go deeper and to begin to address questions that earlier generations didn't address and search for new strategies. They had a huge responsibility because they were the first generation. If you look at Mexican Americans' history since the U.S. occupation of Mexican land, that colonialist history, and the identity that sprung from that, which is now called Chicano identity: we have had a very long history of racist representations in the dominant culture, a real negation of Mexican cultural identity. So, obviously, the first generation had to address that. They struggled to develop new forms of representation to counter simplistic, negative, and racist portrayals and searched for an iconography that would better represent our experience. Yes, that was a very bold project and attempt, and I agree that there are problems with it. There is a lot of criticism from my generation of the older generation, but I don't agree with that criticism when it becomes a polarization. Our generation addresses more of the heterogeneity, the diversity within our population, but those ideas of resistance, of defining oneself outside of individual identity and of a more collective consciousness, definitely are in my work.[73]

When de la Loza talks about the way that the labor of older generations of Chicana/o/x artists changed the field of possibilities for her own generation, she asserts an idea of intergenerational continuity among cultural producers that is based on "ideas of resistance." That is, the artistic tradition de la Loza vindicates consists in art's participation in counterhegemonic struggle.

Other radical and revolutionary art movements of the United States and Mexico also influenced de la Loza's political consciousness and her ideas about what art could be and do. For example, seeing the murals of the Mexican Revolution in Mexico City "opened [her] mind to the possibilities of art being revolutionary at many levels."[74] She also underscored the influence of

U.S. poets and musicians of color who "used their words to critique power . . . to look at how power operates, to speak about violence in very accessible ways, in languages that were their own, not of the academy," including Amiri Baraka, Alurista, John Trudell, the Last Poets, and Public Enemy, as well as "Latino, very politicized punk groups like Huasipungo."[75]

When, in a 2001 interview, I asked de la Loza about how she understands art's potential to bring about social change, she responded:

> I think too many people think of social change as something more immediate. No, I don't think art's going to keep the U.S. from bombing Iraq. No, I don't think Siqueiros's murals were going to make the working class rise up and overthrow bourgeois society. I think that's just a simplification of what social change is. I think social change happens through small advances. The impact of an act, a poem, a discourse isn't known until maybe, one, two, three generations afterwards. If I look at some of my teachers and some of the people who have influenced me most and what they did: . . . they articulated an experience that hadn't yet been articulated, and in doing so, in just naming it, they created a space that didn't exist before. That is especially true when I look at what most immediately impacted me: the woman of color feminists, especially the Chicana feminists. They were the first generation to be very critical of Chicano nationalism, critical of white feminism, critical of homophobia, and they found a voice and articulated who they were, created something that has allowed the next generation to have a space that already exists for them. And yeah, the totality of what's going on in the world seems overwhelming, but I think those acts are really important in the long run.

De la Loza was educated in woman of color and Chicana feminist thought during her undergraduate studies at Berkeley, where, as a first-generation college student, she earned a degree in Chicano studies. In describing how her undergraduate education shaped her political consciousness, she emphasized the importance of studying writing with Cherríe Moraga, as well as her exposure to Marxist, anticolonial, and Third World feminist thought:

> Definitely, Marx was transformational, and Fanon later on. . . . At Berkeley, I was introduced to a radical critical understanding of history by Third World feminists and decolonial, anticolonial thinkers. Then my experience in Mexico City definitely helped expand my political consciousness. One thing I appreciated about studying in Mexico was [having] access to a more embedded Marxist critique and being exposed to discourses in

which Marxist thought was applied to historical understandings of the legacy of the colonization of the Americas. As much as I was exposed to radical critical thought at Berkeley or within the U.S. context, by going to Mexico City I realized how even that radical thought was limited and shaped by being produced in a [U.S.] American context.[76]

De la Loza would continue to learn from political and artistic communities in Mexico in the following decades. She told me of her decision to pursue an MFA in the early 2000s: "I was fully aware that, in a U.S. context, art academic programs are pretty white, and there wouldn't be a lot of people there who would have the references . . . to help me grow in the ways I wanted to grow." So she supplemented her formal education by spending time with activist and artistic communities in Mexico City, who directed her to "critical theory related to art and culture with a strong Marxist analysis [and to] a perspective of culture and art across the colonial processes that marked and shaped our continent."[77]

De la Loza sees her guerrilla art practice as a means of contesting the policing of public spaces and its role in legitimating the prison-industrial complex. When I asked how she developed the PRS's guerrilla practice, she said:

I was very aware of how policed the city was and how controlled public space was—or is—and I thought it was important to do unsanctioned acts and reclaim public space. You know, with the heavy fines and the heavy policing, that apparatus instills a certain fear in the general public: a fear of being punished, whether with jail time or severe fines, and so forth. That apparatus, on a certain level, creates a docile population. So I thought it was important to contest that. I was inspired by the graffiti artists who go up against that as a lifestyle. But sometimes that form itself is limited to their name or their crew or certain characters. So, I also wanted to use those guerrilla tactics of inserting . . . countersignage, but also content that got people to look a little more critically at their landscape.

After college, de la Loza returned to live in Los Angeles in 1992, during California's worst recession since the Great Depression and just weeks after the L.A. Rebellion, also known as the Rodney King Riots. Set off by the acquittal of white cops who were tried for viciously beating King, a working-class Black man, the L.A. Rebellion was a grassroots uprising of strata of L.A.'s Black and Latina/o/x working class. It was a "revolutionary democratic protest characteristic of African-American history when demands for equal rights have been thwarted by the major institutions."[78] It was also a "postmodern

bread riot," an uprising of the "multicultural and transnational working poor who had suffered most from economic restructuring" associated with globalization and neoliberalization, and who were most savaged by the recession.[79]

In Los Angeles, as across the United States, inequality and state repression were both intensified by neoliberalization and conservative policymaking in the 1980s and 1990s.[80] The U.S. military Keynesian state was transformed into a "warfare state." As Antonio Negri describes it, this is a state structured politically and administratively so that "the needs of the proletariat and of the poor are . . . rigidly subordinated to the necessities of capitalist reproduction" and that uses the "array of military and repressive means available (army, police, legal, etc.) to exclude from the [arena of bargaining or negotiating] all forces that do not offer unconditional obedience to its austerity-based material constitution and to the static reproduction of class relations that go with it."[81] Ruth Wilson Gilmore adds to Negri's formulation that, in the United States, "where real and imagined social hierarchies are expressed most rigidly in race/gender hierarchies," the static reproduction of class relations takes the form of the continual production of the "apartheid local of American nationalism."[82]

As neoliberal globalization enabled capitalists to move production to peripheral countries in order to seek out cheaper labor, many U.S. cities, including L.A., were deindustrialized. By the 1990s, Los Angeles had lost most of its Fordist nondefense industries, and its industrial job base in aerospace industries and light manufacturing was significantly eroded, surplussing sectors of the working class.[83] Income inequality soared in the 1990s, and the number of people classified as living in "high poverty" doubled.[84] The neoliberal restructuring of the city's economy especially impoverished Black and Latina/o/x workers, as the former were surplussed by deindustrialization, the latter were concentrated in low-paying jobs, and both groups were subjected to below-poverty incomes.[85] At the same time, L.A.'s working class was hard hit by the dismantling of social services, which was fueled, in part, by conservative federal policymakers' racist "war on cities," where the withdrawal of federal funding was a means to force cities to privatize socialized assets.[86] "The dismantled social safety net was replaced by a criminal dragnet"[87] as the carceral state was dramatically expanded. California used the expansion of the state prison industry as a motor of development, filling its prisons with persons from precisely those sectors surplussed by economic restructuring: the working and workless poor, particularly Black and Latino men.[88] During the 1980s and 1990s the number of people imprisoned in the state grew by 500 percent, even while crime decreased.[89] The confluence of intensified

policing and surveillance of Black and Latina/o/x youth, including the regular practice of sweeps and mass arrests, together with FBI-enabled surveillance and laws that abet the criminalization of these groups, produced a repressive context that has been compared to colonial contexts in which policing operates as "full-scale counterinsurgency (or 'low intensity warfare,' as the military likes to call it) against an entire stratum or ethnic group."[90]

Returning to L.A. after college, de la Loza was not necessarily interested in pursuing a career in the arts. "That wasn't my main desire, goal or priority," she said. "What I was dreaming was of creating revolution." She had a desire to become a "maker" that emerged from learning about the material exigencies of social transformation while traveling in Guatemala, Cuba, and Nicaragua in the early 1990s:

> I got to see and feel and experience firsthand the U.S. embargo in Nicaragua, and that was really illuminating ... seeing how powerful the United States was, and how an embargo can literally starve a country into submission. . . . Those trips helped me realize that, in order to make revolutionary change, we'd have to go beyond just confronting power; we'd have to actually have the tools to create that other society we envision, through our social relations, but also through our knowledge. So, going home in the nineties, I wanted to turn all my theory into action. I wanted to develop the tools to live autonomously. I started becoming a maker. I started gardening, producing food, trying to develop ways to not be a consumer, but to be a producer, and do things that I need to survive.[91]

De la Loza's ambition to forge more autonomous modes of living, as well as the desire she shared with friends to "take the knowledge we had acquired through our university education, and share it with our community," led her to become involved in creating autonomous cultural infrastructure and to participate in collectively run cultural and political spaces in L.A. throughout the 1990s. These included the anarchist Peace and Justice Center, Regeneración, Aztlán Cultural Arts Foundation, and Flor y Canto Centro Comunitario. As "art and culture were always really powerful parts of those projects," she began to develop her work as a cultural producer in these spaces. She described the intersections of culture and radical politics in them:

> I met a lot of politicized Chicanos who were trying to create cultural infrastructure as an alternative, as a way to politicize culture. . . . In those kind of spaces there was an intersection of radical politics and a lot of people came out of those spaces doing solidarity work, or trying to get support for

issues outside of L.A., such as water rights for the Zapatista movements, combined with the local issues we were dealing with. . . . There were a lot of political influences shaping those projects, from anarchism to Zapatismo to Chicano indigenismo and nationalist politics, to feminism.[92]

De la Loza's experience of the music and arts scenes of downtown and East L.A. in the 1990s was an important influence on her artistic formation. As she described it, during the "KLM postpunk era in Downtown L.A.— before certain areas were called 'arts district'—space was cheap and people were occupying industrial buildings and building them out, and creating these magical, wild worlds." There she experienced an "intersection of great music, wildness, drunkenness, hot partying, [and] a lot of performance work, this queer culture, where there weren't a lot of lines between who is the performer and who is the audience."

In the late 1990s, while working as a public high school teacher, de la Loza took art classes at East L.A. Community College under the pretext of getting a secondary credential to be an art teacher. She became increasingly interested in contemporary art, and when she "got totally disillusioned" with working for the L.A. United School District, she quit teaching and pursued an MFA in photography. During her graduate studies in the early 2000s, she was especially influenced by photographic work "from the 1990s by artists of color, like Dinh Q. Lê, Laura Aguilar, Cristina Fernández, and Carrie Mae Weems," as well as the "looseness and grittiness of photographers like Nan Goldin and Larry Clark."

De la Loza was in graduate school when she created the Pocho Research Society and began making guerrilla interventions with her own historic plaques in 2002. This practice emerged, in part, from her photography-based research on ways material culture functions in the consolidation and reproduction of hegemonic thought. In her series *Mi Casa Es Su Casa* (My Home Is Your Home), she used digital collage to defamiliarize the formulaic qualities of family photographs and thereby address the ways in which ideologies about the nuclear family are embedded in material culture and transmitted through time (figure 2.2). This led her to explore the possibilities of "dismantling narratives" and "creating other mythologies," which set the stage for her investigations into history.

As de la Loza turned her focus to history, she began noticing and researching "how historical narratives are constructed throughout the city: through the names of places, through historic monuments." "And that became my project," she said, continuing:

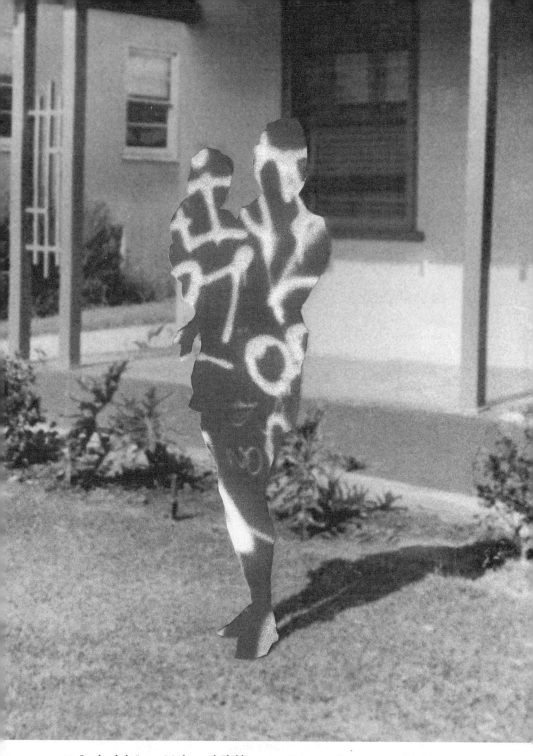

2.2 Sandra de la Loza, *Mother and Child* in series *Mi Casa Es Su Casa*, 2003. Black and white archival ink jet, 11 × 16 inches. Courtesy of the artist.

It coalesces in a simple economic form, which is the historic plaque. The plaques were a way to disrupt the dominant narrative, and also to formally use the city as a canvas, if you will. Within a U.S. context and an L.A. context, if we look at public historic monuments, they are totally colonialist and . . . very bellicose. . . . Initially, the [PRS's plaques'] narratives were meant to create and tell other stories, from the viewpoint of the losers of these wars or, also of everyday people of the working class— identifying spaces that were relevant to the histories of the dispossessed.[93]

The other important precedent for de la Loza's work as the Pocho Research Society is her experience creating street art with Arts and Action. Initially formed to create art actions at the Democratic National Convention in 2000, this collective then created a community space and continued collaborating on art actions in public spaces. Through this experience, de la Loza met the anarchist Mexican architect José de la Lama, who taught her about the history of Situationism and inspired her with his own interventionist performances (including a conceptual soccer game he created at Borderhack, a festival Fran Ilich organized in Tijuana–San Diego in 2000). De la Loza recalled, "I was trying to find ways to activate public space . . . and I really enjoyed taking critical political ideas and creating new forms that weren't your typical agitprop political public art. . . . I was totally interested in the techniques of cultural jamming of the nineties—those creative nonconventional tactics were something that excited me." Noting that activist art often tends to follow a limited repertoire of forms, such as political signage, street theater, and props for marches, she said, "I wanted to find other creative forms that weren't as predictable, so hopefully it would be more effective in terms of jolting people out of their everyday. . . . I wanted people to stop and think and reflect on the space of the city, where they're at."

While de la Loza creates photographic work, videos, and multimedia installations that she exhibits in galleries and museums, she explained to me why she has always maintained a guerrilla art practice:

I am very fortunate because I think I have these choices that earlier generations [of Chicana/o/x artists] don't have. On one level, I've been in many gallery shows and a couple [of] museum shows. It's fine, but who goes and sees those shows? . . . I don't want to solely exist in galleries and museums. I want to engage people outside. . . . I think it's great when art enters spaces that are not contained, . . . when it's put in places where people can stumble on something unexpectedly. That's why I like guerrilla art.

By describing the Pocho Research Society as a collective of "artists, activists, and rasquache historians" de la Loza suggests a framework for thinking of its practice as being rooted in a working-class Chicana/o/x social positioning.[94] *Rasquache* is a Mexican slang term often used to describe something considered crude and "low class." However, it took on new meanings in light of the counterideologies the Chicano movement produced. Like the word "Chicano," "rasquache" was resignified from a term of race- and class-based degradation to become associated instead with a collective valorization of working-class Mexican and Chicana/o/x culture and the contestation of racialized social hierarchies. Scholars and artists have theorized *rasquachismo* as it is expressed in the vernacular culture and quotidian practices of working-class Mexicans and Chicanas/os/xs; they have also theorized rasquache characteristics in artistic production by Latinas/os/xs, including literature, theater, and visual arts of all sorts.[95] The way the PRS deploys the concept of rasquachismo makes an intervention into this discourse, as it stands as a materialist counterpoint to the way the concept is typically deployed in culturalist terms.

Tomás Ybarra-Frausto influentially defined rasquachismo as a "sensibility," "a way of being in the world," an "attitude or taste" that emerges from the lived, day-to-day experience of working-class Chicanas/os/xs. It presupposes an "underdog perspective" and is characterized by resiliency, inventiveness, improvisation, and resourcefulness, which often express themselves in the practice of "making do with what's at hand." As it is expressed in material culture, he notes, rasquachismo tends to be associated with ephemerality and impermanence, which arise from conditions of scarcity.[96] Amalia Mesa-Bains theorized rasquachismo and its feminized version, which she calls *domesticana*, in a way that imputes to them a counterhegemonic ideological positioning. She argues that, as a "world view" characterized by resiliency and defiance, rasquachismo provides the basis of an oppositional identity.[97] These and other critics' theorization and valorization of rasquachismo challenge hierarchies of cultural value that denigrate the aesthetic practices and tastes of working-class and racialized people. Their suggestion that aesthetic practices are shaped by the material conditions from which they emerge also implicitly rebukes ideologies of aesthetic autonomy and value that enforce hierarchies of cultural value and hide their basis in social stratification.

Notwithstanding its valuable questioning of hierarchies of cultural and aesthetic value, much of the critical discourse on rasquachismo is marked

by a fundamental contradiction. On one hand, critics define rasquachismo in relation to a working-class Chicana/o/x social position and the material conditions and positionality (e.g., "an underdog perspective") that this implies; on the other hand, there is an effort to define rasquachismo with an identifiable style, set of expressive practices, formal qualities, and cultural products that are taken to be indices of working-class "Chicano culture" or "Chicano identity." A contradiction arises in that there is no necessary, fixed correspondence between the social position of working-class Chicanas/os/xs and a particular set of cultural practices or styles.[98] To claim as much would be to deny the heterogeneity and dynamism of Chicanas/os/xs' social practices in favor of an essentialist interpretation of their culture. While such formalist characterizations of rasquachismo may seem to unilaterally associate social class with a particular style or set of cultural signifiers, I would argue that they actually ignore the former entirely in order to imbue stylistic qualities with an *allegorical* relationship to social class. While this is a depoliticizing gesture, critics nonetheless claim an oppositional potential for rasquachismo in culturalist and identitarian terms, often presuming the value of cultural continuity.

The valorization of cultural continuity in relation to rasquachismo begs the question: If these practices have arisen out of conditions of material scarcity suffered by working-class people, why would one value their continuity? Ramón García astutely points out this contradiction. He argues that professionals' valorization of rasquachismo (in what I am identifying as its culturalist modality) amounts to an appropriation and neutralization of working-class practices.[99] I would argue, however, that the contradiction is not rooted in the class standing of the critics per se, as García suggests. Rather, it emerges from the contradiction I have identified in the academic discourse on rasquachismo and, specifically, from a reading of Chicanas/os/xs' expressive culture that treats class positioning in culturalist terms. This amounts to a kind of culturalist fetishism that ascribes symbolic value to cultural forms while rendering invisible the social relations that produce them. This procedure is, in fact, endemic to the identitarian discourses of liberal multiculturalism (and their myriad manifestations in cultural criticism) insofar as these enable the interpretation, valorization, and consumption of signifiers associated with a given cultural identity in ways that separate them, in ideology, from the material relations that have produced these identities.[100]

The PRS's theorization of rasquachismo offers a valuable counterpoint to the culturalist and identitarian approaches I have discussed, avoiding the

Chapter Two

conflation of social position with specific styles or cultural signifiers. As it has been theorized in Chicano art history, a rasquache disposition to "make do with what is at hand" is generally associated with one's access to material resources and how this affects the production of objects and adornment of spaces. The PRS translates this concept into the arena of knowledge production. This is reflected in their scrappy commitment to retrieving erased histories of working-class Latinas/os/xs. More fundamentally, it manifests in the PRS's guerrilla mode of production, which provokes questions about how social positioning affects access to the means of cultural production. The claim to rasquachismo, which signals a racialized working-class social position, provides a particular contextualization for the fact that the PRS's interventions in public space are unofficial, clandestine, ephemeral, and illegal. It calls attention to the fact that this rasquache, guerrilla mode of production is not simply one artistic choice among others, but one that is also a consequence of socially stratified groups' unequal access to the means of historical production.

As it re-elaborates theories of rasquachismo that were produced in concert with the Chicano movement, the PRS's work echoes their assertion of a counterhegemonic approach to cultural hierarchies. Yet it takes us beyond identitarian uses of the concept wherein rasquache sensibilities are understood as expressive of a specifically *Chicana/o/x* identity and aesthetic sensibility or as a vehicle for Chicana/o/x cultural continuity. Instead, it mobilizes its alignment with a working-class Chicana/o/x social position to comment on the production of universalized knowledge. At the same time, it models a counterhegemonic way of producing history, one that *socializes* historical production so that others can imagine themselves as, and perhaps become, rasquache historians.

ECHOES OF QUEER NIGHTLIFE

In 2006 and 2007 the PRS collaborated with queer Latina/o/x writers to produce *Echoes in the Echo*, a series of countermonuments that addressed the recent displacement of working-class communities of color from gentrifying neighborhoods in Los Angeles. De la Loza describes *Echoes* as an antigentrification project, though she notes that she uses the term "gentrification" retrospectively. At the time of producing the series, she says, she thought about it in terms of "displacement as something that the PRS constantly explores [based on] an understanding that, historically, colonial processes that evolve into capitalist modes of production continually produce conditions of displacement."[101]

Like the PRS's earlier work, *Echoes* is a visual, performative, and literary response to the dialectic of place-making and displacement that characterizes the relationship working-class Latinas/os/xs have to spatial production in Los Angeles. *Echoes* memorialized spaces of queer culture and encounter that had existed in Echo Park and downtown L.A. before these neighborhoods were gentrified in the 1990s and 2000s, displacing working-class Latina/o/x communities that had resided there. To commemorate these communities, *Echoes* unearthed histories of shuttered bars and nightclubs that had been a kind of home to queer working-class Latinas/os/xs. The text publicly announcing *Echoes* explained that as downtown L.A. and Echo Park were gentrified, many of the buildings that formerly housed queer Latina/o/x bars were taken over by "hipster bars that cater to a straighter, whiter and wealthier clientele."[102] The plaques the PRS installed on the edifices and in the entryways of the "hipster bars" memorialized the bars and clubs that had previously operated in these spaces and the queer nightlife that had enlivened them.

Echoes' title brings out the meaning of "echo" as a sound that reverberates after the original sound has stopped. In this project, memories are what reverberate after their referents have disappeared. The texts on the plaques, which are composed of thick, sensorially rich descriptions, read like evocations of memories. These countermemorials both commemorate the practice of social memory and attempt to preserve in writing memories of these particular bars. While the absence of the bars compelled the desire for writing in the first place, writing inscribes another absence as, of course, a text about a memory is not the same thing as the memory itself. This becomes even more apparent as all the texts suggest how deeply embedded memories are in the senses and in bodily sensations. Thus the doubling of "echo" in the series' title is a referent not just to the neighborhood and bars but also to this double loss, that is, an act of writing that is compelled by loss and absence and that also acknowledges what is lost to language in its attempt to preserve memory.

The gentrification-fueled displacement to which *Echoes in the Echo* responds is a recent iteration of ongoing processes of urban restructuring that subordinate working-class and racialized communities to dominant modes of spatial production and, specifically, to the imperatives of treating cities as vehicles for capital accumulation. But, more precisely, the wave of gentrification and displacement seen in Los Angeles and cities around the world since the 1990s, often called "new gentrification," is a symptom of the ruling-class conquest of urban policy that has operated in a continuum with other facets

of neoliberalization. It is a manifestation of class warfare from above that displaces those workers rendered redundant by the post-Fordist economy and cutbacks of social services.[103]

Neil Smith argues that since the 1990s, gentrification has been adopted as an "urban strategy" that "weaves global financial markets together with large- and medium-sized real-estate developers, local merchants, and property agents with brand-name retailers, all lubricated by city and local governments for whom beneficent social outcomes are now assumed to derive from the market rather than from its regulation." "Most crucially," he adds, "real-estate development becomes a centerpiece of the city's *productive* economy, an end in itself."[104] Insofar as this treatment of space as a commodity conflicts with its use for housing, this is suffered by those communities with the least power and resources, that is, working-class, usually racialized communities. State power is regularly used to wrest control of urban space from these vulnerable communities, including through policing and criminalization. Discourses about security, urban blight, and urban renewal are used as ideological cover for this project.

The greater downtown region of L.A., which was the focus of *Echoes'* study in displacement, was already being transformed in the 1990s by "state-led speculative development particularly oriented toward finance and insurance" and the efforts of property and business owners.[105] The construction of a new sports arena and an enormous sport-retail-entertainment complex (L.A. Live, dubbed a "Times Square of the West") further propelled the neighborhood's restructuring, which pushed out Latina/o/x communities that had occupied downtown's central core.[106]

As Jacob Woocher has shown, gentrification and skyrocketing rents have shaped a "new geography of segregation and exclusion" in L.A. that has a clear racial character.[107] During the first decade of the twenty-first century, median rent in L.A. rose by 30 percent, while median income and purchasing power declined.[108] A contiguous zone stretching across the city in which only wealthy people can afford to live has extended east and south into areas historically populated by working-class Black and Latina/o/x communities.[109] As Woocher writes, "Los Angeles is increasingly becoming solely accessible to the rich, and the rich are disproportionately white"; he cites a 2016 report revealing that "Black and Mexican households . . . have one cent for every dollar of wealth held by the average white household in the [L.A.] metro area."[110]

De la Loza and her collaborators produced *Echoes* while local grassroots anti-displacement organizing efforts were intensifying in L.A. and

the city was becoming a key site for building national coalitions for anti-displacement struggles.[111] De la Loza became involved in antigentrification organizing not long after this, in the late 2000s, while living near Echo Park and facing threats of eviction and skyrocketing rents. She first became involved in the community organization Standing Together Advocating for our Youth (STAY), which had formed to fight a gang injunction that had been imposed on Echo Park and its surrounding areas. Gang injunctions are used to criminalize working-class people of color, strip them of basic rights of assembly, expression, and mobility—with little to no court oversight—and erode the social tissue of these communities.[112] De la Loza notes that the injunction was imposed on Echo Park during "a period where violence was at a twenty-year low, and when the housing market was rebounding." STAY formed to fight against the gang injunction, which residents understood was a means "to criminalize and destabilize the older residents who were working-class people of color who owned properties and apartments that were highly desirable and profitable."[113] After moving to Northeast L.A., de la Loza became more involved in anti-displacement organizing and related popular education initiatives, participating in Defend Northeast Los Angeles, L.A. Rooted, Everything Is Medicine, and the School of Echoes.

Echoes' extra-institutional and guerrilla forms of production and circulation are consistent with the project's antigentrification politics. This coherence stands out in contrast to the ways that art workers' political intentions often enter into contradiction with the place of fine art within the political economy of urban space. When they can be enfolded into discourses of "urban renewal" and used as signs of embourgeoisement to attract capital, art institutions and artistic communities are easily made functional for the displacement of working-class people. The beneficence and autonomy socially associated with art also makes it particularly useful for whitewashing ("artwashing") the violence of displacement. In fact, at the time of writing this, anti-displacement activists in L.A. are protesting art galleries that have established themselves in working-class Latina/o/x and Black neighborhoods because their presence abets the raising of rents and displacement of working-class people.[114] In light of the role art galleries play in gentrification, it is significant that the PRS exemplifies a mode of producing art that does not rely on exhibitionary infrastructure (e.g., galleries) or traffic in signifiers of embourgeoisement, as doing so could abet the gentrification the PRS is denouncing.

Chapter Two

Echoes works to shape our understanding of the stakes of the struggle for urban space to which working-class communities are subjected. Its texts attest to the cultural practices and social fabric that queer working-class people produced *in place* in now-shuttered bars and clubs. As seductive, fragmentary evocations of the aesthetics and erotics that enlivened these places, the plaques' texts vividly recall the joyful eroticism and enthralling sensuality of sweaty dance floors, banda and cumbia rhythms, drag performances, poetry readings, recreational drug use, clandestine encounters, and casual sex, as well as the variously gendered clientele the plaques describe as cholos, travestis, drag queens, go-go boys, "lovers of social justice and freedom, lovers of womyn of color," "butch-femme weekend divas," and "church ladies pressed up against each other in Sapphic bliss."[115] By memorializing these practices and spaces thusly, *Echoes* shows how gentrification-fueled displacement constitutes an assault on entire lifeworlds, as it deprives communities of the material infrastructure that is crucial for their constitution, self-determination, and continuity over time.[116]

By representing the dazzling tapestry of cultural practices and communities that were materially supported by since-shuttered venues, *Echoes* sets forth a counterhegemonic calculus of the value of urban space. Under the reigning imperatives of capitalist accumulation, the use-value of space is subordinated to the exchange-value of space as a commodity or to the function of space in the infrastructure of profit-driven production. The cruelty of this calculus is obscured by profit-driven ideologies of development that dominate discourses surrounding uses of urban space. Raúl Villa underscores the power of ideology to shape perceptions of value and the "common good" as these pertain to uses of urban space, arguing that "the material and discursive power of [metropolitan] growth coalitions allows them to control urban form and meaning such that whatever is good for business is, *ipso facto*, rendered synonymous with civic interest."[117] Villa suggests that one of the ways in which elites secure hegemonic control over urban form is by controlling perceptions of space and spatial practices and the kinds of value that can be imputed to these. He argues that "literary forms of discursive intervention by which Chicanos [have] critiqued the instrumentality of dominant spatial practices in marginalizing their communities" have been an important means by which Chicanos have "defended their use-value orientations to place against the exchange-driven imperatives of the urban growth machine."[118] *Echoes in the Echo* is precisely one such literary intervention. Its memorialization of cultural practices and social tissue that had been materially supported by bars and clubs proffers a

counterhegemonic framework for understanding the value of these spaces, that is, one that centers their use-value for the self-determination of queer working-class communities.

If typical denunciations of gentrification tend to focus on nuclear families, their homes, and "mom and pop" businesses, *Echoes* suggests that a defense of the barrio and its communities against displacement should also encompass spaces of queer intimacy, revelry, and casual sex, and the social fabric *these* sustain. Its evocations of queer working-class nightlife attend to the sensorial qualities and signifiers of what Deborah Vargas has theorized as "*lo sucio*" (*sucio* means "dirty" and is a slang descriptor for something considered sexually immoral). For Vargas, lo sucio describes a social construction used to dehumanize racialized surplus populations, especially working-class genderqueer people of color. The concept of lo sucio indexes the proximity between several racialized discourses of difference that mobilize notions of the obscene, dirty, suspect, and impure to represent working-class communities and sensibilities, bodies considered hypersexual or undisciplined, and "suspect citizens" considered nonloyal to the state.[119] She notes, additionally, that the identification of lo sucio does not work solely through representation but also on sensory registers, so that smells and other senses come to be associated with racialized class and gender identities. Vargas argues that subjectivities to which these notions of lo sucio are fastened should be understood as "surplus subjectivities who perform disobediently within hetero- and homonormative racial projects of citizenship." These subjects "reconfigure spaces that have been deemed inferior" in ways that are essentially counterhegemonic "tactics for sustaining queer worlds within hetero- and homonormativity's structural violence."[120] This entails maintaining forms of queer sexuality and sex practices that flout capital's self-disciplining mandates and the transactional relationships these organize. Against dominant ideologies pertaining to love that are organized around "dual-partnership, monogamy, and reproduction on normative time" sucio subjectivities "persistently violate, and at times, willfully fail to arrive to sexual intimacies produced through capital."[121]

Reading *Echoes* together with Vargas suggests that a collective defense of lo sucio ought to be integral to any anti-displacement politics attuned to the roots of displacement in the subjugation of life and freedom to the imperatives of capital. If we consider *Echoes* a literary intervention in the tradition Villa identifies, where Chicanas/os/xs (and others) defend their use-value orientations to urban space, then its memorialization of queer nightlife

broadens the possibilities of what practices, spaces, and subjectivities should be collectively defended.

"MEXICAN LAUNDRY"

I focus on one of the countermemorial plaques for *Echoes in the Echo,* whose text was written by Ricardo A. Bracho. Bracho is a poet, playwright, dramaturg, editor, and educator. He describes himself as a gay L.A. Mexican, noting, "One of the reasons I call myself gay is because it used to stand as adjective to the noun 'liberation,' though this is well before the North American gays' rightward drift . . . and what I call the constitution of the gay and lesbian neoliberal norm."[122] His work represents the lifeworlds of Black and Brown communities in ways that communicate the intensities, sensuousness, and political stakes of everyday practices, while eschewing all traces of sentimentality and identitarianism. He has described his artistic practice thusly: "I'd like to form a praxis that could incorporate, in dialectical friction, antihumanism and whoring; a heart that belongs to Fanon, Marx, Luxemburg and Genet, as well as a fanboy's interest in the Bolivarian Revolution, FARC, the intifada, and the myth-making of conceptual prog-rockers, the Boricua and Chicano L.A. Tejanos, The Mars Volta."[123] Bracho flouts bourgeois moralism, heteropatriarchal social norms, and White/Anglo ethnocentrism by writing worlds and subjects that are indifferent to these. The sex, recreational drug use, and radical critiques of class, empire, and racism that characterize his work are not pitched to provoke bourgeois or liberal sensitivities; rather, they are clearly organic to the worlds he writes.

Bracho was born in Mexico City in 1969 and raised in Los Angeles. In a 2015 interview with me, when he described his generational and ideological formation, he said, "I am a child of the Latin American Left, a red diaper baby, an inveterate Marxist-Leninist. And none of those things I see or operationalize as identity, as a way to feel about myself and others, but more so how Genet talked about what writing was when he said it was a way to return to the social by other means."[124] While describing himself and his generation as children of the radical political militancy of the late 1960s, he emphasizes the importance of his personal experience of both localized and transnational social and political movements of the 1980s and 1990s: "There's AIDS. There is the antiapartheid movement in the U.S. There was the defense of Nicaragua and El Salvador in U.S.-based solidarity movements that were compelling me into just being a wrong man." Bracho also studied at Berkeley, where he met de la Loza. Like de la Loza, he emphasized the

importance in his own formation of working with Cherríe Moraga, who would become a close comrade and collaborator of his.

Bracho lived in San Francisco for much of the 1990s, when the city, was, as he describes it, "really a good lab. You could try things out.... You could take over the streets. Disruption could be part of your everyday in a very enlivened way." During this time, Bracho was especially marked by the L.A. Rebellion and activism against the first Gulf War: "I was in an organization called Roots against War, which was, say, a people of color, people of the Global South political organization that ran the gamut of Marxists, Maoists, some cult nats [cultural nationalists], (that was definitely the tension within a portion of the leadership), various Third Worldist perspectives, feminists, and that was just a really good way to launch into the world with some articulated and strategic rage."[125] While reflecting on his early formation as a writer, Bracho also spoke about the influence of a gay men of color movement that articulated artistic communities and AIDS activism. He noted, in particular, the profound importance for him early on of an East Coast nexus of Black gay male poets that included Assotto Saint, Donald Woods, David Warren Frechette, and Craig Harris.

Alongside and sometimes dovetailing with his writing, Bracho has worked extensively in public health, focusing on HIV and STI risk reduction with queer youth of color, immigrants, and the incarcerated. The sexual liberationist politics that characterize his writing also shaped his work in public health. In San Francisco, Bracho worked in health education with Proyecto ContraSIDA por Vida, a community-based HIV prevention organization that primarily served queer working-class Latinas/os/xs. Juana María Rodriguez has shown how the political vision Bracho brought to health education there situated Proyecto's purpose within an ethos of sexual liberation and a nonidentitarian politics that hailed communities constituted by action and shared political commitments.[126] This ethos is also evidenced in Bracho's contribution to *Echoes in the Echo*, in which he poetically evokes the sex and sensations that once enlivened a now-shuttered bar.

Bracho's poem "Mexican Laundry" memorializes the downtown bar The Score. De la Loza printed the poem on one of the PRS's countermemorial plaques and installed it in the vestibule of the hipster dive bar that took over the building after The Score was closed (figure 2.3).

"Mexican Laundry" articulates a counterhegemonic aesthetics of history through its materialist apprehension of memory and the social life of the senses. It begins with a series of commands addressed to the reader's body and senses: "stop at this threshold / close eyes / breath[e] beneath...

Former Site of *The Score*

Mexican Laundry

stop at this threshold
close eyes

breath beneath

the newly signed condo lease
usc diploma

and smell
the pre-Smell
smell of

Suavitel in the blue bottle
tortillas de maiz hot in their plastic
Ralph Lauren Polo Sport

hard work scrubbed off

a mouth made sweet with joint, mint
and his mouth too

and the possibility wafting thru the air

you could always score at The Score.

. Declared Monument #11
Operation Echoes in the Echo
By the Pocho Research Society of Erased and
Invisible History

2.3 Pocho Research Society of Erased and Invisible History, *Former Site of The Score, Declared Monument #11*, 2008, plaque from guerrilla intervention, Los Angeles. Photograph by Sandra de la Loza. Text by Ricardo A. Bracho.

and smell."[127] It hails its reader as an embodied, sensing subject, located in a concrete space—a space whose specificity is both material and discursive. "Threshold" refers to the architectural space that surrounded the plaque, as it was installed in the bar's vestibule. "Threshold" also means the point at which something begins or changes and the point at which a stimulus begins to be sensed. Thus while the poem's opening address situates the reader in this specific space, it is also an invitation to occupy a temporal border, as well as an invitation to sense. This temporal liminality is then performed by the poem as the practice of memory: it brings into the present the memories of this place as it was in the past. More than anything, the poem tells us about the sensations that circulated there, as it represents memories through the senses—primarily through smell but also taste.

Visual recollections are nearly entirely absent from the poem's sensory evocations of The Score. Moreover, vision is refused with the phrase "close eyes." The poem's rejection of the visual can be understood as an effort to evoke a counterpublic memory in a sensory key different from imagistic renderings of the city, which, as Andreas Huyssen argues, is the dominant mode through which the city is constructed as a space of mass consumption and a lure for tourism and development.[128] Given that "Mexican Laundry" addresses gentrification, the poem's avoidance of visual representations can specifically be understood as a resistance to a visual regime that is often recruited by discourses that champion capitalist development and misrepresent its effects on working-class populations. While the causes of gentrification stem from financial speculation in real estate and urban policies that prioritize uses of urban space that will generate profit for elites, superficial representations of gentrification often frame it as an aesthetic project that is registered visually—that is, a transformation in what a neighborhood *looks* like (which is ultimately, of course, inseparable from the transformation of who is there). Discourses of urban beautification are one obvious example of the ways that imagistic representations of urban landscapes are mobilized to represent gentrification as a politically neutral project and to obscure the displacement of racialized working-class populations that it produces. Moreover, images taken to represent "long-gone" pasts, as well as images of ethnic or racial difference, are easily appropriated and recontextualized as part of the process of gentrification. After all, images and artifacts of the popular past are common currency in hipster bars in gentrifying neighborhoods, where they are rendered ironically folksy or as a kind of sanitized camp. (In fact, bars where the Pocho Research Society installed their plaques have precisely this aesthetic.) Thus, even though "Mexican Laundry" is itself a text and not an image, the

fact that it doesn't offer visual descriptions of the queer Latina/o/x bar or bar-goers suggests a refusal to represent them in a way that would be easily assimilated to ideological uses of the visual, wherein signifiers of difference are consumed and sundered from the material realities of racialized groups.

In "Mexican Laundry," the phrase "close eyes" is also, paradoxically, a refusal of the written text itself, followed by an appeal to "breath[e] beneath / . . . and smell." This suggests that the practice of memory doesn't originate in our reading of its text. Rather, it invokes an act of memory through the communion with the place itself, while suggesting that the past comprises a sensory strata within it. The present is figured as surface, while the past is figured both as sedimented depth and as smell, emphasizing the materiality of the senses.[129] The poem's graphic disposition on the plaque also mirrors its figuration of the past as depth; as we read and move away from the present and deeper into memories of the past, we visually move down the layers into which the poem is divided. In the poem, memory and sense are not the sole prerogatives of an individual subject. It treats the senses as a social phenomenon and decenters the individual subject in the act of constructing memory, so that the act of memory comes to appear as a latent potential embedded in places and their sensorial landscapes.

After its opening command to stop and smell, the poem recalls memories of the bar as it was in the past and juxtaposes these to its present. "Newly signed condo lease / USC diploma" signify the white and upwardly mobile demographic of the bar and the neighborhood in the present, while the phrase "hard work scrubbed off" speaks to the working-class status of those who were here before. The transformation of the bar and neighborhood brought about through gentrification is described as an olfactory shift. The now absent Mexican barrio is recalled by its smells: those of Suavitel fabric softener and tortillas de maíz. The way the poem indexes the displacement of working-class Latinas/os/xs through the evocation of smells offers a sense of the day-to-day and intimate experiential realms in which processes of displacement, the shuttering of neighborhood institutions, and the sundering of social ties are registered.

Although "Mexican Laundry" is about displacement, the way it calls up memories of the bar and barrio as they were before actually suggests that they are not wholly consigned to the past. The same sensorial language used to signal the displacement of the queer bar also pulls us into the sensuality and sex of this place as if it could still be sensed. *This* is the threshold we cross with this poem: the way its invocation of social memory opens up an alternative temporality not apprehended by a linear sense of time. When the

poem suggests that the past makes itself felt in the present through the practice of memory, this is specifically a call to a *counterpublic* memory, posed against the public amnesia gentrification entails and the forward-marching discourses of progress and development that are central to the capitalist growth-driven urbanism of L.A.

In "Mexican Laundry," the social memory of The Score bar is so potent and so present precisely because the sociality it entails is steeped in the senses and in sex. The poem evokes these memories, first, through scent: the smells of clean clothes, cologne, and skin, which all suggest physical closeness. The poem describes a kiss through taste—"a mouth made sweet with joint, mint / and his mouth too"—and then suggests that "possibility waft[s] thru the air," like another scent (or something sensed). As we move down through the lines of the poem, its sensory recollections also move down the vertical axis of the body: from closed eyes to smell to the mouth, until the poem's final line plays on the bar's name to pithily praise its reliability as a space for casual sex (and drugs): "you could always score at The Score." The reference to scoring furthers the poem's own insistence on an erotics of transitory encounters and sensations. Its emphasis on ephemerality complements the poem's attention to a specific, concrete space of encounter and specifies its analysis of the effects of gentrification and displacement. That is, it foregrounds the importance of spaces of transitory encounter to the self-determination and reproduction of queer working-class communities.

As it memorializes the bar and its barrio, "Mexican Laundry" evokes them through smells that are both intimate and social, both public and private, like the smell of hot corn tortillas and the smell of Suavitel fabric softener. On the one hand, "Mexican Laundry" and the reference to Suavitel evoke the recognizable sweet scent that lingers on the clothes and skin of the men at the bar. The scent then becomes sensual, a marker of the proximity of bodies, entwined with the possibility of sex, which the poem figures as another scent. But "Suavitel in the blue bottle" is also a smell and an image that recalls the barrio *lavanderia*, where the domestic ritual of laundry is performed among neighbors. This orients us to both the materiality and sociality of the senses, the ways they inhabit spaces and linger on bodies and how they are a medium of communication and connection. Moreover, by tracing the social lives of the scent of laundry, the poem connects the space of social reproductive labor that is the lavanderia with the space of queer nightlife. In doing so, it places squarely within the material life and social fabric of the barrio the eroticism, queer subjects and practices, illicit consumption, and casual sex that are framed, but not contained, by the space of the queer

bar. This is a reminder of a common vulnerability to capital that cuts across what may otherwise be compartmentalized practices and identities of the working-class neighborhood. If typical denunciations of gentrification focus on nuclear families and their homes, "Mexican Laundry" suggests that a position defending the barrio and its communities is also about defending its queer spaces, spaces for scoring—whether sex or drugs—and the social fabric these sustain.

I have shown how the PRS's historical production entails an alternative historical epistemology that allows for the emergence of different objects of analysis and explanatory frameworks. By producing history in ways not beholden to dominant logics of history, the PRS struggles against colonial capitalism's attempts to monopolize the forging of social imaginaries. By making countermonuments to spaces where undocumented men have sex, spaces where anarchist collectives operated, and places where migrants share stories or L.A. Mexicans smoke weed, the PRS broadens the possibilities of who and what can be defended—not only the nation, or notions of progress used to justify capitalist urban development, or the nuclear family enshrined in expressions of Chicano and other nationalisms—but also stoners, punks, queers, lumpen, and the land.

Reframing Violence and Justice

HUMAN RIGHTS AND CLASS WARFARE

When one individual inflicts bodily injury upon another such that death results, we call the deed manslaughter; when the assailant knew in advance that the injury would be fatal, we call his deed murder. But when society places hundreds of proletarians in such a position that they inevitably meet a too early and an unnatural death, one which is quite as much a death by violence as that by the sword or bullet; when it deprives thousands of the necessaries of life, places them under conditions in which they cannot live—forces them, through the strong arm of the law, to remain in such conditions until that death ensues which is the inevitable consequence—knows that these thousands of victims must perish, and yet permits these conditions to remain, its deed is murder just as surely as the deed of the single individual; disguised, malicious murder, murder against which none can defend himself, which does not seem what it is, because no man sees the murderer, because the death of the victim seems a natural one, since the offence is more one of omission than of commission. But murder it remains.—Friedrich Engels, *The Condition of the Working Class in England* (1845)

AT THE BEGINNING OF THE TWENTY-FIRST CENTURY, Argentina was a hotbed of self-organized, grassroots social movements that strategically enacted resistance to the mandates of neoliberal capitalism, repudiated the

political institutions that imposed these, and practiced forms of politics not mediated by state institutions. In 2001 a massive popular insurrection ousted the country's president and entire cabinet and was met with the deadliest single episode of state repression since the country's last dictatorship. It was among a constellation of contemporaneous popular uprisings seen throughout the Americas in which the popular classes rose up in defiance of the inequality and dispossession that had been exacerbated by neoliberalization, including the Caracazo in 1989, L.A. Rebellion in 1992, Zapatista Uprising in 1994, Cochabamba Water Wars in 2000, and at least fifteen others.

The Argentine uprising and the crisis of state hegemony it signaled gave a new visibility to popular movements that had already been organized around various sites of social conflict, including labor, education, and human rights, and it enabled their mutual interrelation without mediations of state politics.[1] The political conjuncture it opened was marked, generally speaking, by a tendency toward the socialization of production and reproduction, the breakdown of logics of specialization that typically segregate different practices, and an experimentalism among popular movements.[2] One manifestation of this was the flourishing of politicized, collective, and paradisciplinary art, as many artists' practices were transformed through their participation in popular movements and protest actions.[3]

This chapter focuses on two Buenos Aires–based art groups that fused their artistic production with social movement-based practices of direct action: Etcétera . . . and Grupo de Arte Callejero (Street Art Group), known as GAC. Their work gives expression to crucial aspects of the antisystemic politics that erupted on an international stage with the Argentine uprising. But, just as the uprising was rooted in a longer history of movements, so is the work of GAC and Etcétera Therefore, to tell these groups' stories and explain the significance of their politico-aesthetic practices, this chapter begins with the history from which they—and the 2001 uprising—emerged.

The 2001 Argentine uprising and the movements it articulated must be understood within longer histories of class struggle. As occurred elsewhere in the Southern Cone, the neoliberalization of Argentina's economy was initially made possible in the 1970s by the ruling class's use of massive state violence and authoritarian military governance. The imposition of antiworker policies was backed by state terrorism and a political genocide that aimed to bury socialist and communist organizations and aspirations in the past. State repression and macroeconomic restructuring shifted the balance of class forces, eradicated the armed Left, destroyed gains won by labor struggles, and pushed much of the Left into a defensive position of seeking

minimal protections for human rights. After the return to constitutionalism, nominally democratic liberal governments continued to impose the diktats of the IMF and U.S. Treasury, so that, by the end of the twentieth century, decades of neoliberal "shock therapy" had drastically increased wealth inequality, immiserated the working and popular classes, shredded the social safety net, and subordinated the country to the mandates of transnational financial capital.

Occupying an important place in the recent history of popular politics in Argentina, the human rights movement has a multifaceted, if somewhat ambiguous role in social struggles around neoliberalization and the violence it has entailed. It has been the most important force for building a social condemnation of state terrorism committed during the dictatorship and seeking justice for its perpetrators. Facing the impunity of such persons, the movement developed a practice of direct action–based popular justice that challenges the state's monopoly on defining and arbitrating justice. Yet insofar as the movement's dominant tendency has been to frame the human rights struggle as pertaining primarily to political violence under the last dictatorship, it has naturalized a past-oriented, liberal, and humanitarian conception of human rights that depoliticizes social conflict and marginalizes socioeconomic dimensions of justice. In some senses, then, human rights politics has actually complemented the hegemonization of the neoliberal social order that was imposed with the very violence the human rights movement denounces.

GAC and Etcétera...incorporated their art into direct-action tactics used in the human rights movement, as well as other social struggles. This confluence of art and social movement praxis illuminates the ways artists can take up and transform discourses, tactics, and politico-aesthetic forms produced by movements. In so doing, they not only contribute to movements' repertoires and archives but also participate in struggles over movements' social meanings and political horizons. Indeed, while the art of GAC and Etcétera...elucidates the dynamism and internal heterogeneity of Argentina's human rights movement, it also engages in struggles over the movement's politics.

The art GAC and Etcétera...have created within the movement expresses and contributes to its more radical tendencies—ones that contravene the liberal moorings of human rights cultures hegemonic in Argentina and globally. In fusing their artistic production with the movement's tactical forms of struggle, these artists marshal the movement's powerful condemnation of state terrorism under dictatorship toward a far more capacious critique

of ruling-class violence and its myriad instantiations in the postdictatorship social order. This includes critiques of the postdictatorship neoliberal state's defense of fascists, as well as its own repressive actions, the violence of labor exploitation and the obscene ways in which this is feted, and the economic terrorism of globalized finance capital.

THE AESTHETICS OF VIOLENCE AND HISTORY

The ways in which GAC and Etcétera . . . reframe human rights discourse to put forth a more expansive social critique turn upon their interventions into the aesthetics of history and of violence. In the previous chapter, I defined the former as the reality-producing effects of historical representations (broadly understood), which not only create specific ideas about the past but also produce the very categories of past, present, and future and the ways these are understood in relation to each other. I use the concept of an *aesthetics of violence* to address the social forging of perceptions of violence. This includes the social meanings ascribed to violence and their normative functions; it also includes the very constitution of violence as an epistemological object in specific contexts—or the foreclosure of this possibility.[4] The maintenance of a hegemonic aesthetics of violence has enormous political implications. It regulates what is or is not recognized as violence or violent; it shapes the perception of the agents, logics, and spatial and temporal extension of specific instantiations of violence, often framing these within certain narratives; and it produces different categories of violence, while differentially moralizing these.[5]

Liberal ideology elaborates a hegemonic aesthetics of violence that works to naturalize and render imperceptible the violence inherent in capitalist social relations, including the violence capitalist states exercise to secure processes of accumulation and guarantee the reproduction of class relations.[6] The quotation by Engels that appears as an epigraph to this chapter points to this aesthetics of violence by noting how the organized, systematic destruction of proletarian lives is not socially recognized as such: it is "disguised, malicious murder, murder against which none can defend himself, which does not seem what it is, because no man sees the murderer, because the death of the victim seems a natural one." Similarly, Mark Neocleous succinctly notes that political liberalism operates hegemonically by "threaten[ing] violence while denying or masking the violence it inflicts in the name of liberal order."[7] This is why the ideology of law is so central to liberalism, he argues, as it regulates what is considered legitimate versus illegitimate violence and

masks the way law depends on state violence and exercises it through state institutions.[8] Neocleous underscores Nicos Poulantzas's insight that, in capitalist societies, law organizes repression *and* "materializes the dominant ideology," giving "expression to the imaginary ruling-class representation of social reality and power" in order to "[organize] the consent of the dominated classes."[9]

Historical representations do enormous work to shape the aesthetics of violence. This was demonstrated in the previous chapter's discussion of state histories of Los Angeles that efface colonial violence against indigenous and Mexican people. As Randall Williams argues, the hegemonic function historical representations have for regulating perceptions of violence is especially important "when the 'illusory opposition between Law and terror' suffers a fundamental breakdown," such as following periods of extreme political violence and dictatorship. In such contexts, history's hegemonic function is to abet the reconsolidation of the state's legitimacy, he argues.[10] Citing Etienne Balibar's assertion, "History is the means by which violence is converted into non-violence and transferred into political institutions," Williams clarifies that historical representations function in this regard by *"preserving* violence and reproducing it in the structure of state institutions."[11] The role of hegemonic aesthetics in this process is to foreclose the very possibility for certain forms of violence—particularly that of state institutions—to be perceived.

As it has emerged from frameworks of transitional justice, human rights discourse is organized by a progressivist, periodizing temporal logic that seeks to create the illusion of a radical break with the past, a quick shift from one sociopolitical reality to another.[12] Creating this illusion requires a hegemonic aesthetics of violence that operates through both the temporal distribution of violence and its selective effacement. As Allen Feldman argues, the progressive, periodizing emplotment of human rights discourse "is meant to culminate in a cathartic 'break' with the past—establishing the pastness of prior violence, and managing and controlling the conditions and terms of its periodic reentry into the present, usually through appropriate commemoration."[13] This periodization is both normative and moralizing, as it enables the continual staging of a "moral opposition" between those legal and psychomedical rationalities that have been identified as abusive and those that are then cast as "post-violent" and corrective.[14] I will show how this periodizing logic has operated in human rights politics in Argentina, as well as in cultural productions and memorial practices that represent the political violence of dictatorship in ways that consign it to a discrete and past "time," separate from a presumably "post-violent" present.

Many representations of Latin America's late twentieth-century political history are also organized by a progressivist and periodizing historical logic that serves to naturalize the neoliberal order and bury struggles for revolutionary social transformation in the past. John Beverley identifies these logics in historical narratives that cast the postdictatorship neoliberal order as a historical "stage" that supposedly transcended a preceding "stage" of armed struggle and counterrevolutionary violence.[15] As he notes, this deeply ideological view of history is articulated with a conservative biographical narrative, one in which the hope for a revolutionary transformation of society is represented as a romantic illusion of adolescence, and the forsaking of this struggle is cast as a natural result of a generation's maturation—rather than a result of violent counterrevolution or of individuals' embrace of (neo)liberal ideology.

In summary, the progressive, periodizing logics operative across juridical and cultural aspects of human rights politics, historical representations, and other cultural productions articulate a hegemonic aesthetics of violence that naturalizes the violence of class and (neo)colonial domination and the institutionalized and routine violence of liberal states. This works to render invisible the continuities between Argentina's social order under authoritarian and neoliberal state regimes and the *complementariness* of these two forms of governmentality for maintaining class rule.[16] This periodization is bolstered by and further naturalizes the technocratic liberal ideology that represents the economy as if it were autonomous from politics.[17]

Contravening the hegemonic aesthetics I have described, the work of GAC and Etcétera . . . represents ruling class violence realized under Argentina's last dictatorship as it prevails upon the present, as it helped to constitute and has been institutionalized in myriad aspects of the postdictatorship social order. They identify this violence in the living agents and profiteers of state terrorism and the neoliberal state that protects them, and in this state's violence against the poor and repression of political dissent; in corporations whose exploitation of workers has been greased by repression; cultural institutions that whitewash this reality; and in the very sociospatial form of the contemporary city. For these reasons, these artists' work about the history of the dictatorship does not memorialize its violence or its victims. Rather, it represents this history in ways that can enable an intervention in the present: as a call to arms, as a tool for grassroots organizing, and as a key for understanding contemporary class relations and the social function of state institutions.

While the dominant aesthetics of history and violence attempt to impose a radical break between the authoritarian past and (neo)liberal "present,"

GAC and Etcétera ... show how class warfare from above is historically and temporally continuous between these state and capital formations, notwithstanding differences in their modes of governmentality or forms of coercion. Their counterhegemonic interventions into how both history and violence are perceived not only enable their radical visioning of human rights militancy; these also constitute a broader challenge to important ideological-aesthetic underpinnings of (neo)liberal hegemony.

FROM THE 1970S TO THE 1990S, A HINGE GENERATION

Nowadays, the 30,000 "disappearances" perpetuated by the dictatorship have been protracted through exclusionary, impoverishing policies.—Sandra Lorenzano, *"Angels among Ruins" (2009)*

To borrow a metaphor from members of Etcétera..., they and the artists of GAC belong to a "hinge generation" within the Latin American Left,[18] insofar as they strive to connect the antisystemic movements of their parents' generation to those of their lifetime, while straddling the rupture in Left politics instantiated by counterrevolutionary violence and the globalization of neoliberal capitalism. Born in Argentina and Chile in the 1970s, these artists are the children of a generation that directly experienced the possibility of revolutionary social transformation. Social and political movements of the Left gained increasing power across Latin America after World War II, and by the beginning of the 1970s Chile and Argentina were home to militant student and worker movements, Left guerrillas, and, in the case of Chile, a democratically elected socialist president. A violent counterrevolutionary assault by the ruling class would shift the relation of class forces in their favor and give the military a central role in enforcing their class interests.[19] In a succession of military coups between 1973 and 1976, authoritarian military regimes took power in Chile, Argentina, and Uruguay. (Brazil and Paraguay were already under Right-wing dictatorships.) These regimes imposed antiworker economic programs that constituted the beginnings of economic neoliberalization and a continuance of U.S. imperialism in the region.[20]

The authoritarian civil-military regime that ruled Argentina from 1976 to 1983 called itself the Proceso de Reorganización Nacional (National Reorganization Process). Breaking with the model of import substitution industrialization that had organized the Argentine economy in previous decades, the Proceso imposed a neoliberal economic model like that which had been

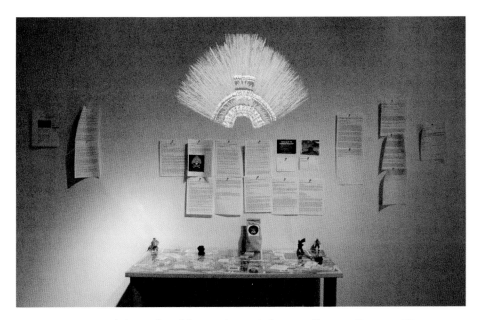

PLATE 1 Fran Ilich, *Raiders of the Lost Crown Archive*, installation in *Resurgent Histories, Insurgent Futures*, Slought Foundation, Philadelphia, 2017. Photograph courtesy of the Slought Foundation.

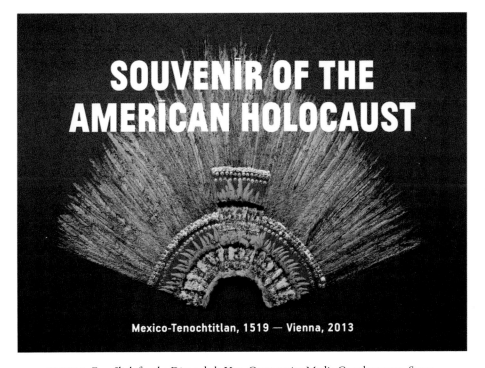

PLATE 2 Fran Ilich for the Diego de la Vega Cooperative Media Conglomerate, *Souvenir of the American Holocaust*, 2013. Postcard, 5.8 × 4.1 inches. Courtesy of Fran Ilich.

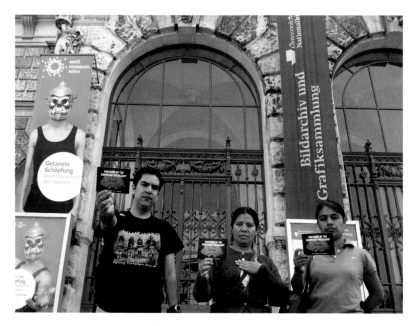

PLATE 3 Intervention for *Raiders of the Lost Crown* with *Souvenir of the American Holocaust* at the Weltsmuseum Wien, Vienna, 2013. Photograph by Alonso Cedillo.

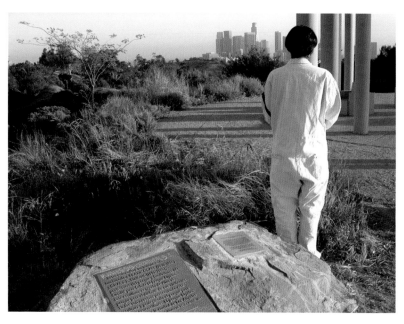

PLATE 4 Pocho Research Society of Erased and Invisible History, *Displacement of the Displaced*, 2002. Site view of guerrilla intervention, Los Angeles, California. Photograph courtesy of Sandra de la Loza.

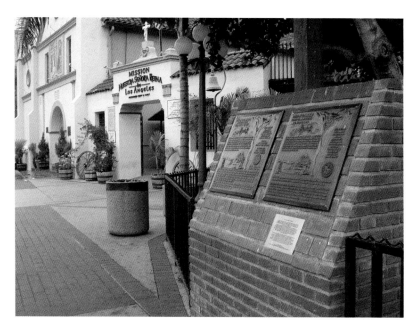

PLATE 5 Pocho Research Society of Erased and Invisible History, *El Otro Ellis, Invisible Monument #1*, 2002. Site view of guerrilla intervention, Los Angeles, California. Photograph by Sandra de la Loza.

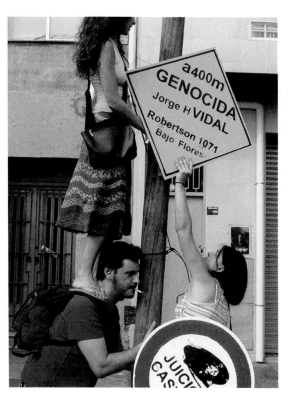

PLATE 6 Members of GAC installing *carteles viales* (street signs) including *Juicio y castigo* (Trial and Punishment) for an escrache of Jorge H. Vidal, Buenos Aires, 2003. Photograph courtesy of Archivo GAC, Grupo de Arte Callejero.

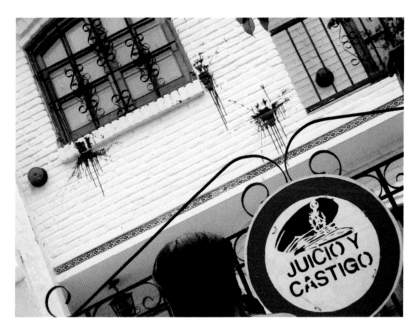

PLATE 7 Grupo de Arte Callejero, *Juicio y castigo* (Trial and Punishment), 1998–ongoing. Photograph courtesy of Archivo GAC, Grupo de Arte Callejero.

PLATE 8 Grupo de Arte Callejero, *Ud. está aquí* (You Are Here), Buenos Aires, 1998. (Translation of text: "You are here. The Camp (or The Thrushes). The clandestine detention center known as The Camp operated here from 1975 until at least 1978. Thousands of persons who form part of the list of the 30,000 disappeared were kidnapped, tortured and assassinated in this extermination camp.") Photograph courtesy of Archivo GAC, Grupo de Arte Callejero.

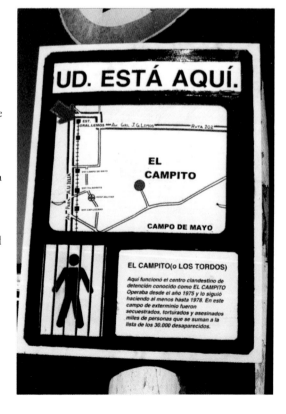

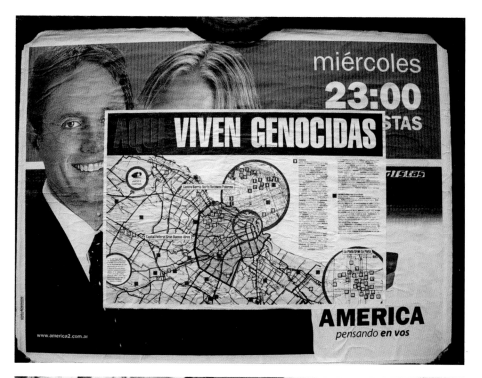

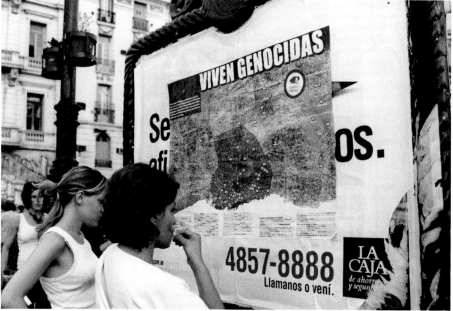

PLATES 9 & 10 Grupo de Arte Callejero, *Aquí viven genocidas* (Genocidists Live Here), guerrilla interventions realized annually in Buenos Aires from 2001 to 2006. Photographs courtesy of Archivo GAC, Grupo de Arte Callejero.

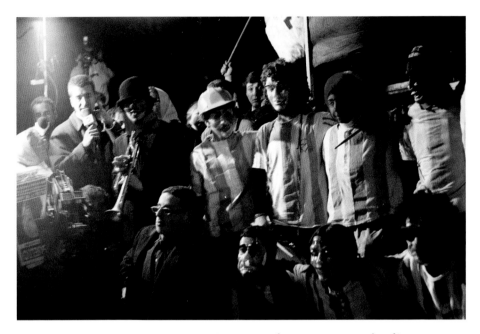

PLATE 11 Etcétera . . . , *Argentina vs. Argentina*, performance in an escrache of Leopoldo Fortunato Galtieri, Buenos Aires, 1998. Photograph courtesy of the Etcétera . . . Archive.

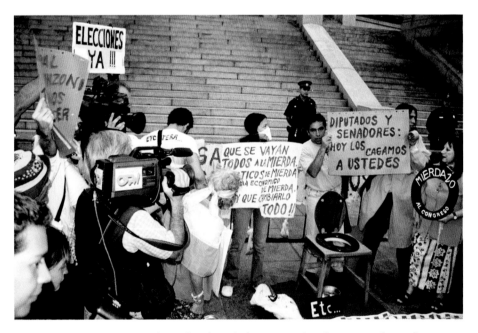

PLATE 12 Etcétera . . . , *El Mierdazo* (Big Shit), protest and performance in front of the Congreso Nacional, Buenos Aires, 2002. Photograph courtesy of the Etcétera . . . Archive.

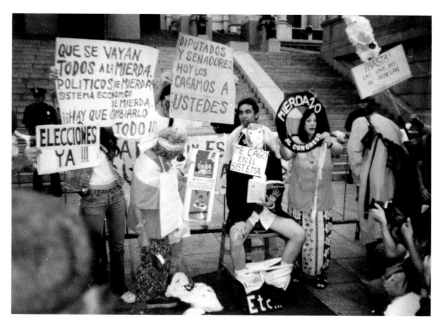

PLATE 13 Etcétera . . . , *El Mierdazo* (Big Shit), protest and performance in front of the Congreso Nacional, Buenos Aires, 2002. Photograph courtesy of the Etcétera . . . Archive.

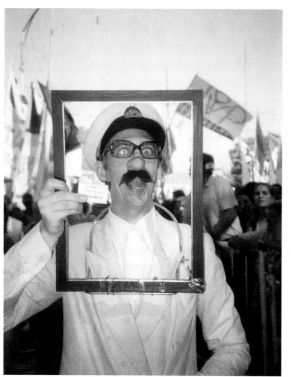

PLATE 14 Etcétera . . . , *Limpieza General* (General Cleaning), performance at the inauguration of the Espacio Memoria y Derechos Humanos (ex-ESMA), Buenos Aires, 2004. Photograph courtesy of the Etcétera . . . Archive.

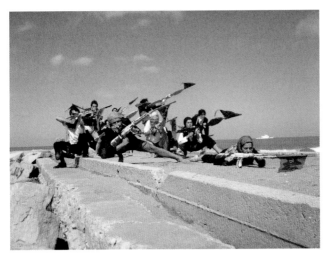

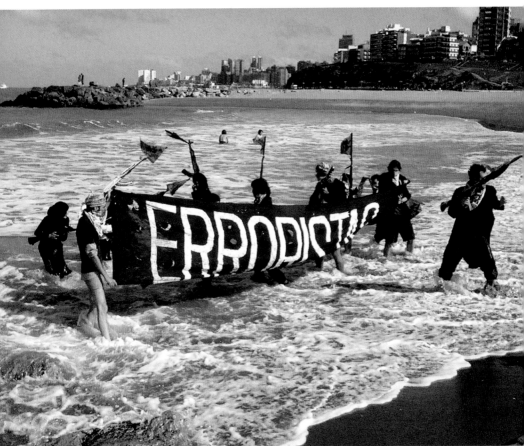

PLATES 15 & 16 Internacional Errorista, *Operación BANG!*, media intervention and performance in Mar del Plata, 2005. Photographs courtesy of the Etcétera . . . Archive.

forced on Chileans by the dictatorship of Augusto Pinochet (also known as the "Chicago School model" for the key role Milton Friedman and his acolytes had in developing and promulgating it).[21] The changes the economy minister of Argentina's military junta celebrated as beginning "a new era" in the country included the depression of wages, the reduction of public employment and formal employment in general, a shift from production for internal markets to export promotion, de-industrialization, and the increase of Argentina's foreign debt and emphasis on financial valorization. These policies produced an unprecedented upward redistribution of wealth at the expense of workers, while the Proceso assailed labor rights and dissolved key unions and prohibited others from taking political action or controlling their own finances.[22] Before he was assassinated by members of the Argentine military, the Left militant and journalist Rodolfo Walsh wrote that this economic program was the greatest atrocity committed by the regime because it "punished millions of human beings through planned misery."[23]

Walsh's statement is all the more striking in light of the brutality with which the Proceso imposed its policies: with training from U.S. and French militaries, the Argentine armed forces and their civilian allies used kidnapping, torture, murder, and forced disappearance against Left militants, labor organizers, social workers, students, and intellectuals in an effort to decimate the Left, break the labor movement, and rid the country of socialist and communist ideologies and practices. State terrorism under the Proceso resulted in the disappearance of approximately thirty thousand people and the exile of thousands more in what is widely recognized as a political genocide.[24]

The U.S. military had trained this and other repressive regimes in Latin America as mandated by its National Security Doctrine, which aimed to consolidate the global hegemony of the United States, discipline labor in its area of influence, and block the growth of Soviet influence.[25] Building on France's strategies of colonial war in Algeria and Indochina, the Doctrine cast a portion of the national population—persons of Leftist political affiliation—as potential "subversives" and enemies of the state who should be systematically annihilated in the name of fighting communism, while also subordinating democratic institutions and political participation to this objective.[26]

While the scale of state violence under the Proceso is unprecedented in the history of the Argentine state, the practice of state terrorism has long been integral to processes of primitive accumulation, colonial conquest and genocide, and the repression of organized labor and the Left.[27] Moreover, the Proceso's total dehumanization of a part of the country's population, which legitimated violence toward those subjects and cultivated the

indifference of others to their suffering, expresses logics foundational to settler colonialism, which has always been intrinsic to the Argentine state's practices of nation-building.[28]

By the time the members of GAC and Etcétera . . . began making art and forming their collectives in the 1990s, the socioeconomic order the Proceso had imposed via authoritarian rule had been made hegemonic with the imprimatur of liberal institutions and civilian rule. The military regime faced mounting popular opposition by the early 1980s,[29] and shortly after its disastrous defeat in the Malvinas War (1983), it called for elections, and elite civilian rule was restored. This was among a series of elite transitions that occurred across Latin America (and elsewhere in the world) in the 1980s and early 1990s. María del Carmen Verdú argues that the reestablishment of constitutional governments in Latin America reflects the fact that the Right-wing dictatorships had achieved their principal goals, and liberal governmentality became a more effective means of class domination. She writes, "The economic politics that the dictatorship hadn't managed to implement would be implemented by a 'presentable' constitutional government, legitimated by its electoral origin, which was made possible only through the physical annihilation of the resistance and the terror imposed on society as a whole."[30] Similarly, William I. Robinson argues that, by the 1980s, as national economies were increasingly integrated into globalized circuits of capital, authoritarianism became increasingly less effective for producing the stability (or governability) desired by the transnational capitalist class. Therefore these elites—and the U.S. state—promoted a transition to a form of elite rule that "performs the function of legitimating existing inequalities, and does so more effectively than authoritarianism."[31] While many refer to this form of rule as "liberal democracy," Robinson convincingly argues against describing as "democratic" a form of governance "in which the participation of the masses is limited to choosing among competing elites in tightly controlled elections."[32] He instead proposes the term "polyarchy" to describe this type of elite rule that works largely through consensual domination, in which "the state is the domain of the dominant classes, while the popular classes are incorporated into civil society under the hegemony of the elite."[33]

The liberal "democratic" (polyarchic) regimes established across Latin America in the 1980s and 1990s dedicated themselves to further integrating their countries into global circuits of capital, while eschewing social democratic aspirations and principles of welfare and social rights.[34] They implemented neoliberal structural adjustment programs oriented toward servicing foreign debt and assuring an attractive environment for global financial

markets, thereby strengthening the power of transnational finance capital over these countries.[35] Following IMF and U.S. Treasury Department guidelines, Argentina's president Carlos Saúl Menem (1989–99) turned the country into a "poster child" of neoliberal economic orthodoxy. Although he was a member of the Peronist Partido Justicialista, which was historically associated with a proletarian base and nationalist and populist politics, Menem quickly revealed himself to be a neoliberal crusader for the ruling class with a penchant for governing by executive decree. His administration's policies massively transferred wealth from labor to local and foreign elites. It liberalized trade, deepened the financialization of the economy, and increased the external debt; it privatized national industries, gutted labor rights, and continued the process of deindustrialization initiated in the 1970s.[36] This produced what Maristella Svampa designates an "exclusionary society," characterized by increased class polarization and a greater concentration of power in the hands of economic and political elites, the defeat of the traditional labor movement, the precaritization of labor and the expulsion of huge sectors of workers from the formal labor force, the immiseration of the popular classes, and the fragmentation of the middle class and downward mobility for large sectors of it.[37] Menem not only pursued largely the same economic agenda as that of the dictatorship; governmentality under his administration is described as "electoral neoauthoritarianism," as it worked within the "authoritarian institutional framework" the dictatorship had set up.[38]

FROM THE CRISIS OF REPRESENTATION TO AUTONOMOUS MOVEMENTS

When I asked members of GAC and Etcétera . . . about their experience as young people living in Buenos Aires in the 1990s, they consistently recalled their total disaffection with state politics. Pablo Ares, who was a member of GAC before cofounding Iconoclasistas, said, "Imagine the 1990s: a total lack of faith in politics. And political parties? The Left had totally lost credibility and Peronism was neoliberal. There was nothing. The breeding ground for 2001 was being created, but we didn't know. . . . We felt alone."[39] In their own words, these artists described what is often referred to as "crises of representation" or "crises of authority" afflicting hegemonic modes of governance in societies subject to neoliberalization. These crises have two objective bases: first, the fact that the neoliberal mode of capitalist accumulation has undermined the material basis by which dominant groups secure legitimacy among subordinated groups, and second, the challenges oppositional forces

have posed to global capitalist hegemony.[40] Writing on Argentine political culture specifically, Pablo Hupert argues that, by the 1990s, the dismantling of the welfare state, decline in productive capital, and eclipse of certain ideologies of citizenship by those oriented to consumption brought into crisis the ideology of political representation that is based on people's "sense of representation" by a state and its functionaries.[41] Federico Zukerfeld, a founding member of Etcétera . . . , succinctly expressed this to me in an interview when he said that in the 1990s he witnessed "an emptying-out of the idea of politics" and people's growing acceptance of "the idea that politicians are a class and also are actors; the idea that it's a show, that it's all a big show."[42]

By the 1990s, many young people in Argentina came to reject political parties and syndicates. Zibechi attributes this to the failure of Left institutions wedded to orthodox perspectives to effectively address the changed labor conditions young people faced, as well as to young people's rejection of vertical forms of organization because they associated these with authoritarianism and patriarchy.[43] This was certainly reflected in my interviews with artists. For example, Carolina Golder, a cofounder of GAC, said that she doesn't participate in political parties because she "doesn't like [their] vertical organization." "It's not that I am against them," she said, "but as a human being I don't like being told what I have to do all the time. I'm more anarchist or more autonomous."[44] Although Ares was part of a Left Latinamericanist party in the 1980s, he said, "Politics was super boring at that time. So moralistic. We went looking elsewhere." Although Peronism was hegemonic in the working-class neighborhood he grew up in, Ares never wanted to be part of a Peronist party. "I'd have to accept a pyramidal structure; they'd impose a political line. I don't like it; I won't do it," he said, adding, "Sometimes I accept orders to make money, but I don't do it for ideology."[45] Speaking about Etcétera . . . , Loreto Garín Guzmán said, "When we became activists at the end of the nineties, for many in Latin America, to be a Left-wing militant was to be boring, an idiot, a jerk. But for us it wasn't that way: we smoked dope, threw parties, danced techno, and constructed many spaces, and we were united."[46] Given their alienation from cultural norms and institutional structures of political parties, these artists sought out spaces and communities where youth culture was not at odds with Left militancy but could instead redefine it.

Young people's disaffection with the traditional politics of parties and state-aligned unions was not necessarily a turn away from politics per se. Some turned to grassroots social movements that had emerged outside of these structures, such as the human rights movement, the student movement,

the unemployed worker movement, and others. Zibechi argues that these movements more effectively organized young people because they practiced a different form of politics, one that organized social relations, collective labor, and decision-making in ways that put into practice the social transformation they aim to bring about.[47] Moreover, these movements publicly affirmed new political subjects that had otherwise been marginalized by institutional politics, such as women, young people, and the unemployed.[48]

In the late 1990s GAC and Etcétera ... both became active in the human rights movement, transforming their practices in the process. Ares's recollection of his first impressions of the human rights organization HIJOS underscores the marked difference between their political praxis and the more traditional forms of militancy with which he had been familiar: "It was like an antipolitics," Ares recalled. "They said it was politics. . . . But it was very new. It was a different concept."[49]

HUMAN RIGHTS POLITICS

The Argentine human rights movement was organized in the 1970s, during the country's most recent dictatorship, to support victims of state repression and their families and to publicly denounce this repression in order to gain support for the struggle against the regime. After the country's transition back to constitutionalism in 1983, the movement carried forward demands that the history of state terrorism and disappearances during the dictatorship be elucidated, that those responsible for it be brought to justice, and that institutional apparatuses be established to more fully protect human rights.[50]

Organizations working against state violence and the protection of political militants existed in Argentina long before the 1970s.[51] What changed in this decade was that a sector of the Latin American Left began to couch their resistance to state repression in the language of human rights. As the spread of authoritarian dictatorships had increasingly closed down the possibilities for Left militancy, ascendant international human rights frameworks offered the possibility of convergence around a purely defensive common cause of defending the physical integrity of those targeted by these regimes.[52]

Its pragmatism notwithstanding, the turn to human rights politics constituted a marked retreat from the robust visions for sociopolitical transformation that had animated Left struggles. With the consolidation of the international human rights regime in the 1970s, human rights politics came to supplant anticolonial and other national revolutionary struggles,

marginalize Left internationalisms, and bolster the global hegemonization of political and economic liberalism.[53] In place of emancipatory struggles' efforts to secure collective self-determination and construct socialist alternatives, human rights promulgated a defensive politics of individual protection against specific forms of state violence, while framing that violence as violations of abstract rights rather than as expressions of class warfare.[54] Moreover, as Williams argues, international human rights politics naturalizes the ways that international law and its execution are deeply shaped by uneven, often imperial relations of power.[55] He and other scholars have shown how human rights has historically been mobilized in opposition to anticolonial liberation struggles and has accommodated, and even championed, imperial and colonial wars.[56]

Robert Meister argues that while human rights culture has been peddled as a means to overcome potentially destabilizing divisions between revolutionary and counterrevolutionary forces in order to secure liberal democracy, it has actually functioned as a "continuation of the counterrevolutionary project by other, less repressive means."[57] This is because human rights frameworks "reassign political responsibility for past injustice from the class that benefited to the individuals who implemented the old regime's policies, thereby functioning to secure the accumulated gains of the beneficiaries of injustice." This functions to marginalize questions of economic justice and political power, substituting for these a moralizing vision of politics.[58] As human rights politics seeks a moral consensus on the past, it operates through a "social compact" wherein a moral victory is seen as sufficient, and future claims that might otherwise follow from this are abjured. As such, "the cost of achieving a moral consensus that the past was evil is to reach a political consensus that the evil is past," Meister argues. The full consequences of such a compact come into view "when we remind ourselves that the 'victims' in the victim/beneficiary distinction are generally a larger and more lasting group than those who were victims of the physical cruelties inflicted by perpetrators."[59] This argument recalls Rodolfo Walsh's assertion that the Proceso's victims were not only the tens of thousands the regime tortured and disappeared but the millions it condemned to "planned misery" through its economic policies. Of course, the effects of these policies outlived the dictatorship itself, and the policies have been extended by postdictatorship governments that pursued a similar neoliberal agenda. Hegemonic human rights discourse works to foreclose the recognition of precisely what Walsh identified as the Proceso's "greatest atrocity" *and* its continuation under constitutional governments.

In Argentina, as elsewhere in the region, the defensive adoption of human rights frameworks as a response to state terrorism had the effect of supplanting revolutionary discourses with a humanitarian narrative that obfuscated the political and economic causes of the violence it denounced and depoliticized the social conflict taking place in the region. As Emilio Crenzel argues, the Marxist understanding of class struggle and the "populist people-oligarchy antimony that had prevailed among radical activists prior to the coup" were displaced by a "defense of the principles of political liberalism."[60] As human rights activists were enjoined to represent those persons they defended as "proper" subjects of human rights, this entailed effacing their political affiliations and any involvement they had in armed struggle.[61]

After the end of the dictatorship in 1983, the application of the human rights measures associated with transitional justice functioned to shore up the authority of the liberal state, promulgate nationalism, naturalize the neoliberal social order, and obliterate the socialist political imaginary that had animated the political struggles of many of the disappeared. As Greg Grandin argues, the truth commission and trial of top military officers publicly solemnized the opposition of law and violence central to liberal ideology and cultivated a notion of liberal citizenship in which the state is understood "not as a potential executor of social justice but as an arbiter of legal disputes and protector of individual rights."[62] The authors of the report by the Argentine truth commission represented "political violence decontextualized from all but the most hazy history and social relations, with a valuation of liberal morals transcendent of those relations."[63] This obfuscated the collective motivation behind the state's violence and effaced the political struggle of its victims, who were "defended as individuals whose human rights had been violated rather than as political activists."[64] Moreover, human rights discourses have misrepresented the anticapitalist struggle of the disappeared as a "struggle for democracy" or resistance to dictatorship.[65]

Luís Mattini, an Argentine intellectual and former leader of the Ejército Revolucionario del Pueblo (People's Revolutionary Army), has criticized the historical erasure of the revolutionary politics of the disappeared by memory discourses. He argues that the positioning of Hebe de Bonafini, the president of the Asociación Madres de Plaza de Mayo, as the spokesperson for the memory of the 1970s has enabled this historical erasure.[66] The Madres' discourse pertaining to the denunciation of war crimes has been granted a "monopoly" on the memory of that epoch, while the memories of surviving militants has been marginalized. As a result, Mattini argues, most discourses on the memory of the 1970s focus on "the memory of death" and fail to

recognize that the ferociousness of the counterrevolutionary violence was a reaction to the strength of the popular movement for revolutionary change.[67]

Cultural productions and memorial sites related to the history of dictatorship in the Southern Cone have also played a role in overwriting revolutionary history with a human rights narrative assimilable to liberal ideology. They have tended to reproduce the liberal humanitarian narratives I have outlined, obfuscating the motives of state violence and depoliticizing the lives of its victims.[68] Because they promulgate a historical aesthetics that instates a radical break between this past and the postdictatorship neoliberal social order, dominant "memory culture" tends to normalize social injustices endemic to the latter.[69]

Even new historical narratives that acknowledge the militant politics of the disappeared have leant themselves to the consolidation of a minimalist, liberal conception of the human rights struggle. As Andrew Rajca has shown, discourses that enshrine the figure of a political militant victimized by political violence under dictatorship as the consummate subject of human rights render invisible the many other forms of social injustice excluded from this paradigm *and* the subjects who suffer these injustices.[70] In short, a focus on authoritarian state violence against political militants helps to insulate human rights discourses from consideration of systemic injustices suffered by the working and popular classes.

In Argentina, the predominant notion of "human rights" refers exclusively to the history of political violence under the last dictatorship.[71] For Verdú, this has been made possible by a failure to analyze state violence within the framework of class struggle, as well as a tendency to define human rights violations based on an idea of the victim rather than through a focus on the state in its repressive capacities as victimizer.[72] In an interview I did with Etcétera . . . member Nancy Garín, whose family was exiled from Chile during the dictatorship of Augusto Pinochet, she observed that this dominant idea of human rights, which focuses "solely on the issue of the disappeared and the idea of political repression during the dictatorship, has had the effect of effacing all the other aspects of human rights."[73] It contributes to the fragmentation and segregation of social struggles that otherwise could be articulated together, as Elizabeth Jelin argues, and prevents the cultivation of a "culture in which human rights could be understood and defended in their broadest sense: including economic, social, and cultural rights, as well as civil and political ones, for individuals as well as collectives."[74]

In summary, dominant human rights discourses promulgated in the wake of Argentina's dictatorship through activism, statecraft, cultural

productions, historical narratives, and practices of memorialization have done the following: (1) bolstered minimalist interpretations of human rights that are largely restricted to the civil and political rights of those who suffered state violence under dictatorship; (2) put under erasure the socialist political imaginary that animated those political struggles that were targeted for extermination by the Right, instead (3) representing this history in ways that shore up the hegemony of economic and political liberalism in general and the postdictatorship neoliberal social order in particular; while (4) representing state terrorism as if it were extraneous and opposed to the "law and order" of the liberal state, thereby rendering invisible the latter's routine violence.

While I have heretofore adumbrated the logics of dominant human rights discourses, this is by no means a comprehensive account of the Argentine human rights movement. The movement has been ideologically heterogeneous from its beginnings, and there have been debates and divergences within it about strategies and tactics, its relation to state institutions, its operative conception of human rights, and the ways in which it should represent the victims of state violence and their political militancy.[75] There are some organizations in the movement that address violence by the postdictatorship state, as well as some that have worked to expand the concept of human rights to also include social and economic rights.[76]

Moreover, the politics of individual organizations are multifaceted and dynamic. This is evident, for example, in the movement's best-known organizations, Asociación Madres de Plaza de Mayo and Madres de Plaza de Mayo Linea Fundadora, which were founded (as a single organization) in 1977 by mothers of disappeared persons. Some scholars have critiqued the Madres for maintaining a limited conception of human rights, moralizing politics, and embracing liberal ideologies.[77] Others emphasize their public denunciations of neoliberal politics and argue that their praxis of popular politics, in which direct action has figured prominently, operates in contradistinction to liberal state politics and the ideologies of political representation it entails.[78] The Madres have had an undeniable influence on younger generations of militants, including organizations that embrace more expansive definitions of human rights, and those, such as HIJOS, that publicly vindicate the revolutionary struggle of the disappeared.[79] HIJOS, whose name is an acronym meaning Children for Identity and Justice against Oblivion and Silence (Hijos e Hijas por la Identidad y la Justicia contra el Olvido y el Silencio), was founded in 1995 by the children of persons whose parents were disappeared, exiled, or imprisoned during Argentina's last dictatorship. Their

organization and its offshoot, Mesa de Escrache Popular (Popular Escrache Roundtable), have emphasized the importance of horizontalism, consensus, and the nondelegation of power in their structure and the centrality of direct action in their activism.[80]

Zibechi situates Madres and HIJOS within a genealogy of movements that made the 2001 uprising possible. These movements are characterized by their communitarian ethos; autonomy from political parties and rejection of bureaucracy;[81] their constituencies of subjects otherwise marginalized by institutional politics, such as women and young persons; their constant tactical use of public space; the expressive character of their forms of social action; and the fact that they do not separate their political objectives from their means of struggle. For Zibechi, this genealogy also includes the unemployed workers' (*piquetero*) movement that emerged in the mid-1990s and the popular assembly movement of the early 2000s.[82]

Zibechi demonstrates how many facets of social movement praxis exceed political discourse and that their effects operate transgenerationally and across different movements. His careful attention to the social relations organized by movements—including those, like the human rights movement, that do not explicitly embrace a class politics—is not meant to marginalize questions of class struggle. Rather, he argues that attention to the social worlds created by various movements helps us see how the "recomposition of the world of workers," which was fragmented by state repression and neoliberalization, has proceeded in many different forms, including forms of political praxis oriented more toward spaces and processes of social reproduction than traditional labor struggles have been.[83]

ESCRACHES

In 1998, both GAC and Etcétera . . . began using their art to participate in exposure protests that are known in Argentina as *escraches* (a word that means "to drag into the light" in the Italianate urban argot Lunfardo). HIJOS had been organizing escraches since 1996 as a means to publicly denounce persons responsible for state terrorism during the last dictatorship.[84] As escraches are a form of popular justice that does not depend on institutions of the state, the human rights movement developed this tactic in response to the Argentine government's policy of impunity for crimes of the Proceso. Although the postdictatorship transition government of Raúl Alfonsín tried and convicted the top officers of the Proceso for human rights violations, Alfonsín shortly thereafter issued executive orders that prevented any further

trials, and by 1990 Menem had pardoned those persons still serving their sentences. Once the Argentine human rights movement was faced with the closure of channels for seeking justice from state institutions, it became increasingly oriented toward bringing about "*social* condemnation" of the perpetrators of state terrorism.[85] Escraches became the key tactic for doing this.

As they are used in the human rights movement, escraches typically begin with grassroots organizing in the neighborhood where the targeted individual lives or works, with the dual aims of exposing the perpetrator's crimes and building a social consensus around the need for justice. Organizers use flyers, posters, murals, radio announcements, door-to-door campaigns, and public meetings to organize the escrache in what GAC has described as an effort to "symbolically corral the *genocida* [genocidist—literally, one who commits genocide]."[86] The escrache culminates in a march through the neighborhood and to the front door of the criminal's home or workplace, which provides the staging for a ritualized performance of collective denunciation. This may include speeches and theatrical actions and it is punctuated by the marking of the perpetrator's home with red paint. The exposure of a genocida's identity is intended to incite others to socially exclude that individual, and cases when the denounced individual is forced to move or loses his job are counted as special victories.[87] Activists describe escraches as a tactic that aims to "turn the neighborhood into a prison" for the targeted individual.[88]

Escraches express the vibrant youth culture embraced by HIJOS and Mesa del Escrache. When I first participated in an escrache, accompanying members of Etcétera . . . , I was immediately struck by its energy, which was largely upbeat and even festive. Young people mixed with members of the Madres and Abuelas (Grandmothers) de Plaza de Mayo. Popular art forms did a great deal to shape the tenor of the collective action: people graffitied political messages onto the walls of buildings they passed; there was music, *murgas* (a popular form of street performance that combines percussion-laden music, theater, and dance), and pogo-style dancing to lively protest songs. A chant heard in this and other escraches likens the Argentine genocidas to Nazis and affirms the movement's ability to pursue and expose them: "Como a los Nazis, les va a pasar, adonde vayan los iremos a buscar!" (Just like the Nazis, it will happen to you; wherever you go we'll go after you!)

While escraches have effectively functioned as a tactic for pressuring the state to prosecute and punish war criminals, they are a form of popular justice not reducible to state-centric conceptions of politics or to the rights-based and representational logics of liberalism. They are a form of nonrepresentational politics, where representation is understood as the delegation

of power, as well as an ideology of politics that would separate a political "content" from the act that expresses it.[89] An escrache derives its legitimacy as an act of justice from a social consensus, not from a law or a moral dictum; as a form of popular justice and direct action, its social force is immanent to its realization.[90] In contraposition to the juridical character of liberal human rights politics, escraches imply a collective subject that regulates its own ethical community and recognizes its own criteria of justice, including in opposition to the state's law. Zibechi argues that the importance of this and other forms of direct action for the grassroots Argentine human rights movement is linked to its orientation toward nondelegatory politics, horizontalism, and its distance from the mediations of political representation.[91] His analysis homes in on the politics operative in movements' forms of social action and organization, which cannot be reduced to their discourses or a means–ends approach to tactics.

Adopting a similar approach, Santiago García Navarro argues that escraches are "expressive systems" that connect, by giving a collective form to, "a search that is already taking place" in other minds and bodies. The social relationality this implies, which is different from forms of expression in which a pregiven content is communicated unidirectionally, makes escraches into aesthetic correspondents to the "nonrepresentative" politics of the human rights movement.[92] García Navarro's analysis suggests that an understanding of the cultural politics of an expressive practice vis-à-vis a movement of which it is part lies not only in the content it communicates but also in the relation between the social relations its production entails and the forms of relationality the movement strives to organize.

GAC and Etcétera . . . began creating art in escraches in 1998. As Ana Longoni writes, their works "were, at first, completely invisible in the art field as 'art actions' while, in turn, they provided an undeniable identity and social visibility to escraches, contributing to [escraches] being perceived as a new form of struggle against impunity."[93] Their art did not simply represent or give visibility to an already constituted political action. Rather, it participated in the very constitution of escraches and worked to shape their social meaning.

GAC'S COUNTERMAPPING OF URBAN SPACE

GAC works from the need to create a space in which the artistic and the political form part of the same mechanism of production. —Grupo de Arte Callejero, "Grupo de Arte Callejero" (2003)

GAC's guerrilla urban interventions suggest something like a temporary malfunction in the dominant visual coding of public space, such that the historical scaffolding of the present, otherwise invisible, suddenly announces itself. In the spirit of Situationist détournement and culture jamming, GAC mimics the ways in which corporations and the state impose meanings on public spaces and organize movement within them through representations such as signage, maps, and advertisements. GAC mimics these visual forms and modes of circulation in guerrilla interventions that highlight the ways in which state violence is materially constitutive of the present sociospatial order. By visually marking sites where clandestine torture-detention centers once operated and where the perpetrators of state violence live and work, their works contribute to what Diana Taylor has characterized as the human rights movement's "alternative map[ping] of Argentina's socio-historical space."[94] By citing ubiquitous forms of state and commercial signage through their mimicry of them, GAC calls attention to the ways that our quotidian perceptions of urban space have already been molded by and been made functional for a hegemonic aesthetics of history, one that effaces the brutalities of class warfare from above that shape the contemporary sociospatial order. While the state's urban signage asserts its control over public space and the movement of bodies within it, GAC's signs encourage a spatial practice that not only defies this administered spatial order but also displaces the state's centrality as arbiter of social relations.

Unlike forms of memorialization that bear witness to past violence in order to affirm its being *past*, GAC's interventions make visible the ways histories of state violence have a continued material presence in social spaces and practices of the present. In so doing, they challenge the periodizing aesthetics of history and violence discussed earlier. In particular, their interventions mark continuities between the repression the Proceso carried out in the name of "national security" and the neoliberal state's violence toward those it treats as the nation's new "internal enemies"—namely, the often racialized, urban poor.

Founding members of GAC situate their group's origins in 1997, when they formed as a group to enact their solidarity with the teachers' movement. This movement protested Menem's reforms to the national education system, which included the slashing of budgets for public universities, while articulating a broader rejection of his regime's neoliberal economic policies. As GAC members explain, "Most of us in the group were students in our final years of the teaching degree program in Fine Arts [at the Prilidiano Pueyrredón National Fine Arts School] and, having been formed in a program

of teaching and visual arts, we felt directly affected by the concrete problems in education." Moreover, they note that witnessing "the grave effects of the implementation of the neoliberal model" impelled them to develop an activist art practice. They saw that the teachers' struggle, as well as people's antagonism to it, revealed "the tip of the iceberg of a larger conflict facing a society that, in general, had been supporting the neoliberal politics of the epoch."[95] With the intention of "intervening in public space with visual tools" to show support for the teachers' hunger strike, the artists painted more than thirty protest murals throughout Buenos Aires, a series titled *Docentes ayunando* (Teachers on Hunger Strike; 1997). This experience initiated the artists into a guerrilla and collective mode of art production, which would come to characterize GAC's practice thereafter.[96]

STREET SIGNS

GAC's involvement in the human rights movement, beginning in 1998, definitively shaped the group's artistic production.[97] They began producing guerrilla urban interventions, installing their own signs in public spaces to facilitate the organization of escraches. GAC's *Carteles viales* (Street Signs; 1998–ongoing) mimic official traffic signage. They are stenciled or screen-printed with synthetic enamel in the style of industrial graphic design and installed on lampposts (plate 6).[98] They adapt traffic signs' formal conventions for indicating the distance between their viewer and a destination to direct people to the home of the person being denounced in an escrache. Appearing as a kind of interference in the visual signage people normally see along their daily routes, GAC's *Carteles* address persons who are participating in an escrache or who are simply going about their quotidian activities in the city.[99]

GAC customizes their signs to indicate the identity and crimes of each person being denounced (figure 3.1). Some include screen-printed photographic images of the face of the person; others use graphics to indicate the nature of the perpetrator's crimes. As these signs expose the actions of specific individuals, they also familiarize the social identity of the genocida as a category of persons presently living in the neighborhood or city, insisting that this genocide is not a "closed chapter" of the past.

In a 2002 escrache, GAC's signs posited the social identity of the *genocida económica* (economic genocidist) to denounce Roberto Alemann, an economist, academic, bank lobbyist, and publisher who served as secretary of the treasury and national minister of the economy during the dictatorship

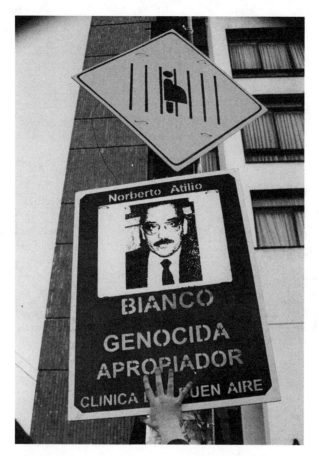

3.1 Grupo de Arte Callejero, *Carteles viales* (Street Signs) for an escrache of Norberto Atilio Bianco, Buenos Aires, 1999. Photograph courtesy of Archivo GAC, Grupo de Arte Callejero.

(figure 3.2). By referring to Alemann with the same moniker used to denounce those persons involved in recognized human rights violations, GAC's sign asserts the culpability of the civilian accomplices of the Proceso and contends that the regime's economic project is as much deserving of social condemnation as its campaigns of torture and disappearance.

GAC has also created protest signage and long-lasting guerrilla installations in public space that feature its best-known graphic design, *Juicio y castigo* (Trial and Punishment). They created the design in collaboration with members of HIJOS. The latter suggested the slogan *juicio y castigo*, which refers to the demand that those responsible for state terrorism be subjected

Reframing Violence and Justice

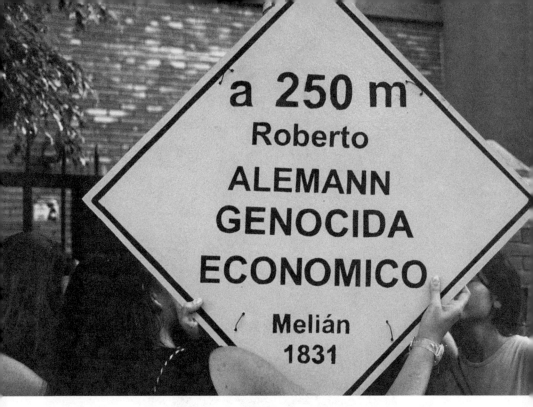

3.2 Grupo de Arte Callejero, *Cartel vial* (Street Sign) for an escrache of Roberto Alemann, Buenos Aires, 2002. Photograph courtesy of Archivo GAC, Grupo de Arte Callejero.

to retributive justice.[100] GAC produced a bold graphic to accompany the phrase that makes clear precisely *who* should be tried and punished: a white circle bordered in red evokes a bull's eye; at its center is an image of a military officer's cap (plate 7). This design became a mainstay in escraches and an iconic symbol of the human rights movement, circulating widely beyond GAC's own use of it.

In their artistic contributions to escraches, GAC has also mimicked other quotidian visual forms that circulate in public space. In 2001 they collaborated with Mesa de Escrache Popular to organize a publicity campaign against Metrovías, the private company that owns the Buenos Aires subway system, and to denounce its chief of security, Miguel Angel Rovira. To do this, they infiltrated the infrastructure of the subway system with graphic signage that mimicked Metrovías's own. They created thousands of copies of an *Escrache Pass*, which looked like real subway passes but bore the likeness of Rovira and announced the upcoming escrache against him. GAC's stickers, placed throughout the stations and subway cars, mimicked the subway

company's informational signage but instead included the following text (translated here):

GENOCIDA MIGUEL ANGEL ROVIRA

One of the leaders of the Triple A, a parapolice organization that assassinated more than 2,000 persons in the three years prior to the 1976 coup d'état.

Security Chief for Metrovías

The following year, GAC created another work that focused on a genocida who was currently employed by the private security industry. The signs they created to denounce Luís Donocik and announce the escrache against him mimicked the signage of private security companies that is ubiquitous in affluent parts of Buenos Aires: bright yellow signs that feature a silhouette of a security guard and the word *conectada* (connected), which indicates that the building on or near which the signs appear has a security system connected to the central monitoring system of a private security company (figure 3.3). In their own version, GAC rerouted the meaning of "connected" to point out the material and ideological connections between the repressive apparatus of the Proceso and the private security industry that has boomed in Argentina since the 1990s. Beneath the word *conectado* GAC printed:

1976: Doctrina de Seguridad Nacional [National Security Doctrine]
2002: Seguridad Privada [Private Security]

This was followed by a brief chronology of Donocik's employment since the 1970s. It began with the clandestine torture centers in which he had worked as a police commissioner during the dictatorship, continued with his police work in the 1990s, and closed with the name of the private security company for which he currently worked, as well as the logos of the multinational corporations in Buenos Aires that contract that company. It also included Donocik's home address.

In addition to denouncing individuals, GAC's contributions to the escraches of Rovira and Donocik underscore the porosity between the state and private sector in organizing repression. Indeed, the Argentine state uses private gangs (known as *patotas*) to perform extraofficial repression, which it generally directs against organized workers, Left militants, and students.[101] As Verdú notes, this "subcontracting" of repression allows the state to evade responsibility for repression it organized, and it is regularly aided in this regard by the corporate media. She also notes that employees of private

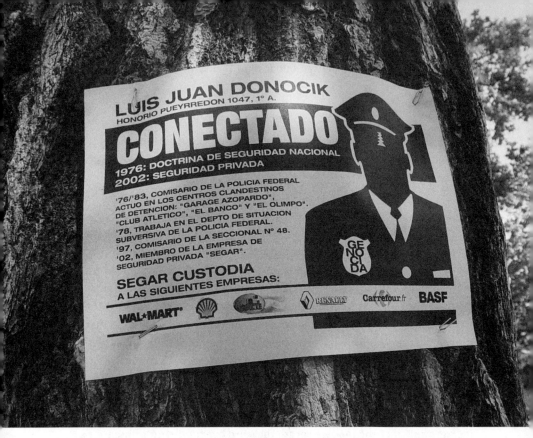

3.3 Grupo de Arte Callejero, *Conectado* (Connected) for an escrache of Luis Juan Donocik, 2002. Photograph courtesy of Archivo GAC, Grupo de Arte Callejero.

security agencies are also enlisted to "carry out the role of their official peers" in repressing workers involved in labor conflicts.[102]

Conectado defamiliarizes the security ideology that associates increased policing and surveillance with citizens' "security" by reframing one of its familiar indices with reference to the horrifying repression that has been carried out in its name. Moreover, this work suggests that the historical emergence of the contemporary securitized metropolis (the "fortress city," to use GAC's term), which is a hallmark of neoliberal restructuring and expression of class warfare from above, was materially dependent upon the violent repression of the working class and organized Left.[103]

Sociopolitical conflict is always already spatial conflict, and Argentina's neoliberalization has always been a spatial project of and for its ruling class. This was evidenced during the last dictatorship by the intense policing of public and private space, the construction of hundreds of clandestine

concentration camps, the razing of slums as a counterinsurgency measure, and elimination of rent control, while urban spatial production in the 1990s entailed the creation of new shopping and tourist districts and fortress-like suburban gated communities (*countries*) for the wealthy, the privatization and subsequent dismantling of national transportation infrastructure, and the growth and militarization of urban slums.[104] As I argued in the previous chapter, the aesthetics of history is necessarily bound up with the aesthetics of space. Dominant ideologies work at this intersection through histories that naturalize the spatial production of the powerful, making it seem natural or historically inevitable, while rendering invisible the social conflict upon which it is built. State historical narratives pertaining to the Proceso, which attempt to bury its consequences in the past through stagist narratives of Transition, work to naturalize the neoliberal social order, including those spatial forms it has produced.

GAC's hijacking of the aesthetics of state signage to make visible histories the state has attempted to bury underscores the ways in which battles over history are also played out as battles over perceptions of space, including the possibility of perceiving its historical constitution. Because GAC's signs represent material histories and living agents of the Process as part of the quotidian reality of the present-day city, they suggest that the neoliberal city, its class order, and the spatial organization that flows from this are built on the political violence they mark out.

MAPS

GAC has produced signs featuring maps that identify the otherwise unmarked sites of former clandestine prisons (plate 8). Their style mimics street maps that direct pedestrians to commercial and tourist attractions by indicating the viewer-pedestrian's location on the map with an arrow and the phrase "*Ud. está aquí*" (You are here). GAC's signs do not memorialize these as historical sites that pertain to the past nor suggest that they are exceptional spaces within the urban landscape. Rather, by using the form of a quotidian street map, GAC situates the history of clandestine prisons within the everyday sociospatial order of the present-day city. This is emphasized by the way the maps index their viewers' location within their abstract representation of space ("You are here"), which asserts that the space-time to which they are referring is the present. Moreover, the maps' quotidian, commercial aesthetic suggests that the infrastructure of state violence to which they refer is somehow normalized—that is, that

this past political violence has been structurally preserved in the city's present sociospatial order.

From 2001 to 2006, GAC produced maps of the city of Buenos Aires that provide a potent visual representation of the presence in the city of unpunished genocidists. Titled *Aquí viven genocidas*, meaning "Genocidists live here," the maps display the names, crimes, and home addresses of all the persons the human rights movement had denounced with escraches up to the time of each map's production (plates 9 and 10). GAC updated these maps annually and posted them in public spaces in the city. The maps participate in the human rights movement's practice of popular justice by publicly exposing and denouncing genocidists. Like escraches, they deny them social anonymity and the possibility of disassociating their public identities from their crimes.

GAC's maps provide a temporal framing of the history of state terror that counters the representational borders state narratives erect between a dictatorial past and a nominally democratic present. In their use of the spatializing visual abstractions of cartography, the maps represent present-day Buenos Aires as a space suffused with a material history of state terrorism, as exemplified, in particular, by the living presence of its unpunished agents (many of whom, the maps show, live in the metropolis's most elite neighborhoods). Whereas state narratives mobilize linear representations of time and progressivist ideologies of history to represent systematic state violence as a past phenomenon, GAC's maps represent the legacies of state terror as belonging to the same time-space formation as the present-day city their viewers inhabit. They give a spatial anchoring to bearers of a contemporary social identity, genocidas, which the state has attempted to disavow and erase through its policies of impunity, while their use of the present tense and the indexical "here" (*aquí*) gives the political and ethical questions raised by the presence of genocidas a spatial and temporal immediacy.

GAC's maps insert their viewers into a collective history in a way that implores them to take a position and, potentially, take action vis-à-vis this history and the presence of genocidas in their city. They address viewers on the city's streets, persons who would identify in the space they also inhabit the indexical "here" that appears in the maps' title. This translates the history of state terrorism and the implications of impunity to a spatial register and scale in which quotidian experiences of urban space are also apprehended rather than leaving these as abstract, placeless histories. In so doing, it emphasizes that a social tolerance for state terrorism and authoritarianism, which is enforced by policies of impunity, means that city dwellers must live

among persons who have never been held to account for committing geno-
cidal violence.

Notably, these maps call upon people to take a political and ethical posi-
tion vis-à-vis the history of state terror and its perpetrators. They do not
hail their viewers as citizens or through a discourse about the state. Rather,
they address them as inhabitants of a shared social space and shared his-
tory, while highlighting the popular form of justice practiced by HIJOS.
Like other practices within the human rights movement that incite a social
condemnation of genocidists through their public exposure, the maps both
constitute and encourage a practice of direct action that articulates a popu-
lar conception of justice not dependent on the state, its laws, or ideologies
of representation.

THE POLITICS OF PRODUCTION AND CIRCULATION

GAC's art demonstrates how the politics of aesthetic practices manifest in
these practices' social life, which includes their production, circulation, and
reception, or what Gabriel Rockhill theorizes as their "social politicity."[105]
For instance, their collaboration with human rights organizations extends
to collaborative artistic production, as in the case of their *Juicio y castigo*
design. GAC rejects the intellectual property regimes and individualist at-
titudes toward authorship that dominate institutionalized art practice, and
circulates their work in ways that amount to the renunciation, in large part,
of its being classified and valued as fine art. The majority of their interven-
tions are anonymous insofar as there is no mark of authorship on the objects.
This "emphasizes the ambiguity of their origin" such that they could be seen
as "deviations" within the state's own signage, the artists suggest.[106] They have
also said that they hope the lack of signs of authorship may encourage others
to create their own interventions.[107] Their rejection of proprietary attitudes
allows GAC to socialize their art production. They have written, "We foment
the re-appropriation of our work and their methodologies by groups or indi-
viduals with similar interests as ours."[108]

The lack of marks of authorship is related to what Stephen Wright has
described as GAC's works' "impaired visibility as art."[109] Documentation of
their work circulates in arts institutions and art critical writing. However,
all told, this is a minor aspect of their work's social life, and not one that
provides significant financial remuneration for the producers (all of whom
sell their labor power in other ways). Their works' initial instantiations as
anonymous guerrilla interventions in public space lack a signal system that

would indicate that they are artworks. Wright argues that this supports their political efficacy because it functions as a bulwark against the overcoding of their use-value (in a Marxist sense) by the symbolic capital associated with works of fine art.[110] What is of interest to me here is not that GAC's art often passes unperceived as fine art, as this would presume that their practice has an essence that transcends its social inscription. Rather, I want to point out that they have shaped the production, circulation, and reception of their art so that it can be integrated into collective social movement praxis, and doing so has meant detaching their art practice from certain conventions that are used to socially identify and valorize works of art. For instance, by eschewing proprietary attitudes toward their work, GAC has allowed it to freely circulate across different social movement contexts. This has imbued the work with new meanings and ultimately contributed to a more comprehensive critique of state violence beyond a sole focus on the dictatorship.

In 2002 Buenos Aires–based sectors of the movement of unemployed workers used GAC's *Juicio y castigo* signs in escraches that denounced police repression against their movement. Also known as the *piquetero* (picketer) movement, this social movement first emerged in the Argentine provinces in the mid-1990s in resistance to the massive unemployment and poverty produced by the neoliberal restructuring of the national economy, including privatization of national industries. *Piquetero* is a neologism derived from *piquete* and refers to their tactical use of pickets to block roads in order to interrupt the circulation of goods.[111] This tactic served to give national visibility and political leverage to a profoundly marginalized sector of the working class that had been surplussed by neoliberalization.

In the early 2000s, the state increasingly repressed the piquetero movement and the corporate media waged an ideological crusade against them.[112] In July 2002, police officers attacked protesting piqueteros in Buenos Aires and assassinated two of the movement's leaders, Maximiliano Kosteki and Darío Santillán.[113] GAC created signage for an escrache against the commissary where the police who killed the activists worked. The artists produced street signs featuring the slogan "*Policía asesina*" (Murderous police) and protestors also took up GAC's iconic *Juicio y castigo* signs, resignifying them through their circulation (figure 3.4).

This circulation of designs originally popularized by the human rights movement to denounce crimes of the Proceso powerfully reworks their anti-authoritarian symbolism. It frames police repression of piqueteros as part of a longer history of state violence against workers and antisystemic movements, tracing the historical connection between state terrorism in

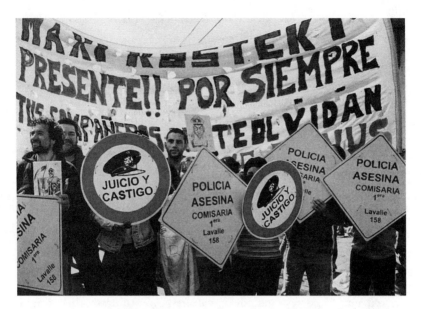

3.4 Grupo de Arte Callejero, *Carteles viales* (Street Signs) and *Juicio y castigo* (Trial and Punishment) in an escrache of Avellaneda police station, Buenos Aires, 2002. Photograph courtesy of Archivo GAC, Grupo de Arte Callejero.

the 1970s and the police violence used to repress a contemporary workers' movement. The Argentine state and corporate media's demonization of piqueteros worked to make the political stakes of their movement illegible by casting their forms of social action as signs of disorder and insecurity, thereby legitimating repression of them as a restoration of citizens' "security." In this context, the way GAC's signs mobilize symbolism that refers to uses of state violence for the purpose of exterminating political opponents reveals the *political* motives behind the neoliberal state's repression of piqueteros. As GAC's work resolutely counters the notion that politically motivated state violence is unique to authoritarian regimes, it reveals it instead to be a constitutive feature of (neo)liberal governance and an expression of the state's function to crush antisystemic challenges to the capitalist social order.

ETCÉTERA...

Negation was the origin of our movement's becoming. Negation as a response in the face of a corrupt world in decay, repudiation of governments of decadent morals, . . . of stereotypes and clichés of all types, of capitalism's violence as a system.

—Grupo Etcétera..., in Loreto Garín Guzmán and Federico Zukerfeld, Etcé-
tera...Etcétera...*(2016)*

The trans- and paradisciplinary art practice of Etcétera...is marked by its
anticapitalist and antinationalist social critique, gleeful iconoclasm, black
humor, and surrealist sensibility. To describe the collective desires around
which they formed as a group, they write, "We wanted to take art to the
streets, to the contexts of social conflict, as well as displace those social con-
flicts to those spaces that had remained silenced: the cultural institutions,
mass media, and the mega-events of the culture industries." Much of their
work is performative, emerging from the artists' formative collective self-
education in theater, while also integrating the literary and visual arts. It has
taken the forms of street theater, guerrilla performances in political and cul-
tural events, poetic manifestos, videos, media interventions, and transmedial
narratives that unfold across multiple mediums.

Etcétera...was formed in 1997 by principally self-taught artists of
theater, music, poetry, and the visual arts. According to their origin
story, the group emerged from the street culture of downtown Buenos
Aires of the 1990s, which they describe as a "circus" where "tourists and
street vendors mixed with café intellectuals and marginal artists, artisans,
hippies and punks with dealers and psychoanalysts, in a fauna of vaga-
bonds, nomads and drifters."[114] Their initial experience in collective ar-
tistic creation was the Encuentro Permanente de Creadores (Permanent
Gathering of Creators), which created improvised guerrilla performances
throughout the city. This experience led to the formation of Etcétera...
and a larger network of artists who would occasionally collaborate with
the group.[115]

Etcétera...identifies two important influences on their formation.
First, their militancy in the human rights movement and, in particular,
their collaboration with HIJOS in planning and executing escraches, and
second, their collective self-education and artistic experimentation that
was made possible by squatting an abandoned house and creating their
own artistic laboratory and theater, Teatro Antonin Artaud, in it. This lat-
ter experience was also an object lesson in objective chance, as the home
they squatted was still filled with the printing press, books, art, and other
belongings of its former inhabitant, the surrealist artist Juan Andralis.
Squatting this space led to the group's self-education in surrealist thought
and aesthetics and proved, they write, that "not respecting private prop-
erty can lead to a revelation."[116] The formative influence of surrealism is

evidenced in Etcétera . . .'s nonnaturalistic aesthetics, their use of artistic strategies to explore the terrain of the unconscious, and their coupling of revolutionary thought with poetic language. I see their work as a contribution to the tradition of Leftist surrealism and as *sur*realist, meaning a Brechtian realism of the South.

While having maintained their autonomy vis-à-vis political parties and other political organizations, Etcétera . . . claims Left militancy as an underlying ethos for their practice. As Federico Zukerfeld has said, "The militant subject is basic for us. The basis of a militant attitude is, first, the commitment to the cause; second, solidarity; third, to value your colleague as yourself because you're struggling for a collective way out; fourth, coherence; fifth, to fight for large-scale change, not only small-scale."[117] They situate themselves within an internationalist anticapitalist (and non-Peronist) Left. Describing the group's ideological alignments to me in an interview, Nancy Garín noted that she comes from a more Leninist formation, while social anarchism and Trotskyism are also key touchstones for other members: "We come from various sides, but Marxism is a fundamental base for all of us— that is, as a tool for reading reality. Not as a bible, but as a means to analyze the world."[118] The group roundly rejects orthodoxy in political ideology and practice, and they embrace a capacious liberationist politics as this concerns work, art, and social relations.

Garín used the metaphor of a "hinge" to describe the group's political ideologies as they are inflected by their generational relationship to the Left of the 1960s and 1970s. "On one hand," she said, Etcétera . . . "maintain[s] the tradition of political struggle of our parents' generation," but, at the same time, they are very critical of it (*not* reactive, she emphasized). Specifically, they are critical of that earlier generation of the Left for its "dogmatic character" and for "not having taken on a series of other struggles that were part of, and necessary to, the Left's struggle," such as those pertaining to gender and sexuality. They are also critical of the ways parts of this Left have taken up a narrative that "ends up accepting defeat and definitively giving themselves over to the new order." Garín insisted, however, "[While] we are very critical [of the earlier generation], we ally ourselves with them." "We need their political legacy. I think that that has been a fundamental aspect of Etcétera . . .'s discursive production. We make a formal critique of those forms of aesthetic production of the Left, but we don't reject them."[119]

To critique the solemnity and austerity often associated with Left political militancy, Etcétera . . . takes up symbols and aesthetic expressions associated with the revolutionary Left with a complicit playfulness that is, at once,

a means of desacralization and also a gesture of identification and vindication. As Loreto Garín Guzmán, one of the group's founding members (and sister of Nancy Garín) has described this:

> We felt that part of our role was to generate that self-criticism in order to attract others. The strategy that has to be followed, we said, is to not abandon the flags, the pamphlets, the megaphone, the figure of the leader, but we are going to question them. And the best way of questioning them is to use them, alter them. The problem was the seriousness, solemnity, and monumentality of the old discourses. We also recovered surrealism, thus, we could never generate an idea of the poor or worker as socialist realism does.[120]

Etcétera . . .'s critique of discourses and aesthetics of the Left falls within the Left's tradition of self-critique, and the artists understand it to be part of the work of maintaining the vitality of Left cultures.

In the late 1990s and early 2000s, Etcétera . . . created works of street theater within escraches. These were examples of "tactical performance," understood as "the use of performance techniques, tactics, and aesthetics in social movement campaigns."[121] In an interview I did with members of the group in 2006, they described their Escrache Theater as a tool for movement-building that "functioned as a bridge, as a trampoline, as a catalyst for the protest."[122] Zukerfeld described its function as producing representations useful for the human rights movement:

> We began collaborating with HIJOS, participating in the escraches in a manner in which the function of the supporting artistic groups was to give visibility . . . to the demonstration: on the one hand, to bring more people to the protest or the demonstration, but on the other hand, to construct an image. In the beginning, we had to be functional, in a certain sense, because we were organic—that is, we went to all of the meetings with the other militants. The artists had a very pragmatic function, which was to illustrate with examples, let's say "to show." That's why we used certain characters, like the military officer and the character of the priest, and what we did was show what these people did during the military dictatorship.[123]

To "illustrate" or "give visibility" to a history or political cause is, of course, never a neutral or transparent operation. In producing representations within, for, and about the human rights movement, Etcétera . . . puts forth particular political narratives about it, and about the history of the dictatorship and its relevance in the present. As they articulate their art with escraches, they

also assert specific conceptualizations of the political significance of this act. The artists do not simply support the escrache with their art; they use the escrache as material support (insofar as it organizes audiences and possible participants) to interpolate others into the worldviews their art materializes. As such, their theater has a dialectical relationship to the social actions of the human rights movement in which it is embedded, and it is through this relationship that it participates in collective struggle over defining the meaning and scope of the movement.

ARGENTINA VS. ARGENTINA

A performance Etcetera... created with members of HIJOS as part of a 1998 escrache demonstrates how they advance a more radical vision for the human rights struggle, one that refuses to memorialize the disappeared as victims (the paradigmatic subjects of hegemonic human rights discourse) but instead vindicates their Left political struggle as a living presence that is carried forward by others in the present. The performance, which they titled *Argentina vs. Argentina*, also makes a sharp critique of nationalist ideologies by showing how they are used to both incite and whitewash the brutalities of class war. The performance frames the escrache as a convocation of a collective subject that defines and regulates its own community in explicit rejection of the state's nationalist hailings, including calls for postdictatorship "national reconciliation."

The escrache for which Etcétera... and HIJOS performed *Argentina vs. Argentina* denounced Gen. Leopoldo Galtieri, the penultimate de facto president (1981–82) of the last dictatorship and leader of an anticommunist death squad and intelligence unit that operated in Argentina and internationally. In 1982, as Argentina was in the midst of a severe recession and the military regime was facing increasingly militant resistance from workers, Galtieri and his regime launched a military invasion of the Malvinas/Falkland Islands, which have been a colony of Great Britain's since it seized the archipelago from Argentina in 1833.[124] This was a bald effort to stoke patriotic sentiment, relegitimize the state and the capitalist class fractions that controlled it, and transform the image of Argentina's armed forces into heroes of the nation rather than agents of oppression.[125] It was accompanied by a massive propaganda campaign, and the desired effect was achieved, at first.[126] However, the poorly equipped and unprepared Argentine armed forces were quickly defeated by the British navy, resulting in the deaths of nearly seven hundred mostly conscripted Argentines. The humiliating de-

feat thwarted the junta's "project of establishing 'national unity' behind a nationalist current of its own making" and severely weakened its hold on state power.[127]

The theatrical performance HIJOS and Etcétera . . . created in the escrache of Galtieri alluded to the war between Argentina and the United Kingdom through its allegorization of war as a soccer match. This was supported by the escrache's felicitous timing. It took place just days before Argentina would compete against England—a long-standing soccer rival—in the quarter-finals for the FIFA World Cup. Etcétera . . .'s performance used a soccer match as a multivalent allegory wherein the nationalist sentiments associated with this popular sport were interwoven with references to histories of war and political genocide and the use of nationalist discourses in these contexts.

Argentina vs. Argentina took place in the culmination of the escrache, when the protestors were gathered in front of the apartment building where Galtieri lived, which was guarded by police and their metal barricades. In Etcétera . . .'s video documentation of the performance, the performer-activists are surrounded by the crowd of protestors. The performance begins when Zukerfeld, playing a clown emcee, addresses the crowd: "On this beautiful June night, the final match will be played, and with our satellite it will reach the whole world: Argentina versus Argentina!"[128] After squawking out a few painful notes on a trumpet, accompanied by another performers' haphazard playing of a snare drum, the clown crows, "Let the team come out!" The "players" enter while others chant "Ar-gen-tina! Ar-gen-tina!," as is typical in soccer games. All the players are wearing the iconic jersey of the Argentine national soccer team, along with eerie transparent masks and hard hats (plate 11). A military officer (El Militar), played by Federico Langer, then takes center stage. El Militar is a stock character that appears throughout Etcétera . . .'s performances to represent military officers as a social position, as well as to evoke specific officers as needed in each performance. In this performance, he first appears as Galtieri in his role as instigator of the war with England. He addresses the crowd with a bombastic speech that parodies the performance of valiant and determined masculinity as nationalist hailing: "We are about to start the war! We have to get the islands back! We have the church on our side! We have God on our side!" An actor dressed as a priest joins him and addresses the crowd in the patronizing tone of a bourgeois patriarch, saying, "Argentine youth, Argentine community: we are gathered here to defend the national territory." Becoming more pugnacious, he concludes, "If they want a battle, we'll give it to them!," which is echoed by a similarly cocky taunt-cum–war cry from El Militar. All of the performers

immediately erupt into a chant regularly sung at national soccer games, whose lyrics begin, "*Vamos, vamos Argentina! Vamos, vamos a ganar!*" (Let's go, let's go Argentina! We're going, we're going to win!) At this point, the concoction of bellicose masculinity, nationalist fervor, and nationalist identification operating through the personification of conflict (as if it reduces to the psychology of personal rivalries) seems to be interchangeably applied to both the war and the soccer match.

The game begins. As the "players" kick the ball between them, one of them is knocked down and left sprawled on the asphalt. The Military Officer yells, "Hide it! Hide his fall!," and other performers quickly remove the fallen player on a stretcher, in an allusion to the junta's covering up and disavowal of its domestic war against Leftists. The Referee announces that Leopoldo Fortunato Galtieri is being expelled from the game for the foul (an allusion to his regime's downfall) and that Argentina will get a penalty shot. Thus expelled, the Officer takes up the position of goalie in front of what we now realize is the "goal": the police barricade protecting Galtieri's home. A Player, a member of HIJOS, kicks the penalty shot toward the house, which the Military Officer unsuccessfully attempts to block. As Etcétera . . . has explained, this penalty shot was the signal for the other protestors. They launched dozens of red paint bombs, and even a whole can of red paint, onto the façade of Galtieri's apartment building as shouts of "Goooaal!" mix with the sounds of the crowd chanting insults at Galtieri.

In *Argentina vs. Argentina*, the soccer match functions as a multivalent allegory that condenses references to the war for the Malvinas Islands and to the clandestine war the state carried out against the Left and the working class. Its allegorical representation of political conflict is enabled by the fact that, in Brechtian fashion, Etcétera . . .'s characters represent social roles rather than individuals. While the soccer match is a reference to Argentina's war with Great Britain, it also alludes to another well-known and more successful endeavor by the military regime to boost nationalist sentiment: the country's hosting of the FIFA World Cup in 1978. The soccer games held in Buenos Aires during the height of the Proceso's violence translated the regime's masculinist nationalist ideology into the arena of public spectacle.[129] The state and corporate media deployed a massive propaganda campaign around the World Cup games that promoted ideas of national identity and unity, while disparaging denunciations of the state's human rights violations as "anti-Argentine" disinformation.[130] This campaign was intensified when the Argentine national team won the World Cup, framing the nationalist fervor around the sport as support for the government.[131] The games were

played in a stadium located less than a mile from one of the Proceso's largest clandestine concentration camps, located in the Escuela Superior de Mecánica de la Armada (Navy Petty-Officers' School of Mechanics), which is known as ESMA. Graciela Daleo, who was a political prisoner in this torture center during the World Cup, pithily summarized the function this sport event had for the Proceso when she recalled a military officer's celebration of the Argentine team's victory: "When he said, 'We won, we won,' I had the absolute certainty, which I always repeat: if they won, we lost. I think that is the most concise evaluation of what the 1978 World Cup was."[132]

By layering together direct allusions to both the 1978 World Cup and the 1982 Malvinas war, *Argentina vs. Argentina* highlights these as two instances when the junta produced costly spectacles of nationalist virility to be played out on an international stage with the purpose of whipping up these sentiments among the Argentine people to increase support for its regime. The performance emphasizes this by prefacing the match-cum-war with a deluge of nationalist hailings, which are performed by figures of the military and ecclesiastical elite and use the language of national identity and unity. Their nationalist convocations are embedded in performances of a muscular masculinity and through calls to personally identify with and psychologize a conflict between states over territorial sovereignty as if it were a personal rivalry between individuals. These hailings are then echoed in the popular soccer chant, suggesting both the success of nationalist interpellation and its saturation of popular culture. Yet the crucial irony, of course, is that the match is actually played out as "Argentina versus Argentina." Thus the match becomes a metaphor for division and opposition *within* the nation or between multiple Argentinas, which flouts the images of national cohesion that both the popular sport and the (initially popular) war were meant to foster.

Insofar as the performance of a soccer match represents Argentina's war with England, the fact that it is actually played out as a competition of Argentina against Argentina alludes to the Argentine state's subjection of conscripted soldiers to abuse and death. This reframes the nationalist hailings performed to incite the "war" to show how they were used by a ruling elite to obscure their readiness to use working-class members of the imaginary "Argentine community" as cannon fodder in an effort to preserve their own power.

The nationalist hailings that frame the bellicose face-off between two Argentine "teams" also allude to the ruling elite's deployment of nationalist ideologies in its war against Leftists, whom it represented as "internal

enemies" of the nation.[133] As the soccer game–cum-war allegorizes this use of nationalist ideologies, it also serves as a broader commentary on the work they perform for the class and (neo)colonial warfare the Argentine state has waged within its own territory, wherein the construction of a national citizen-subject and projection of the myth of a national community is constitutively bound up with the exclusion of sectors of the state's population from this community and their transformation—in ideology and in practice—into an enemy within to be eradicated or expelled.

Argentina vs. Argentina, as well as Etcétera . . .'s work, in general, bears important distinctions from art created for the human rights movement whose focus lies in bearing witness to the dictatorship's violence or memorializing those individuals killed. Artworks of this sort have served to make visible a history that the state and the Right have disavowed and misrepresented, to counter apologias for the Right's violence, and memorialize and humanize its victims.[134] By contrast, *Argentina vs. Argentina* does not attempt to represent the brutality or extent of the violence of the Proceso. Decentering state violence in this way allows the performance to put forward an image of intense political conflict between antagonistic forces without scripting massive state violence as its denouement.

In a pointed retort to the notion of a "national community" introduced in the performance's beginning, the match's allegorical representation of the period of dictatorship is one of antagonistic forces that both operate under the sign of the nation-state: on one side, the ruling class project that was carried forward by the Proceso; on the other, the political project of the disappeared, which represents various movements of the reformist, radical, and armed Left. Representing these two "teams" in a vigorous face-off provides an image of the past as one of active political struggle in which Left movements are given equal protagonism as the forces of reaction. As such, the escrache's condemnation of the Proceso's political genocide also becomes an occasion to lionize the political struggle of the Leftists it sought to eliminate.

The vindication of the disappeareds' political struggle refutes the Proceso's political project in a way that the condemnation of its violence or an accounting for its victims alone cannot. The Proceso's organized violence, its assault on institutions that foster social solidarity, and its machinations in the cultural field were all aimed to extinguish the political imaginary that animates movements of the Left and transform it into something of the past.[135] I have discussed how state narratives of Transition continue this project. Historical narratives that follow the structure of tragedy, in which the Right's brutal violence is scripted as the denouement of the Left's radicalization and

armed struggle, also participate in a counterinsurgent historical aesthetics. So do forms of memorializing the disappeared that represent them primarily as victims, as these easily lend themselves to the project of burying their political struggles in the past and effacing their world-historical significance.

The artists of Etcétera . . . refuse to act as pallbearers of the past. They conscientiously do not traffic in figures of victimhood in their work and instead represent the social figures of victimizers, such as military officers and priests.[136] *Argentina vs. Argentina* refutes the dominant historical aesthetics pertaining to Argentina's state terror by vindicating the political project of the terrorized as a vital and ongoing struggle within which younger generations can take up a position. While forms of memorialization that solely focus on bearing witness to the past impose a cyclical temporality upon politics, Etcétera . . .'s performance suggests a living and ongoing struggle that opens up to an unforeseen future.

The multivalent allegorical rendering of political conflict in *Argentina vs. Argentina* insists on the continuity between past and present struggles. Because Etcétera . . .'s theater has no fourth wall and it is integrated into the setting and context in which it takes place, *Argentina vs. Argentina* also signifies in relation to the larger collective performance of the escrache of which it forms part. Thus, while on one register its dramatic action represents political conflicts of the 1970s, on another register it allegorically reiterates the confrontation manifested in the escrache itself, wherein the human rights movement faces off against the Military Officer, who is both a representation of Galtieri and a symbol of all the repressors the movement pursues. As the performance overlays multiple representations of the past and present, the Military Officer is present in all of them, signifying the continued presence of genocidas from the dictatorship in Argentine society. Yet because the performance is integrated into its surrounding context, the figure of the Military Officer is also echoed in the real police officers guarding Galtieri's home, whom the actors further integrate into the performance by making the police barricades the goal the Military Officer guards. In the scene thus composed, the arraying of all the "players" emphasizes the political alignment between the aging genocidas and the neoliberal state that protects them. In this overlaying of past and present, the actors from HIJOS and Etcétera . . . symbolically take up the same role as the militants of the 1970s, thus asserting a younger generation's commitment to political struggles of their parents' generation. Representation merges with the performative act of the escrache itself when the "penalty shot" signals the climax of the escrache and the painting of Galtieri's house.

Etcétera . . .'s performance integrates itself with the collective performance of denunciation in such a way that it highlights the radical politics operative in escraches and, by extension, in the movement that organizes them. It frames the escrache as part of an ongoing political struggle of the Left against the forces of Argentina's authoritarian Right, which is represented not only by aging genocidas like Galtieri but also by the neoliberal state that protects these persons and their economic project with its laws, cops, and ideologies of national reconciliation. When the triumphant climax of the performance is an act of collective denunciation that symbolically expels Galtieri from a self-regulated community, this stands as a collective rejection of the terms of national reconciliation and cohesion upon which postdictatorship national hegemony has been constructed.

The performance inhabits paradigmatic scenes of nationalist subjectivation—national sport and war—and makes them into allegories that corrode the basis of nationalist myths. Its final scene—punctuated by triumphant chants from the mass of protestors shouting "Goal!" and denouncing Galtieri—recalls and inverts the nationalist chants with which the game began, becoming, at once, a negative image of the interpellation of a national subject and the manifestation of a *truly* popular form of politics. This marks the opposition between the ruling class's imposition of nationalist ideologies and the possibility of collective self-determination. In summary, *Argentina vs. Argentina* helps us see how the escrache convokes a collective subject that asserts its own criteria of justice and its ability to regulate its own ethical community, thereby rejecting nationalist notions of collectivity and the ideological identification of justice with the bourgeois state's Law.

SITUATED MATERIALIST THEATER

Etcétera . . .'s escrache theater transforms the apparatus of theater: the ways it is produced, the social practices of reception and participation it organizes, and the theatrical form. In so doing, it wrests this art form's capacities from the uses to which they are usually put in bourgeois theater so they can instead be channeled toward building a social movement and promulgating radical political imaginaries within and through it. To elucidate these characteristics of Etcétera . . .'s theater, I situate it within a tradition of materialist theater that has aimed to transform the theatrical apparatus so that it can help produce subjects who are able to apprehend the actual character of social relations, including their availability to be transformed.

Materialist theater is based in an understanding that the ways a given apparatus of theatrical production organizes social practices (e.g., how it is produced, the forms of reception it organizes, etc.) are crucially important for the ideological work theater does, in addition to whatever it represents. This understanding is grounded in a materialist conception of ideology, such as that concisely summarized by Althusser when he writes, "The existence of the ideas of [a subject's] belief is material in that *his ideas are his material actions inserted into material practices governed by material rituals which are themselves defined by the material ideological apparatus from which derive the ideas of that subject.*"[137] With this in mind, it is clear that a theater intended to operate as a counterideological apparatus must transform the material practices and rituals of bourgeois theater as these have been institutionalized to abet the function of theater as an ideological state apparatus.

Brecht famously described the institution of bourgeois theater as essentially consisting in "amusement centres" in which the "audience hangs its brains up in the cloakroom along with its coat."[138] He argues that this theater courts a form of spectatorship in which the audience identifies with the characters onstage and seeks theatrical catharsis. This renders them passive and encourages them to view the "structure of society (as represented on the stage) as incapable of being influenced by society (in the auditorium)."[139] Following Brecht, Boal theorized the relationship between theater's subjectivizing effects and the distribution of political agency through modes of governance. He argues that the representational structure of bourgeois theater is itself pedagogical. It trains subjects to relinquish their agency by identifying with roles scripted by others, thereby taking a passive relationship to history. Aristotelian theatrical aesthetics solicit spectators' identification with actors and other forms of "empathy" so that the spectator "delegates power to the dramatic character so that the latter may act and think for him."[140] Thus Boal suggests that the subjectivizing function of bourgeois theater supports the naturalization of the ideology of representation in bourgeois politics, insofar as both cultivate a subject with a passive and spectatorial relationship to politics.

Materialist theater, like that of Brecht, Boal, and Etcétera . . . , aims to produce a spectator who has an active and critical relationship to social reality. Brecht wanted to "make the spectator into an actor who would complete the unfinished play, but in real life."[141] Understanding theater as an apparatus of subjectivation, turning "the spectator into an actor" can be understood as a metaphor for "encourag[ing] those thoughts and feelings" so that one would act to transform human relationships rather than simply be a passive

spectator to them.[142] Brecht's theater does this through its formal structure, which creates an alienation effect that distances the spectator from the representation the play puts forth in order to cultivate in the spectator an active and critical relationship to illusions of self-consciousness.[143] It also uses other aesthetic tactics, such as antinaturalistic acting and breaking the fourth wall, to disrupt spectators' identification with the characters onstage and activate a new form of spectatorship.

Boal argues that Brecht's theater encourages a critical agency in spectators only "on the level of consciousness," as action is still represented within the play's dramatic action. In Boal's Theater of the Oppressed, the division between actor and spectator is dissolved completely, producing a spect-actor who launches themself into the action and thus thinks *and acts* for themself. In doing this, Boal argues, the spect-actor "trains himself for real action."[144]

The street theater of Etcétera... resonates with qualities of Brechtian and Boalian theater, as well as Antonin Artaud's Theater of Cruelty, in different measures depending on the work in question. For example, the way Etcétera...'s characters represent social roles rather than individuals has a decidedly Brechtian quality, as does their theater's antinaturalistic aesthetic. However, the latter is as much evidence of the influence of surrealism on their work, which is seen, in particular, in the way they eschew realism by turning toward poetic and conceptual verbal and visual languages that make generous use of metaphor and symbolism. Etcétera...'s theater evinces the influence of Artaud's rejection of classical representation (i.e., an imitative conception of art), his call to dissolve the roles of actor and spectator, and his deprioritization of the written word as a master text of theater.[145] Boal's argument that theater can perform an embodied pedagogy when spectators launch themselves into the action illuminates the significance of escrache theater's participatory nature and dissolution of representational distance.

There is, of course, an important quality that distinguishes Etcétera...'s escrache theater: it is already embedded in a collective, participatory performance-cum-ritual-cum–direct action. In this way, Etcétera...'s theater brings a situational quality to the tradition of materialist theater I have adumbrated, as it harnesses the capacities of theater to restage and enframe real social actions and scenarios. Their theater not only eliminates the fourth wall; real scenarios and settings become the mise-en-scène for the performance, and spectators are interpolated as participants in the performance's dramatic action, which is also a practice of direct action. Thus theater does not represent a space apart from the real world. Instead it is a set of tools to proffer a political narrative about the social reality it frames, thereby inciting particular forms of social action.

In light of aforementioned considerations about the ways theater operates as a mechanism of subjectivation, we can see how Etcétera . . .'s escrache theater articulates itself with a practice of direct action that itself refutes the passive, spectatorial relationship to social reality (and politics, specifically) that Brecht and Boal decry. That is, direct action, like escraches, should be understood as an embodied form of pedagogy for those who participate in it, in addition to those who are affected by it in other ways. Etcétera . . .'s theater harnesses the pedagogical power of this practice, while framing it within specific political narratives.

Etcétera . . .'s theater has a dialectical relationship to the scenarios in which it is embedded. Fundamental aspects of its production, reception, form, and function respond to its embeddedness in public social performances, such as escraches, protests, and state rituals. These social performances serve as a material support for Etcétera . . .'s theater by serving as its mise-en-scène and organizing its audience (including spectator-participants). At the same time, the artists compose an aesthetic-ideological framing for the social actions with which their performances are articulated. In this way, their escrache theater is able to represent the escrache, the history it addresses, and even the meaning of the human rights movement with relative autonomy, not dictated by a political line of the movement. It is in this dialectical relationship that their art practice exercises agency within the human rights movement of which it is part.

The dialectical relationship Etcétera . . .'s theater has to the scenarios in which it is embedded distinguishes it from contemporary site-specific art and performance practices that use sites and other people's bodies as inert backdrops or props over which the artist unilaterally imposes a meaning.[146] It also stands as a useful counterpoint to the bogeyman of "instrumentalized art" that appears in critiques of art that is articulated with collective politics, usually to assert that this art is degraded by being made to "illustrate" a political idea. Such critiques tend to posit a historically transcendent notion of what art is and what it should do; they also often fail to understand the nature of the relationship a given art practice has to collective politics and the multiple agencies that operate within this relationship.

CATHARSIS AGAINST RECONCILIATION

The artists of Etcétera . . . have described one approach they took in developing escrache theater as their adaptation of elements of classical Greek theater into the ritualized performance of escraches. In the 2006 interview I conducted with several members, Zukerfeld said:

We were working with the format of classical Greek theater, where there is a forum, which is what we gathered in front of in each space. . . . And then there were the protagonists, the antagonists, and the chorus. The public was included as participant and spectator, because they worked as chorus: accompanying, denouncing, accusing. What we were looking for was that this would produce catharsis in the most profound sense, which means that you forget that you are witnessing a work of art. At that moment, what is happening is the freeing of a trauma, and for that reason it has a psychoanalytical meaning that has to do with catharsis. It is when there is a drive—that, in this case, is memory and justice—that needs to come out.

Loreto Garín Guzman also noted that Etcétera . . .'s work in "a type of cathartic theater" aimed to "generate an instance so that what was asleep inside those who created the escrache could come out through theater: anger, pain, fear, hysteria. To let out what had been repressed and what is rationalized in political militancy."[147]

The artists articulate a heterodox and anti-Aristotelian theory of theatrical catharsis, whose function is specified by their performance's integration into political protests and rejection of a mimetic notion of theater. They embrace theater's capacity to stir people's emotions and to bring to the surface feelings that have been repressed. But repression does not have to be understood only as a mechanism manifested in individual psyches. Zukerfeld's reference to "memory and justice" as the drive they aim to liberate gestures toward an eminently *social* conception of psychic life (as articulated in the psychoanalytic theory of Frantz Fanon and others) that aims to grapple with the sociopsychic effects of the lack of justice for political genocide and the state's efforts to bury this history. In other words, their use of psychoanalytic concepts in this context addresses the micropolitics of impunity and state history—that is, how they shape subjectivity.

Etcétera . . . puts forward an anti-Aristotelian conception of theatrical catharsis as the desublimation of repressed memories and feelings that can be channeled into political activism. Brecht and Boal both argue that Aristotelian catharsis is essentially a conservative mechanism because it encourages spectators to expiate negative feelings through their identification with the actions depicted on stage, and thus continue in real life within the social conditions that gave rise to those negative feelings. In other words, Aristotelian catharsis functions as a form of sublimation that channels potentially "antisocial" feelings into the socially acceptable practice of viewing a

theater play.[148] By contrast, because Etcétera . . .'s nonmimetic theater eliminates representational distance and directly integrates itself into political protest, the provocation of emotion and memory actually works to direct these feelings toward the *real* social condition and agents that are responsible for them, while giving additional intensity and meaning to the practice of direct action. The difference from Aristotelian catharsis as it operates within bourgeois theater is profound: against a mediated catharsis that would function to purge feelings potentially disruptive to the social order, Etcétera . . . vaunts the unleashing of precisely those memories and feelings the state has attempted to bury (through its politics of Transition, reconciliation, and impunity and its historical aesthetics) in order to disrupt the hegemony of the neoliberal state.

Etcétera . . .'s theory of catharsis resonates with Diana Taylor's argument that the human rights movement's protests, including escraches, engage embodied knowledge of their participants. In so doing, they "depathologize trauma" and "publicly canalize" it into activism, she contends.[149] Etcétera . . .'s escrache theater uses the theatrical arts to contribute to this canalization of trauma into activism. I argue that the aesthetic-ideological framing with which such memories are convoked, and through which they are represented, determines their potential political significance for a collective politics, and it is in this dialogized space of maneuver that Etcétera . . .'s theater articulates and amplifies a more radical social critique and political horizon for the movement. While Taylor argues that escraches canalize trauma toward a demand for "institutional justice" and that they use live performance in a manner analogous to the use of testimonials in truth and reconciliation commissions, I argue that Etcétera . . . 's theater frames escraches—and the human rights struggle, more broadly—as a negation both of the state's claims to arbitrate justice and of the politics of truth commissions.

Etcétera . . .'s theater in escraches frames them as the precise inverse of the political theater of truth commissions, which are a central mechanism in human rights politics and transitional justice. As Williams writes, truth commissions function as a "therapeutic apparatus" wherein victims' stories are recorded in the official archive, but, "in the interest of reconciliation and in exchange for representational agency, . . . [they] are expected to forgo or convert any demands for retribution."[150] In these "memory theaters," the narratives of political terror relayed before the commission "are expected to produce a cathartic effect that will convert the violence described in order to generate a (legal) therapeutic resolution."[151] This form of political theater, then, vaunts the value of representation—specifically within the state's ar-

chive—as a means of bolstering the hegemony of the liberal state and the interpellative power of its ideologies of political representation. As Williams argues, this form of cathartic "therapeusis" is precisely designed to prevent acts of rebellion or demands for justice that would exceed the juridical mechanisms implemented by the state. The theatrical praxis Etcétera . . . brings to escraches frames these as the *negation* of the political theater of truth commissions: in escraches, catharsis is activated *against* ideologies of reconciliation and closure; the postdictatorship state and its laws are seen not as neutral authorities but, rather, as accomplices of the terrorist regime, and the public narration of political terror is not a substitute but a catalyst for a rebellious practice of popular justice, which, in its very manifestation, refuses to recognize the state as the arbiter of justice.

MASS MEDIA AND THE POLITICS OF CIRCULATION

Documentation of Etcétera . . .'s live performances include videos, photographs, and texts produced and circulated by the artists as well as by the mass media. For example, photographs and a description of *Argentina vs. Argentina* appeared in a full-page article in one of Argentina's major national newspapers as part of a report on the escrache of Galtieri.[152] Notably, this article appears in the "Politics" section of the paper, which is typical of media coverage of Etcétera . . .'s work through the early 2000s. Zukerfeld commented on this to me at the opening of the group's ten-year retrospective exhibition, in which many of these early news articles were displayed. He also said that much of their work had been illegible *as art* to the local culture industry for many years. This is particularly interesting as an acknowledgment of the ways in which the ideological state apparatuses of the media and culture industries shape the circulation and reception of their work so profoundly that they determine its very legibility as art and/or as politics. This takes us beyond questions of how these industries confer cultural value upon art and how they shape opinions about politics (both of which are widely acknowledged as ways in which their ideological force is exercised). It shows how they participate in the production of the very categories of art and politics, telling society what they are and how they function, and managing the ways given practices are understood within these frameworks or made invisible by them.

Etcétera . . .'s work evinces the artists' self-reflexive awareness of the contingencies inherent in the circulation and reception of their work, including as this pertains to its legibility as art or politics. The way Etcétera . . . anticipates

and exercises agency in the circulation of their work and its legibility as one type of practice or another is part of their creative practice. This is also true for GAC, though Etcétera . . . is more explicitly engaged with the possibilities and interpretive contingencies offered by the mass media's circulation of their images. While this becomes a central thematic in Etcétera . . .'s work as the Internacional Errorista, discussed in the following chapter, it is also evident in their earliest performances in escraches and their handling of documentation of these.

In our 2006 interview, Zukerfeld, Ariel Devincenzo, and Antonio O'Higgins discussed the significance of and debates about the mass media's coverage of escraches in a political context characterized by impunity:

ZUKERFELD: We have this inheritance from the 1960s, that the media is very important for our artistic expression, as it's expansive. Many people have accused us, saying that what we did was a form of spectacularization by making [escraches] into a "show" in order to look for spectators, a public. And in one way, that's true. But not from a commercial point of view because with this, nothing is being sold.

DEVINCENZO: It only involved using that tool to put forward a spectacle of what was actually happening in reality, though it wasn't spoken about, which was that all the genocidists were free.

ZUKERFELD: There's always fear of the media because of the idea of co-optation. From a realistic point of view, that can happen. But in the case of escraches, it was impossible, because the cause was so much bigger. We're talking about thirty thousand disappeared. And responding a bit to this very postmodern problematic of the possibility that people were "selling something" in order to appear on television: that's just a lie because those people were screaming for a camera to come, because it was the only way that people would know in the country and in the world [what had happened]. . . . The mass media began to rapidly incorporate images that we and the other groups produced and assimilate them into the collective unconscious. *That's* what's important about what we did. The important thing is that, today, when someone talks about "escraches," it's a word that has entered into everyone's vocabulary: the mass media, the press, politics, everyone. And ten years ago that word wasn't anything.

DEVINCENZO: Escraches were taken up by a ton of sectors, even by those that weren't traditionally of the Left. After 2001 there were escraches

against everyone. When people had a problem with a bank or a corrupt commissary, they organized escraches.[153]

The artists' comments remind us that the mass media is not a monolithic force but a site of multiple agencies. They highlight the national and international reach of the mass media and its capacity to seed ideas in a "collective unconscious" as powerful capacities that activists and artists can utilize (and *have* utilized for decades, as their mention of the "inheritance of the 1960s" emphasizes). They also note the contingencies the circulation and reception of representations bring to activism, as much as to the politics of art. That is, they note that the media's representation of escraches prompted the socialization of this tactic beyond the human rights movement, such that it became part of the repertoire of protest seen in the wake of Argentina's 2001–2 crisis. The reimagination of escraches is evidenced in Etcétera . . .'s own 2002 protest performance *El Mierdazo*, which I discuss later in this chapter.

Etcétera . . .'s work evinces the artists' keen awareness of the ways that state and corporate power use the mass media as an ideological weapon. They incorporate this critique into some of their work through a self-reflexive commentary on ways the work itself could possibly be circulated and reframed within a reactionary discourse. By anticipating such possible manipulations, they demonstrate their own awareness of the ways in which the media landscape in which they intervene is not in any sense neutral but is overdetermined by its structural alignment with capital and the state. This is exemplified by their presentation of video documentation of their performances in *Etcétera . . . TV*.

Etcétera . . . TV (2005), which circulates as a DVD, in screenings, and on YouTube, is a ludic, semifictional documentary that incorporates video and photographic documentation of five of Etcétera . . .'s performances from 1998 to 2002. Some of its documentary footage was produced by Etcétera . . . , while the artists poached some footage from television news coverage of their actions. *Etcétera . . . TV* frames this documentation within a humorous narrative that parodies a televised national address by a military dictator. The dictator is Etcétera . . .'s stock character of a Military Officer. Langer portrays him as a send-up of Jorge Rafael Videla, whom he visually evokes with a fake nose, mustache, and thick black glasses.

In *Etcétera . . . TV* the Military Officer directly addresses the camera with an urgent message about political enemies who have denounced him and about whom he is gathering "visual evidence." He introduces videos of Etcétera . . .'s performances as follows: "Dear everyone: thank you for

this opportunity to recount to you the odyssey I have lived, so that you can see with your own eyes when this group of makeshifts came to bang on my door, and the doors of my neighbors, my friends, and of memory! . . . They've been identified on this video that today we will show you, where we have images as evidence."[154] The "makeshifts," of course, are Etcétera . . . and the other human rights activists who appear in the video documentation of escraches. Thus the artists present their only video documentation of their escrache theater by producing a parody of how it might be used by and presented to their political enemies: those individuals they have denounced and these persons' sympathizers and apologists. This acknowledges that interpretations of the escraches, and Etcétera . . .'s performances in them, are overdetermined by the political alignments of the viewer. It also shows that the political meaning of Etcétera . . .'s practice is not contained within its live instantiation. Because the social life of their art is expanded through the circulation of documentation of it, this makes it all the more available to reframings and divergent political interpretations. Etcétera . . .'s decision to imagine a military officer presenting documentation of a human rights protest to sympathetic viewers is not a cynical representation of co-optation. Rather, it is a pointed reminder that, because history is a production in the present, insofar as human rights struggles entail a battle over history, this battle cannot be definitively lost or won, but will be ongoing.

The contingency of meaning of texts and images stems from the different ways in which they can be interpreted; it also operates in the ways objects of analysis are constituted in the first place, and the social functions that are thereby assigned to them. *Etcétera . . . TV* explicitly points this out by suggesting in its fictional narrative that video documentation of their performances could be made into evidence for the state. This, of course, is a crucial part of the social life of countless cultural productions. It was certainly the case with the Proceso's attempts to control cultural production and in its targeting of Left cultural producers.[155] *Etcétera . . . TV*'s invocation of this history is a reminder that, while the meanings of expressive practices are socially constituted, unfixed, and always a site of struggle, the battlefield is far from even, as those who avail themselves of state and corporate power (ideological and outright repressive) are poised to enforce their definitions, categories of analysis, and judgments.

Etcétera TV . . . also develops this insight as it bears upon the ways in which social practices are defined, categorized, and made apprehensible (or invisible) in accord with a dominant aesthetic-ideological matrix. After video documentation of *Argentina vs. Argentina* concludes, El Militar addresses

the camera while holding a red paint-filled balloon and says, "The evidence is more than sufficient. One by one, I've collected all the evidence that will allow us to demonstrate if this is art or it is not art! If this is politics, or this is not politics!" He then adds with exaggerated condescension and incredulity, "Or if this is a battle for human rights!" Whereas a likely reading of the video's fictional narrative would be that the Military Officer was amassing evidence to prove something about the oppositional politics documented in the videos, this unexpected shift in his discourse suggests that the evidence could be used to prove that it is not, in fact, politics (or art) to begin with. Within *Etcétera . . . TV*'s reflection on the social politicity of cultural artifacts, and the ways they are constantly open to redefinition and redeployment in accord with different political ideologies, this segment shows that the power of ideology perhaps works most insidiously through the management of the very categories through which reality is coded and through which social practices and artifacts are made apprehensible—or jettisoned from consideration at all. The fact that *Etcétera . . . TV* makes this point within a representation of a dictator's televised address underscores the power of the state and its ideological apparatuses to shape a dominant aesthetic matrix in this way.

COLLABORATION, DISSONANCE, AND AUTONOMY

In interviews with me, artists of Etcétera . . . described a trajectory in which their desire to expand the artistic language of their performances and maintain full independence to do so led them to work autonomously from human rights organizations by 1999. After a time spent collaborating directly with HIJOS and participating in its assemblies, they "began to have a crisis in respect to artistic language." As Zukerfeld said:

> We wanted to delve deeper and withdraw more from the figure of the repressor, the military officer, and enter into another kind of symbolism. It was very difficult because we felt political pressure in respect to what type of works, performances, and ideas we were starting to put forth that perhaps appeared off-topic to the other militants. . . . We wanted to do more abstract things. For example, instead of [creating] the image of a military officer, one day we wanted to put a toilet in front of the military officer. That time we used [the character of] a construction worker. . . . Just a guy with a toilet and the cement, laying the cement.[156]

Zukerfeld alludes to Etcétera . . .'s performance in a 1998 escrache against Enrique Peyón, a retired army lieutenant who had worked in the clandestine

torture-detention center at the ESMA. In the performance, a masked actor dressed as a construction worker installed a real toilet in front of Peyón's home and then proceeded to urinate in it. The artists describe this performance as signaling a shift in their own artistic language, as well as a shift in the state's response to the escraches. It was the first time the Buenos Aires police repressed protestors for doing an escrache. They jailed twelve activists, including two members of Etcétera..., in the name of protecting private property.[157] Devincenzo quipped, "At that time, the police batons themselves performed the censorship [of Etcétera...'s art]."[158]

Discussion among the activists of HIJOS and Etcétera... following this episode of repression revealed divergent attitudes about the artistic element of escraches: "In the assemblies they said that the artistic element was exceeding the politics and that it was becoming a carnival and a party, which was what we actually wanted. We had to give priority to preserving creative freedom. For that reason, by 1999 we said we wanted to form an independent movement. Because, just as we consider art to have a very important social function, we also believe that it is its own territory and that it has to have independence in its language and expression."[159] While the artists worked independently of human rights organizations after 1999, they continued to be active in this and other movements with their guerrilla street theater.

When reflecting on divergences between Etcétera...'s activism and that of human rights organizations, Nancy Garín began by describing the artists' relationship to the human rights movement as "one of great love, and at the same time, of misunderstandings." She noted, in particular, differences in tone and rhetoric. The "serious tone" most human rights organizations use has "often been dissonant with the irony and sarcasm that is a permanent feature of Etcétera...'s work." She notes that the tendency toward a painful or tragic ("doloroso") discourse among some human rights organizations, especially in Chile, has sometimes created distance from other kinds of spaces and communities that would like to be part of the human rights struggle: "The disappeared, our comrades, didn't die to have a sad and dark world, but rather, the opposite. Their struggle was for a joyous world. Therefore, this question of how to change this painful discourse: I think Etcétera... has always sought out ways to do this without diminishing the seriousness of the human rights struggle. A lot of times we weren't understood."

Etcétera...'s members' comments call up long-standing debates about artists' autonomy of expression when their art production is articulated with collective politics and evaluated by political organizations.[160] Conflicts that arise in this arena should not be framed as a debate about art's relative

autonomy from politics. Rather, they can be understood in regard to the internal ideological heterogeneity of antisystemic movements, conflicts that arise from this, and the ways this affects (and is affected by) the organization of labor within them. While Etcétera . . . described their divergence from other human rights activists as turning on questions of tone, in the next chapter I will discuss their open critiques of politico-ideological positions taken by major human rights organizations in the mid-2000s, when these organizations come to work more closely with the state.

As I have discussed in detail, the human rights movement does not have a monolithic political ideology. It has been internally heterogeneous since its beginnings, and there have always been divergences among different collectivities that participate in the movement in regard to political ideologies, tactics, and their relationship to the state. For this reason, I have argued that the politics of this movement should be understood as a site of ongoing struggle, in which artists can participate with their art. It is precisely the dynamic, collective, and decentralized politics of the movement that makes possible the reframing and radicalization of human rights discourse I track in this chapter. The performance I turn to next puts in evidence the crucial politico-ideological stakes for this reframing of human rights politics, as it indicts the brutality of the local ruling class (from the period of the dictatorship to the present) as this is manifest in the exploitation of labor and production of poverty, disease, and environmental destruction, in addition to "traditional" human rights violations.

TRACES OF VIOLENCE: EXPANDING THE FRAME OF HUMAN RIGHTS

Those who are against Fascism without being against capitalism, who wail about the barbarism that comes from barbarism, are like people who want to eat their share of the calf without the calf being slaughtered. They want to eat veal, but they can't stand the sight of blood. They are satisfied if the butcher washes his hands before he brings out the meat. They are not against the conditions of ownership that produce barbarism, just against the barbarism. —Bertolt Brecht, "A Necessary Observation on the Struggle against Barbarism," in Brecht on Art and Politics *(2003)*

Human rights discourse emerging from the framework of transitional justice has traditionally marginalized considerations of distributive justice, social and economic rights, and economic forms of complicity in rights abuses.[161] It is for this reason that Meister suggests the net effect of human rights

politics is to preserve accumulated gains of beneficiaries of injustice, while offering "moral victories" as a kind of palliative to a limited group of victims.[162] In marked contrast to this, Etcétera...'s 2000 performance-cum-escrache *Huellas del ingenio, escrache a Ledesma* (Footprints from the Mill, Escrache against Ledesma) channels the human rights movement's social condemnation of state terrorism under dictatorship toward a critique of socioeconomic relations that have been secured through this violence. While the discourse and activist practices of the human rights movement have principally focused on agents and institutions of the state's repressive apparatus that were directly involved in state terrorism, Etcétera...'s work brings into view larger networks of complicity and a longer historical view of the ways capitalist accumulation is abetted by violence and fear. In so doing, it expands the frame of human rights discourse to make explicit its relevance to questions of labor exploitation, the culture industry, philanthropy, and environmental justice.

Etcétera... performed *Huellas del ingenio, escrache a Ledesma* in front of Argentina's Museo Nacional de Bellas Artes (National Fine Arts Museum) in 2000. It was among multiple escraches and other protests staged that June to publicly mark the history of the Apagones de Ledesma (Ledesma Blackouts). Ledesma is an enormous Argentine agribusiness that got its start in the sugar industry in the nineteenth century and has since established itself nationally as a name brand. Its sugar plantations and mills are located in Ledesma in the northern Argentine province of Jujúy. Apagones de Ledesma is the name given to nighttime terror raids that were carried out in June 1976 in several towns where the mill's workers live. During planned nighttime electricity blackouts, police kidnapped and detained hundreds of people, dozens of whom they disappeared. The former president of Ledesma, Carlos Pedro Blaquier, is accused of being an accomplice in these terror raids, which targeted his employees—in particular those who were union organizers.[163] With the Proceso's antiworker reform of labor laws and its repression of union activity and social dissent, Blaquier was empowered to slash his workers' wages and instate twelve-hour workdays.[164] Since the end of the dictatorship in 1983, activists have carried out annual protest marches in Jujúy to mark the history of the Blackouts and commemorate those who were disappeared.[165]

In Ledesma, mill workers and others who live near the mill continue to suffer pulmonary diseases due to the air pollution produced by the mill.[166] The vulnerability of Ledesma's inhabitants to this poisoning stems from their class position and the corporate power Ledesma wields. It is one of the principal employers in a province that has extremely high rates

of unemployment and poverty. Human rights activists have publicly denounced Ledesma for the environmental pollution its mill discharges and have attempted to use Argentina's courts to force the corporation to stop contaminating.[167] In 2000, when activists protested against Ledesma in Jujúy, Etcétera ... participated in this collective denunciation with *Huellas*. In *Huellas*, Etcétera ... used the historical example of the Blackouts to shed light on more naturalized forms of violence inherent in capitalist accumulation—such as the violence of labor exploitation and environmental poisoning. Because the Blackouts pointedly exemplify the collusion between powerful industrialists and agents of the state's repressive apparatus, *Huellas* draws on this sordid history to show how the alignment of the state and ruling class also operates through ideological state apparatuses, including cultural institutions.

Huellas traced the surplus value that Ledesma has appropriated from workers to the patronage, prestige, and power exercised in and through elite cultural institutions. The performance in fact centered on the National Museum of Fine Arts and its long-standing patron and functionary Nelly Arrieta de Blaquier. An oligarch of Ledesma fortune who was once married to Carlos Blaquier, Nelly Blaquier was president of the museum's Society of Friends from 1977 to 2011. In *Huellas*, Etcétera ... stenciled footprint silhouettes in white sugar on the street in front of the museum and ascending its stately front staircase. An actress playing "Nelly" followed this trail up to the museum's entrance. She carried a gilded frame around her own face as she approached the museum, as if anticipating a portrait of her that would hang inside it in homage to her patronage (figure 3.5). As the actress followed the sugared footpath, other artists walked behind her, dousing the footprints in alcohol and setting them afire. The flaming footpath leading up to the museum's entrance then burned down into sticky traces.

In its title and aesthetics, the performance plays on the multiple meanings of *huellas*, which can be translated as "footprints" and "tracks" and also means, more generally, "traces" or "markings" in reference to signs or remnants left behind by the actions of something or someone. In the performance, huellas are footprints from the Ledesma mill that symbolize the disappeared Ledesma workers. They are also the traces of the mill at the museum: signs that mark the museum's material connection to Ledesma's practices.

In Argentina, silhouettes have long been used in activist artworks to make visible the history of forced disappearances, serving as a social icon for absent bodies. The best-known use of silhouettes in this manner is the activist

3.5 Etcétera..., *Huellas del ingenio, escrache a Ledesma* (Footprints from the Mill, Escrache of Ledesma), performance and escrache in front the Museo Nacional de Bellas Artes, Buenos Aires, 2000. Photograph courtesy of the Etcétera... Archive.

artwork *El Siluetazo* (1983), a collective art action that was carried out during the dictatorship in the Third March of Resistance coordinated by the Madres de Plaza de Mayo. Thousands of life-size silhouettes of human bodies were collectively produced and displayed in public spaces in Buenos Aires representing the absence of the disappeared.[168]

Working within the recognized symbolism of silhouettes as pertaining to the disappeared, *Huellas* uses footprint silhouettes stenciled in sugar to symbolize those persons disappeared in the Blackouts. The performance's spare narrative, in which "Nelly" follows the path of footprints up to the museum, asserts that her trajectory to becoming a cultural powerbroker is materially based upon the exploitation and repression of Ledesma's workers. Beyond indicting an individual family or corporation, this is a powerful refutation of liberal ideology's naturalization of the social distribution of power and wealth as if these were the "natural" outcome of market logics alone. Ultimately, bringing Ledesma, the Blaquier family, and their fortune into the frame of the human rights movement orients the movement's calls for justice toward the question of redistribution.

As it brings into view the historical and material bases of the fortune undergirding Blaquier's art patronage, *Huellas* counters dominant historical narratives with both temporal and spatial reframings. Against progressivist representations of history, in which the Blackouts are a discrete incident that exists only in the past, *Huellas* shows how that instance of capitalists' class warfare provides the basis for an oligarch's current social position. It also refutes the insularity of the metropolitan spatial imaginary (which is acute in Argentina's capital city) by showing how the financial and symbolic capital that circulates in a prestigious institution in one of the capital's wealthiest neighborhoods is materially dependent upon surplus produced by industrial and agricultural

Chapter Three

workers in one of the country's most impoverished regions. The spatial and temporal aesthetic reconfiguration that *Huellas* performs ultimately reconfigures the scope of human rights struggle, as it places at its very center the issue of the accumulated gains of the economic beneficiaries of injustice.

Huellas is a materialist rejoinder to the ideology of art's autonomy, including the perception that hierarchies of value, power, and taste within the field of the fine arts somehow operate independently of the movement of capital and hierarchies of power in the workaday world. The frame "Nelly" carries in the performance serves as a poignant metaphor for this ideology of autonomy. Insofar as a frame functions as a material border between an art object and the space in which it is situated, it separates the work from its context and also instates this division and defines the artwork in so doing. While the social enunciation and enframing of an object as an artwork occurs through multiple agencies, the frame symbolically condenses this operation in a way that emphasizes the centrality of the ideology of art's autonomy to the modern aesthetic regime of the arts. In *Huellas*, Nelly, in her gilded frame, is reframed by the performance's narrative about the political economy of the Fine Arts Museum. Thus the frame becomes a materialist metonym for the ideology of art's autonomy, which separates the artwork from its context, the museum from the countryside, arts philanthropy from the source of the wealth it moves, and cultural institutions from processes of accumulation and class domination. A dominant aesthetic matrix creates these separations, as it carves up the world we perceive. *Huellas* makes that aesthetic-ideological operation visible, not only by asserting the material relations between what may appear to be atomized practices, but also by reframing the frame—that is, making visible the aesthetic partitioning that produces the illusion that art is separate from the social world.

The symbolism and aesthetic qualities with which *Huellas* imbues sugar and the museum enforce the performance's inversion of the values ascribed to philanthropy and fine art within bourgeois ideology. While sugar is usually consumed as food and associated with sweetness, in *Huellas* it is consumed by fire and associated with torture and death. The burning of the sugar footprints gives a destructive and infernal cast to the performance's depiction of Nelly's role as art patron and powerbroker. As she ascends the museum's stairs, ready to hang her own portrait within it, the image of beneficence surrounding cultural patronage is replaced by that of a wealthy capitalist asserting her power and managing her social image in and through the cultural institution. The National Fine Arts Museum then appears as a mechanism for whitewashing the history of Blaquier's fortune.

This does not need to be read as simply a condemnation of a cultural institution's association with money from nefarious sources. More powerfully, it is a critique of the social function of the museum. Situated as it is in a performance about accumulation and class domination, the fine arts museum is revealed as another institution through which the alignment of the state and ruling class is secured and through which class domination extends itself. In their function as ideological state apparatuses, museums like Argentina's National Fine Arts Museum have historically functioned to bolster the cultural hegemony of ruling classes. They do this by promoting nationalist ideologies of culture, enforcing hierarchies of cultural value that naturalize extant class relations (and corresponding ideologies of race, civilization, etc.), and promulgating the notion that bourgeois states and philanthropic oligarchs are benefactors of the people. By bringing the arts museum into the frame of its critique of state violence and capitalist exploitation, *Huellas* underscores the way that the ideological work performed by cultural institutions is a crucial component to reproducing relations of domination, as it serves to manage the perception of these.

Huellas' conceptualist adaptation of escrache aesthetics expands the frame in which the violence perpetrated by Ledesma can be apprehended—not only in its temporal extension into the present but also in the various forms this violence takes. In *Huellas*, the sugar footprints that evoke the disappeared are burned down into caramel traces that mark the museum in a manner akin to the way red paint is typically used in escraches to mark a genocida's home. Resembling blood, red paint evokes the torture and assassinations that occurred under the dictatorship. The use of burned Ledesma sugar in its stead suggests that the denunciation of Ledesma, Blaquier, and the museum extends beyond their complicity with or profiteering from the state terror of the Proceso. As its typical use-value and sensory appeal is put under erasure, the sugar's character as an industrial product and commodity of the Ledesma corporation is made more apprehensible. As the commodity form of the mill workers' abstracted labor, the sugar indexes those workers who produced it. This implies, then, the question of how these workers and the conditions they currently face are related to the escrache's exposure and denunciation of violence that otherwise goes unpunished and unseen.

With the sugar footprints' layered symbolism, *Huellas* draws a connection between the violence of state-led terrorism used against Ledesma's workers in the past to the workers' current situation, in which they are subjected to conditions of exploitation in which they also meet "a too early and an unnatural death," to quote Engels, if by slower means. By denouncing brutali-

ties associated with waged labor, which are often naturalized, *Huellas* draws our attention to the fact that the very conceptualization of violence is a field of ideological-political struggle. Moreover, by asserting a historical connection between the terrorization of workers, used to extract greater profits, and injurious conditions of exploitation, *Huellas* refutes liberal ideologies of agency in regard to waged labor. As Ledesma is the principal employer in a province with high levels of structural poverty and unemployment, the corporation's ability to impose especially deleterious conditions on its workers puts into evidence the ways that poverty and precarity operate as coercive forces to enable exploitation. As it connects the history of the Ledesma Blackouts to the present-day poisoning of workers and the environment, *Huellas* asserts a continuum of the different forms of domination and violence that capitalists' class war entails: from the disciplining of labor through terrorism to brutalities of exploitation, the coercive force of dispossession and proletarianization, and the slow violence caused by capital's destruction of the biosphere, which is suffered most by the popular classes.

CRISIS AND REVOLT

I have shown how the work of GAC and Etcétera . . . , situated at the crossroads of a national human rights movements and global anticapitalism, fomented a radical understanding and practice of human rights activism. Refusing the progress narratives of the neoliberal state, and especially its efforts to bury state violence in the dictatorial past, these groups exposed the multiform violence of their neoliberal present, from its historic debt to political genocide, the enduring power of this genocide's beneficiaries and agents, to the deadly exploitation and policing of the popular classes. Perhaps most important, their work participated in autonomous collective political practices that challenged the liberal ideology of political representation and convoked political subjects whose capacity for action and sense of justice were not oriented to the neoliberal neocolonial state.

The autonomist politics seen in the more radical aspects of the human rights movement form part of what Zibechi calls the "genealogy of the revolt," in reference to the grassroots autonomous movements that made possible a popular insurrection in 2001 that toppled two governments and created an extraordinary opening for autonomist movements, practices of social solidarity, and anticapitalist social relations to flourish. Zibechi's genealogical approach is a crucial antidote to linear historical logics, periodization, and treatment of uprisings as singular events. It reminds us that the temporality

of antisystemic movements is incommensurable to that of bourgeois politics and the regime of visibility controlled by state histories and the corporate media. I emphasize this because dominant historicizations of the 2001–2 revolt and its aftermath, which focus on the financial crisis and sovereign debt default and the spectacular insurrection of 2001, can obscure the long labor of antisystemic movements that gained a new scope and visibility with the national crisis of 2001–2. To imagine an alternate temporality, Zibechi suggests the image of a new world being born in society that slowly takes shape in the heart of popular organizations, which serve as a kind of winter garden that allows for the flourishing of counterhegemonic social relations.[169] The traffic between the radical politics in human rights organizing from the 1990s, which I have analyzed here, and the politics of the 2001–2 insurrection, which I discuss next, is evidence of this.

By the end of the 1990s, neoliberal policies Menem's government had implemented to attract transnational capital induced what is known as the Great Argentine Depression (1998–2002). William Robinson explains that, as the Argentine economy was completely in hock to transnational capital, the state was only able to "keep the economy buoyed so long as there were state assets to sell off or as long as it could sustain the conditions for attracting mobile capital from global institutional and portfolio investors."[170] When it could no longer do this, it entered into what has been described as the "worst peacetime economic collapse in recorded history."[171] After decades of neoliberal economic policies had eroded the welfare state and what had been a sizable middle class, by 2002 "the number of those living below the poverty line rose to 58 percent of the population—nearly half of whom were totally destitute."[172]

During the Depression, working-class resistance to austerity intensified. Food riots and road-blocking protests (piquetes) spread, with protestors blocking train routes as well. General strikes proliferated and became increasingly decentralized, spilling beyond the control of traditional unions.[173] By the end of 2001, people's resistance to austerity produced what Antonio Gramsci calls a crisis of hegemony, or general crisis of the state.[174]

In late 2001, in the face of capital flight, the Argentine government froze people's bank accounts, allowing only minimal cash withdrawals of the national currency and forbidding withdrawals from accounts denominated in dollars. (The Argentine peso has been pegged to the U.S. dollar since 1991.) People's fury at this measure drew middle-class Argentines into mounting popular mobilizations. In response to another general strike, increased looting, and the mobilization of piqueteros in the capital city, President

Chapter Three

Fernando de la Rúa declared a state of siege (essentially a state of emergency) and deployed the police, gendarmerie, and coast guard to repress protestors. In the next two days, state forces killed thirty-eight protestors in the deadliest single episode of repression since the dictatorship. Rather than cow the people, de la Rúa's declaration of a state of siege had the opposite effect. As tens of thousands of people protested in cities across the country, the streets were filled with the chant "Qué boludos, qué boludos, el estado de sitio, se lo meten en el culo!" (What idiots, what idiots, they can shove the state of siege up their ass!)[175]

Protestors called for the end of the state of siege and the resignation of the president and his minister of economy. Moreover, they repudiated the political class en toto, as expressed in the chant that became emblematic of the insurrection: "¡Que se vayan todos! Que no quede ni uno solo!" (All of them out! Not one should remain!) The protests manifested a "disestablishing power" (*potencia destituyente*), that is, a popular power capable of unseating a constituted power.[176] First, de la Rúa's cabinet members resigned; then, as the capitol building in Buenos Aires was encircled by thousands of protestors, de la Rúa resigned and fled in a helicopter, producing an image Luís Mattini cannily describes as that of a "*deus ex machina* in reverse."[177]

The political productivity of the insurrection was enormous. Its negation of bourgeois politics was an invitation to create new forms of social organization, which were already being practiced in the popular movements.[178] There was a flourishing and interrelation of autonomist grassroots movements, including piqueteros, the popular assembly movement, bartering clubs, and worker takeovers of businesses. Practices of self-organization, mutual aid, and collectivism that thrived and expanded in this context organized noncapitalist social relations and modalities of grassroots politics not mediated by state institutions.[179] A shared repudiation of neoliberal globalization created new affinities between middle-class urbanites and the mobilized working classes who had long been its principal victims and opponents.[180] These movements also shared their rejection of the existing political institutions and, more broadly, of liberal political representation as practice and ideology.[181] They aspired to institute a new politics that gave priority to social self-organization at a distance from state institutions.[182]

The Argentine uprising was part of a wave of popular uprisings that have taken place across the Americas since the late 1980s in which the popular classes have enacted their repudiation of neoliberal policies and the institutions and elites that have imposed them. These include the Caracazo (1989), the L.A. Riots (1992), Zapatista Uprising (1994), Cochabamba Water Wars

(1999–2000), multiple indigenous-led uprisings in Ecuador, and others. Some believed the Argentine uprising and subsequent popular mobilizations had opened a path toward a social revolution.[183] In such an understanding, the popular assemblies prefigured a constituent assembly, the piqueteros were seen as a "popular army in formation," while "occupied factories revealed the red grassroots of an insurrectional proletariat, and the barter nodes . . . an alternative to the functioning of the capitalist economy."[184] Although this did not occur, the popular politics of this time deeply affected Argentine civil society, as people of the working classes "(re)discovered [their] capacity for action, creating ties of cooperation and solidarity that had been acutely undermined during the long decade of neoliberalism."[185]

This period of popular mobilization also saw the breaking down of divisions that typically segregate specialized knowledges and forms of production, as well as a tendency toward the socialization of means of production.[186] This produced a situation where it was understood that "anybody can produce images or concepts, forms of struggle, means of communication, or ways of expression."[187] The work of GAC and Etcétera . . . anticipates and reflects this ethos in the ways it reorganizes the social relations of artistic production, circulation, and reception, fusing art and direct action and producing art through collaborations between artists, organizers, and protestors.

EL MIERDAZO

The popular politics seen in Argentina at the beginning of the twenty-first century demonstrated the political productivity of the people's repudiation of the ideology of representation by the capitalist state, as this enabled popular organizing not beholden to state institutions, their powerbrokers, or even their ways of doing politics. Thus the spirit of negation seen in political protests was not simply reactive; it was intrinsically tied to the production of new political subjectivities and the emergence of forms of grassroots counterpower. This rejection of political representation (as delegation) finds aesthetic expression in Etcétera . . .'s work in a form of street theater that eschews representation entirely and instead uses theater as a means to catalyze and organize collective political protest and convoke an insurrectionary political subjectivity.

In the first days of 2002, with people's bank accounts still frozen, Argentina's currency board devalued the national currency by 200 percent. Dollars held in national banks were converted into the devalued national currency, which had the effect of destroying approximately a third of

savings held in them.[188] As Sandra Lorenzano writes, "The 'fat cats,' as always, saved their own hides"; in the months before the devaluation, "19 billion dollars in withdrawals poured out of the nation's banks, continuing a hemorrhage that the country's most powerful sectors had set in motion some time before."[189]

The devaluation sparked widespread protests against state institutions, banks, and international creditors, while rampant inflation produced even greater hardship for working people. It was in this context that Etcétera... organized a protest-cum-performance that channeled working Argentines' furious repudiation of the economic system and political class and organized its collective expression. The form the performance took is revealed by its title: *El Mierdazo*. This means "Big Shit," as well as a strike or assault with shit, while echoing a formulation often used to name popular uprisings (e.g., Cordobazo, Argentinazo, Caracazo).

As the artists have described it, the idea for *El Mierdazo* was inspired by vernacular expressions people used to describe their feelings of being oppressed and exploited. In the context of the financial crisis, "SHIT was a word that resonated in the vox populi," as people constantly referred to the "shitty government and shitty banks" (*gobierno de mierda* and *bancos de mierda*).[190] The artists literalized these vernacular expressions, while inverting the action implied by the common metaphor "the politicians really shit on us" (*cómo nos cagan los políticos*).

Etcétera... organized *El Mierdazo* through the popular assemblies in Buenos Aires that had been formed after the 2001 uprising. Zukerfeld explained this process to me in a 2006 interview:

> *El Mierdazo* was first convened by one of Etcétera...'s members [Polo Tiseira] who attended the big interneighborhood gathering of popular assemblies. After the uprising, people had created popular assemblies in each neighborhood, and these all met up together every Sunday. These assemblies were huge gatherings where everyone voted—voted to not pay the external debt, for example. So [Tiseira] went to this interneighborhood assembly and made the proposal for *El Mierdazo*: now that we had nothing, we should give back to the politicians the only thing we had left, our shit. The first Sunday they voted for *El Mierdazo*, but then, the next Sunday, the people who worked at the Congress said they were opposed to it because if people went and threw shit on the Congress building they were the ones who would have to clean it up. So it was decided that it would still happen, but that each person would bring the excrement in a little bag.

The performance was scheduled for the date in February when the Congress decided on the federal budget for the upcoming year. The television news that transmitted live from the popular assemblies helped to disseminate the plans for *El Mierdazo,* and Etcétera . . . members also directly contacted journalists and television news reporters and distributed flyers encouraging people to participate in the action.[191] As Zukerfeld said, "On the day of the action all the media was there waiting. And a lot of people showed up—especially senior citizens—with their little bags in hand."[192]

The performance began with a march along a major avenue, with some of the protestors depositing their holdings on ATMs, banks, and state buildings they passed along the way. The protestors gathered, "little bags in hand," in front of the National Congress building. Etcétera . . . laid out a red carpet that extended to the police barricades at the base of the building's stairs (plate 12). There they placed a toilet and a toilet paper stand holding a roll that had the phrase *sistema capitalista* (capitalist system) printed on each sheet. The members of Etcétera . . . , who wore masks to hide their identity, and other protestors held aloft banners and signs (some painted in feces) with slogans such as "Diputados y senadores: Hoy los cagamos a ustedes" (Congresspersons and senators: Today we shit on you). The performance's protagonist, played by Antonio "Checha" O'Higgins, wore a suit, tie, and a sheep mask. He lowered his pants and took a seat on the toilet (plate 13). Around his neck hung a sign reading "Me cago en el sistema" (I shit on the system). His role in the performance was the literalization of this phrase. With his duty discharged, he unsheepishly leaped to his feet and all of the other protestors hurled their own shit, in unison, onto the Congress building.

The form of *El Mierdazo* expresses a rejection of the ideology of representation by the bourgeois state. In it, theater is not an artistic mediation or a virtual space apart from the real world. Rather, it is a device for convoking, organizing, and giving aesthetic form to direct-action protest and to an emergent insurrectional political subjectivity. The way it connects this visceral form of theater to a rejection of the ideology of political representation is illuminated by Antonin Artaud's theory of nonrepresentational theater as festival. Artaud called for a complete rejection of representation in theater, arguing that the performance should not illustrate a text that preceded it, nor should the stage represent a present that would exist elsewhere.[193] Summarizing Artaud's theory, Derrida writes, "There is no longer spectator or spectacle, but festival, . . . [and] the festival must be a political *act* and not the more or less eloquent, pedagogical, and superintended transmission of a concept or a politico-moral vision of the world."[194] Artaud's critique of theatrical

representation is intimately connected to a critique of political representation (as delegation), as his understanding of the political sense of a public festival is animated by a vision of a community present to itself and, thus, without need for recourse to political representation.[195] *El Mierdazo* formally expresses a repudiation of the ideology of political representation, as it is, at once, a nonrepresentational theatrical performance in the sense that Artaud described and also a collective act of direct action whose politics is immanent to its performance.

As a collective, ritualized protest that culminates in the symbolic marking of an edifice, *El Mierdazo* resonates with the form of escraches. As with their escrache theater, Etcétera . . . describes the function of *El Mierdazo* as providing a "catalyst for protest." For the artists, *El Mierdazo* was a "social performance" that provided a cathartic outlet for a drive that was already present in the people. They described it thus in an interview with me:

ZUKERFELD: It's when there is a drive that needs to come out, come out, come out! But to be able to come out it needs something like lubrication. And I think our artistic experience functioned in that way: so that, for the participants in the protest at the Congress, we functioned like Vaseline.

DEVINCENZO: Like a laxative.

ZUKERFELD: Yes, like a laxative! That's true, because more than for going in, it's for coming out, right?[196]

The artists suggest that their function in organizing *El Mierdazo* was to enable people to collectively express ideas and sentiments they already had about political and financial elites, though these might have been inhibited or repressed. Like escraches, then, *El Mierdazo* can be understood as an expressive system, as García Navarro defines this. He argues that the social relationality of expressive systems corresponds to the nonrepresentational politics of the grassroots human rights movement; I would also suggest that the social relationality of *El Mierdazo* corresponds to the antirepresentational horizontalist politics operative in the sociopolitical conjuncture of which it formed a part. This is evident in the way *El Mierdazo* provided an aesthetic-political form that connected and gave expression to sentiments already circulating in the people, as well as in the process whereby it was discussed, organized, and adapted through the radical democratic practice of the popular assemblies.

More than the artists' laxative metaphor suggests, *El Mierdazo* brought a particular organizational process and politico-aesthetic form to people's

expression of their political sentiments, demonstrating the dialectical relationship Etcétera . . .'s situated theater has to the popular politics in which it is embedded. *El Mierdazo* was articulated with the popular politics seen in Buenos Aires at that time, including the insurrectionary spirit of the 2001 uprising and the horizontalist politics of the assemblies. The artists also choreographed a specific aesthetic-political experience and intervention in the public sphere: they organized widely felt political sentiments into a collective act of direct action, which they imbued with an anticapitalist and anti-state discourse and a liberatory and rebellious spirit. As the artists' analysis suggests, the aesthetic form they created with the protest was just as significant for the protestors as for potential spectators, calling our attention to the ways that aesthetic dimensions of political practices—and direct actions, in particular—shape their pedagogical function.

The ways in which *El Mierdazo* deploys both the symbolism of shit and its materiality intensify the performance's insurrectionary, radically democratic, and collectivist politics. It revives dead metaphors common to everyday popular speech by convoking others to collectively perform their literalization—and do so through a form of protest that involves an unusually intimate and creative relationship to their own body's excrement. In so doing, it emphasizes the material impact that neoliberal financial policies have on the living bodies of those persons on whom they are imposed. In other words, it zeroes in on a point where the seemingly immaterial character of transnational finance capital and monetary policy impacts people's flesh-and-blood reality. In a sense, the financial crisis and massive devaluation fully revealed the real costs to the people of years of neoliberal economic policies: they were left with shit, as *El Mierdazo* suggests.

El Mierdazo reimagines what it can mean to be left with shit after being fleeced by elites. While it emphasizes the material effects the upward distribution of wealth has on the bodies of workers, it organizes a symbolically potent action in which these same bodies are bearers of a rebellious political agency and capacity for self-organized collaboration. By performatively literalizing and inverting the action suggested by the common expression "Cómo nos cagan los politicos" (Politicians really shit on us), *El Mierdazo* traces a trajectory from people's awareness of their oppression to their enacted and collective repudiation of their oppressors and the economic system they serve. The performance's broad and nonidentitarian convocation of all of those who had been shit on by state managers, which cuts across different social positions and identities of nonelites, as well as its radically democratic mode of organization, are supported by its use of feces and defecation as

means of protest. It imbues the commonality of defecation with an affirmation of a common and elemental political agency. Reflecting the spirit of the broad-based mobilizations seen in Argentina at this time, *El Mierdazo* both participates in and allegorizes a process of collective politicization in which a common sentiment of abjection and betrayal becomes the basis for a collective rejection of a capitalist system that divides and atomizes those it exploits and oppresses in order to preserve itself.[197]

El Mierdazo choreographs a collective and public performance with defecation and human excrement, which are otherwise sequestered to individualized and private relations and spaces. This flouting of the social coding of bodies and spaces as public/private and social/individual, which functions as a powerful mechanism of social control and atomization, supports its convocation and representation of an insurrectionary collective subjectivity. Thus *El Mierdazo* allegorizes the movement from a positionality of oppression to collective revolt as being coextensive with a move from individualized subjective feelings and the atomized confines of private spaces and private property (e.g., individuals' feeling about their own diminished savings) toward collective action that creates a common space for refusal, based in similar experiences of exploitation and in a shared and unmediated political agency.

State Theater, Security, T/Errorism

[During the crisis] we said that capitalism was shit, a miserable system of so-cial life that created relationships incompatible with man's dignity. Today the return of [bourgeois] politics offers us inclusion in this sewer as its biggest prize.—Raúl Cerdeiras, "¿El regreso o la re-invención de la política? Algunas reflexiones pensando en la juventud Kirchnerista" (2011)

THE CRISIS OF HEGEMONY and popular uprising in Argentina in 2001–2 created an extraordinary opening for antisystemic movements, practices of social solidarity, and the enactment of popular politics that prioritized self-organization over mediation by state institutions.[1] However, these movements were also met with reactionary responses, which were regularly cloaked in the rhetoric of a return to "normality."[2] These took the form of "demands for state intervention (the return of the state) to guarantee order, enforceability, and security," which were seen as having been threatened by popular mobilizations.[3] The corporate media, which is largely controlled by sectors of the Right, fomented this reactionary response with a contemptu-ous antiplebian discourse that deployed the figure of the "dangerous classes" and discourses on insecurity to produce fear of the working and workless poor and dehumanize piqueteros, in particular.[4] While the depression and financial crisis had brought large sectors of Argentine society to perceive

the illegitimacy of the economic inequality neoliberalization had created, "the demand for normality worked to again naturalize—and, as a result, legitimize"—this inequality.[5]

The Argentine state appealed to and fomented reactionary responses to the crisis and uprising in its efforts to pacify the people and reconsolidate its hegemony. Evincing Gramsci's theorization of the modern liberal state as operating through "hegemony protected by the armour of coercion,"[6] the state reasserted its representational institutions while also repressing popular movements. In 2002 the interim president called for early federal elections; in 2002 and 2003 state forces forcibly evicted popular assemblies and worker-run recuperated businesses and jailed and assassinated leaders of the piquetero movement.[7] The state used these acts of repression to "erase the visible 'marks' of the society's self-organization and self-management" and establish the idea that the upcoming general elections would close the cycle of popular struggle that had been opened by the uprising.[8] The state's translation of some movement demands into reforms, as well as its incorporation of some movement leaders into the state bureaucracy, also helped to put a brake on popular mobilizations.[9]

GAC and Etcétera . . . responded to this changed political conjuncture. In the context of post-uprising pacification, they shifted toward the practice of ideology critique situated in scenarios and spaces that were immediate sites of political-ideological struggle. We might think of this as a shift from an offensive to a defensive strategy, as the latter focused on defending antiauthoritarian, anti-imperialist, and anticapitalist political imaginaries that had been developed within antisystemic movements.

The work of GAC and Etcétera . . . proffers a view of Argentine society in the wake of the 2001–2 uprising that counters the dominant narratives of "postcrisis" "recovery" and "normalization" in which the bourgeois state and global capitalist market are cast as the redeemers and benefactors of Argentina's working classes. On one hand, the narrative of financial "crisis and recovery" naturalizes the domination of people by transnational capital and celebrates the ecologically devastating, neocolonial model of extractivist capitalism as the savior of Argentina's people. On the other hand, the state's narrative of postcrisis normalization is a celebration of elite liberal governmentality against the "threat" of people power that was enacted and prefigured by popular movements. This narrative casts the bourgeois state as a redeemer of society after a period of chaos and as a benefactor that brought inclusion and uplift to dissident movements and the poor, thereby nullifying any motives for rebellion. The imposition and naturalization of these

dominant narratives is part and parcel of the counterinsurgent strategy to disarticulate and neutralize the radical politics of popular movements. This makes the alternate, critical perspective proffered by Etcétera ... and GAC all the more crucial.

In this chapter, I analyze a selection of interventionist works GAC and Etcétera ... produced from 2002 to 2005 that articulate a counter-counterinsurgent aesthetics, one that critiques the multiform strategies of pacification the ruling class deployed to repress and neutralize antisystemic movements, marginalize the practices of social solidarity and anticapitalist worldviews these movements had socialized, and socially atomize the people.

Works by GAC and Etcétera ... address intertwined methods of domination and social stratification liberal states exercise upon nonelites. Specifically, they interrogate two tactics in the overall strategy of pacification that were especially consequential for closing the period of popular mobilization in Argentina after 2001. One involved the reassertion of the ideology of political representation in the wake of its crisis. Etcétera ... examines the way this was accomplished through traditional institutions and practices of liberal representational politics, as well as through cultural institutions, the enfolding of social movement actors into state institutions, and the rescripting of popular histories into narratives in which the bourgeois state is cast as redeemer and benefactor.

A second tactic of pacification GAC and Etcétera ... critique is policing and the discourses used to legitimate it. Specifically, they address the ways that police power and its legitimating discourses of (in)security and terrorism are used to repress poor, racialized, and potentially rebellious subjects and enforce class stratification. In one sense, this continues GAC's and Etcétera ...'s practices of denouncing state-sanctioned violence against workers and political dissidents, as seen in their work in escraches. However, the work I examine in this chapter homes in on the ways that policing and its attendant ideologies also operate as and undergird forms of hegemonic rule in class society.[10] For example, I consider how policing works to produce subjects who are disposed to accept the established social order, including the violence that is used to defend it, and how fear is produced in order to enforce class stratification and consolidate state hegemony. As their work demonstrates the interpenetration of ideological and repressive mechanisms of domination and the interplay of hegemony and coercion, it specifically highlights their function for reproducing class relations. Thus it shows how the formation of proper citizen subjects is consubstantial with the criminalization and dehumanization of surplus populations, organized workers, and

other political dissidents, and how the state security apparatus provides both brute force and an ideological framework for accomplishing this.[11]

POLITICAL THEATER AGAINST POLITICAL THEATER

The nation-state performs its own being relentlessly.—Ngũgĩ wa Thiong'o, "Enactments of Power: The Politics of Performance Space" (1997)

The form and concept of theater have long served as privileged grounds for analyses of governance by modern states, particularly their naturalization of the ideology of political representation.[12] In the previous chapter, I addressed critiques of bourgeois theater as an ideological state apparatus that produces subjects predisposed to uncritically accept the status quo and delegate their power to others. Scholars have also shown how many other types of public performances (beyond the arts) function as acts of statecraft.[13] These acts of "political theater" seek to efface their own theatricality, naturalize their form, and render their production inapprehensible. They produce a *scene* that attempts to efface its character as a production, leaving only the *seen*—that is, an image of reality that would pass itself off as transparent or real.[14] With their absorptive aesthetics, they mobilize the ideological thrall of representation in its most powerful forms, interpellating subjects into roles within a script that was already composed, into "those transparent myths in which a society . . . can recognize itself (but not know itself)."[15] Etcétera . . .'s acts of situational street theater reveal the *seen* of state theater as a *scene* (i.e., a production) in order to interrogate its aesthetico-political function.

In the wake of the 2001 uprising, and in the context of flourishing grassroots autonomist movements, the Argentine state's assertion of elections and their political theater worked to put a brake on popular mobilizations and channel people's aspirations for social transformation into the electoral process and established parties, while reconsolidating the ideology of representation.[16] Facing intensified scrutiny after the state's assassination of two piquetero leaders, in July 2002 Argentina's interim president Eduardo Duhalde called for early presidential elections to take place in April of the following year. In March 2003, just ten days before the first round of elections, Etcétera . . . created a ludic performance that parodied rituals of electoral campaigning and critiqued their subjectivizing function. While the Argentine state cast elections as a means to rationalize and normalize political life (in opposition to popular politics), the absurdist nature of Etcétera . . .'s performance denaturalized electoral politics as a form of state theater.

In a raucous street performance titled *El Ganso al poder* (Power to the Goose), Etcétera... worked with over forty collaborators to perform an electoral caravan for their own presidential candidate: El Ganso. In the Argentine slang Lunfardo, *ganso* means "dimwit" or someone inept, so the performance associated these qualities with the political class. But Etcétera... created an absurdist spectacle by literalizing this term of ridicule and casting a real *ganso* (goose) as their candidate (... almost; they actually cast a white duck as El Ganso, as it was easier to snatch one from a local park—a feat the artists accomplished by "performing" as ice-cream vendors).[17] Wearing a presidential sash and framed by crimson bunting, El Ganso rode in a carriage painted like a globe, which (as the actors state in their video of the performance) was meant to symbolize his pretensions to "world domination." He was surrounded by actors representing the various characters of a party apparatus—advisors, the business lobby, hired thugs (*grupo de choque*), and local caudillos (*punteros*)[18]—as well as a throng of supporters whose vigorous marching was choreographed so they would occasionally bow down in unison to El Ganso. They wore T-shirts and carried signboards that bore images of El Ganso (figure 4.1). These consisted of the same graphic rendering of a goose's head in profile, though they were customized with garb associated with different political movements: one depicted El Ganso in Che Guevara's beret; in another he wears a keffiyeh; and he appears as a hippie in a third version. In a video of the performance, Federico Zukerfeld, who plays a member of El Ganso's cabinet, crows, "The Goose doesn't have a political platform. He has *all* the platforms that this postmodern era requires! And we want the people to know that, even if they don't vote, he will win anyway. And then we will achieve a surrealist world!"[19]

Etcétera... has described *El Ganso al poder* as a critique of the electoral strategy known as transversalism, through which Néstor Kirchner garnered support of centrist and center-Left parties from different voting districts in the 2003 presidential election.[20] I also read the performance as a critique of electoral politics more broadly, and of the Peronist Justicialista Party's machinations as a political apparatus. For the 2003 presidential election, the Justicialista Party uncharacteristically presented three candidates, including the Right-wing neoliberal Menem, and Kirchner, who represented the progressive wing of the party.

Using a strategy similar to their escrache theater, Etcétera... embedded their performance within a collective political action organized in reference to the history of the dictatorship, thereby bringing to that context a social critique that exceeded the normative parameters of human rights discourse.

4.1 Etcétera . . . , video still from *Etcétera . . . TV*, 2005, showing T-shirt from *El Ganso al poder*, 2003. Photograph courtesy of the Etcétera . . . Archive.

They staged *El Ganso al poder* within the annual march that takes place in Buenos Aires on the Day of Remembrance for Truth and Justice (March 24), a public holiday that marks the anniversary of the 1976 military coup and commemorates the disappeared and their struggle.[21] *El Ganso al poder* critiqued Argentina's political parties, the pageantry of elections, and the sham version of democratic participation they theatricalize. This reiterates Etcétera . . .'s long-standing critique of liberal politics and amplifies this critique as it was made by popular movements that flourished in the context of the crisis. As Etcétera . . .'s work consistently critiques the (neo)liberal state's role in reproducing the capitalist social order that brings exploitation and oppression to the masses, their staging of a critique of the state's ideological pageantry on the Day of Remembrance is wholly consistent with their heterodox and radical reading of human rights politics.

El Ganso al poder is an example of electoral guerrilla theater, a technique Larry Bogad has identified whereby activists "desacralize and satirize the electoral ritual."[22] Within this international tradition of protest performance, *El Ganso* resembles a 1968 protest performance by members of the

Youth International Party (better known as the Yippies). As part of protests leading up to the 1968 Democratic National Convention in Chicago, Abbie Hoffman and Jerry Rubin held a press conference where they announced the presidential candidacy of a pig named "Pigasus the Immortal." These performances by the Yippies and Etcétera . . . both proffer absurdist critiques of the spectacle of electoral politics and the monopoly on state politics exercised by established capitalist parties. By proposing nonhuman animals as candidates, they suggest that the electorate's agency exercised by voting in liberal democracies does not actually involve a real engagement in governance but is more like choosing a mascot for a game to which they are spectators.

The hodgepodge of discordant political symbols that appear in *El Ganso* suggests a cynical appropriation of signs of political difference that empties them of their meaning. The series of portraits of El Ganso, in which the same image is customized with politically symbolic garb, represents politicians' professed platforms as superficial and interchangeable "costume changes." It depicts electoral campaigning as a deployment of logo-like political signifiers in a bid for identification that is detached from possibilities for real change (it's the same Ganso in every image) and ultimately serves to amass power for a political mafia (represented by the apparatus surrounding El Ganso). This can be read, on one hand, as a critique of the way the Justicialista Party functions, as Alberto Bonnet writes, as a "mere apparatus of domination available for whatever bourgeois politics that materially guarantees its reproduction as an apparatus."[23] In light of the way federal elections put a brake on the escalation of popular mobilization in Argentina after 2001–2, *El Ganso al poder* also suggests that the content of the candidates' platforms was less significant than the politico-aesthetic effect of electoral theater for reconsolidating the ideology of political representation and channeling people's energy and desires for change toward electoral politics and away from antisystemic movements.

El Ganso al poder emphasizes the central role of aesthetics in channeling people's desires toward electoral politics. In it, the electoral spectacle—with its excessive fanfare, grandiose rhetoric, and the sea of contrasting political signifiers—swirl around a duck who looks particularly indifferent to it all. It depicts electoral politics as depending on the choreographed production of a popular sentiment and the management of its performance. In addition to its specific critique of the 2002–3 electoral campaign and elections in Argentina, *El Ganso* proffers a counterhegemonic representation of liberal states' electoral politics by depicting them as a kind of theater whose principal function is to produce manageable subjects. Within the scene of "politics" the performance

stages, there is no self-determined popular subject; El Ganso's partisans only act in the capacity of followers and promoters of their candidate. Political affect appears as an aggressive, almost delirious identification that is obviously disconnected from any concrete political position. Despite the abundance of references to heterogeneous and contradictory political movements that appear in *El Ganso*, in the end it is all an exaggerated exaltation of just one "candidate." This suggests that the spectacle of ideological diversity by polyarchic governments works in the interest of a changing-same: the rule of capital stewarded by an entrenched political class and party apparatus.

Etcétera . . .'s portrayal of electoral pageantry evokes Walter Benjamin's famous critique of fascism's "introduction of aesthetics into political life," while making clear that this is in no way unique to fascist regimes. Benjamin wrote, "Fascism sees its salvation in giving these masses not their right, but instead a chance to express themselves. The masses have a right to change property relations; fascism seeks to give them an expression while preserving property."[24] *El Ganso* highlights the power of aesthetics in contemporary electoral politics—to mobilize and organize people, to create an appearance of ideological diversity where there is little, and to organize social rituals that function as simulacra of participation—while showing this to function as an elaborate ratification of the existing capitalist order and its managers. This implies that strategies of ideological domination Benjamin observed in twentieth-century fascism are not wholly unlike those deployed by nominally democratic (neo)liberal states in the twenty-first century.

KIRCHNERISM AND THE RETURN TO "NORMAL CAPITALISM"

In 2003 Néstor Kirchner was elected to the Argentine presidency, inaugurating a twelve-year period of Peronist progressive populism, known as Kirchnerismo, that would be carried forward by his successor and wife, Cristina Fernández de Kirchner (2007–15). Verdú argues that, in the wake of the social process that had its strongest expression in the uprising of 2001 and that brought the legitimacy of the Argentine government's institutions into question, the bourgeoisie's mandate to Kirchner was to reestablish this legitimacy to ensure governability, and this is precisely what he did.[25] Similarly, Bonnet argues that Kirchnerismo amounted to the "restoration of the bourgeois order that had been refuted by the insurrection of 2001," although the insurrection "determined the distinctive characteristics Kirchnerismo's bourgeois restoration took."[26]

After taking office, Kirchner promoted economic and political stabilization, an appeal to order and security, and a vision of Argentina's future under what he called "normal capitalism"—that is, the pursuit of capitalist development not characterized by extreme neoliberal adjustment. In the first years of his presidency, Kirchner rebuilt an organic base for the discredited Justicialista Party, preserved the party's alliances with the ruling class, and neutralized oppositional social movements by combining a liberal economic program with "human rights measures and widespread but minimalist welfare policies."[27] Kirchner's political discourse pitched to the so-called public opinion formed by the corporate media and its demands for a "return to order" after the crisis.[28] In so doing, he "emphasized a contraposition between street protests and 'institutional normality'" that stigmatized protest and specifically promoted the idea that Argentine democracy was threatened by piquetero groups.[29]

El Ganso al poder anticipates certain Left critiques of Kirchner's government. In *El Ganso*, signifiers of Leftist movements are vigorously deployed in a scenario of ideological recognition, which we are made to understand has no necessary connection to the "candidate's" political program. Similarly, some Leftist intellectuals criticized Kirchner's government, as well as other centrist governments of the Pink Tide, for putting forth a political discourse that was far more Leftist than their actual policies. For example, Francisco de Oliveira argues that the governments of Kirchner in Argentina and of Luiz Inácio "Lula" da Silva in Brazil both enacted "hegemony in reverse": a mode of domination wherein the dominant class concedes the political discourse to the dominated because the economic bases of domination are not in question.[30]

While Kirchner adopted a strong anti-neoliberal and Latinamericanist rhetoric, his government's development model, including its policies toward natural resources, facilitated processes of capitalist accumulation by transnational finance and extractivist industries that displayed significant continuities with the established neoliberal model.[31] William Robinson argues that the governments of Kirchner, Lula, and the Socialist Party in Chile were all able to usher in a new wave of capitalist globalization in South America with "greater credibility than their neoliberal predecessors" because they were able to deploy "new mechanisms for consensual domination and hence governability." They were able to "de-radicalize dissent and ameliorate social unrest by being less exclusionary than the neoliberal state in terms of the politics of redistribution," he contends.[32]

Kirchnerism promoted an "ultra-centrist" political culture organized around "an exclusionary dualism," wherein political positions were framed as being either pro- or anti-Kirchner and Left critics of Kirchnerism were

accused of strengthening the Right.[33] As a consequence, struggles for radical social transformation that had gained momentum in the early 2000s were marginalized.[34]

To reconsolidate state hegemony, Kirchner's government expropriated power from popular movements in a way that undercut their transformative potential.[35] It incorporated actual and potential leaders of movements and subordinate groups into state institutions in a successful "effort to prevent the formation of counter-hegemony."[36] This deracinated the antagonistic and transformative elements of those social organizations that aligned with the state and eliminated their autonomy, while those movements that did not align with the state were stigmatized.[37]

Kirchner also promulgated a political narrative that enforced the state's monopoly on politics in the social imagination, while rendering illegible the political significance of antisystemic movements and popular politics. As Raúl Cerdeiras argues, Kirchner represented 2001–2 as a time of anarchy and suffering and claimed that he had returned Argentina to order and brought about a "return to politics," where "politics" took the form of "state-as-rescuer."[38] Moreover, Kirchner represented the progressive reforms his government made "as if these were autonomous decisions of the Kirchner conglomerate" and not the result of the long labor of movements and their resistance to neoliberalization since the 1990s.[39]

As Verdú writes, the "human rights movement was one of the most explicit targets of the politics of cooption of the [Kirchner] government that had decided to inscribe itself in history as 'the government of human rights.'"[40] After his election, Kirchner formed a "political pact" with major human rights organizations, such as the Madres de Plaza de Mayo.[41] While doing this and discursively affiliating himself with the militant generation of the 1970s, his government overturned the amnesty laws that had maintained impunity for repressors from the dictatorship and forced some top military officers to retire.[42] With the city of Buenos Aires, his administration opened the Espacio Memoria y Derechos Humanos (Remembrance and Human Rights Center). This cultural institute interprets the history of Argentina's most recent dictatorship and the human rights struggle, supervises memory initiatives in Buenos Aires, and provides institutional support for human rights organizations, including the Madres de Plaza de Mayo and HIJOS.

While these reforms are salutary in many regards, Leftist scholars and human rights activists have pointed out their limitations, as well as their function for legitimating the Kirchner governments. Petras and Veltmeyer argue that because Kirchner's reforms did not significantly affect

the "nature of the public institutions and their political class allegiances," they left intact the conditions that could again produce an authoritarian capitalist state regime.[43] Verdú's critique focuses not on the potential of mass repression but on the actual repressive politics of the Kirchner governments. She is a founding member of CORREPI (Coordinadora contra la represión policial e institucional/Coordinator Against Police and Institutional Repression), a grassroots human rights organization that focuses on current police violence and advocates a class analysis of state repression. She points out that the trials opened by Kirchner's government "do not affect people upon whom the structure of the state's repressive apparatus currently rests."[44] To illustrate her point, she notes that, while one man was tried for his involvement in repression during the dictatorship, his son, who was the chief of the Federal Police, was professionally rewarded after his involvement in repressing popular mobilizations, including the deadly repression that followed the 2001 uprising. While the son was useful to and protected by Kirchner's government, the father was not, so he could be sacrificed.[45] Some see the Kirchner governments' overtures to human rights (namely, as this pertains to the last dictatorship) as being in contradiction with its own repressive practices. But Verdú argues that these must be understood as part of a single, calculated political strategy that uses the manufacture of consent to achieve its ends. That is, Kirchnerism's human rights politics was a tool that allowed the government to "propagandiz[e] its profile as 'progressive' and almost 'leftist,'" while repressing organized movements and the popular classes.[46]

While Kirchnerism's policies about repression under the dictatorship translated into significant political capital for the government, it undermined the combativeness and autonomy of the human rights movement.[47] The institutionalization of its leading organizations led to fragmentation in the movement and conflict among militants, particularly between those who had focused exclusively on impunity and those who criticized policies of the Kirchner administration.[48] In the trials, human rights organizations came to occupy the same position as state functionaries insofar as they pressed charges on behalf of the government. Verdú contends that, once in this position, the organizations were made to function as a "permanent factor of legitimation for Kirchnerism." Moreover, she argues that the proceedings put such extensive demands on these organizations that they were able to do little else.[49]

Etcétera... members Loreto Garín Guzmán and Federico Zukerfeld reflected on the postcrisis period of "normalization" under Kirchner when I interviewed them in 2013 (during the administration of Fernández de Kirchner). Garín Guzmán said, "We were beginning to see everything that was

going to be included in order to generate a hegemony—a hegemony that is very dangerous because we are not in a socialist social project. It is a capitalist project—what they call 'friendly capitalism' or 'social capitalism,' but it's a kind of capitalism."[50] Zukerfeld said that one of the factors that made possible "the process of normalization that occurred in the country postcrisis was the recuperation of symbolic capital that before belonged to antagonistic elements." Both artists saw the integration of formerly autonomous human rights organizations into state institutions, as well as a certain legitimation of escraches, as factors in this "recuperation of governability" after the 2001–2 uprising. Garín Guzmán suggested that the public image the Madres de Plaza de Mayo and HIJOS had in Argentine society by the time of the crisis—given their status as victims and the fact that many consider them to be morally irreproachable—made them an especially important antagonistic element to include in the new postcrisis hegemony.[51]

As Kirchner's government adopted language of the human rights movement as its own and formed a pact with organizations that had been the movement's most public figures, the context for GAC's and Etcétera . . .'s work changed significantly.[52] As members of GAC have described this, they saw the language and symbols they had produced in collaboration with human rights organizations lose their antagonistic potency as they were recontextualized within official discourse.[53] The group cites this dynamic when explaining their turn toward a critique of those forms of state violence left uninterrogated by the state's human rights politics, such as police violence and the discourse of security that provides it ideological cover.[54]

In a context where the state's deployment of human rights discourse operated as a form of hegemonic counterinsurgency, these artists' more radical vision of the human rights struggle and the history to which it pertains became ever more meaningful. Their counter-counterinsurgent aesthetic interventions point to the contradictory nature of politicians' representation of the liberal state as a defender of human rights. They suggest that, given the systemic class-based violence the state deploys and legitimates, its embrace of human rights discourse functions as a form of ideological whitewashing.

MEMORIALIZATION AS WHITEWASHING: LIMPIEZA GENERAL

On the Day of Remembrance in 2004, which marked the anniversary of the 1976 military coup, Kirchner presided over a public ceremony that announced the creation of the Espacio Memoria y Derecho Humanos. Although the state

had created other cultural spaces memorializing the history of the dicta-
torship, the Espacio had special political significance and symbolic charge,
owing to its location, controversy surrounding its mission, and its meaning
for Kirchner's public image. The Espacio is housed in what was formerly
the campus of the Escuela de Mecánica de la Armada, known as the (now,
ex-)ESMA. During the civil-military dictatorship of the Proceso de Reorga-
nización Nacional, the ESMA housed one of the regime's largest clandestine
detention and torture centers. When, in the early 2000s, the city of Buenos
Aires and Kirchner moved to use the site as an educational institution that
would house a "museum of memory," there were extensive debates among
different human rights groups, organizations of former prisoners, and family
members of the disappeared about the institute's mission, programming, and
architecture.[55] Meanwhile, Right-wing activists and journalists, including
apologists for the state terrorism of the Proceso and members of a citizens'
security movement, protested the establishment of the institute altogether.
Their assertion that the Espacio did not address the human rights violations
that were of concern to them neatly demonstrates the political ambiguity of
liberal human rights discourse.[56]

Kirchner used the inauguration of the Espacio to stage a major act of po-
litical theater in which he hitched the public image of his administration
to the history of the 1970s and the human rights struggle. Scholars have re-
ferred to it as "one of the most significant inaugural acts of his presidency"
and a key moment in his development of a distinctive discourse and identity
as president.[57] In the public ceremony, Kirchner characterized the creators
of concentration camps like that which ESMA had housed as "assassins re-
pudiated by the Argentine people," and he apologized on behalf of the state
for the "atrocities" of the dictatorship and its decades of silence about them.
He memorialized the militant generation that had been its victims and
rhetorically aligned himself and his administration with their legacy.[58] The
ceremony also publicly staged Kirchner's alliance with certain human rights
organizations, such as the Madres and HIJOS. Beatriz Sarlo argues that,
because Kirchner did not have a relationship with these organizations before
he assumed the presidency, he needed to performatively produce it through
such public speech acts.[59]

Etcétera . . . staged a guerrilla performance at the ceremony that denatu-
ralized its function as an act of state theater and challenged the political
narrative it put forth. The artists took as inspiration for their performance
the fact that Kirchner had just removed portraits of generals who had been
part of the military junta from their place of honor in one of the ex-ESMA's

¡Limpieza General!

jabón

Brisa Marina

Es la mejor opción para quitar manchas difíciles.
Brisa Marina puede conseguirse también, en polvo o en Pan puro.
Un producto para el "tocador", ideal para lavaditas de cara o manos, recomendado para el lavado de cabeza.
Aplique corrientemente
¡Limpieza General!
Para uso diario:
garantiza el efecto burbuja.
Su formula efectiva, testeada en mas de 30.000 personas, a dado, hasta el momento, resultados no favorables.
Fabricado en la Argentina pero de procedencia alemana.

¡Limpieza General!
Ya es parte de su kit familiar.
Tras 28 años de experiencia declarándole la guerra a *la suciedad...*

¡Limpieza General!
Chau a las Manchas
Mode de uso: Lave su cuerpo masajeando suavemente.
Deje actuar. Repita la operación.

Produce y distribuye: Etcétera...
ni olvido, ni perdón
no usemos el jabón

4.2 Etcétera..., *Limpieza General* (General Cleaning), flyer distributed in performance, Buenos Aires, 2004. Photograph courtesy of the Etcétera... Archive.

buildings. Etcétera...'s darkly humorous performance imagined an expunged portrait animated, returning to the former ESMA campus to join in the state ceremony. Federico Langer dressed as Etcétera...'s stock character of the Military Officer, although this time he wore the white uniform of a naval officer. He wore a wooden picture frame that stood upright before his head and shoulders, framing him like a living portrait (plate 14).

The artists distributed bars of hand soap wrapped in a flyer titled "Limpieza General" (General Cleaning; figure 4.2). This phrase refers to "spring cleaning" and to the changing of personnel. In the context of the state ceremony, it alluded to the removal of the navy from the buildings and the "cleaning" of the site, which was exemplified by the "general cleaning" enacted with the removal of the genocidal generals' portraits. The flyers were printed with a poem by Etcétera... that mimicked the language of advertising to vaunt the qualities of the "Marine Breeze"–scented soap (in reference to the Naval School).

My abridged translation of Etcétera...'s poem:

General Cleaning!
Marine Breeze
Soap

It's the best option to get rid of
tough stains . . .
ideal for washing faces or
hands, recommended for
brainwashing. . . .
Its effective formula, tested on
more than 30,000 people,
has, up to now, produced
unfavorable results.
Made in
Argentina
but of
German origin.
General Cleaning!
Now it's part of your family's kit
After 28 years of experience
declaring war on
filth
General Cleaning!

Goodbye stains . . .
Produced and distributed by: Etcétera . . .
No forgetting, no forgiving
Let's not use the soap

The poem's social critique (as well as the potential for varied readings of its politics, discussed later) turns on the multiple meanings with which it invests signifiers of cleaning. It clearly makes reference to the "social cleansing" performed by the Proceso in its allusions to the twenty-eight-year anniversary of the military coup, the thirty thousand disappeared, and the junta's use of metaphors of hygiene and purity in its security discourse.[60] In the context of the ceremony at the ex-ESMA, this could be read as a triumphalist account of the founding of the Espacio Memoria in the former naval campus, as if the dictatorial legacies of the Argentine state have themselves been made into the object of a *limpieza general* (as a spring cleaning and a change in personnel). This interpretation of *limpieza* would affirm the message the state ceremony put forward, which has been echoed by scholars who claim that the ceremony signaled nothing short of "the restructuring of the social order through the establishment of a new political contract in which human rights, justice, and memory vanquished impunity and forgetting."[61] But I would argue that, if Etcétera . . .'s poem and performance invites such a reading, it does so only in order to critique its credulousness vis-à-vis the state's political theater.

The visual elements of Etcétera . . .'s performance, as well as the varied meanings "cleaning" has in the poem, undermine a triumphalist and state-aligned interpretation of Kirchner's inauguration of the Espacio. While Kirchner's act of removing the generals' portraits meant to symbolically expunge their legacy from the public image of the state under his own administration, in Etcétera . . .'s performance the portrait returns to haunt the state ceremony. In the poem, signifiers of "cleaning" also refer to historical erasure and "brainwashing" as performed by the state ceremony at the ex-ESMA. The visual reference to the removal of the portraits and the poem's reference to "getting rid of tough stains" (*quitar manchas difíciles*) suggest that the repurposing of the ESMA campus is an attempt to eliminate the "stains" of state terrorism on the Argentine state's recent history, as well as visible marks of the armed forces' continued adulation of state terrorists. This operation is then likened to "brainwashing" (*lavado de cabeza*). The careful management of an isolated blemish, which stain removal suggests, is an apt metaphor for the way the government's memorialization of state terror as an "exceptional,

pathological occurrence elides its central role in the formation and preservation of modern states."[62] Therefore the poem's metaphors of stain removal also refer to the state's careful management of perceptions of its own history and function, which amounts to a whitewashing of history and "brainwashing" as perception management.

Guillermina Seri argues in her analysis of the creation of the Espacio Memoria that the Argentine state's memorialization of and apologies for past state terror is a means of atoning for the past without bringing into question the legitimacy of its own forms of governance. As I argued in chapter 3, the ideological division of the dictatorial past from a purportedly postviolent present undergirds hegemonic human rights politics. Human rights politics' ability to "archaize" terror, to use Allen Feldman's term, is especially useful for the postdictatorial state's consolidation of its hegemony. Thus the state's memorialization and museumization of a recent history of state terror performatively instantiates the archaization imposed by human rights' redressive framework.[63]

It is not only the ongoing violence of the liberal state that is whitewashed in the state's theater of memorialization, but also the class and political conflict of the time period it purports to represent. The Argentine state's human rights discourse participates in a dominant form of contemporary memory politics that, as Eugenio di Stefano writes, "takes one type of conflict (between capitalism and communism) and re-describes it as another type of conflict (between human rights and authoritarianism)."[64] The state's vaunting of a human rights politics focused on war crimes of the dictatorship, and its carefully delimited depiction of the history and legacy of the disappeared— that is, as martyrs or as having engaged in an "impossible politics"[65]—effaces the class warfare that was the foundation of this history. It provides "a vision of the past divided into victims and perpetrators rather than into rich and poor," and it erases the anticapitalist politics of those militants targeted by state terrorism.[66] The substitution of a critique of capitalism by a critique of authoritarianism, which is performed both by hegemonic post-Transition human rights regimes and their cultural complement in memory politics, naturalizes the liberal social order and depicts incremental reforms to it (e.g., Kirchner's "friendly capitalism" and human rights concessions) as the only possible horizon for social change.

Limpieza pointedly turns the discourse of the human rights movement against the state-led project that purports to represent it. The rhyming couplet that concludes the poem cites a well-known slogan of the movement: "Ni olvido ni perdón" (Neither forgetting nor forgiveness). Its longer

version, popularized by HIJOS, also refuses reconciliation: "no olvidamos, no perdonamos, no nos reconciliamos" (We do not forget, we do not forgive, we do not reconcile). By yoking the first part of this slogan to the refusal that follows, "No usemos el jabón" (Let's not use the soap), the couplet equates "the soap," as a symbol of the state's limpieza of the ex-ESMA, with reconciliation, while exhorting its readers to reject both. This is all the more pointed, given that major human rights organizations associated with the politics of nonreconciliation had aligned themselves with Kirchnerism and were present at the state ceremony.

Kirchner's reopening of trials of perpetrators of state terrorism and his support of organizations like the Madres might suggest a rejection of the politics of reconciliation, which has largely been associated with official impunity. Indeed, when Hebe de Bonafini, president of the Asociación Madres de Plaza de Mayo (Mothers of the Plaza de Mayo Association), described the motives for the Madres' rapprochement with Kirchner, she emphasized his departure from Menem's policies of impunity.[67] However, Seri argues that Kirchner ultimately *did* appeal to a politics of reconciliation, albeit through a strategy significantly different from Menem's. Both of their governments "express alternatives through which the democratic state seeks to turn atrocities and sites of slaughter materialized by its previous, authoritarian face into narratives and spaces where a reconciled and re-imagined national community can come together to 'move on,'" she writes.[68]

By invading the ceremony at the ex-ESMA with their own situational performance and poetic polemic, Etcétera . . . pushed its audience to interrogate the ceremony's function *as a kind of theater*. *Limpieza General* denaturalized the stagecraft of the state ceremony and reframed it as a scene of nationalist hailing. The ceremony carefully managed people's confrontation with a space that was part of a well-known history of state terrorism *and* part of the normalized operations of the armed forces. This was presided over by the president, who symbolically performed a redemption of the state by apologizing for its past crimes, thereby situating its violence in the past. Kirchner's speech moralized history and situated him on its "right side," as part of the "family" of human rights defenders and "compañero" of the disappeared. It reinforced the ideology of political representation, threading it through notions of family, political camaraderie, and the moral redemption of the capitalist state. Thus the ceremony hailed its spectators as citizen-subjects of a beneficent state and a national community, which it cast in familial terms. The subject this performance hailed is, in short, the liberal subject of hegemonic human rights discourse that "seeks a mode of freedom dependent on the be-

nevolence and enlightenment of the powerful, and which dutifully circuits all its aspirations and desires for equality and justice through the regulatory structures of Law."[69]

Limpieza General repudiates Kirchner's claim that his government represents the politics of the disappeared. Even more polemically, it associates the "whitewashing" and "brainwashing" performed by the contemporary state's memory politics with the politics of the Proceso. Though this may seem polemical from the perspective of a dominant human rights discourse, in which authoritarianism and the vindication of human rights are cast as the opposite bookends of political possibility, Etcétera...'s comparison reflects a historical materialist understanding of the role of the liberal state in general and of Kirchner's counterinsurgent and capitalist political program in particular. Kirchner's "redemption" of the bourgeois state amounted to the promise of hegemonic subjection to it (vaunted over a history of coercive domination) and the ideological consecration of the nation-as-family. *Limpieza General* refutes Kirchner's claim upon the anticapitalist political struggle of the disappeared and calls our attention to the historical erasure and perception management his performance of "redemption" entails. In so doing, it clearly demarcates different political strategies encompassed by the human rights movement. The anticapitalist politics Etcétera... always brought to their art and activism refuses alignment with the capitalist-colonial state and genuflection to its functionaries.

The reception of *Limpieza* further demonstrates the divisions within the human rights movement that became more salient after the institutionalization of some of its leading organizations. Hebe de Bonafini publicly denounced Etcétera...'s performance on television and claimed that their poem was among several threats she had received from ultra-Right-wing groups. The artists of Etcétera... were floored by Bonafini's reaction, especially since she and the Madres knew their group. "That the Madres would publicly denounce us [*nos escrachen*] was the worst thing that could happen to us!" Zukerfeld said.[70] Nancy Garín recalls, "It was quite violent for us. The next day we went to the Madres' House to meet with them and explain the situation. They didn't let us enter."[71] With help from members of Abuelas de Plaza de Mayo (Grandmothers of Plaza de Mayo) and Madres de Plaza de Mayo Línea Fundadora, the artists were eventually able to explain their intention with *Limpieza General*.[72] When I asked members of Etcétera... about this controversy, they stood by the critique the work made and affirmed the importance for their group of being able to take positions autonomously from political organizations.

In our 2013 interview, Zukerfeld and Garín Guzmán analyzed the consequences of the institutionalization of the human rights movement after a decade of Kirchnerism. Garín Guzmán observed that the autonomy of the Madres and HIJOS had significantly diminished under the Kirchner administrations. While noting that "there are still certain ethical elements and concerns on the part of individual subjects that form part of these human rights organizations," she believed that the organizations themselves have "almost become standard-bearers in defense of the current government," with the result that they don't have sufficient distance from it to be able to critique the social exclusions it perpetuates. For Garín Guzmán, the dynamism Madres and HIJOS had once had was rooted in their autonomy from the state and its institutions, as well as their difference from institutionalized political organizations in their modes of action and self-organization. This had given these organizations an "experimental dynamic" and the ability to address current problems with autonomy from the state, she said, adding that this autonomy is of special importance given the long-standing problems with corruption in the Argentine state. She also noted that, as the human rights movement was "appropriated by Peronist political parties," the social memory of the role Left political parties, such as Trotskyist parties, had in the movement was being erased. "It is terrible that human rights organizations are participating in this negation of a social sector whose demands are just, because that is a very powerful negation," she said.[73]

Zukerfeld criticized Kirchnerism's deployment of a redemptionist political narrative as an erasure of histories of self-organization and popular power:

> [Now] one is supposed to thank Kirchner, as if *he* did it, and not that we did it ourselves. . . . Yet I always think of all the pressure [people exercised] over so many years; seeing my father going to protest in the Plaza de Mayo over so many years; seeing so many people who were struggling. . . . We achieved this ourselves. It's not that some guy came to power and said, "What nice people, let's help them out." So the story that is being constructed now has to do with the fact that now *they* are the ones who set the political agenda, who control it. . . . And many of us end up excluded. Many of the protagonists become consumers of the circus of memory.

Zukerfeld argues that Kirchner's appropriation of the human rights movement's discourse threatens to efface the social memory of the movement itself as a decades-long, multigenerational popular struggle whose true protagonists were not members of the political class. He also suggests

that state-led liberal human rights politics effaces the political subject that emerged with the popular movement, which is emblematic of self-organized popular power, and replaces it with a subject interpellated as a consumer of political narratives constructed by the ruling class.

Garín Guzmán also criticized the strategic use of state narratives about human rights to deflect questions about the political economic project the state was pursuing:

> In the present, a narrative is being constructed that is going to be very difficult to change in the future because it is an official narrative that is being constructed with the voice of the victims, with the voice of the "good guys," we'll call it. And this narrative is being used to hide, to stop discussions about, to stop transforming other spaces that are more interesting, namely, the economic project that is behind all of this. Thus, it is as if human rights, being such a fundamental, important banner, is transformed into a palliative.[74]

NORMALIZATION, PACIFICATION, SECURITY

Security is what the bourgeois class demands once it has exploited, demoralized, and degraded the bulk of humanity.—Mark Neocleous, Critique of Security *(2008)*

Inseguridad es la policía en la calle. *(Insecurity is the police in the streets.)*—CORREPI, "Boletín informativo no. 779" *(2016)*

In the period of "normalization" following 2001–2, policing and its legitimating ideology of security were used to reconsolidate state hegemony, socially atomize the people, and marginalize practices of social solidarity and collective self-determination that antisystemic movements had socialized. The counter-counterinsurgent interventionist art GAC and Etcétera . . . produced in this conjuncture addresses the central and multifaceted role of police power to the liberal state. In contraposition to the populist Kirchner government's representation of a redeemed state redeeming its people, their work argues that the state's hailing of citizen-subjects is *coextensive* with its violence against those subjects it has deemed a threat to the capitalist social order.

The work of GAC and Etcétera . . . does more than critique the coercive violence of the liberal state; it examines the centrality of policing in *hegemonic* governance—that is, in the production of subjects who consent to be ruled and who reproduce a stratified social order. It shows how the liberal

state produces subjects who perceive their own enjoyment of citizenship to be bound to their need for the state to protect them and their property. As their work traces the traffic between forms of violence and ideologies of security that have been deployed by liberal-colonial, authoritarian-neocolonial, and neoliberal states, it suggests that liberal subjects willingly embrace authoritarian practices when these are deployed against groups that have been ideologically constructed as disposable and/or threatening. In short, their work reveals the embrace of the police state that is at the core of liberal subjectivities. As GAC and Etcétera . . . interrogate the legitimation and naturalization of state violence, they suggest that the very possibility of perceiving this violence or recognizing its victims is overdetermined by class relations and the ideologies that flow from these.

Neocleous and Seri offer useful conceptual tools for understanding the political technology deployed in the exercise of state power that goes by the name of "security" but that is better described, as Neocleous argues, as pacification.[75] Both scholars suggest that pacification articulates repressive and ideological dimensions of state power. It not only entails the use of police to crush opposition to the bourgeois social order; it also involves the "shaping of the behaviour of individuals, groups and classes, and thereby ordering the social relations of power around a particular regime of accumulation."[76] Seri uses the concept of the "security *dispositif*" or "security apparatus" to analyze how this process is articulated across different domains of the state and civil society, including the police, law, and the corporate media.[77]

With neoliberal globalization's surplussing of large sectors of the working class, policing practices and new discourses of security play an increasingly central role in reproducing class relations.[78] States "isolate and neutralize the real or potential rebellion" of the poor and dispossessed by criminalizing them, and discourses of security and crime aid in the political and ideological construction of surplussed workers as societies' "internal enemies."[79] These discourses also manage social perceptions of violence by representing people's resistance to oppression as threatening and uncivil, while casting state violence as politically neutral and even beneficent.[80]

In the 1990s, in the context of post-Transition neoliberalization, the Argentine state and its ideological apparatuses produced a new discourse on security that associated crime with poverty and the poor. Politicians and the corporate media installed the problem of crime at the center of the social imaginary. They represented it as a national problem and made (in)security a way of describing reality.[81] Seri argues that the security apparatus operative in Argentina since this time breaks society into two groups: the poor are cast

as *delincuentes* (criminals), and "the wealthier, perceived as in need of protection, are turned into decent citizens, *la gente* [the people]."[82] The corporate media plays a key role in this class-based "casting" as it peddles representations of crime organized around a basic narrative plot in which middle-class citizens are victimized by slum-dwelling criminals.[83] The class-based division of society the security apparatus performs produces an "imagined community of decent Argentine families" that are bound by their fear and by the collective demand to neutralize or eliminate those who are perceived as threatening them.[84]

The criminalization of the working and workless poor in Argentina enables their subjection to a "permanent state of exception" and their effective exclusion from full citizenship, Svampa argues.[85] The state's repressive apparatus subjects them to arbitrary detention, torture, summary execution (*gatillo fácil*), and police raids (*razzias*) that are used as a form of intimidation and social control.[86] These phenomena are not exceptions to the normal functioning of the liberal state, nor are they "remnants" of dictatorship.[87] Rather, as Verdú writes, they are manifestations of the liberal democratic state's "policy of repression that is unleashed upon determined sectors of the population . . . , which is supported by judicial and legislative policies."[88] "Poor, dark-skinned young persons" are the principal victims of these policies, which organize, legalize, and naturalize what Verdú refers to as the "invisible repression" of the democratic state." The corporate media regularly renders invisible the state violence that is systematically unleashed on the popular classes.[89] Even when it is acknowledged, it is not perceived as the "application of a state policy, and much less as a violation of human rights."[90]

The machinations of the security apparatus in the early 2000s demonstrate how the criminalization of the oppressed serves the function of social control in moments of hegemonic crisis.[91] The state's discourse on (in)security was part of the reactionary backlash against the mobilization and movements of the popular classes. Spaces of popular politics opened up by the 2001 uprising fomented practices of social solidarity and enabled the mixing of people of the middle and popular classes. By "making individuals perceive each other as a threat," security ideology worked to reestablish the social stratification of nonelites and erode their potential for collective political action.[92] Politicians called for tough-on-crime (*mano duro*) policies, including the "broken windows" policing developed in New York in the 1990s.[93] The media promoted the idea that roadblocks, pickets, and street demonstrations were violent and antidemocratic, claiming that these infringed on the rights of the "rest of society" to move freely.[94]

The state and corporate media targeted the piquetero movement with special virulence. They constructed an image of piqueteros as animal-like and dangerous and represented their appearance in metropolitan centers as a kind of invasion.[95] The federal police formed an antipiquetero brigade in 2003.[96] Verdú notes that, while the Kirchner government claimed to be tolerant of popular mobilizations, it worked through "less official channels" to demonize and isolate those political groups that didn't negotiate with the government. In order to disarticulate the piquetero movement, it gave workfare to those who aligned with the government and used repression to manage those who did not ("ideological piqueteros," in the state's parlance).[97]

Verdú and CORREPI have assiduously demonstrated that the Argentine state's repression of organized movements and of the popular classes in general continued under the Kirchner governments, notwithstanding the governments' self-representation as defenders of human rights. For example, within the first five and a half years of Kirchnerism, the state repressed popular mobilizations, demonstrations, and worker and student movements; it subjected approximately six thousand people to penal processes for strictly political reasons; and its police and jailers killed more than one thousand people by summary execution or torture.[98] Verdú found that hallmarks of the Kirchner governments' repressive policies included its regular use of unofficial parastate forces (*patotas*) to attack organized workers, Left militants, and students, which allowed the government to evade responsibility for the attacks, as well as its "military occupation—of factories, schools, hospitals, and even entire cities"—as a means of pacification.[99] Verdú reminds us that the exercise of repression as a form of social control over the popular classes is a "foundational necessity" for any government that upholds the division of society into classes, and the Kirchner governments' efforts to secure as much consensual domination as possible was always conditioned by their readiness to use "all the repression necessary."[100]

POLICING AND THE PRODUCTION OF SUBJECTIVITY: POEMA VISUAL

GAC's urban intervention *Poema visual para escaleras* (*Visual Poem for Stairs*; 2002) contests state security discourse by affirming a working-class counterideology vis-à-vis policing. With its dialogical form, it shows how policing practices operate differently in relationship to subjects of different classes, and it shows how this difference relates to the production of subjectivity and class stratification. By giving priority to a subject position rendered invisible

within the state's representation of its own policing, the poem lays bare the fundamental ambivalence in the meaning of "security."

Poema's affirmation of a working-class consciousness about policing practices reflects its collective mode of production, in which organizations with working-class constituencies and political alignments had a central role. GAC describes their collaboration as follows:

> In order to create *Visual Poem* in 2002, we met with unemployed workers' movements from the Coordinating Committee in the Zona Sur, with organizations of family members of victims of "trigger-happy" [police] brutality [*gatillo fácil*], and with CORREPI for two months. During these meetings, we dealt with the testimonies of family members, who were denouncing the relationship between what happens in the neighborhoods and its connections to local power structures, in order to understand why security forces operate in a mafia-like manner. We also learned about the racism and xenophobia that characterizes our society, even though we rarely speak about it.[101]

After developing the poem in this collaborative process, GAC and their collaborators stenciled it in public spaces in working-class neighborhoods in Buenos Aires, sometimes as part of protests against police violence. A video by GAC, which was exhibited in their 2017 retrospective *Liquidación por cierre* (Going Out of Business Sale), documents the poem's installation in a train station in Lanús. It shows a large group of people gathered on and around the station's stairs as members of GAC begin painting. Several policemen try to prevent the action and also prevent the filmmaker from recording. When it seems like GAC's members are ready to abort the mission in the face of the police repression, the group of activists—who vastly outnumber the police—erupts into song, encouraging them to continue. Adapting a celebrated declaration by Rodolfo Walsh, they sing, "Pinte, pinte compañera, y no deje de pintar, porque todas las paredes son la imprenta popular!" (Paint, paint comrade, and don't stop painting. Because all of the walls are the people's printing press!) When its installation was completed, the poem read:

¿SEGURIDAD?	SECURITY?
TE VIGILA	WATCHES YOU
TE CONTROLA	CONTROLS YOU
TE PERSIGUE	FOLLOWS YOU
TE INTIMIDA	INTIMIDATES YOU

TE REPRIME	REPRESSES YOU
TE DETIENE	ARRESTS YOU
TE TORTURA	TORTURES YOU
TE ASESINA	MURDERS YOU
POLICÍA-PREFECTURA- GENDARMERÍA	POLICE–COAST GUARD– GENDARMERIE[102]

Poema visual's physical dispersal in urban space emphasizes its critique of the ubiquitous nature of the police state. Because the spatial arrangement of its lines on steps or pavement is keyed to a pedestrian's movement, movement toward the text brings each line successively into the center of one's field of vision (figure 4.3). Its anticipation of a viewer's movement emphasizes *Poema's* aggressive second-person address and creates the sensation that the viewer is being surveilled in the very space she traverses. Like much of GAC's other work, it adapts a visual form commonly used in state and commercial signage. In Buenos Aires, corporations often use subway stairways as an architectural support for their advertisements. In other cities, like New York, for example, staircases are used for precisely the type of messages *Poema* critiques, like the ubiquitous solicitation "If you see something say something" that hails city-goers as potential collaborators in the so-called War on Terror, while suggesting that their fellow commuters may be terrorists.[103] By imbuing a spatial form commonly used to address pedestrians as consumers or citizens with a text that makes the reader feel surveilled and threatened, *Poema* denaturalizes the corporate and state control of so-called public space (which is evidenced in their visual contamination of it) and reminds the reader that she is always already hailed as a subject of the state as she moves through these spaces.

Instead of representing specific past instances of police violence or memorializing its victims, *Poema visual* represents policing practices *in general* through a series of present-tense transitive verb phrases, whose direct object is *te* ("you" in the informal). While the deictic pronoun *te* hails the pedestrian reader, it also provides a generalized representation of policing practices because "you" can potentially be anyone. While a representation of specific instances or victims of police violence could be interpreted as exceptional cases or recuperated into a reformist discourse, *Poema's* generalized and present-tense representation of police practices enables a critique of this systemic violence *as* policing's social function.

Poema engages in what Herbert Marcuse theorized as "linguistic therapy." This names the practice of wresting control over the meanings of words and

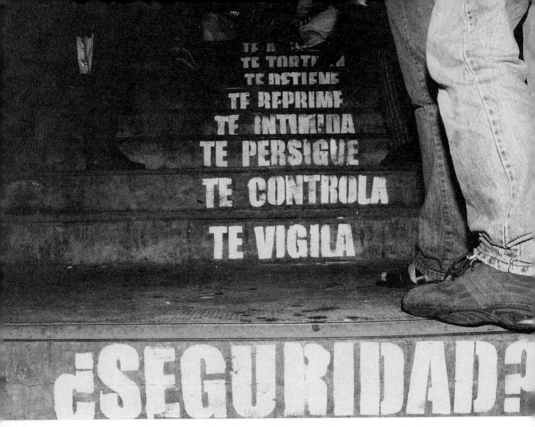

4.3 Grupo de Arte Callejero, *Poema visual para escaleras* (Visual Poem for Stairs), guerrilla intervention in the Lanús train station, Greater Buenos Aires, 2002. Photograph courtesy of Archivo GAC, Grupo de Arte Callejero.

concepts from the moral standards and ideologies of the ruling class in order to resignify them in ways that align with the collective revolt against capitalist domination. Asserting that "in the face of an amoral society, [morality] becomes a political weapon," Marcuse argued that the Left should differently moralize concepts bourgeois ideology invests with its values but presents as objective and neutral descriptors.[104] By engaging state security discourse as its intertext, *Poema visual* denaturalizes and reworks the meaning of *security*. The symmetry between the first and last lines echoes the state's assertion of an identity between the value concept of "security" and its repressive apparatus (named in the last line as the various corps involved in domestic policing). However, the first line is posed as a question, and the increasingly violent actions the poem inventories are directed at the same "you," the reader, to whom the question "Security?" is posed. This rends the value concept of security from the identity of the police. As the poem progresses,

Chapter Four

the signifier "security" is made to appear catachrestical—that is, improper and out of place.

Poema visual has a contrapuntal relationship to security discourse's hailing practices. With its second-person address, it mirrors the ideological hailing security discourse performs, thereby highlighting the way this discourse operates upon subjectivity and through the appeal for identification. In fact, there is no representation in the poem that is not already a hailing and thus bound up with an expression of subjectivity. To borrow a concept from Ricardo Bracho, it "effects hailing from a 'non-dominant dialogic voicing,'" such that the reader can perceive both the operation of hailing by dominant ideology as well as the possibility of a counterhegemonic discourse about the so-called security apparatus.[105]

More than juxtaposing different representations of policing, *Poema visual* juxtaposes different subject positions in relation to which policing functions differentially (and therefore derives its meaning): on one hand, the subject interpellated by state security discourse, who imagines herself to be protected from victimization by the state's repressive apparatus; on the other hand, the subject of *Poema visual*'s counterhegemonic hailing, who is, or could be, repressed and violated by this apparatus. More precisely, *Poema visual* critiques the way security discourse enlists a collective citizen-subject by hailing its own reader as the subject this collectivity excludes. As Gabriela Rodríguez and Gabriela Seghezzo argue, the subject of enunciation produced by the Argentine state's and corporate media's (in)security discourse is an "inclusive we" that exhibits the "pretension of totalization," while it simultaneously "instantiates, delimits and naturalizes" the otherness it must constitutively exclude.[106] Understood in Seri's terms, this describes security discourse's enunciation of "the imagined Argentine community" (the social body to be protected by the state) as consubstantial with its production of "enemy" subjects who are necessarily excluded from this community.

Although I initially suggested that *Poema visual* renders the signifier *seguridad* catachrestical, the poem does not simply critique the state's discourse as a false representation of what its police do. Rather, by focusing on the subject position this discourse effaces, the poem juxtaposes objective differences in social positioning vis-à-vis policing. As the social function of the police is the preservation of class and colonial domination, police power operates upon subjects from different classes in different ways.[107] After all, "security" is not a misnomer when used to describe what the police provide the ruling class or how the police secure existing property relations. Because the security apparatus is a tool of class domination and is perceived as such

(if not completely or always), the meaning of security discourse, like the material effects of the security apparatus as a whole, is asymmetrically divided along lines of class and race. By addressing this division (and taking it up as its formal organizing principle), *Poema visual* encourages us to consider how "security" is related to the *in*security of the popular classes. Its opening question, "Security?," is not to be simply answered in the negative. Rather, it provokes other questions, such as: security for whom (or what)? And who is the "you" rendered expendable within the worldview security discourse proffers? It also prompts us to consider broader meanings of in/security: to ask, for example, how a social order that entails systemic insecurity—understood as precarity, poverty, and social exclusion—requires a repressive apparatus dressed up as "security" for its reproduction.

SELLING SECURITY AND THE LIMITS OF MORAL INDIGNATION

In 2003 GAC produced *Seguri$imo* ($uper Secure[108]), an interventionist guerrilla performance that critiqued contemporary policing practices and security ideologies by situating them within longer histories of state-led violence, including colonial and political genocide and state terrorism. Rather than depicting the state's repressive apparatus as the only agent of this violence, *Seguri$imo* addressed the profit motives of the booming weapons and policing industries, as well as the complicity of consumers of these products and services in classist and racist violence and the militarization of everyday life. *Seguri$imo* specifically critiqued the urban middle class for its embrace of the ideologies that undergird policing. Lorena Bossi said about the work, "We are part of this middle class, but we were also criticizing it for its xenophobia, its racism, for issues related to its thinking that a 'tough-on-crime' approach [*mano dura*] is best."[109] As I will explain, the unexpected reception of *Seguri$imo* suggests that these ideologies undermine the possibility for ethical or moral consternation in the face of state-sanctioned violence.

Members of GAC set up a stand in front of a supermarket and distributed a flyer they had produced that mimicked the style of sale ads retailers typically distribute. GAC's fake advertisement featured assault weapons and private security services (figures 4.4 and 4.5). It adapted a convention of commercial ads in which text bubbles highlight features of an item, using text to situate different weapons within histories of state violence in Argentina: from colonial genocide to state terrorism and extralegal executions by the police. For example, the blurb alongside an image of a portable electric prod reads, "The

ones from the dictatorship, now modernized for private security agencies. Specialized for the confession of crimes not committed."[110] Another offers a "Collector's Special!" on the model of rifle used in the Argentine military's genocide of indigenous people in Patagonia in the nineteenth century, adding with bitter irony, "20,000 massacred indigenous people confirm it."[111] It advertises one rifle as being used since 1976 (the date of the most recent military coup) for "repressing the people's demands," while confirming that it has been "proven many times against protests and pickets [*piquetes*]."

Corporate and state security discourses regularly hail people as subjects in need of self-defense, inciting fear to enforce their appeal. *Seguri$imo*, however, makes no mention of crime to promote its wares. Rather, by adopting the format of a retail sale ad, it hails its readers, first and foremost, as *consumers*. In so doing, it suggests that security discourse can be understood as a form of marketing for the weapons and policing industries. Thus *Seguri$imo* emphasizes the *business* of "security"—that is, repression.

Militarism and repression have long been recognized as provinces of capitalist accumulation that generate markets and investment opportunities (and do not need private consumers to function in this regard).[112] Robinson uses the concepts of "accumulation through repression" and "militarized accumulation" to refer to the contemporary "development and deployment of . . . systems of warfare, social control, and repression . . . as a means of making profit and continuing to accumulate capital in the face of stagnation." Examining militarized accumulation in the twenty-first century, he underscores the increasing convergence between the economic use of repression to perpetuate accumulation and "global capitalism's political need for social control" and repression to "contain the real and potential rebellion of the global working class and surplus humanity."[113]

Seguri$imo specifically critiques aspects of accumulation through repression that are particularly salient in the neoliberal conjuncture. It points out that increased investment in repression has directly corresponded with state policies of austerity, wherein what remains of a social safety net is dismantled and more costs of social reproduction are shifted onto the working class. A graph at the bottom of the flyer indicates that the amount of money invested in the security industry in Argentina nearly tripled between 1994 and 2003. On the graph, the steadily rising line that represents money invested in repression is overlaid on a steadily falling line, which represents employment. Beneath it, the following text appears: "Remember that, now, in Argentina, more money is spent on security than on education or welfare. What better way of ensuring your investment?" This underscores militarism's double

SEGURI$IMO

HIPERSERVICIOS

ESCOPETA ITACA
La que usa Gendarmería, muchas veces probada en manifestaciones y piquetes.

Desde **1976** reprimiendo los reclamos de la gente.

GARANTIZADA

BROWING 9 MM
¡Infalible! Utilizada por la policía en todo el país.

1600 casos denunciados de gatillo fácil la garantizan.

GARANTIZADA

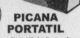

PICANA PORTATIL
Las de la dictadura, ahora modernizadas para agencias de seguridad. (Especiales para confesar delitos no cometidos)

GARANTIZADA

Desde **1928** en todas las comisarías de la Argentina.

¡Especial coleccionistas!

GARANTIZADA

REMINGTON "PATRIA"
Los poderosos rifles que usó el ejército de Roca en la "Campaña al Desierto".

20.000 originarios masacrados lo confirman.

Atrás excluidos!!!

Hay un ejército de **80.000** guardias privados ¿Todavía no tiene el suyo?

INVERSION A FUTURO

La "seguridad" es el único negocio que crece al compás de la caída del empleo. Las casualidades no existen:

900 millones de u$s — 1994

GASTOS EN SEGURIDAD

EMPLEO

2600 millones de u$s — 2003

Tenga en cuenta que en la Argentina, hoy, se gasta más en seguridad que en educación o planes sociales, ¿qué mejor forma de asegurar su inversión?

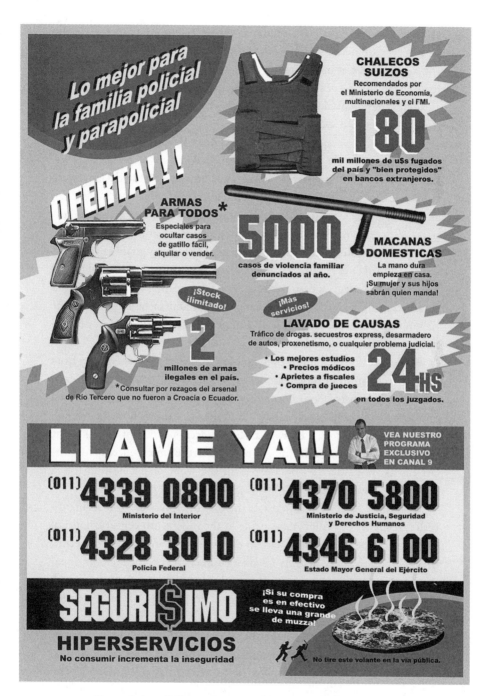

4.4 & 4.5 Grupo de Arte Callejero, *Seguri$imo* ($uper Secure), flyer used in guerrilla performance, Buenos Aires, 2003. Courtesy of Archivo GAC, Grupo de Arte Callejero.

assault on the working class, insofar as the state appropriates social wealth and, instead of investing it in socialized goods and services that would benefit social welfare, it increasingly invests it in a repressive apparatus that defends extant property relations. The fact that this is satirically delivered as an address to potential investors emphasizes the profit motives that underlie *both* militarism and social disinvestment.

Second, *Seguri$imo* critiques the expansion of the private security market in Argentina since the 1990s, which has opened up new markets for repression industries (including large transnational firms) and created a largely unregulated, quasi-feudalistic regime of policing space.[114] The flyer includes an ad for private security services next to the aforementioned graph. Its text states, "There is an army of 80,000 private security guards. Don't you have yours yet?" It is illustrated with a photograph of a security guard saying, "Get back, excluded ones!" (*Atrás excluídos!*) *Seguri$imo*'s juxtaposition of this ad with the graph suggests that, in the context of increasing social polarization (indexed in the graph by rising unemployment and austerity politics), the rich minority ever more intensively arms itself to defend its unjust hold on the majority of social wealth.

While it shifts the framing of the subject of security discourse away from the citizen desirous of protection from the state and toward a consumer of the security industry, *Seguri$imo* also emphasizes the use of its advertised products by the police and military. In so doing, it shows how the naturalization of state violence is entwined with the accumulation of capital by the weapons and policing industries, as these industries interpellate consumer-citizens as "potential collaborators"[115] in the work of pacification (often pitched as a "war on crime").

Seguri$imo proffers a palimpsestic history of repression by braiding together references to colonial genocide in the nineteenth century, political genocide by the neocolonial state in the twentieth, and privatized securitization in the twenty-first. As I explained in chapter 1, the concept of palimpsestic time posits the coevalness and mutual imbrication of colonial, neocolonial, and neo-imperial time-space formations, thereby refuting developmentalist representations of state forms.[116] *Seguri$imo* underscores continuity in logics of governance between different capitalist state forms by tracing material connections among their repressive practices. It emphasizes the traffic across time among forms of organized, state-sanctioned violence directed against specific classes and groups—those targeted as "internal enemies" of the Argentine state. Indeed, Svampa argues that Argentina's authoritarian and nominally democratic regimes alike have relied

on the political and ideological construction of an internal enemy. While the anticommunist National Security Doctrine cast political "subversives" in this role, the neoliberal state's "Citizen Security Doctrine" (Svampa's critical modification of the discourse of *seguridad ciudadana*) treats members of its surplus population (e.g., the urban poor) as the nation's internal enemies.[117] By emphasizing the *logics* of systematic state violence, which has chosen different targets, *Seguri$imo* contests the aura of exceptionalism associated with state terrorism (be it colonial or anticommunist) and points to the persistence of these logics in contemporary practices of securitization. Moreover, as it traces the traffic among ideologies the ruling class has deployed to make its colonial and political violence seem legitimate, *Seguri$imo* provokes us to consider how contemporary security ideology updates colonial ideologies, such as the discourse of "civilization versus barbarism," as it dehumanizes the poor and associates them with disorder and crime, or how the contemporary use of policing to govern the oppressed echoes colonial modes of domination.[118]

The reception of *Seguri$imo* suggests that security ideology's subjectivizing power can trump an ethical or moral appeal to condemn violence suffered by others. Some shoppers expressed genuine interest in purchasing the products advertised in GAC's flyer, apparently oblivious to its satirical tone. The artists suggest that this occurred because people paid attention only to the images.[119] But what if the artists simply miscalculated the work's reception because they misapprehended the consciousness they aimed to critique?

In an interview I conducted with GAC members Lorena Bossi and Carolina Golder in 2013, they reflected on GAC's work from the early 2000s that critiqued security discourse in light of the increasingly intense deployment of this discourse in the subsequent decade (particularly as a Right-wing attempt to discredit Kirchnerism). Bossi said that, while works like *Seguri$imo* used exaggeration to expose the authoritarian, classist, and racist attitudes embraced by much of the middle class, by 2013 many sectors of that class openly expressed these attitudes. Golder agreed, citing middle-class protests against "insecurity" (which often focus on property crime) and people's expressed support for mob attacks (*linchamientos*) against poor youth accused of petty theft.[120] The artists' comments, as well as the reception of *Seguri$imo*, suggest that the authoritarian, racist, and even genocidal logics embedded in contemporary security ideology do not necessarily pose a moral quandary for subjects who have been interpellated by it. The expectation that these things would be morally repugnant to a liberal subject makes sense only

within a perspective calibrated to the mythologies, rather than the material history, of liberalism.

While common sense (in Gramsci's use of the concept) considers liberalism's imputed embrace of liberty to be a bulwark against authoritarianism and fascism, the historical record shows that this is far from the case.[121] Neocleous argues that liberalism is better understood as a "strategy of governance in which security is deployed as liberty," where "security" signifies the "ideological guarantee of the . . . self-interested pursuit of property."[122] This commitment to security "leaves liberalism with virtually no defence against authoritarian or absolutist encroachments on liberty, *so long as these are conducted in the name of security*."[123] The reception of *Seguri$imo* succinctly illustrates this point. While the work aimed to expose and denounce the authoritarian and genocidal logics underlying national security regimes, its reception suggests that these logics may not be so shocking or repugnant to liberal subjects after all.

Rather than reading *Seguri$imo* as a failed exercise in provoking consciousness-raising discomfort in its audience, it can be read as a realist work (in a Brechtian sense) whose social critique is enriched by consideration of its unexpected reception. It is particularly revealing of the power of ideologies of security to produce a liberal subject who readily embraces authoritarian violence when she sees it as necessary for preserving her own propertied "security" and assumes that this violence will be directed toward those subjects with whom she does not identify. *Seguri$imo*'s reception illustrates how successfully security ideology works to maintain stratification among nonelites, fostering a fidelity to the security state in the place of class consciousness. In other words, it shows how the capitalist state's practices of internal pacification choreograph the consolidation of a citizen-subject through an active disidentification (understood as counteridentification and repudiation) vis-à-vis the working and popular classes it has criminalized.

Finally, *Seguri$imo* poses a challenge to a predominant conception of ethics (embraced by hegemonic human rights discourse) that posits "a general human subject, such that whatever evil befalls him is universally identifiable," and claims that there is widespread consensus about what is evil.[124] *Seguri$imo*'s compact history of genocide and pacification suggests that states' production of disposable and enemy subjects already excludes these people from a category of human subjects who would be recognized as deserving of protection. The work and its reception also question the idea that collective brutalities waged on those who have been thus dehumanized are

widely recognized as "evil." Indeed, the very contradictions that plague the embrace of ethics as a basis for a human rights politics, which *Segurísimo* brings into full view, help to explain hegemonic human rights' history of complicity with colonial and imperialist social relations.[125]

The critique of predominant notions of ethics suggested by *Segurísimo*'s reception underscores the difference between a human rights politics founded on such notions and the radical vision of human rights activism I have analyzed in this and the preceding chapter. The latter focuses on the political potential of popular movements that do not expect ruling classes or colonial-capitalist states to recognize ethical imperatives. *Segurísimo*'s reception also highlights the insufficiency of a human rights politics that focuses on condemning past crimes, as if this itself would produce future justice, as compared with a politics that understands abuses to be systemic and responds to their changing configurations, while recognizing the limits of reforming a (neo)liberal state whose class function requires such abuses.

INTERNATIONAL ERRORISM

In 2005 the Argentine government adopted antiterrorism laws at the behest of the U.S. state, the United Nations, and international financial institutions. Leftists immediately denounced the laws as a tool to further criminalize popular movements and social protest, and characterized them as a reformulation of anticommunist Cold War policies. The Madres de Plaza de Mayo called the laws a "pretext for state terrorism," and Congressman Miguel Bonasso said, "This law takes us right back to the principles of the infamous National Security Doctrine, which permitted state terrorism and the genocide in our country."[126]

It was in this context that Etcétera . . . founded the Internacional Errorista (Errorist International) as a critical response to the expansion of policing powers that has been carried out under the aegis of the so-called global War on Terror. They conceived of it as an artistic movement that would operate beyond Etcétera . . . and its members. The Errorists' work examines ways that repression is organized and ideologically legitimated through discourses of terrorism, criminality, and security. Their work shows how these discourses provide cover for the violence global capital deploys to secure accumulation, whether through imperialist wars, repression of antisystemic movements, or the forging of social relations and cultures of perception that naturalize social stratification and incite fear-induced fidelity to the state. As the Errorists interrogate contemporary practices of pacification, they reframe the

concepts of *terror* and *error* to indict the normalization of terror practices against those subjects who are cast as disposable or potentially threatening to the capitalist social order. The work I examine here builds on the critical work on pacification I examined earlier, while specifically interrogating its geopolitical dimensions, the imbrication of spatial scales at which it operates, and the traffic among different figures of criminality constructed by the transnational policing apparatus.

THE "WAR ON TERROR" AND TRANSNATIONAL POLICING IN LATIN AMERICA

While state discourses of terrorism would have us believe that "terrorism" can be known outside of political decisions, they actually *produce* terrorism as an epistemological object.[127] Like other security ideologies, terrorism discourse works to manage the manifest contradictions between hegemonic representations of liberal states and these states' actual practices of pacification. It moralizes different uses of violence by depicting the savagery of those it claims to be civilized as just and the violence of those deemed terrorists as barbaric. In so doing, it manages perceptions of political violence to make them fit with liberal discourse's championing of justness, rationality, and Judeo-Christian morality.[128]

The political utility of antiterrorist laws consists in the expansion of state power (and police power, in particular), the criminalization of opposition to the dominant order, and the remodeling of citizens' "expectations about political rights, individual liberties and social freedoms, all in the name of security."[129] "Political targeting is hardwired into the heart of counterterrorism," Christos Boukalas asserts.[130] In their aforementioned comments about recent antiterrorism legislation, Bonasso and the Madres refer to the use of antiterrorism discourse and laws by the Argentine and other capitalist states to criminalize and repress Leftists. Latin American states updated this tactic in the 1990s, using it, in particular, against indigenous movements, such as the EZLN in Mexico and communities of Mapuches engaged in social protest for territorial rights in Chile and Argentina.[131]

Across the hemisphere, the criminalization of antisystemic movements was intensified after the initiation of the so-called War on Terror in 2001. As Robinson writes, this war has "legitimated new transnational social control systems and the creation of police states to repress political dissent in the name of security."[132] Within the United States, the Homeland Security regime has institutionalized an "authoritarian hardening" across all areas of the state's activity, as Boukalas has shown, including the intensified and system-

atic repression and criminalization of antisystemic popular politics.[133] The military operation used against antiglobalization activists protesting the Free Trade Agreement of the Americas (FTAA) at the 2003 Summit of the Americas in Miami was an early example of the model of policing that has been institutionalized in the Homeland Security regime, wherein antisystemic popular politics are a "priority target" for "a mammoth policing mechanism designed to thrash popular resistance whenever its political directorate determines necessary, while infiltrating, monitoring and harassing political groups as a matter of course."[134]

The U.S. state's long-standing imperialist militarism in Latin America found a renewed alibi in the War on Terror. Under its aegis, the U.S. government has expanded its military and administrative powers in the region, "integrated Latin American security forces more tightly into the U.S. military's command structure," and pressured Latin American countries to expand the role of their armed forces in domestic policing.[135] The growing U.S. transnational military architecture in Latin America "supports the objectives of securing access to markets, strategic resources (especially oil), controlling narcotic trafficking and immigrant flows, as well as more traditional counterinsurgency, intelligence gathering, and possible actions against leftist governments and social movements."[136] The U.S. security state has explicitly targeted antisystemic movements in the region. As Greg Grandin notes, the U.S. National Security Council was concerned that a radicalization and convergence of indigenous movements with other radical movements, such as the piqueteros in Argentina, the landless movement in Brazil (Movimento dos Trabalhadores Rurais Sem Terra), and peasant movements in Paraguay and Ecuador could lead to an "indigenous irredentism" entailing a "rejection of the western political and economic order maintained by Latin Americans of European origin" and armed insurgency.[137]

The targeting of popular movements organized against policies of dispossession and austerity as "security" threats handily demonstrates the fact that, as Neocleous writes, for liberal states, "security" refers to securing processes of capitalist accumulation.[138] The War on Terror must be understood in this regard. As Robinson notes, the U.S. state has used the War on Terror, as well as the War on Drugs, as pretexts to "create a global war economy" to "sustain global accumulation."[139] For a global capitalism beset by crisis, the War on Terror has provided a "seemingly endless military outlet for surplus capital."[140] Globally, it has unleashed "cycles of destruction and reconstruction [that] generate enormous profits" and has been used to dispossess and proletarianize people and open new spaces to capitalist accumulation.[141] Neocleous

argues that the vagueness of its timeframe, geography, and targets is part of a *"deliberate strategy*, since it creates the need for permanent pacification," the purpose of which is securing capital accumulation.[142]

Under the aegis of the War on Terror, the U.S. government, the United Nations, and international financial institutions, such as the International Monetary Fund, enlisted antiterrorism laws and accords as a means to expand global capital's control over peoples and space. Many Latin American countries, including Argentina, passed antiterrorist legislation with provisions like those of the U.S. Patriot Act.[143] The Argentine government not only faced the UN's demand that it criminalize terrorism; it was also pressured to pass antiterrorism laws by international financial institutions, which leveraged the fact that the country was in the middle of negotiations related to restructuring its foreign debt.[144]

Etcétera . . . created the Internacional Errorista in response to the Argentine government's adoption of antiterrorism legislation in 2005[145] and in anticipation of a visit to the country by the self-appointed leader of the War on Terror, George W. Bush. The Errorists made their first appearances in late 2005 with a series of interlinked guerrilla street performances, texts, and media interventions. Together, these works introduced the Errorists' political and artistic platform and composed an "origin story" for the group that puts forward, in a tongue-in-cheek manner, their mythified image as a kind of surrealist guerrilla force, while also tactically using the fiction of this image to critique policing practices.

AN ERRORIST MANIFESTO AND FIGURES OF CRIMINALITY

The language of the prevailing Law and Order, validated by the courts and the police, is not only the voice but also the deed of suppression. This language not only defines and condemns the enemy, it also creates him; and this creation is not the Enemy as he really is but rather as he must be in order to perform his function for the Establishment. —Herbert Marcuse, An Essay on Liberation *(1969)*

The Errorists published "Internacional Errorista: Primera Declaración" (International Errorist: First Declaration) on the website of *Argentina Indymedia* in October 2005.[146] This manifesto begins by describing Errorism as "a mistaken philosophical position, a ritual of negation, [and] a disorganized organization" that is "based on the idea that 'error' is reality's ordering principle." Errorism's "field of action . . . encompasses all practices that strive for the LIBERATION of the human being and of language," it states. The

Declaration elaborates an allusive lexicon of errorism and error to denaturalize state terrorism discourse and interrogate its political and ideological function. The proximity of *error* and *chance*, which one moment recalls Surrealist "objective chance," soon slips from chance coincidence to paranoiac coincidence to the dissolution of chance in the hermeneutics of suspicion, and the chances that some people (poor, racialized, imperialized) are, "by chance," regularly treated as suspect.

The Declaration closes with an incisive tract about the contemporary discourse of terrorism. The Errorists argue that the discourse of terrorism is used "to criminalize in a uniform and generalized manner non-Western societies, deviants, the poor, the different, foreigners." It asserts that the "Global War on Terrorism" is used to renew ideological justifications for familiar practices of state terrorism, legitimize the racist and xenophobic logics of state repression, and justify imperialist warfare, while providing a ready excuse to explain away any too obvious "errors" as collateral damage in a necessary project of national defense. The Errorists' poetic analysis moves between the state's practice of preemptively assaulting "suspicious" individuals, the discourse of terrorism that "makes visible the crime of being 'suspect of everything,'" and its logical elaboration at a geopolitical scale: familiar justifications for "interventions" and preemptive wars of the Global North on the Global South. By asking who suffers for whose errors, who punishes error as crime, and whose crimes go unpunished, the Errorists lay bare the radical asymmetries between the ways criminality is ascribed and terror is meted out.[147]

When the Errorists published their *Primera Declaración* on the *Indymedia* website, they illustrated it with photographs from their first guerrilla street performance, which they had just carried out five days before, when they participated in a Malvenida Mr. Bush (Un-welcome Mr. Bush) protest-festival in downtown Buenos Aires. It was organized in anticipation of the U.S. president's impending visit to the Argentine city of Mar del Plata, where he would attend the fourth Summit of the Americas, organized under the aegis of the Organization of American States. There, Bush planned to win the passage of the FTAA, which would further institutionalize neoliberal policies throughout the hemisphere and bolster U.S. hegemony in Latin America.[148] Since FTAA negotiations began in 1994, activists had been protesting them with increasing intensity, and protests at previous summits were flashpoints in the antiglobalization movement. The Malvenida Mr. Bush protest addressed the U.S. president as both warlord and political figurehead of imperialist accumulation, as it repudiated the expansion of neoliberal trade policies the FTAA proposed, as well as the U.S.-led wars in Afghanistan and Iraq.

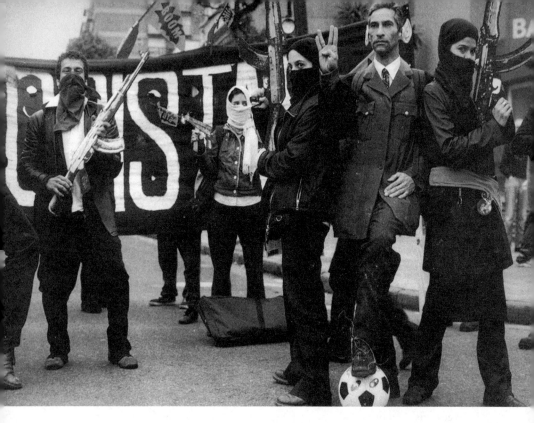

In their photos, the Errorists usually appear in black clothes with keffiyehs or hijabs partially covering their faces. They carry machine guns, rifles, and pistols (figures 4.6 and 4.7). These "poetic arms," as the artists call them, are hand-made, obviously theatrical props. They are flat silhouettes cut from pressed cardboard and painted in black and white. Red pennants printed with onomatopoeic gunfire (e.g., "BANG!" and "BOOM!") are affixed to the guns' muzzles, making them look as if they were plucked from the pages of a retro comic book and enlarged to life-size.

After the Errorists appeared in several protests, reports on them proliferated in news media and blogs. These included local and international media coverage, as well as media interventions in which the Errorists themselves had a hand. In these various reports, the Errorists were variously described as piqueteros, actors playing terrorists, street artists dressed as Arabs, activists dressed as Palestinians, antiglobalization protestors, and suspected vandals.[149] As I will argue, the ambiguity of their perceived identity is itself part of their aesthetic intervention.

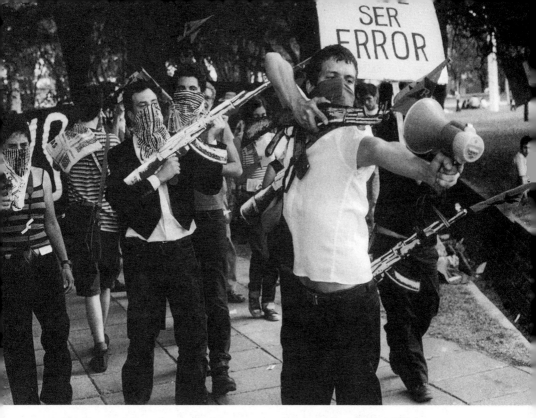

4.6 & 4.7 Internacional Errorista, documentation from street actions, Mar del Plata and Buenos Aires, 2005. Photographs courtesy of the Etcétera . . . Archive.

Zukerfeld has described Etcétera . . .'s creation of the Internacional Errorista as emerging from their research on the way the corporate media "convert determined social subjects into enemies, and use that as justification for imperial advances, wars and economic interests."[150] He explained that this built off an earlier work by Etcétera . . . , *Gente Armada* (2004), whose title means both "Armed People" and "Constructed People." This urban intervention addressed the corporate media's construction of an image of piqueteros as an "enemy" within the nation that "had to be separated from society, because it could potentially form part of a guerrilla force someday."[151] While they observed the production of this image of piqueteros, the artists of Etcétera . . . saw circulating in the global media analogous images of Palestinians and of persons in the Middle East resisting the U.S.-led wars there. They studied this aesthetic construction of enemy subjects—that is, "the manner in which the media criminalized [people] and turned them into terrorists"—to develop the aesthetic intervention they would make as the Internacional Errorista.[152]

The antirealist aesthetics that have always characterized Etcétera...'s work play a crucial role in their critique of terrorism discourse. It allows them to evoke various representations of "terrorists" without suggesting that these have a real referent behind them, that is, terrorists as a category of people that exists apart from its ideological and juridical manufacture. The Errorists' visual appearance is an antirealist send-up of a composite image of a contemporary "terrorist"—a composite of the images produced by states and corporate media to produce figures of terrorists and their cognates (e.g., dangerous dissidents, guerrillas, criminals). The aesthetic-ideological force of these images includes the relations that are established between them as they circulate. As they summon each other across time and space, they articulate an ur-image of a barbaric enemy whose presence is ubiquitous, protean, and global, thereby legitimating capital's endless, global efforts at pacification (waged, oftentimes, in the name of "civilization," "security," or "democracy"). The interrelations between figures of barbarous enemies also reinforce the racist and nationalist ideologies that undergird them by articulating the different spatial scales at which these ideologies operate. For example, the fear mobilized toward dissidents or the racialized poor in a local setting can be reinforced by, while also feeding, fears of the figure of the "international terrorist."[153] The Errorists' theatrical parody of a composite image of "terrorists" renders visible the symbolic production of enemy subjects at multiple and imbricated scales and the function of social control this serves.

OPERATION BANG!

After their appearance at the Un-welcome Mr. Bush protest, the Errorists culminated their first series of anti-antiterrorist actions by following the U.S. president to Mar del Plata. The group's actions there were part of massive antiglobalization protests and gatherings that were held in the coastal city during the summit. Tens of thousands of people traveled there to protest the FTAA and to attend the anti-imperialist III Cumbre de los Pueblos (Third People's Summit).[154] The long-standing popular resistance to the FTAA negotiations found a powerful spokesperson in Venezuela's socialist president Hugo Chávez, who predicted in his closing speech at the Cumbre de los Pueblos that the FTAA would be buried in Mar del Plata. He was right. Political mobilizations against the FTAA that took place across the hemisphere over the course of several years, as well as people's enacted repudiation of neoliberal policies more generally, helped bring about the definitive collapse of FTAA negotiations in Mar del Plata.[155]

During the summit, the Argentine and U.S. states militarized Mar del Plata with the excuse of protecting the U.S. president from a potential terrorist attack. They deployed thousands of police and military officers in the city and patrolled its coast and airspace with warcraft. Describing his impression of the atmosphere this created, Santiago García Navarro writes, "I perceived that the people were afraid, above all, of the enormous security apparatus, much more than of the hypothetical threat of a terrorist attack."[156]

It was in this context that Etcétera... created *Operación BANG!*, a work that tactically (and often hilariously) blurs the borders between fact and fiction, realism and parody. I read it as a transmedial narrative work that is composed across live actions in Mar del Plata, news reports on these, the Errorists' own media interventions, a narrative documentary video, and museum installation.

After participating in the anti-FTAA protests, the Errorists went to a nearby beach to "film a fictitious movie," as they describe it.[157] That same afternoon, they circulated photos that appear to be stills from film on an independent online news site. This form of expanded cinema recalls the No Movies of the L.A.-based Chicano art group Asco. In the 1970s and 1980s Asco disseminated their photographs, which they stamped with the phrase "Chicano Cinema," as if they were stills from and advertisements for films that did not actually exist.[158] Asco used postal mail and mail art networks to disseminate individual photos as No Movies. The Errorists, on the other hand, composed two series of photos, titled and captioned them in ways that mimic conventions of journalistic reportage on breaking news, and disseminated them on *Indymedia Argentina*. This media intervention is, at once, a fictitious archive of a nonexistent film and documentation of a live action that itself catalyzed another cinematic work, which I discuss later. Through the combination of photos, headlines, and captions, the two "news reports" loosely narrate a story about the Errorists' documentary film shoot, while also playing up the Errorists' own tongue-in-cheek self-stylization as a surrealist guerrilla group. One report bears the headline "Urgent! Errorists Took a Beach in Mar del Plata," and the other is titled "Errorists Continued Advancing across Mar del Plata's Coast."[159] The Errorists are shown advancing on the beach as if they were an invading guerrilla army. They crawl across the sand and pose with their weapons raised (plate 15). In one photograph, they are arrayed in the breakwater, holding a large banner, as if they had just crossed the Atlantic to bring Errorism to Argentina's shores (plate 16). Other captions refer to the Errorists shooting a documentary, and some photos appear to be behind-the-scenes documentation of the (fictitious) film shoot.[160] In

one, the Errorist who appears to be directing the film (Ezequiel Monteros) speaks into a loudspeaker while holding his fake rifle and a forty-ounce beer in the other hand.

The two "news reports" refer to the same scene, juxtaposing at least two ways of constructing their object of representation: one playfully projects the fiction of the Errorists as a surrealist guerrilla group; the other shows the Errorists composing a representation of themselves in the form of a film. This narrative technique of juxtaposing two perspectives, or nesting one within the other, is used throughout *Operación BANG!* This technique self-reflexively comments on the fact that every representation is composed and is therefore never a transparent lens on reality. At the same time, with their very gesture of revealing the composition of specific representations (e.g., showing behind the scenes of the "film shoot"), the Errorists also tempt a viewer into believing she has been given the *real* story—though, in reality, she may just be drawn farther into an Errorist fiction.

The day after the OAS Summit ended, a different independent news site reported that, while the Errorists were on San Sebastián Beach, people had mistaken them for piqueteros and called the police on them. The Errorists narrate this crucial twist in *Operación BANG!*'s narrative in their video *Error Errorista* (2006) as well as in interviews and their own published texts. As they recount the story, the Errorists were filming scenes for *Operación BANG!* on the beach and, while they were posed with their guns aiming at the sky, two Blackhawk helicopters and a U.S. military jet flew right over them. Minutes later, a squadron of police cars arrived, sirens blaring. With guns drawn and attack dogs readied, the cops ordered the artists to kneel and drop their "weapons."[161]

It is when the police brought the fictional film shoot to a halt that the action of the real video begins. The "film shoot" on the beach served as a form of invisible theater. It catalyzed and framed a drama among unwitting spect-actors (to use Boal's term), which the artists' video recorded and composed into *Error Errorista*.[162] This documentary video depicts a spontaneous social performance that plays out like a Brechtian drama. The spect-actors play roles that have been scripted by intersecting social forces: class relations, the criminalization of protest and of the poor, anticommunist ideologies, the militarization of Mar del Plata, antiterrorism discourse and law, and U.S. imperialism.

Error Errorista opens with sounds of a child's screams as the word "ERROR-ISMO" appears, followed by a still image of the U.S. flag. The chilling scream brings forward the idea of "terrorism" that always shadows the signifier

"errorism," while the montage associates terrorism with the U.S. state and U.S. nationalism, symbolized by the flag. The sinister tone of the video's opening is quickly replaced by a buoyant sonic rendering of nationalist bombast: a brass band's rendition of the U.S. national anthem. As the song plays, intertitles and photographs indicate that the setting is Mar del Plata during the 2005 Summit of the Americas. A still image of the Errorists in formation with their weapons raised is followed by an image of Airforce One, then one of George W. Bush's worried face. An intertitle then states, "In error, the Errorists aimed at Airforce 1, in which George Bush was traveling."[163]

While it is plausible, it is beside the point if Airforce One actually flew over the artists. What is significant is that they open their video with a story about the political figurehead of the global War on Terror cutting across their southern skies like a specter of the U.S.'s military power, its global reach, and omnipresence. The video's suggestive description of an attempted tyrannicide (even if orchestrated "by chance") complements the story about the guerrillas the Errorists play at being. The artists tactically enshroud their production of a scene representing an attempted "terrorist" attack within a story of chance so that, in typical surrealist fashion, objective chance enables (a performance of) wish fulfillment. By beginning *Error Errorista* with this narrative, the Errorists provoke us to consider what the U.S. military presence in Argentina and Bush's politics that go under the name of "antiterrorism" have to do with the live action we will see next.

The live action, which is recorded with a handheld camera, begins right after the cops have accosted the artists. From this point onward, the video proceeds in the style of cinéma verité. From some distance, we see five uniformed cops on the beach. One of the artists, Ezequiel Monteros, is talking and gesticulating to them. The U.S. national anthem continues to play, thereby introducing the Argentine police with a soundtrack that recalls U.S. nationalism and militarism, suggesting that this localized exercise of the Argentine state's repressive apparatus is actually overdetermined by U.S. political and military power. One of the cops approaches the camera and the diegetic sound begins just in time to hear him command, "Lower the camera! Lower the camera!" With this, the shot ends.

The next scene establishes a complicity among the Errorists, cameraman, and viewer by presumably letting the viewer in behind the scene. In contrast to the opening photos of the Errorists in their bellicose poses, here we see them as young middle-class artists, milling about on the beach amid their props while one of them strums a guitar. Several of the Errorists announce that they are searching for a letter. Once they've found it, someone off-screen

asks the cameraman if he filmed the cops looking at it. "No, they'd kill us," he replies, chuckling. As they show the letter to each other, we hear more laughing off-screen. We'll soon learn that the letter indicates that the artists have state authorization to film on the beach. But (as the artists' laughter suggests) it, too, is another prop. As Etcétera . . . explains, an "Errorist cell well-trained in Photoshop" created the authorization letter.[164] Next, Monteros directly addresses the camera to explain the situation in which the artists have found themselves: "Well, there has been a huge error, obviously. For people looking from far away, it looked like there were armed people on the beach, and so they called the police!" He adds, "Look: that guy walking over there arrived *armed,* with his forty-five ready," as the camera pans to show a cop retreating.

In the next scene, it becomes clear that the Errorists are performing a kind of invisible theater for the cops. The artists are playing professionals from the film industry who were interrupted while shooting a film. As Monteros and a cop walk side by side, Monteros speaks to the cop, but for the benefit of the camera, which follows them from behind. His speech signifies on two parallel registers, as he performs for the cop, keeping up the pretense about the authorized film shoot, while also performing for the cameraman and viewer, who apprehend the overarching story in which the cop is being fed a fiction. Monteros explains what is happening: "We are going to deliver the letter that authorizes us to film scenes from a movie." When the cameraman asks, "Which scenes are they?," Monteros responds, "Seventy-four, Nineteen seventy-eight, and Seventy-three." These numbers refer to key dates in the history of U.S.-backed state terrorism and dictatorship in the Southern Cone in the 1970s, including the dates when the Argentine state passed an antiterrorism law, which was the first in a series of measures that legalized the state's violence against those citizens it designated the nation's "internal enemies."[165] By bringing into the diegesis a history in which state terrorism was used to repress dissent and discipline workers into ever more punishing regimes of capitalist accumulation, the speech provokes consideration of how similar dynamics operate in the present—be it in the policing of public space and protest we are witnessing in the video or in the globalization of antiterrorist politics to which the film alludes.

When the cop asks Monteros what the film is about, Monteros replies, "The International Errorist." After the cop repeats the phrase with incredulity and suspicion, Monteros explains that Errorism is "a movement whose philosophy is error as liberating action." He continues, "For many years we have analyzed political reality, the contradictions of modernity and their

genocidal resolution for the people of the world. We discovered that error is the only path to liberate the world. That's why we came to bring salvation." The cop responds with silence.

Error Errorista has a split, asymmetrical structure, in which the diegesis contains two different, noncontinuous "realities"—that is, two different perceptions of the mise-en-scène. The diegetic world of the film encompasses the Errorists' invisible theater for the cops, as well as the perspective of the viewer, who can perceive that it is an act. Monteros's breaking of the fourth wall with his direct address to the camera brings viewers into this behind-the-scenes perspective on the performance. It affords viewers a superior epistemic position, as they see the Errorists' performance for the apparently unwitting cops and spectators. It also solicits viewers' complicity via their identification with the perspective of the artists who are deceiving the cops. The second "reality" is the one perceived by the cops. It is a multilayered fiction composed at the meeting point of the Errorists' performance (with their garb, fake guns and letter, and fictionalized explanations) and the predisposition of the cops and bystanders to interpret this performance according to existing social scripts. This perceived reality doesn't function as a focalizing perspective in *Error Errorista*. Instead, it is made into an object of scrutiny and an element of the plot. It appears self-contained, following a logic and temporality that is noncontinuous with the diegetic world with which the viewer's perception is aligned. Viewers' potential identification with the cop's perspective is foreclosed by this formal structure.

When Monteros and the cop arrive at the sidewalk we see the larger audience for the Errorists' invisible theater. A crowd of onlookers has gathered there. They are presumably neighbors and passersby, and perhaps include those persons who called the police on the artists. They look curious, and certainly not threatened. Another cop approaches Monteros with an air of deference and professionalism to say he will take the authorization letter to make a photocopy of it. The cops' and crowd's interactions with Monteros—who is a well-spoken, white, middle-class Porteño—mark a striking reversal from the police's violent arrival at the beach when they anticipated confronting armed piqueteros.

It may first appear that the comic reversal in *Error Errorista* turns on the revelation that the artists are not actually "terrorists" or piqueteros, but only dressed like them. However, the very possibility for this reversal to occur rests on the divulging of the Errorists' class and race. This conditions the shift in the cops' behavior from gun-wielding aggression to affable professionalism.

One can be quite sure that if the Errorists were perceived as members of a racialized and criminalized stratum of the working class, instead of as middle-class professionals from the capital, the scenes in *Error Errorista* would have unfolded quite differently, notwithstanding the discovery that their guns were fake.

When Monteros strikes up a conversation with the cop who initially commanded the artists to stop filming, the cop's demeanor and dialogue has changed so markedly that it registers almost like a shift in genre, as if we had changed the channel from a police reality show to a situation comedy in which a good-natured if somewhat doltish police officer is another neighborhood character. This emphasizes the fact that subjects of different classes inhabit entirely different realities vis-à-vis the state's repressive apparatus.

When Monteros notes that the cops' erroneous assailing of the artists complements the latter's work on error, the cop interrupts him to reflect on his own fortuitous apprehension of a film crew: "And I always wanted to be an actor. But they didn't let me, so that's that." To the viewer, the cop's comment is ironic, because he *has* been made into an actor in *Error Errorista,* though he doesn't perceive this (or, at least, this is what the video leads us to believe). The irony of the cop's comment perfectly condenses the way *Error Errorista*'s split structure—its nesting of the cops' perceived reality within a distinct diegetic world—aesthetically reconfigures the social relations through which pacification operates. The security apparatus "produces its own materialities by organizing storylines and plots with 'forces, victims, and villains,'" Seri writes.[166] Initially, the Errorists were apprehended within this apparatus's storyline. They were cast in the role of dangerous, criminal, working-class subjects. The power of the state to impose this script upon the artists was emphasized and allegorized in *Error Errorista*'s first live-action scene, in which the cop controlled what could be recorded and, therefore, seen. In Althusser's classic allegory of ideological interpellation, the cop, as synecdoche of the state, performs the state's power to produce subjects in ideology, who are therefore always already subjected to it.[167] *Error Errorista* redeploys this allegory of subjectivation in cinematic language by showing a cop control what can be seen by exercising state power over the production of a cinematic scene. This opening live-action sequence allegorically represents the state's power to shape perceptions of reality to accord with the "storylines and plots" it imposes. But *Error Errorista* reflexively reconfigures these social relations by representing the very same cop as an unwitting character within their own story. This dramatically shifts the seen—that is, the reality the viewer can perceive.

Monteros asks the cop, "What was the error?," in reference to the fact that the actors were mistakenly assailed while making their film. The cop replies, "There was no error. The thing is that people were passing by, they saw hooded people with facsimiles of guns—okay, maybe they're weapons for theater or film. And we don't know anything. But, we do know the people of Mar del Plata are shaken up because of the Summit, because Leftists destroyed a lot of the city. . . ." As he speaks, it is evident that he presumes the sympathy of his audience, as he believes the Errorists and gathered crowd to be "upright" middle-class citizens who would understand the danger posed by Leftist protestors. His presumed complicity with the Errorists is ironic and funny, while it underscores the tactical importance of their casting their protest actions as art in a context where protest is criminalized.

Were it not denaturalized within *Error Errorista*'s decentered structure, this scene in which the cop emphasizes his confusion and total lack of malice in accosting the artists could be interpreted as a humanizing depiction of the police. However, it is actually the centerpiece of *Error Errorista*'s critique of state repression and the way different modes of governance are applied to subjects belonging to different social classes. By situating the cop's representation of his own experience within the split structure of the diegesis, while obstructing a viewer's potential identification with the cop's perspective, the video makes the perceptual-ideological framework the security apparatus produces into an object of scrutiny. This Brechtian maneuver shows how the character is not the "absolute subject" of his actions, but rather the "object of economic or social forces to which he responds and in virtue of which he acts."[168] Far from controlling the seen, the cop is revealed as a character in a social script that determines *his* perception. This is further emphasized by his resigned comment that he "always wanted to be an actor, but they didn't let [him]." It acknowledges that this working-class man's possibilities for selling his labor power are indifferent to his artistic aspirations, as it is unsurprising that he'd much sooner be recruited into the role of a poorly paid foot soldier for the ruling class.

The split structure of *Error Errorista*'s diegesis transforms the spontaneous statements and actions of the unwitting cop into a kind of Brechtian performance within a work of cinéma verité. It recalls Althusser's analysis of the latent, decentered structure of the materialist theater of Brecht and Bertolazzi. Althusser argues that the way their work stages the "silent confrontation of a consciousness (living its own situation in the dialectical-tragic mode and believing the whole world to be moved by its impulse) with a reality which is indifferent and strange" to it "makes possible an immanent critique

of the illusions of consciousness."[169] The "dialectical-tragic mode" refers to a consciousness "imposed from without on a determinate condition but without any dialectical relation to it," such that it "can only be dialectical if it ignores its real conditions and barricades itself inside its myth."[170] In light of Althusser's analysis, we can see how *Error Errorista*'s structure enables an immanent critique of the cop's perspective, which itself is a synecdoche of the state's "script" and its power of subjectivation. The video choreographs a confrontation between a perceived reality ordered according to the state's script (the cop's) and the wholly distinct diegetic world, focalized and composed by the Errorists. Even though the cop's spontaneous dialogue appears to be unscripted and sincere, the video's overall structure denaturalizes his perspective and the ideologies in which it is rooted.

When the cop says, "There was no error," and proceeds to explain the causal chain behind what has happened, he suggests that the neighbors' and cops' perceptions and actions follow a coherent logic. This is true when the frame of reference is the aesthetic matrix security ideology produces. The drama the cop narrates—including the perceptions, emotions, and beliefs it entails—demonstrates the successful operation of the security state and its subjectivizing mechanisms. The cop's statement that he and the other officers "don't know anything" except that people are presumably frightened of dangerous Leftists further emphasizes that the cops are simply acting out their part in the security script.

As the cop is made to appear as a puppet and mouthpiece of security ideology, his explanation dramatizes the logics of securitization and the criminalization of dissidents and the poor. First, his comments underscore the importance manufactured fear has for the successful operation of security as an ideology.[171] The cop naturalizes people's fear, even though it is *produced* by the security apparatus, including the corporate media and the militarization of Mar del Plata. Second, the cop invokes the specter of violent Leftist protestors that the media incessantly peddles, including the media's claims that protestors' generally threatening character is proven by their damaging corporate property. His explanation displays the self-referential and self-reinforcing character of security ideologies, as he both peddles fear and produces a figure of criminality to appear as its cause.

After someone from the crowd objects, the cop modifies his claim that Leftists destroyed half the city and says, "I don't know if they were of the Left, but Quebracho. Maybe I expressed myself poorly." While apparently conciliatory, the cop stokes fear of a Left political organization that the Argentine state and corporate media demonize in order to associate Left militancy with

Chapter Four

criminality. The Movimiento Patriótico Revolucionario "Quebracho" (Patriotic Revolutionary Movement "Quebracho") is a revolutionary Left political organization that has been involved in Argentina's pensioner, student, and piquetero movements. Marcela Perelman explains that representations of Quebracho as a "hyperbolic figure of the piqueteros" are deployed to excuse state repression. "To allege Quebracho's presence in a protest is to reiterate an argument at the service of institutional violence, used not only in police discourse but also in that of political authorities."[172] In *Error Errorista*, the cop's readiness to blame Quebracho when his blanket condemnation of Leftists is rejected exemplifies both the state's strategic construction of enemies to be feared and the mutability of these figures.

Error Errorista reveals the proximity between the criminalization of working-class social movements, Left activists, and the racialized poor. It also suggests that these criminalizing discourses are haunted by the ever-malleable figure of the terrorist that is circulated in the discourse of global terrorism. These figures of criminality operate as floating signifiers that the state deploys as needed. They are articulated in signifying chains, so they can be made to summon each other, such that ideologies of dehumanization and criminality deployed against one "enemy" can be mobilized toward other targets.

Error Errorista's social critique rests in the way it interrogates the exceptionality and spontaneity implied by the idea of "error." While the events that unfolded in it were spontaneous in the sense that they were not scripted or planned, the video reveals these to be expressions of the "spontaneous ideology in which men live."[173] It shows how perceptions, attitudes, and even feelings are socially forged, focusing specifically on the power of policing and its attendant ideologies to shape them. The Errorists set a perceptual trap by appearing in a militarized city, in the paranoid atmosphere antiterrorism discourse and urban militarization produce, having composed themselves as an exaggerated composite of images of terrorists and other criminalized figures. The artists leverage social perceptions of this constructed figure in order to provoke the unfolding of a "script" that the cops and neighbors spontaneously, though predictably, play out. For example, when people call the cops to report armed piqueteros on the beach, the point is not that this was in error, but rather that they *did* perceive the *figure* that had been constructed for their gaze by the mass media: the threatening working-class/lumpen criminal whose appearance in public space is understood to be the proper object of management or eradication by the police. This demonstrates Neocleous's assertion that "perception is as important as reality" for the successful

functioning of security politics.[174] The perceptions and actions that unfold in *Error Errorista* that could be understood as errors are actually symptoms of a "successful" process of pacification that dehumanizes and criminalizes the poor and political dissidents, instills fear of them in others, and presents agents of repression as guardians of "security."

After attempting to name a criminalized scapegoat on which the gathered crowd could agree, the policeman leaves. Monteros then takes advantage of the gathered crowd and improvises an impassioned speech about the philosophy of Errorism. He cajoles them into participating, asking, "Who here hasn't committed an error? . . . Who got married by error?" An older woman immediately responds in the affirmative and explains that she was pressured to get married because of social codes of propriety. Though it may appear as a non sequitur, her comment enriches *Error Errorista*'s ideology critique, as it underscores the ways in which patriarchy and bourgeois sexual mores script social relations in ways that limit people's possibilities for self-determination. In short, it demonstrates that real, existentially meaningful errors are often not deviations from the established social order but products of it.

The Errorists intervene in the aesthetic matrix that dictates the boundaries of what is seen as real and what is seen as fiction. In their live guerrilla action and *Error Errorista*, they marshal the capacity of fiction to manipulate and make visible the machinations of ideology, revealing *it* to be a fiction that passes itself off as reality. In this sense, we can understand it as a realist work in a Brechtian sense. It demonstrates that a representation that deploys obvious artifice, such as fiction, parody, and deception, can hew more closely to reality than the ideological representations promulgated by states and corporate media that lay claim to transparency and use aesthetics of objective realism. The Errorists also use fiction and the artifice of art as a tactic for making protest possible when it is widely criminalized and repressed. In *Operación BANG!* their tactical use of fiction (as deception) allows them to create a provocative work of protest art in the middle of a militarized city, while avoiding the repression directed at Leftist protestors, whom they are pretending not to be.

Crucially, *Error Errorista* shows how pacification, criminalization, and the concomitant forging of subjects of perception operate through multiple, intersecting scales. By framing *Error Errorista* with references to the OAS Summit, the War on Terror, and the U.S. military's omnipresence, the Errorists insist on the geopolitical dimension of localized processes of pacification. Specifically, they suggest that the onslaughts of global capitalism, exemplified by the FTAA negotiations and profiteering under the aegis

of fighting terror, are connected to the criminalization and repression of anticapitalist activists in Mar del Plata and elsewhere. Transnational complicity among ruling elites in their criminalization and repression of antisystemic movements is, of course, long-standing and well-documented. (The anticommunist violence discussed in chapter 3 is just one instance of this.) Yet the manufacture of enemies and wars of varying types (against terror, crime, drugs, etc.) attempts to conceal the function of police power for securing capitalist accumulation, thereby also obfuscating the transnational dimensions of these processes. The Errorists' attention to the ideological-aesthetic manufacture of enemies as a transnational process with local manifestations provides a crucial perspective on capital's global wars of pacification and efforts to destroy movements that might challenge its imperatives.

Another Aesthetics—Another Politics—Is Possible

THROUGHOUT THIS BOOK, I have shown how an *other* aesthetics needs to be understood in multiple senses. To begin with, I have modeled a way of apprehending and analyzing aesthetics in an expansive sense, which concerns the social forging of perception (and, by extension, thoughts, values, feelings, etc.), rather than in the restricted sense that pertains only to those practices and productions associated with fine art. Understanding aesthetics in this fashion sheds light on how aesthetic dimensions of social practices of all types are implicated in contemporary class struggles, including myriad practices that are typically perceived as being neutral, objective, transparent, or otherwise having little to do with social conflict.

I have argued that because cultural production participates in the creative process of world-making, it is never socially neutral. The artists discussed in this book fully assume the political agency of their artistic labor. Their efforts to amplify the political use-value of their work for antisystemic politics is evident in what they make and for whom and how they make it. This kind of artistic practice exemplifies exceptional creativity. This is because their creative practice addresses the entire system of production, circulation, and reception in which it is implicated, treating it as something artists can seek to

transform (rather than as an unquestioned overdetermining framework for their labor). As they recognize that political battles over aesthetics take place across the entire social landscape, they bring their work to bear on sites that are meaningful within contemporary struggles, and they transform their very mode of producing art in order to participate more effectively in them. These activities manifest a conscientiously counterhegemonic use of creative labor. This necessarily entails resisting the political uses toward which intellectual and artistic work is regularly channeled, in which I include the corralling of creative labor by market imperatives.

The art practices I have highlighted, and others like them, are far less likely to achieve the kind of visibility or financial valorization in the so-called art world than those that are oriented to its protocols, audiences, and value hierarchies. This is simply a reflection of the social function of these institutions and their value hierarchies for managing creative labor and organizing markets. I hope that this study will encourage those seeking astute social critique and capacious creativity in contemporary art practice to look beyond those figures consecrated by ruling-class institutions and luxury markets and to challenge their imagined monopoly on recognized artistic value (by, in effect, making it material in the form of symbolic and financial capital).

I have shown how artists and communities of which they are a part articulate alternative visions of artistic labor, where its value can be understood in regard to its creative contributions to struggles for emancipation and equality. In this conception of art practice, the social role of the artist far exceeds the production of artworks. Rather, artists—as intellectuals—have the possibility of marshaling their artistic labor and creativity to conscientiously participate in collective social struggles. Learning from movements and connecting artistic labor to them requires a profound experimentalism, as it means opening up the very idea of what art is and what it can do.

As much as this book has sought to showcase what an apprehension of the politics of aesthetics can mean for understanding the potential of artistic practice to participate in counterhegemonic world-making, it has also aimed to analyze a counterhegemonic *aesthetics of politics* produced by antisystemic movements and their allied art practices. By aesthetics of politics, I mean a perceptual framework that identifies what politics is and how it functions. For aesthetics produces a practical mode of intelligibility of political processes, which is fully incorporated into subjects' apprehension of themselves and the world.

The counterhegemonic aesthetics of politics at work in the antisystemic movements and cultural expressions I have examined in this book critique dominant representations of political and economic liberalism to render apprehensible the actual social relations these organize. For example, *Raiders* contests the progress narratives of liberalism to reveal the colonial violence, domination, and pillage on which the global economy and its capitalist nation-states are built. Where a hegemonic aesthetics would have us see modernization, the promise of inclusion in democratic nation-states, and globalist cosmopolitanism, *Raiders* shows us brutal dispossession, the destruction of worlds, and moral hypocrisy. Whereas bourgeois institutions and histories promote national identities, all of the artists addressed in this book reveal the aesthetic constitution of national identity as a cover for capital's class and colonial warfare. As the Pocho Research Society's work upends nationalist myths, it lays bare the colonial and neocolonial character of the U.S. state and shows how even the most local sites are shaped by the history and agency of an international working class. The Research Society's work on gentrification with Ricardo A. Bracho shows that those processes that go by the name of urban redevelopment are manifestations of class war wherein spatial displacement is also an assault on entire social worlds. By proffering counterhegemonic representations of historical time and the spatial coordinates of historical processes, while focusing on the lives of working-class and colonized subjects, both Fran Ilich and the Pocho Research Society develop a counterhegemonic aesthetics of politics that is particularly effective at revealing the (neo)colonial character of the neoliberal social order and the ways this manifests across multiple geographic scales.

Etcétera... and GAC also reconfigure dominant representations of history to shift perceptions of contemporary liberal politics and economics. But the force of their interventions lies in their challenge to the commonsense notion that authoritarian modes of governance are extrinsic to liberal governance. By calling into question liberal ideology's representations of violence, law, and justice, their work instead shows how the ruling class avails itself of both forms of bourgeois rule, which are, in fact, complementary in their function for maintaining class domination. Etcétera...'s work thoroughly denaturalizes the aesthetic capture of the people's will through which liberal representational politics operates, while showing how this functions in the overwriting of popular histories and the corralling of political desires, as well as the whitewashing of elite rule. The work on policing and criminalization by both GAC and the Erroristas highlights how the co-constitutive ideologies of citizenship and security that create an image of the state-as-benefactor

function to expand the police state and enforce class stratification. These artists' trenchant critiques of liberal ideologies that mask the actual operations of the capitalist state also suggest that the aesthetics of politics is distributed across the social field and operates through practices and institutions not associated with "politics proper" (as understood in liberal ideology).

Crucially, the critique of bourgeois politics and its self-mythologizations is only part of what these artists do. This negation and clarification work hand in hand with their efforts to make legible antisystemic politics from below and their forms of political agency, which are imperceptible from the perspective of a bourgeois aesthetics of politics. Their counterhegemonic aesthetics of politics helps to illuminate the other worlds that movements create and defend. For example, the work of GAC and Etcétera . . . illuminates visions of justice and history people collectively assert in direct opposition to state laws and historical narratives, as well as the ways movements cultivate rebellious subjects and political collectivities that defy forces of social atomization and "normalization." The Pocho Research Society's work charts a largely hidden history of L.A., carved out by cultural and political countercurrents that extend into Mexico and Central America, by spatial practices of working people that enable communities' self-determination, and notions of collectivity that defy ideologies of citizenship, national belonging, and bourgeois civility. Ilich's work participates in and vindicates practices of solidarity that help sustain autonomous communities that model a radically democratic, anticapitalist, and anticolonial politics and energize the international Left. All of these works illuminate practices of world-making that do not pass through the institutions of capitalist states or defer to the power of elites. Rather, they affirm the capacity of politicized and collective labor to create another possible world.

This other world appears to be a distant possibility when it is perceived from the point of view of hegemonic aesthetics. What these artists' work shows—and what I have tried to demonstrate—is that this world already exists. From the vantage point of counterhegemonic aesthetics, it is *actual,* even if fragile and under siege. The purpose of this book has been to open our horizons of perception so that this actual other world can be seen for what it is, in the hopes of contributing to its defense and future growth.

NOTES

NOTES TO INTRODUCTION

1. Fran Ilich, email to Penacho email list, March 23, 2013.

2. "Antisystemic movement" is a concept developed within world-systems theory to analyze a wide array of social and popular movements that have organized against injustices of the capitalist world-system in ways that challenge prevailing social relations of production, including "socialist or labor movements, national liberation movements, peasant movements, women's movements, peace and ecology movements," among others. Amin et al., introduction to *Transforming the Revolution*, 9–10.

3. See, for example, the archive of texts by the EZLN commanders and spokespersons on *Enlace Zapatista*, http://enlacezapatista.ezln.org.mx, and their self-published book, Comisión de la Sexta del EZLN, *El pensamiento*.

4. Marx, *Economic and Philosophic Manuscripts*, 105.

5. Marx, *Economic and Philosophic Manuscripts*, 106. Useful commentaries on this aspect of Marx's thought include Gandesha, "Three Logics," 5–10; Sánchez Vázquez, *Las ideas estéticas*, 47–95.

6. Marx, *Economic and Philosophic Manuscripts*, 99–114; Wynter, "Rethinking 'Aesthetics'" and "1492." My reference to "the human" is purely heuristic and is not meant to inscribe a strict dividing line between so-called *Homo sapiens* and other sentient beings.

7. Rancière, *Politics of Aesthetics*, 85.

8. For a discussion of some of the limitations of Rancière's work, as well as an argument in favor of a materialist and "radically historicist" approach to aesthetics,

see Rockhill, *Radical History*, 1–55 and 163–82; and Rockhill, *Interventions in Contemporary Thought*, 100–116, 214–42.

9. Ponce de León and Rockhill, "Toward a Compositional Model of Ideology."

10. As discussed in detail in "Toward a Compositional Model of Ideology," Marxist theories of ideology upon which I draw include Marx and Engels, *Collected Works*, 36; Marx, *Capital*, 165; Althusser, *On the Reproduction of Capitalism*, 171–272; Althusser, *For Marx*, 227–36; Galeano, *Upside Down*; Therborn, *Ideology of Power*; Hall, "Signification, Representation, Ideology"; Fields and Fields, *Racecraft*, 128–41; Rosaura Sánchez, "Critical Realist Theory of Identity"; and Eagleton, *Literary Theory*, 13; as well as Balibar's writing on Marx's concept of commodity fetishism in *Philosophy of Marx*, 60.

11. Wolff, *Aesthetics*, 14–18.

12. Gramsci, *Antonio Gramsci Reader*, 395.

13. Gramsci, *Antonio Gramsci Reader*, 192–96. For an excellent summary of Gramsci's concept of hegemony, see Robinson, *Promoting Polyarchy*, 21–22.

14. Gramsci, *Antonio Gramsci Reader*, 211–12; Gramsci, *Selections from the Prison Notebooks*, 203.

15. Ponce de León and Rockhill, "Compositional Model of Ideology," 16; Gramsci, *Antonio Gramsci Reader*, 325–26.

16. For example, Denning, *Cultural Front*; Reed, *Art of Protest*; McCaughan, *Art and Social Movements*; Expósito, *Walter Benjamin*; Gómez-Barris, *Beyond the Pink Tide*; Streeby, *Radical Sensations*; Sholette, *Dark Matter*; Noriega, *Just Another Poster?*; Fuentes, *Performance Constellations*; Bogad, *Tactical Performance* and *Electoral Guerrilla Theater*.

17. Tapia, *Política salvaje*, 72–80.

18. Examples include Tse-Tung, "Talks at the Yenan Forum"; Cabral, *Return to the Source*, 39–69; Guevara and Castro, *Socialism and Man*, 22–29; Freire, *Pedagogy of the Oppressed*; Fernández Retamar, *Caliban*, 3–55.

19. See, for example, Escobar, *Territories of Difference*; Zibechi, *Territories in Resistance*; Martins de Carvalho, "Emancipation of the Movement"; Alvarez, Escobar, and Dagnino, "Introduction"; Gómez-Barris, *Extractive Zone*.

20. Guattari and Rolnik, *Molecular Revolution*, 261, 467.

21. Lloyd and Thomas, *Culture and the State*, 161.

22. Tapia, *Política salvaje*, 73.

23. Alvarez, Escobar, and Dagnino, "Introduction," 1–8.

24. Marx, qtd. in Zibechi, *Territories in Resistance*, 89.

25. Zibechi, *Territories in Resistance*, 20, 89.

26. Galeano, *Upside Down*, 308.

27. Fran Ilich, interview with author, May 30–June 1, 2016.

28. Garín Guzmán, O'Higgins, and Zukerfeld, "International Errorista," part 2.

29. See Beverley, *Latinamericanism*, 95–109.

30. Comisión de la Sexta del EZLN, *El pensamiento*, 316. All English translations from Spanish texts and interviews I conducted in Spanish are my own, unless otherwise noted.

31. Subcomandante Marcos, "La Cuarta Guerra."

32. Robinson, *Into the Tempest*, 72.

33. Ahmad, *Selected Writings*, 219.

34. Robinson, *Into the Tempest*, 208. Also see Amin, *Capitalism*, 46, 56–60.

35. Robinson, *Into the Tempest*, 11.

36. Robinson, *Into the Tempest*, 55–56; Smith, "New Globalism, New Urbanism," 432–33.

37. Robinson, *Latin America*, 14.

38. Immanuel Wallerstein, "Antisystemic Movements," in Amin et al., *Transforming the Revolution*, 39–48; Robinson, *Latin America*, 15.

39. Davis, *Planet of Slums*, 151–73.

40. Robinson, *Latin America*, 16–20.

41. Robinson, *Into the Tempest*, 18–19.

42. Robinson, *Into the Tempest*, 65–67.

43. Antonio Negri, qtd. in Ruth Wilson Gilmore, "Terror Austerity Race Gender Excess Theater," 26.

44. Amin, *World We Wish*, 33.

45. Robinson, *Into the Tempest*, 85; Midnight Notes Collective, "New Enclosures," 315–24.

46. Neocleous, *War Power*, 84–85. Also see Marx, *Capital*, 914–26; Luxemburg, *Accumulation of Capital*, 345–51; Nichols, "Disaggregating Primitive Accumulation"; Harvey, *New Imperialism*; Coulthard, *Red Skin, White Masks*, 6–15.

47. Nichols, "Disaggregating Primitive Accumulation," 27. Also see Neocleous, *War Power*, 48–87.

48. Midnight Notes Collective, "New Enclosures," 317–33; Subcomandante Marcos, "La Cuarta Guerra."

49. Sader, *New Mole*, 19.

50. Veltmeyer, Petras, and Vieux, *Neoliberalism and Class Conflict*, 62–78.

51. Bayer, Borón, and Gambina, *Terrorismo de estado*, 111–222; Harnecker, *Rebuilding the Left*, 13; Klein, *Shock Doctrine*, 75–141; Blum, *Killing Hope*, 201–16.

52. Sader, *New Mole*, 17.

53. Veltmeyer et al., *Neoliberalism and Class Conflict*, 111–22; Veltmeyer, *On the Move*, 19–29; Chomsky and Herman, *Washington Connection*, 1–99, 242–98; Blum, *Killing Hope*, 201–16; Grandin, *Empire's Workshop*, 52–222.

54. Harvey, *Brief History of Neoliberalism*, 39–40.

55. Caffentzis, "Capitalist Crisis to Proletarian Slavery"; Gilmore, "Globalisation and US Prison Growth," 176; Churchill and Vander Wall, COINTELPRO Papers, x.

56. Gilmore, "Globalisation and US Prison Growth," 137; Wacquant, *Punishing the Poor*, xvi–xvii, 306–308.

57. Robinson, *Promoting Polyarchy*, 51. Also see Harnecker, *Rebuilding the Left*, 13–14.

58. Sader, *New Mole*, 17–18.

59. Robinson, *Into the Tempest*, 114–15.

60. Robinson, *Latin America*, 43.

61. Robinson, *Latin America*, 43.

62. Saldaña-Portillo, "From the Borderlands," 502–4; Robinson, *Latin America*, 202–7.

63. See Robinson, "Remapping Development."

64. Denning, *Culture*, 35–50.

65. Robinson, *Latin America*, 300–304.

66. Soja, *Seeking Spatial Justice*, 144. Also see Mike Davis, "Uprising and Repression," 142.

67. Denning, *Culture*, 48–49. On the multiplicity of the movement and its sources, also see Amin, *World We Wish*, 36; Zibechi, *Movimientos sociales*, 35.

68. Barker, "Class Struggle," 46–47.

69. Barker, "Class Struggle," 45–46, 53. Also see Losurdo, *Class Struggle*, 7–51; Bhattacharya, "How Not to Skip"; Federici and Carlin, "Exploitation of Women."

70. Robinson, *Latin America*, 280–81.

71. See Therborn, *Ideology of Power*, 96.

72. Robinson, *Latin America*, 279–80.

73. Robinson, *Latin America*, 281, 286; Grandin, *Empire's Workshop*, 211–15.

74. Graham, *Cities under Siege*, 20–28.

75. Robinson, *Global Capitalism*, 205–8; Gilmore, *Golden Gulag*; Sandoval Palacios, *La frontera*.

76. Robinson, *Into the Tempest*, 22–28. Also see Sartre, "Plea for Intellectuals"; Althusser, *Lenin and Philosophy*, 85–126; Gramsci, *Antonio Gramsci Reader*, 301–22.

77. Brecht, "Short Organum for the Theater," in *Brecht on Theater*, 189; Boal, *Theater of the Oppressed*, 97.

78. Lloyd and Thomas, *Culture and the State,* 7.

79. See Lloyd, "Representation's Coup," 11–23; Robinson, *Into the Tempest*, 31–43.

80. Lloyd, "Representation's Coup," 23.

81. Rockhill, *Radical History*, 6–7.

82. Brecht, *Brecht on Film*, 41–48; Benjamin, "Author as Producer."

83. Benjamin, "Author as Producer," 89.

84. See, for example, Boal, *Theater of the Oppressed*; Getino and Solanas, "Toward a Third Cinema"; Ilich, "Otra cultura"; Valdez, *Luis Valdez*; Whitener, "Politics of Infrastructure"; Expósito, *Walter Benjamin*; Longoni, Carvajal, and Vindel, "Socialización del arte."

85. Expósito, Vidal, and Vindel, "Activismo artístico," 45.

86. I am drawing on Brian Holmes's theorization of "extradisciplinary art," although I use the term "paradisciplinary" because I think these practices are better described as being *beyond* or *alongside* artistic and other disciplines. Holmes, "Extradisciplinary Investigations."

87. Kester and Wilson, "Autonomy, Agonism, and Activist," 114; Bürger, *Theory*, 49.

88. See Rockhill's critique of Bürger in *Radical History*, 102–11.

89. Jameson, "Presentation IV," in *Aesthetics and Politics*, 149.

90. Brecht, "Against Georg Lukács," 81–82.

91. Brecht, "Against Georg Lukács," 83.

92. Also see Brecht's "Notes on the Realist Mode of Writing," in which he argues that "when defining [art] we should feel free to draw on such arts as the art of surgery, of university lecturing, of mechanical engineering and of flying. In this way we would run less risk of talking nonsense about something called 'the realm of art', something very narrowly delimited, something that permits very strict, albeit very obscure, doctrines" (*Brecht on Art and Politics*, 242–43).

93. Rockhill, *Radical History*, 5–6.

94. Rockhill, *Radical History*, 5–6.

95. Wolff, *Aesthetics*, 11–18. The modern ideology of art's autonomy represents art as a specialized realm that is separate from other aspects of social life and obeys its own inner logic. Grant Kester argues that one way this ideology manifests itself in contemporary art discourse is in the embrace of theories of politics that cast political organizing as a contaminating influence on supposedly more authentic forms of political expression, which operate within institutions of the arts and higher education. Kester, *One and the Many*, 58–59.

96. Davis, *9.5 Theses on Art*, 31; Williams, *Sociology of Culture*, 126–27.

97. Davis, *9.5 Theses on Art*, 27–37.

98. Williams, *Sociology of Culture*, 130–37.

99. Wright, "Future of the Reciprocal."

100. Wright, "Future of the Reciprocal" and "Delicate Essence," 539–42.

101. For a few examples, see Akers Chacón and Davis, *No One Is Illegal*; Alexander, *Pedagogies of Crossing*; Denning, *Culture in the Age of Three Worlds*; Gómez, *Revolutionary Imaginations of Greater Mexico*; Gómez-Barris, *Extractive Zone*; Kazanjian and Saldaña-Portillo, "Traffic in History"; McCaughan, *Art and Social Movements*; Robinson, *Global Capitalism, Latin America*, and *Promoting Polyarchy*; Saldaña-Portillo, "From the Borderlands," *Indian Given*, and *Revolutionary Imagination in the Americas*; José Saldívar, *Dialectics of Our America* and *Trans-Americanity*; Ramón Saldívar, *Borderlands of Culture*; Streeby, *Radical Sensations*; Taylor, *Archive and the Repertoire*; Williams, *Divided World*; Zibechi, *Movimientos sociales, Polítca y miseria*, and *Territories in Resistance*.

NOTES TO CHAPTER ONE

1. "Activista buscará de recuperar el penacho de Moctezuma," *El Universal*, Feb. 1, 2018, http://www.eluniversal.com.mx/cultura/artes-visuales/activista-buscara-recuperar-el-penacho-de-moctezuma.

2. Milady Nazir, "A Symbol of Mexico's Pre-colonial Grandeur Fades out of Sight," *Fox News Latino*, Nov. 14, 2014, https://www.foxnews.com/lifestyle/a-symbol-of-mexicos-pre-colonial-grandeur-fades-out-of-sight.

3. As Santiago García Navarro suggests in "Live and Learn," a metawork consists of a totality of processes and social relations, not just their sporadic material manifestations as art objects. It exists as a "to-ing and fro-ing between object and process."

4. Ilich, email to Penacho email list, Mar. 23, 2013.

5. Ilich, "Repatriate."

6. Fran Ilich, interview with author, June 8, 2015.

7. Schrank, *Avant-garde Videogames*, 24.

8. Jagoda, *Network Aesthetics*, 182–96.

9. As Marie-Laure Ryan suggests, we can understand how narratives are composed in and across various media, which need not be exclusively verbal media, by conceiving narrative in cognitive terms rather than strictly as a linguistic object. Ryan, introduction to *Narrative across Media*, 9.

10. Schrank, *Avant-garde Videogames*, 115.

11. Jagoda, *Network Aesthetics*, 191. Here, Jagoda builds on Jane McGonigal's writing on ARGs' immersive aesthetics in "This Is Not a Game."

12. Flanagan, *Critical Play*, 2–4, 226, 247.

13. Ilich, interview with author, May 31, 2016.

14. Ilich, interview with author, May 31, 2016.

15. McGonigal, "This Is Not a Game."

16. Chakrabarty, *Provincializing Europe*, 243. See also Saldaña-Portillo, *Indian Given*, 24–25.

17. Alexander, *Pedagogies of Crossing*, 189–90.

18. Alexander, *Pedagogies of Crossing*, 195.

19. See, for example, Comandancia General del Ejército Zapatista de Liberación Nacional, "Declaración."

20. Ilich, *Otra narrativa es posible*, 24; my translation.

21. Ilich, interview with author, May 31, 2016.

22. Throughout this book, I use the concepts of social position, positionality, identification, and identity as these are theorized by Rosaura Sánchez in "On a Critical Realist Theory of Identity."

23. On Contra-Cultura (menor), see Villanueva, *Detonación*.

24. Fallon, "Negotiating a (Border Literary) Community," 162–63.

25. Baugh, "*Hecho en Mexico*."

26. Benjamin, "Author as Producer," 93.

27. Baugh, "*Hecho en Mexico*," 143.

28. Ilich, interview in *En Voz Propia*, 393.

29. Díaz Polanco, *Rebelión Zapatista*, 171–77.

30. See Zibechi, *Territories in Resistance*, 127.

31. González Casanova, "Internal Colonialism," 33–36.

32. Bartra, "Guerras del Ogro," 92–93; Saldaña-Portillo, *Revolutionary Imagination*, 254–56.

33. García Linera, "Zapatismo," 296; Harvey, *Chiapas Rebellion*, 68–168; Saldaña-Portillo, *Revolutionary Imagination*, 226–27.

34. Robinson, *Latin America*, 208–9; Gerardo Otero, "Mexico's Double Movement: Neoliberal Globalism, the State and Civil Society," in Otero, *Mexico in Transition*, 1–36; Darcy Victor Tetreault, "Mexico: The Political Ecology of Mining," in Veltmeyer and Petras, *New Extractivism*, 177–91; Harvey, *Chiapas Rebellion*, 169–90.

35. Armando Bartra, "Rebellious Cornfields: Toward Food and Labour Self-Sufficiency," in Otero, *Mexico in Transition*, 23; Bartra, "Las guerras del ogro," 63–82.

36. Bartra, "Rebellious Cornfields," 25.

37. Akers Chacón and Davis, *No One Is Illegal*, 120–22; Harvey, *Rebellion in Chiapas*, 25–8.

38. Akers Chacón and Davis, *No One Is Illegal*, 116–22.

39. Robinson, *Latin America*, 208.

40. Robinson, *Latin America*, 208.

41. Midnight Notes Collective, *New Enclosures*; Harvey, *New Imperialism*.

42. Subcomandante Marcos, "La Cuarta Guerra Mundial."

43. Subcomandante Marcos, "La Cuarta Guerra Mundial."

44. Comandancia General del Ejército Zapatista de Liberación Nacional, "Primera Declaración."

45. Saldaña-Portillo, *Revolutionary Imagination*, 243–47.

46. Saldaña-Portillo, *Revolutionary Imagination*, 247.

47. Saldaña-Portillo, *Revolutionary Imagination*, 248–49.

48. Zibechi, *Territories in Resistance*, 127, 129.

49. Zibechi, *Territories in Resistance*, 128, 129.

50. Zibechi, *Territories in Resistance*, 127–58. The books the Zapatistas produced and disseminated at the 2013 Escuelita Zapatista La Libertad según l@s Zapatistas discuss these initiatives in detail.

51. García Linera, "El Zapatismo," 299; Zibechi, *Territories in Resistance*, 139–40; Esteva, "Desarollo del mandar-obedeciendo."

52. Midnight Notes Collective, "Hammer," 12.

53. Raúl Ornelas, "La autonomía cómo eje de la Resistencia Zapatista," unpublished manuscript (2004), qtd. in Zibechi, *Territories in Resistance*, 143.

54. Ponce de León, "On the Zapatistas."

55. See, for example, Subcomandante Insurgente Marcos, "The Southeast in Two Winds: A Storm and a Prophecy" (1992), in Marcos et al., *Zapatistas*, 26–27.

56. Saldaña-Portillo, *Revolutionary Imagination*, 223–30.

57. Comité Clandestino Revolucionario Indígena Comandancia General, "Sexta Declaración."

58. Zibechi, *Territories in Resistance*, 145–52; Hernández Navarro, "Breaking Wave," 44–50.

59. Zibechi, *Territories in Resistance*, 148–54.

60. See Hernández Navarro, "Breaking Wave," 21.

61. Ilich, interview with author, Aug. 8, 2009. Interview transcript published on Latinart.com, http://www.latinart.com/transcript.cfm?id=99.

62. Ilich, "Otra cultura es posible," 2; Ilich, "Existencia y resistencia," 472.

63. Ilich, interview with author, Aug. 8, 2009.

64. See Ilich, "Fragmentos."

65. See Ilich, "Barter for Coffee at This Brooklyn Pop-Up"; "Fieldworks: Fran Ilich, Diego de la Vega Coffee Co-op," Vimeo video, 5:04, posted by A Blade of Grass,

Nov. 3, 2015, https://vimeo.com/144518926; Stephanie Andreou and Sarah Keeling, *Love and Labor*, 2017, https://www.loveandlabormovie.com.

66. Ilich, interview with author, May 31, 2016.

67. See Ponce de León, "On the Zapatistas."

68. Ilich, interview with author, June 8, 2015.

69. Ilich, interview with author, May 31, 2017.

70. Ilich, interview with author, May 31, 2017.

71. Ilich, interview with author, May 31, 2017.

72. Ilich, interview with author, May 31, 2017.

73. Ilich, interview with author, Aug. 8, 2009.

74. Brecht, "Popularity and Realism," 81–85; Benjamin, "Author as Producer."

75. Ilich, interview with author, June 1, 2017.

76. Ilich, interview with author, June 1, 2017.

77. Ilich, interview with author, June 8, 2015.

78. See, e.g., Kunzle, "Dispossession by Ducks."

79. Ilich, interview with author, May 31, 2016.

80. See Sholette, *Dark Matter*, 178.

81. On the use of this term and concept by Native Americans, scholars, and activists, see Mann, "And Then They Build Monuments." On the denial of the American holocaust, see Churchill, *Little Matter of Genocide*, 119.

82. Césaire, *Discourse on Colonialism*, 14.

83. Churchill, *Wielding Words like Weapons*, 59–60.

84. Churchill, *Wielding Words like Weapons*, 60–67

85. Churchill, *Wielding Words like Weapons*, 62–67.

86. Finkelstein, *Holocaust Industry*, 63.

87. Sources on this history include Ganser, *NATO's Secret Armies*; Lichtblau, *Nazis Next Door*; Jacobsen, *Operation Paperclip*; Blum, *Rogue State*, 162–221; Chomsky and Herman, *Washington Connection*.

88. Whitman, *Hitler's American Model*, 9–10, 47. In the latter passage, Whitman is drawing directly on the work of Detlef Junker. Also see Domenico Losurdo on the historical relationship between the Nazi Holocaust and the colonial violence of the United States and other liberal imperialist states, Hitler's admiration for U.S. policies, and historical revisionists' obfuscation of these relationships (e.g., *War and Revolution*, 156–223).

89. Taylor, *Archive and the Repertoire*, 66.

90. Ilich, email to the Penacho email list, Mar. 23, 2013.

91. See Shiva, *Protect or Plunder?*

92. Topik, "Coffee as Social Drug."

93. Renard and Breña, "Mexican Coffee Crisis"; María Elena Martínez Torres, "Survival Strategies in Neoliberal Markets: Peasant Organizations and Organic Coffee in Chiapas," in Otero, *Mexico in Transition*, 169–74.

94. Saldaña-Portillo, *Revolutionary Imagination*, 213–23.

95. Rodríguez, "Cooperativas"; Martínez Torres, "Survival Strategies," in Otero, *Mexico in Transition*, 176–79, 183–84.

96. Ilich, email to Penacho email list, Apr. 16, 2013.

97. Ilich, email to Penacho email list, Mar. 29, 2013.

98. Invisible theater is a technique in which a performance is created in an everyday setting so that spectators do not realize it is a performance. Boal, *Theater of the Oppressed*, 122–26.

99. Althusser, *Lenin and Philosophy*, 118.

100. Ilich, interview with author, May 31, 2017.

101. Ilich, interview with author, May 31, 2017.

102. Ilich, email to Penacho email list, Mar. 19, 2013.

103. Ilich, email to Penacho email list, Apr. 16, 2013.

104. Alicia Herrero, email to Penacho email list, Mar. 30, 2013.

105. Ilich, email to Penacho email list, Apr. 16, 2013.

106. Ilich, email to Penacho email list, Apr. 21, 2013.

107. Ilich, email to Penacho email list, Apr. 21, 2013.

108. Ilich, email to Penacho email list, Apr. 21, 2013.

109. Galeano, *Open Veins*, 25.

110. Galeano, *Open Veins*, 33.

111. Gómez-Barris, *Extractive Zone*, 110–11; Galeano, *Open Veins*, 55.

112. Marx, *Capital*, 533.

113. Gunder Frank, *ReOrient*, 281–82.

114. Gunder Frank, *ReOrient*, 277–82, 355.

115. See Quijano and Wallerstein, "Americanity as a Concept."

116. Darcy Victor Tetreault, "Mexico: The Political Ecology of Mining," in Veltmeyer and Petras, *New Extractivism*, 188–89; Veltmeyer and Petras, introduction to *New Extractivism*, 5–6.

117. Henry Veltmeyer and James F. Petras, "Theses on Extractive Imperialism and the Post-Neoliberal State," in Veltmeyer and Petras, *New Extractivism*, 223–24.

118. Veltmeyer and Petras, "Theses on Extractive Imperialism," 228–30; Svampa, "Commodities Consensus."

119. Veltmeyer and Petras, "Theses on Extractive Imperialism," 237.

120. Veltmeyer and Petras, "Theses on Extractive Imperialism," 230; Gómez-Barris, *Extractive Zone*, 2–5; Zibechi, "Estado de excepción," 80–81.

121. Subcomandante Marcos, "La Cuarta Guerra Mundial." Also see Robert Nichols's analysis of the multiple processes involved in primitive accumulation, which does not necessarily entail proletarianization of the dispossessed ("Disaggregating Primitive Accumulation").

122. Svampa, "Commodities Consensus," 65.

123. Veltmeyer and Petras, introduction to *New Extractivism*, 36. On this process in Mexico, see Darcy Victor Tetreault, "Mexico: The Political Ecology of Mining," in Veltmeyer and Petras, *New Extractivism*, 178–81.

124. Veltmeyer and Petras, "Theses on Extractive Imperialism," 226–32. Also see Zibechi, "El estado de excepción," 81.

125. Azamar and Ponce, "Extractivismo y desarollo," 151.

126. Azamar and Ponce, "Extractivismo y desarollo," 151; Tetreault, "Mexico," 179–81.

127. Darcy Victor Tetreault, "Mexico: The Political Ecology of Mining," in Velt-meyer and Petras, *New Extractivism*, 179.

128. Azamar and Ponce, "Extractivismo y desarollo," 153; Henry Veltmeyer and James Petras, "A New Model or Extractive Imperialism?," in Veltmeyer and Petras, *New Extractivism*, 24.

129. Neocleous, *War Power*, 85. Also see Robinson, *Into the Tempest*, 99–122.

130. See Amin, *Unequal Development*.

131. See Chakravarty and Ferreira da Silva, "Accumulation, Dispossession, and Debt," 368–71; Robinson, *Latin America*, 259–68.

132. On the financialization of the Mexican economy, see Whitener, *Crisis Cultures*, 5–9; Correa, Vidal, and Marshall, "Financialization in Mexico."

133. Hitchcock, "Accumulating Fictions," 144.

134. On the economy as a contested space of representation, see Gibson-Graham, *Postcapitalist Politics*, 57.

135. Johnson, *Occupation of Alcatraz Island*, 16–48.

136. Johnson, *Occupation of Alcatraz Island*, 55, 47–78.

137. Johnson, *Occupation of Alcatraz Island*, 53–54.

138. Díaz Polanco, *Elogía a la diversidad*, 183n18. For an overview of forms indigenismo has taken in Mexico since the Conquest, as well as critiques of integrationist indigenismo, see Díaz Polanco, Guerrero, and Bravo, "Teoría indigenista." Also see Overmyer-Velásquez's discussion of indigenísmo as a neoliberal multiculturalist politics in *Folkloric Poverty*, 63–88, 142–54.

139. For Bonfil Batalla, "de-Indianization" names a sociohistorical process that occurs as the result of the pressures of ethnocide; it involves Indians' separation from their cultural patrimony, changes to their social organization, and renouncing of a distinctive identity (*México Profundo*, xvi).

140. Saldaña-Portillo, *Revolutionary Imagination*, 212.

141. Bonfil Batalla, *México Profundo,* 54–55. Also see García Canclini, *Hybrid Cultures*, 120–32.

142. See, for example, reports on former president Vicente Fox's call for the Penacho's repatriation, as well as Octavio Paz's comments on the object's importance to Mexican identity. "Mexico Wants Artifact Back," *New York Times*, June 2, 2005, https://www.nytimes.com/2005/06/02/world/americas/mexico-wants-artifact-back.html; "Emociona a especialistas 'regreso' temporal de penacho de Moctezuma," *Vanguardia/MX*, Jan. 19, 2011, https://vanguardia.com.mx/emocionaaespecialistasregresotemporaldepenachodemoctezuma-633834.html.

143. Taylor, "Ends of Indigenismo," 75–86; Overmyer-Velásquez, *Folkloric Poverty*, 142–54.

144. Taylor, "Ends of Indigenismo," 77. Also see Saldaña-Portillo, *Revolutionary Imagination*, 252.

145. Ilich, email to Penacho email list, Mar. 23, 2013.

146. Ilich, email to Penacho email list, Apr. 21, 2013.

147. Bonfil Batalla, *México Profundo*, 57–68.

148. Saldaña-Portillo, *Revolutionary Imagination*, 253.

149. Saldaña-Portillo, *Revolutionary Imagination*, 253.

150. García Linera, "Zapatismo," 296–97; Saldaña-Portillo, *Revolutionary Imagination*, 255.

151. Saldaña-Portillo, *Revolutionary Imagination*, 253.

152. Ilich, email to Penacho email list, Apr. 24, 2013.

153. See, for example, Amin, *Eurocentrism*; Wynter, "Ceremony Must Be Found"; Quijano, "Coloniality of Power"; Césaire, *Discourse on Colonialism*.

154. Comité Clandestino, "Cuarta Declaración."

155. See Díaz Polanco and Gorman, "Indigenismo, Populism, and Marxism," 42–61.

156. See Rivera Cusicanqui, "Ch'ixinakax utxiwa," 96; Echeverría, *Modernidad y blanquitud*, 242.

NOTES TO CHAPTER TWO

1. After a protracted restoration, the mural was unveiled in 2012.

2. De la Loza, *Pocho Research Society*, 15.

3. De la Loza, *Pocho Research Society*, 15.

4. De la Loza, *Pocho Research Society*, 15.

5. I am indebted to Chabram-Dernersesian's theorization of pocho identity in "Whiteness in Chicana/o Discourse," 147.

6. "Countermonument" refers to commemorative public art practices that express skepticism toward assumptions underpinning traditional public memorials and reject their typical aesthetic forms and qualities. Young, "Counter-Monument," 271.

7. Stevens, Franck, and Fazakerley, "Counter-monuments," 962.

8. De la Loza, *Pocho Research Society*, 17. See Laslett, *Shameful Victory*.

9. De la Loza, *Pocho Research Society*, 8.

10. De la Loza, *Pocho Research Society*, 43. This series of interventions was part of a larger collaborative *October Surprise* action in which over forty artists and activists participated.

11. De la Loza, *Pocho Research Society*, 44–48.

12. On the dialectical production of Chicanas/os/xs' social space, see Villa, *Barrio Logos*, 5–8.

13. Sandra de la Loza, interview with author, December 9, 2015.

14. Trouillot, *Silencing the Past*, 16.

15. Trouillot, *Silencing the Past*, 19–22, 25. Also see Martínez's discussion of the way "different professions and disciplines have their ways of making 'history come alive'" in "Archives, Bodies, and Imagination," 167–68.

16. Lefebvre, *State, Space, World*, 186.

17. Gómez-Barris, *Extractive Zone*, 6–9; Pratt, *Imperial Eyes*, 120–29; Mitchell, *Landscape and Power*.

18. Poulantzas, *State, Power, Socialism*, 113.

19. Poulantzas, *State, Power, Socialism*, 113.

20. Poulantzas, *State, Power, Socialism*, 114.

21. Simpson and Corbridge, "Geography of Things."

22. Sztulwark, "Ciudad memoria."

23. Hayden, *Power of Place*, 46–48.

24. Hayden, *Power of Place*, 46.

25. See Gómez-Barris, *Where Memory Dwells*, 5; Young, "Memory/Monument," 237.

26. Deutsche, *Evictions*, 39–41.

27. Rockhill, *Radical History*, 37. Rockhill's theory builds on Marxist, feminist, anarchist, indigenist, anticolonial, and postcolonial intellectual traditions that have interrogated epistemological and practical frameworks that overdetermine how history is produced and understood.

28. Trouillot, *Silencing the Past*, 106.

29. Rockhill, *Counter-History*, 1–32.

30. Guha, "Prose of Counterinsurgency," 1–40.

31. Trouillot, *Silencing the Past*, 70–107. Also see Guha, "Prose of Counterinsurgency."

32. Rockhill, *Counter-History*, 4. Also see Rockhill, "Foucault, Genealogy, Counter-History."

33. Rockhill, *Radical History*, 37–41.

34. Deutsche, *Evictions*, 24.

35. Deutsche, *Evictions*, 51.

36. Sandra de la Loza, artist talk in "Against Conquest: Histories from Below and to the Left," Slought Foundation, Philadelphia, September 22, 2017.

37. Villa, *Barrio Logos*, 49–55.

38. On the history of the plaza area, see Sánchez, *Becoming Mexican American*, 223; Villa, *Barrio Logos*, 55–57; Estrada, *Los Angeles Plaza*.

39. On Manifest Destiny, see Almaguer, *Racial Fault Lines*, 32–33.

40. Poulantzas, *State, Power, Socialism*, 110–14.

41. See Almaguer, *Racial Fault Lines*, 107–50.

42. De Certeau, *Practice of Everyday Life*, 95–96. James T. Rojas argues for such a shift in perspective in his analyses of Mexican neighborhoods in Los Angeles in "Enacted Environment."

43. Rockhill, *Counter-History*, 3.

44. See Akers Chacón and Davis, *No One Is Illegal*, esp. 55–86 and 125–258; Ngai, *Impossible Subjects*, 127–74; Gonzales-Day, *Lynching in the West*; McWilliams, *Factories in the Field*, 86–90 and 152–72.

45. Robinson, *Latin America*, 313–16.

46. Robinson, *Transnational Conflicts*, 105–7, 131, 206.

47. Robinson, *Transnational Conflicts*, 64–132, 203–13.

48. De Genova, "The 'Crisis,'" 48.

49. Robinson, "Aquí estamos," 84.

50. Caffentzis, "Capitalist Crisis to Proletarian Slavery."

51. Akers Chacón, "Anti-Migrant International." Also see Robinson and Santos, "Global Capitalism, Immigrant Labor," 6–8; and *Viewpoint* magazine, "Border Crossing Us."

52. Robinson, "New Global Capitalism."

53. Akers Chacón, "Anti-Migrant International."

54. Akers Chacón and Davis, *No One Is Illegal*, 202–5.

55. Akers Chacón and Davis, *No One Is Illegal*, 203–5; Fernandes, *Targeted*, 16–17.

56. Davis, *Magical Urbanism*, 67–76.

57. Gottschalk, *Caught*, 221.

58. Light, Lopez, and Gonzalez-Barrera, "Rise of Federal Immigration Crimes"; Gottschalk, *Caught*, 224–25.

59. Gottschalk, *Caught*, 67, 233.

60. Gottschalk, *Caught*, 233; Robinson, *Global Capitalism*, 202.

61. Boukalas, *Homeland Security*, 209.

62. Fernandes, *Targeted*, 170.

63. Akers Chacón and Davis, *No One Is Illegal*, 211.

64. Akers Chacón and Davis, *No One Is Illegal*, 215–16. Also see Sánchez and Pita, "Theses on the Latino Bloc," 41; and Davis, *Magical Urbanism*, 67–76.

65. *Viewpoint* magazine, "Border Crossing Us."

66. See Muñoz, *Youth, Identity, Power*; Gómez, *Revolutionary Imaginations*.

67. There is an extensive literature on arts in the Chicano movement. Publications with particular relevance to this book include Gómez, *Revolutionary Imaginations*, 67–137; McCaughan, *Art and Social Movements*; Dávalos, *Chicana/o Remix*, 63–96; Noriega, Romo, and Rivas, eds., *L.A. Xicano*; Goldman, *Dimensions of the Americas*; Noriega, ed., *Just Another Poster?*

68. See de la Loza, "Raza cósmica."

69. Sandra de la Loza, interview with author, December 9, 2015.

70. This argument is based on interviews I conducted with approximately forty Chicana/o/x artists in California and Colorado from 2001 to 2007.

71. See, for example, Johnson, *Leaving Aztlán*.

72. De la Loza, interview with author, December 1, 2004, published in *Latinart.com*.

73. De la Loza, interview with author, *Latinart.com*.

74. De la Loza, interview with author, December 9, 2015.

75. De la Loza, interview with author, December 9, 2015.

76. De la Loza, interview with author, December 9, 2015.

77. De la Loza, interview with author, December 9, 2015.

78. Davis, "Uprising and Repression in L.A.," 142–43.

79. Davis, "Uprising and Repression in L.A.," 142–43; Soja, *Seeking Spatial Justice*, 144.

80. Davis, "Who Killed L.A.?"

81. Antonio Negri, "Crisis of the Crisis State," in *Revolution Retrieved: Selected Writings on Marx, Keynes, Capitalist Crisis and New Social Subjects, 1967–83* (London: Red Notes, 1988), 181–82, qtd. in Gilmore, "Terror Austerity Race Gender Excess Theater," 25–26.

82. Gilmore, "Terror Austerity Race Gender Excess Theater," 26.

83. Davis, *City of Quartz*, xi–xii.

84. Davis, *City of Quartz*, xiii–xiv.

85. Oliver, Johnson and Farrell, "Anatomy of a Rebellion," 124.

86. Davis, "Who Killed L.A.?," 1–14; Oliver, Johnson, and Farrell, "Anatomy of a Rebellion," 127.

87. Oliver, Johnson, and Farrell, "Anatomy of a Rebellion," 126.

88. Gilmore, *Golden Gulag*, 70.

89. Gilmore, *Golden Gulag*, 7.

90. Davis, "Uprising and Repression," 149.

91. De la Loza, interview with author, December 9, 2015.

92. De la Loza, interview with author, December 9, 2015.

93. De la Loza, interview with author, December 9, 2015.

94. De la Loza, *Pocho Research Society,* 83.

95. See Gutiérrez, "Rasquachismo."

96. Ybarra-Frausto, "Rasquachismo: A Chicano Sensibility."

97. Mesa-Bains, "Domesticana," 158.

98. See Hall, "Notes on Deconstructing."

99. García, "Against Rasquache," 214.

100. See Melamed, *Represent and Destroy*, 31–39, 91–117; González, "Postmodernism, Historical Materialism and Chicana/o Cultural Studies."

101. De la Loza, interview with author, December 9, 2015.

102. De la Loza, *Pocho Research Society*, 71.

103. Deutsche and Ryan, "Fine Art of Gentrification," 93.

104. Smith, "New Globalism, New Urbanism," 443.

105. Sims, "More Than Gentrification," 35.

106. Sims, "More Than Gentrification," 37.

107. Woocher, "Los Angeles."

108. California Housing Partnership, "Los Angeles County Renters."

109. Woocher, "Los Angeles."

110. Woocher, "Los Angeles"; De La Cruz-Viesca et al., *Color of Wealth*, 6.

111. Soja, *Seeking Spatial Justice*, 189–92.

112. Barajas, "An Invading Army," 393–94; Rahel Gebreyes, "How Gang Injunctions Precipitate Gentrification in Los Angeles Communities," *Huffington Post*, Jan. 10, 2015, https://www.huffingtonpost.com/2015/01/09/gang-injunction-gentrification-los -angeles_n_6446124.html.

113. De la Loza, interview with author, December 9, 2015.

114. Boyle Heights Alliance against Artwashing and Displacement, "On 356 Mission Closing," April 2, 2018, http://alianzacontraartwashing.org/bye_356mission _2018/; Nizan Shaked, "Why I Am Resigning from x-tra *Contemporary Art Quarterly* and the Problem with 356 Mission's Politics," *Hyperallergic*, April 27, 2018, https://hyperallergic.com/440234/x-tra-contemporary-art-quarterly-356-mission -boyle-heights/.

115. De la Loza, *Pocho Research Society*, 75.

116. In this sense, *Echoes* resonates with Laura Aguilar's *Plush Pony* (1992), a series of black-and-white portraits of the Latina/x denizens of a working-class lesbian bar that reflects the provisional nature of such spaces. See Gómez-Barris, "The Plush View," 325.

117. Villa, *Barrio Logos*, 10.

118. Villa, *Barrio Logos*, 17.

119. Vargas, "Ruminations on *Lo Sucio*," 716.

120. Vargas, "Ruminations on *Lo Sucio*," 717–18.

121. Vargas, "Ruminations on *Lo Sucio*," 717–18.

122. Ricardo A. Bracho, "It Is the Libido," talk delivered at Stanford University, 2008. Text provided by Bracho.

123. Bracho, "It Is the Libido."

124. Ricardo Bracho, interview with author, December 4, 2015.

125. Bracho, interview with author, December 4, 2015.

126. Rodríguez, *Queer Latinidad*, 53.

127. Bracho informed me that the first word in the poem's third line is "breathe," and that it was due to an error of his that "breath" was printed on the PRS's plaque. Personal communication with Bracho, May 24, 2020.

128. Huyssen, *Present Pasts*, 7.

129. Seremetakis's writing on the senses and their relationship to memory have influenced my reading of this poem. See *The Senses Still*, 1–44.

NOTES TO CHAPTER THREE

1. See Zibechi, *Geneaología de la revuelta*.

2. Colectivo Situaciones, "Politizar la tristeza."

3. See Creischer, Siekmann, and Massuh, *Schritte zur Flucht*; the overview of art collectives in Ramona 33 (July–August 2003); Giunta, *Pos-crisis*; Longoni, "¿Tucumán sigue ardiendo?"

4. I am particularly inspired by Allen Feldman's writing on cultural anesthesia and part 1 of Cine Liberación's *La hora de los hornos* (1968) on neocolonialism and violence.

5. See Durán and Rockhill, "It's Time."

6. Poulantzas, *State, Power, Socialism*, 76–86.

7. Neocleous, *War Power, Police Power*, 46.

8. Neocleous, *War Power, Police Power*, 46.

9. Poulantzas, *State, Power, Socialism*, 83.

10. Poulantzas, *State, Power, Socialism*, 76, qtd. in Williams, *Divided World*, 69.

11. Williams, *Divided World*, 69, my emphasis.

12. For a discussion of the historical emergence of transitional justice, conceived as a "shortened 'sequence' of elite bargaining and legal-institutional reforms" rather than a process of socioeconomic transformation, see Paige, "How 'Transitions' Reshaped Human Rights"; Roht-Arriaza, "Why Was the Economic Dimension Missing," 22.

13. Feldman, "Memory Theaters," 170.

14. Feldman, "Memory Theaters," 168.

15. See Beverley, *Latinamericanism*, 98–100.

16. On this relationship, see Landa, *Apprentice's Sorcerer*, 9–13.

17. Mariana Heredia, "Economic Ideas and Power during the Dictatorship," in Verbitsky and Bohoslavsky, *Economic Accomplices*, 47–60.

18. Nancy Garín, interview with author, March 15, 2018. All interviews cited in this and the following chapter were conducted in Spanish. The English translations are mine.

19. Eduardo Basualdo, "The Legacy of the Dictatorship," 76, 98–99.

20. Veltmeyer, *On the Move*, 14–29; Robinson, *Latin America*, 13–25; Gunder Frank, *Crisis*, 6–27.

21. Gunder Frank, *Crisis* 23–24.

22. Gunder Frank, *Crisis*, 23–24 (Economy Minister Martínez de Hoz is quoted on p. 24); Basualdo, "The Legacy of the Dictatorship," 75–89; Bayer, Boron, and Gambina, "Apuntes sobre su historia," 111–222.

23. Qtd. in Klein, *Shock Doctrine*, 95.

24. Munck, Falcón, and Galitelli, *Argentina*, 207–11; Bayer, Boron, and Gambina, *Terrorismo de estado*, 153–58; Crenzel, *Memory*, 14–20.

25. Jorge E. Taiana, "Foreign Powers, Economic Support, and Geopolitics," in Verbitsky and Bohoslavsky, *Economic Accomplices*, 66.

26. McSherry, *Incomplete Transition*, 4–6.

27. Bayer, Boron, and Gambina, *Terrorismo de estado*, 17–110.

28. Bayer, Boron, and Gambina, *Terrorismo de estado*, 21.

29. Munck, Falcón, and Galitelli, *Argentina*, 212–23.

30. Verdú, *Represión en democracia*, 163.

31. Robinson, *Promoting Polyarchy*, 51.

32. Robinson, "Promoting Polyarchy: 20 Years Later," 230.

33. Robinson, *Promoting Polyarchy*, 58.

34. Grandin, "Instruction of Great Catastrophe," 46.

35. Robinson, *Latin America*, 269.

36. José Nun, "The Democratic Process in Argentina," in Epstein and Pion-Berlin, *Broken Promises?*, 38.

37. Svampa, *Sociedad excluyente*, 95–143. On how Argentine monetary policy was used to transfer wealth to transnational elites, see Robinson, *Latin America*, 267. Also see Zibechi, *Geneaología de la revuelta*, 123, 84–85.

38. Petras and Vieux, "Transition to Authoritarian," 5.

39. Pablo Ares, interview with author, December 9, 2013.

40. Robinson, *Latin America*, 232; see 232–34.

41. Hupert, *Estado posnacional*, 24. On the ideology of representation, see Therborn, *Ideology of Power*, 96.

42. Federico Zukerfeld, Ariel Devincenzo, and Antonio O'Higgins, interview with author, September 1, 2006.

43. Zibechi, *Geneaología de la revuelta*, 23–32.

44. Carolina Golder, interview with author, May 22, 2014.

45. Pablo Ares, interview with author, December 3, 2013.

46. Garín Guzmán, O'Higgins, and Zukerfeld, "International Errorista," part 1.

47. Zibechi, *Geneaología de la revuelta*, 49–50.

48. Zibechi, *Geneaología de la revuelta*, 33.

49. Pablo Ares, interview with author, December 9, 2013.

50. Jelin, "Politics of Memory," 50.

51. Jelin, *Lucha por el pasado*, 92.

52. Crenzel, *Memory*, 22–31; Moyn, *Last Utopia*, 144. For a study of this process in Uruguay, see Markarian, *Left in Transformation*.

53. Moyn, *Last Utopia*, 121; Williams, *Divided World*; Striffler, *Solidarity*, 12–13, 117.

54. Moyn, *Last Utopia*, 141–42; Munck, "Farewell to Socialism?"; Crenzel, *Memory*, 27–31; Markarian, *Left in Transformation*, 178.

55. Williams, *Divided World*, xvi–xxii, 109–11.

56. Williams, *Divided World*. Also see Meister, *After Evil*; Perugini and Gordon, *Human Right to Dominate*; Bricmont, *Humanitarian Imperialism*.

57. Meister, *After Evil*, 23.

58. Meister, *After Evil*, 13–14. Also see Jelin, *Lucha por el pasado*, 130–31.

59. Meister, *After Evil*, 24–25.

60. Crenzel, *Memory*, 27.

61. Crenzel, *Memory*, 26–31; Markarian, *Left in Transformation*, 6–8, 177–79; Taylor, "Body Memories," 192–203. Andrew Rajca provides an excellent overview of scholarship that addresses this in *Dissensual Subjects*, 32–34.

62. Grandin, "Instruction of Great Catastrophe," 47.

63. Grandin, "Instruction of Great Catastrophe," 64. Also see Crenzel, *Memory*, 94–96.

64. Taylor, "Body Memories," 198. Also see Draper, *Afterlives of Confinement*, 171–74.

65. Crenzel, *Memory*, 31.

66. Mattini, "Madres pueden ser memoria."

67. Mattini, "Madres pueden ser memoria."

68. Gómez-Barris, *Where Memory Dwells*, 6; Di Stefano, "From Shopping Malls"; Rajca, *Dissensual Subjects*, 34.

69. Rajca, *Dissensual Subjects*, 19–20, 55; Draper, "Against Depolitization."

70. Rajca, *Dissensual Subjects*, 55.

71. Jelin, *Lucha por el pasado*, 274.

72. Verdú, *Represión en democracia*, 63–64.

73. Nancy Garín, interview with author, March 15, 2018.

74. Jelin, *Lucha por el pasado*, 274.

75. Jelin, *Lucha por el pasado*, 109–10, 146–47; Jelin, "Politics of Memory," 41–48.

76. Pereyra, *¿Lucha es una sola?*, 40–41, 45–46; Seghezzo, "Entre los derechos humanos," 57.

77. Gandsman, "Limits of Kinship Mobilizations."

78. Romanin, "De la resistencia," 46–48; Zibechi, *Genealogía de la revuelta*, 37–67; Cerdeiras, *Subvertir la política*, 321–24. The Madres have also undertaken projects in housing and education, and some of their leading figures have been involved in other social movement campaigns, including the antiglobalization movement's resistance to the Free Trade Agreement of the Americas, organizing for the nonpayment of Argentina's external debt, and the feminist pro-choice movement. For a profile of a member of Madres de Plaza de Mayo Línea Fundadora whose activism extends well beyond liberal human rights politics, see Cortiñas, "Nora Cortiñas."

79. Zibechi, *Genealogía de la revuelta*, 38.

80. Zibechi, *Genealogía de la revuelta*, 57–58. See also Mesa de Escrache Popular and Colectivo Situaciones, "IV: La identidad," in *Genocida en el barrio*.

81. The Madres and HIJOS would develop ties to state institutions after 2002, during the progressive populist administrations of Néstor Kirchner and Cristina Fernández de Kirchner. This is discussed in detail in chapter 4.

82. Zibechi, *Genealogía de la revuelta*, 39–49. Also see Cerdeiras, *Subvertir la política*, 322–23.

83. Zibechi, *Genealogía de la revuelta*, 138–39, 90.

84. Zibechi, *Genealogía de la revuelta*, 53.

85. Pereyra, *¿Lucha es una sola?*, 41.

86. Bossi et al., *Pensamientos*, 60.

87. Mesa de Escrache Popular and Colectivo Situaciones, *Genocida en el barrio*.

88. Mesa de Escrache Popular and Colectivo Situaciones, "Discurso de H.I.J.O.S. en el escrache a Weber," in *Genocida en el Barrio*. On escraches, also see Zibechi, *Genealogía de la revuelta*, 50–53.

89. Zibechi, *Genealogía de la revuelta*, 52; Mesa de Escrache Popular and Colectivo Situaciones, "12 hipótesis/preguntas sobre los escraches," in *Genocida en el barrio*.

90. Zibechi, *Genealogía de la revuelta*, 52.

91. Zibechi, *Genealogía de la revuelta*, 32–34.

92. Santiago García Navarro, "El fuego y sus caminos," in Longoni and Bruzzone, *Siluetazo*, 346.

93. Longoni, "(Con)texto(s) para el GAC," in Bossi et al., *Pensamientos*, 10.

94. Taylor, *Archive and the Repertoire*, 165.

95. Bossi et al., *Pensamientos*, 26.

96. Bossi et al., *Pensamientos*, 27.

97. Bossi et al., *Pensamientos*, 79.

98. Bossi et al., *Pensamientos*, 81.

99. Sebastián Hacher, "Prólogo," in Bossi et al., *Pensamientos*, 5–6.

100. For a discussion of this slogan as it relates to the idea of social condemnation, see the essay by Mesa de Escrache Popular in Bossi et al., *Pensamientos*, 61–62.

101. Verdú, *Represión en democracia*, 196–97.

102. Verdú, *Represión en democracia*, 196–97, 199.

103. On Argentina's neoliberalization as a politics of space, see Giorgi and Pinkus, "Zones of Exception," 102–3.

104. Davis, *Planet of Slums*, 109–10; Giorgi and Pinkus, "Zones of Exception," 102–3.

105. Rockhill, *Radical History*, 6–7.

106. Bossi et al., *Pensamientos*, 82–83.

107. Lorena Bossi, exhibition walkthrough at *Liquidación X cierre*, a retrospective of GAC's work, Sala Pays, Parque de la Memoria, December 19, 2019.

108. Bossi et al., *Pensamientos*, 12.

109. Wright, "Future of the Reciprocal."

110. Wright, "Future of the Reciprocal."

111. Petras and Veltmeyer, *Social Movements and State Power*, 40, 48–49.

112. Svampa, *Cambio de época*, 152.

113. Bonner, *Policing Protest*, 60.

114. Garín Guzmán and Zukerfeld, *Etcétera . . .*, 14.

115. Garín Guzmán and Zukerfeld, *Etcétera . . .*, 14.

116. Garín Guzmán and Zukerfeld, *Etcétera . . .*, 32.

117. Garín Guzmán, O'Higgins, and Zukerfeld, "Internacional Errorista," part 2.

118. Nancy Garín, interview with author, March 15, 2018.

119. Nancy Garín, interview with author, March 15, 2018.

120. Nancy Garín, interview with author, March 15, 2018.

121. Bogad, *Tactical Performance*, 2.

122. Zukerfeld, Devincenzo, and O'Higgins, interview with author, September 1, 2006.

123. Zukerfeld, Devincenzo, and O'Higgins, interview with author, September 1, 2006.

124. Dabat and Lorenzano, *Argentina*, 43.

125. Dabat and Lorenzano, *Argentina*, 63–76.

126. Risler, *Acción psicológica*, 266–74.

127. Dabat and Lorenzano, *Argentina*, 125.

128. All quotations are my translation of the original dialogue, documented in Etcétera . . .'s self-published DVD *Etcétera . . . TV*.

129. Taylor, *Disappearing Acts*, 112. Also see Neil Larsen, *Reading North by South*, 82–90.

130. Risler, *Acción psicológica*, 252–63.

131. Risler, *Acción psicológica*, 255.

132. Graciela Daleo, quote from her testimony in the ESMA trial, April 29, 2010, reproduced in the Sitio de Memoria exhibition at the Espacio Memoria y Derechos Humanos (ex-ESMA), Buenos Aires.

133. See Risler, *Acción psicológica*, 277–78.

134. On other visual art created within and for the human rights movement, see Taylor, *Archive and the Repertoire*, 177–87; Longoni, "Fotos y siluetas."

135. Gordon, *Ghostly Matters*, 127.

136. Zukerfeld, Devincenzo, and O'Higgins, interview with author, September 1, 2006.

137. Althusser, *Lenin and Philosophy*, 114.

138. Brecht, "Short Organum for the Theater," in *Brecht on Theater*, 189; also see 27.

139. Brecht, "Short Organum for the Theater," 189.

140. Boal, *Theatre of the Oppressed*, 97; also see 30–31.

141. Althusser, *For Marx*, 146.

142. Brecht, "Short Organum for the Theater," 90.

143. Althusser, *For Marx*, 142–51.

144. Boal, *Theatre of the Oppressed*, 122.

145. Derrida, "Theater of Cruelty," 8.

146. Kelley and Kester, introduction to *Collective Situations*, 3–4.

147. Garín Guzmán, O'Higgins, and Zukerfeld, "Internacional Errorista," part 1.

148. Boal, *Theater of the Oppressed*, 22–42, 86–87; Brecht, *Brecht on Theater*, 57, 87.

149. Taylor, *Archive and the Repertoire*, 165.

150. Williams, *Divided World*, 71.

151. Williams, *Divided World*, 71.

152. "Manifestación frente al domicilio de Galtieri," *La Nacion*, June 18, 1998, https://www.lanacion.com.ar/100403-manifestacion-frente-al-domicilio-de-galtieri, referenced in Garín Guzmán and Zukerfeld, *Etcétera* . . . , 48.

153. Zukerfeld, Devincenzo, and O'Higgins, interview with author, September 1, 2006.

154. Grupo Etcétera . . . , *Etcétera . . . TV*.

155. Risler, *Acción psicológica*, 137–61.

156. Zukerfeld, Devincenzo, and O'Higgins, interview with author.

157. Garín Guzmán and Zukerfeld, *Etcétera. . . .*

158. Zukerfeld, Devincenzo, and O'Higgins, interview with author.

159. Zukerfeld, Devincenzo, and O'Higgins, interview with author.

160. Nancy Garín, interview with author, March 15, 2018.

161. See, for example, André Breton, Diego Rivera, and Leon Trotsky, "Manifesto for an Independent Revolutionary Art," 1938, http://www.generation-online.org/c/fcsurrealism1.htm.

162. Roht-Arriaza, "Why Was the Economic Dimension Missing," 31–46; Arthur, "How 'Transitions' Reshaped."

163. Meister, *After Evil*, 13–14.

164. Alejandra Dandan and Hannah Franzki, "Between Historical Analysis and Legal Responsibility: The Ledesma Case," in Verbitsky and Bohoslavsky, *Economic Accomplices*, 187–88.

165. "Ingenio Ledesma," 163–65.

166. Da Silva Catela, "Apagón en el ingenio," 92.

167. "Ingenio Ledesma," 165; Adriana Meyer, "Contra la contaminación en Ledesma," *Página 12*, Aug. 15, 2005, https://www.pagina12.com.ar/diario/elpais/1-55106-2005-08-15.html.

168. Meyer, "Contra la contaminación en Ledesma"; Adriana Meyer, "La causa por contaminación contra el ingenio Ledesma llega a la Corte," *Página 12*, Dec. 14, 2006, https://www.pagina12.com.ar/imprimir/diario/elpais/1-77689-2006-12-14.html.

169. Longoni, "Fotos y siluetas," 50–58; Longoni and Bruzzone, *Siluetazo*. Silhouettes are also used as an icon of the disappeared in Fernando Traverso's public artwork *Las bicicletas de Rosario*, which consists of 350 life-size bicycle silhouettes stenciled on public walls in Rosario, Argentina, symbolizing the approximately 350 students of the Universidad de Rosario who were disappeared during the dictatorship. In a manner similar to the resignification of GAC's work in light of contemporary police violence, Traverso's bicycles have also come to signify the police's killing of the activist Pocho Lepratti, known as the Bicycle Angel, in the context of the state repression on December 19 and 20, 2001. See Hite, *Politics and the Art of Commemoration*, 90–109.

170. Zibechi, *Genealogía de la revuelta*, 17.

171. Robinson, *Latin America*, 268.

172. Grandin, *Empire's Workshop*, 201.

173. Grandin, *Empire's Workshop*, 201.

174. Zibechi, *Genealogía de la revuelta*, 184.

175. Gramsci, *Selections from the Prison Notebooks*, 210.

176. Mattini, *Encantamiento político*, 101.

177. Colectivo Situaciones, "Causes and Happenstance."

178. Mattini, *Encantamiento político*, 101.

179. Bonnet, "Kirchnerismo."

180. Colectivo Situaciones, "Causes and Happenstance."

181. Robinson, *Latin America*, 161.

182. Hupert, *El estado posnacional*, 65.

183. Svampa, *Cambio de época*, 160.

184. Colectivo Situaciones, "Causes and Happenstance."

185. Colectivo Situaciones, "Causes and Happenstance."

186. Svampa, *Cambio de época*, 119.

187. Colectivo Situaciones, "Politizar la tristeza."

188. Colectivo Situaciones, "Politizar la tristeza." Also see Svampa, *Cambio de época*, 156.

189. Harvey, *Brief History of Neoliberalism*, 105–6.

190. Lorenzano, "Angels among Ruins," 254.

191. Garín Guzmán and Zukerfeld, *Etcétera . . .* , 85.

192. Garín Guzmán and Zukerfeld, *Etcétera . . .* , 86

193. Zukerfeld, Devincenzo, and O'Higgins, interview with author, September 1, 2006.

194. Derrida, "Theater of Cruelty," 8–10.

195. Derrida, "Theater of Cruelty," 14.

196. Derrida, "Theater of Cruelty," 14.

197. Zukerfeld, Devincenzo, and O'Higgins, interview with author, September 1, 2006.

198. On social atomization as a precondition for the capitalist social division of labor, see Poulantzas, *State, Power, Socialism*, 63–64.

NOTES TO CHAPTER FOUR

1. Svampa, *Cambio de época*, 78, 119.

2. My analysis of this politics is indebted to the exhibition and event series *La Normalidad*, which took place in Buenos Aires in 2006, and to their organizers and participants. See Massuh and Arrese, *La Normalidad*.

3. Svampa, *Cambio de época*, 160.

4. Svampa, *Cambio de época*, 162.

5. Svampa, *Cambio de época*, 161–62.

6. Gramsci, *Selections from the Prison Notebooks*, 203.

7. Svampa, *Sociedad excluyente*, 271.

8. Svampa, *Cambio de época*, 158–59.

9. Petras and Veltmeyer, *Social Movements and State Power*, 31.

10. On the interpenetration of hegemonic and coercive forms of domination, and of ideological and repressive state functions, see Poulantzas, *State, Power, Socialism*, 80–85; Neocleous, *Critique of Security*, 5, and *War Power, Police Power*, 33–35.

11. The fact that these processes were administered by a relatively progressive populist government does not deflect from the fundamental critique of them. I am well aware of the merits of Kirchnerism in comparison with the neoliberal and neo-authoritarian

administrations that proceeded it (Menem and de la Rúa) and succeeded it (Mauricio Macri's PRO government). While debates about the challenges and limitations for reforming liberal states within a capitalist world-system that have taken place in regard to Kirchnerism and other governments of the Pink Tide are extremely important, they are not my principal concern here. Rather, I am interested in how artists and other intellectuals who are dedicated to promulgating a Left critique of class society and the capitalist state can interrogate the injustices these inevitably produce.

12. See, for example, Karl Marx, "Eighteenth Brumaire of Louis Bonaparte," in Marx and Engels, *Marx-Engels Reader*, 594–617; Thiong'o, "Enactments of Power," 22.

13. See, for example, Taylor, *Disappearing Acts*.

14. I am drawing on Gabriel Rockhill's elaboration of these concepts from his lecture "On the Politicity of 'Apolitical' Art," University of Pennsylvania, March 14, 2018.

15. Althusser, *For Marx*, 144.

16. Petras and Veltmeyer, *Social Movements and State Power*, 41–42; Colectivo Situaciones, "Causes and Happenstance."

17. Garín Guzmán and Zukerfeld, *Etcétera . . .* , 103.

18. Garín Guzmán and Zukerfeld, *Etcétera . . .* , 104.

19. Grupo Etcétera . . . , *Etcétera . . . TV*.

20. Romero, *Larga Crisis*, 105.

21. Garín Guzmán and Zukerfeld, *Etcétera . . .* , 103.

22. Bogad, *Electoral Guerrilla Theatre*, 6.

23. Bonnet, *Insurrección como restauración*, 51.

24. Benjamin, *Illuminations*, 241.

25. Verdú, *Represión en democracia*, 185–86.

26. Bonnet, "Kirchnerismo es la restauración."

27. Petras and Veltmeyer, *Social Movements and State Power*, 31.

28. Svampa, *Cambio de época*, 165.

29. Svampa, *Cambio de época*, 165.

30. De Oliveira, "Lula in the Labyrinth." See also Zibechi's critique of the new governmentality under Brazil's and Argentina's center-Left governments in *Política y miseria*, 7–8.

31. Svampa, *Cambio de época*, 64; Robinson, *Latin America*, 291–92.

32. Robinson, *Latin America*, 294.

33. Gago and Sztulwark, "Disidencia"; Verdú, *Represión en democracia*, 187–88.

34. See Colectivo Situaciones, "Politizar la tristeza."

35. Robinson, *Latin America*, 343. Also see Gago and Sztulwark, "Disidencia."

36. Gramsci, *Selections from the Prison Notebooks*, 58–59, qtd. in Robinson, *Latin America*, 290.

37. Svampa, *Cambio de época*, 68, 174; Zibechi, *Política y miseria*, 11.

38. Cerdeiras, "Regreso o la re-invención."

39. Cerdeiras, "Regreso o la re-invención."

40. Verdú, *Represión en democracia*, 186.

41. Sarlo, *Audacia y el cálculo*, 186. For a different analysis of the alliance between Kirchner and the Asociación de las Madres de la Plaza de Mayo, as well as a review of scholarship on the topic, see Romanin, "¿Cooptación?," 1–2.

42. Van Drunen, "Struggling with the Past," 214–15.

43. Petras and Veltmeyer, *Social Movements and State Power*, 30.

44. Verdú, *Represión en democracia*, 201.

45. Verdú, *Represión en democracia*, 203.

46. Verdú, *Represión en democracia*, 206.

47. Verdú, *Represión en democracia*, 203.

48. Svampa, *Cambio de época*, 67.

49. Verdú, *Represión en democracia*, 203–4.

50. Loreto Garín Guzmán and Federico Zukerfeld, interview with author, October 15, 2013.

51. Garín Guzmán and Zukerfeld, interview with author, October 15, 2013.

52. Longoni, "Encrucijadas del arte activista," 31.

53. Bossi et al., *Pensamientos*, 227.

54. Bossi et al., *Pensamientos*, 104–5. GAC distanced itself from expressions of human rights as a state politics in the mid-2000s. Members of the group had different perspectives on the institutionalization of human rights organizations under Kirchner. See Longoni, "Encrucijadas del arte activista," 31n4, 35. Lorena Bossi and Carolina Golder later took up staff positions in the Espacio Memoria y Derechos Humanos. In my interviews with them, they said that they saw possibilities to advance meaningful reforms from within this institution and with the backing of the federal government led by Fernández de Kirchner.

55. Draper, *Afterlives of Confinement*, 159. See also Van Drunen, "Struggling with the Past," 253.

56. Van Drunen, "Struggling with the Past," 256–57. Also see Brodsky, *Memoria en construcción*.

57. Tandeciarz, "Citizens of Memory," 163; Sarlo, *Audacia y el cálculo*, 177–78.

58. "Palabras del Presidente de la nación, Doctor Néstor Kirchner, en el acto de firma del convenio de la creación del museo de la memoria y para la promoción y defensa de los derechos humanos," Casa Rosada Presidencia, Mar. 24, 2004, https://www.casarosada.gob.ar/informacion/archivo/24549-blank-79665064; "Discurso completo de Néstor Kirchner en la ex ESMA / 24 de marzo de 2004," Mar. 2004, YouTube, 7:51, https://www.youtube.com/watch?v=lQORpg3Yb6A.

59. Sarlo, *Audacia y el cálculo*, 179–80.

60. Taylor, *Disappearing Acts*, 106.

61. Tandeciarz, "Citizens of Memory," 163.

62. Seri, "Terror, Reconciliation, Redemption," 12.

63. Seri, "Terror, Reconciliation, Redemption," 12; Feldman, "Memory Theaters," 165.

64. Di Stefano, "From Shopping Malls."

65. Seri, "Terror, Reconciliation, Redemption," 12.

66. Di Stefano, "From Shopping Malls."

67. Romanin, "¿Cooptación?," 1–2.

68. Seri, "Terror, Reconciliation, Redemption," 12.

69. Williams, "'. . . or the Bullet?'"

70. Qtd. in Longoni, "Encrucijadas del arte activista," 34.

71. Nancy Garín, interview with author, March 15, 2018.

72. Garín, interview with author, March 15, 2018.

73. Garín Guzmán and Zukerfeld, interview with author, October 15, 2013.

74. Garín Guzmán and Zukerfeld, interview with author, October 15, 2013.

75. Neocleous, "'Brighter and Nicer New Life,'" 191.

76. Neocleous, "'Brighter and Nicer New Life,'" 191.

77. Seri, *Seguridad*, 84.

78. Comaroff and Comaroff, *Truth about Crime*, 29–31. See also Zibechi, *Política y miseria*, 12.

79. Robinson, *Latin America*, 290; Svampa, *Cambio de época*, 86–89. See also Comaroff and Comaroff, *Truth about Crime*, 29–31.

80. For an analysis of how perceptions of violence are managed in relation to current antifascist movements, see Durán and Rockhill, "It's Time."

81. Kessler, *Sentimiento de inseguridad*, 260.

82. Seri, *Seguridad*, 60.

83. Seri, *Seguridad*, 24.

84. Seri, *Seguridad*, 10.

85. Svampa, *Cambio de época*, 88.

86. Svampa, *Cambio de época*, 87–91; Verdú, *Represión en democracia*, 209–13. The colloquial expression *gatillo fácil*, akin to "trigger-happy," refers to extrajudicial police killings.

87. Verdú, *Represión en democracia*, 25–49.

88. Verdú, *Represión en democracia*, 26–27.

89. Svampa, *Cambio de época*, 75.

90. Verdú, *Represión en democracia*, 29.

91. See Hall et al., *Policing the Crisis*, 29, 304.

92. Seri, *Seguridad*, 58.

93. Hinton, *State on the Streets*, 86.

94. Verdú, *Represión en democracia*, 184.

95. Seri, *Seguridad*, 185.

96. Verdú, *Represión en democracia*, 192.

97. Verdú, *Represión en democracia*, 184, 191–92.

98. Verdú, *Represión en democracia*, 209.

99. Verdú, *Represión en democracia*, 196–200.

100. Verdú *Represión en democracia*, 213, 210.

101. Bossi et al., *Pensamientos*, 283.

102. My translation.

103. *Poema visual*'s critical mimicry of state security propaganda resonates with the art collective Fulana's *If You Fear Something You'll See Something* (2004), which they installed in subways in the United States. Fulana's intervention shares GAC's critique of neoliberal security ideology, while emphasizing the way it shapes subjects' perceptions through its mobilization of fear.

104. Marcuse, *Essay on Liberation*, 8.

105. Ricardo Bracho, qtd. in Rodríguez, *Queer Latinidad*, 53.

106. Rodríguez and Seghezzo, "Problematización de la (in)seguridad," 85.

107. Williams, "State of Permanent Exception," 326.

108. "Segurísimo" also means "very certain." This enthusiastic affirmation echoes the marketing language used in this work.

109. Lorena Bossi, interview with author, May 22, 2014.

110. These quotations are my English translations of the original Spanish text.

111. Bossi et al., *Pensamientos*, 274–75.

112. See Luxemburg, *Accumulation of Capital*, 434–47. On contemporary militarized accumulation, see Robinson, *Global Capitalism*, 147–54, 205–7. Also see Gilmore, *Golden Gulag*; Boukalas, "Class War-on-Terror"; Sandoval Palacios, *Frontera México–Estados Unidos*.

113. Robinson, "Accumulation Crisis," 2.

114. Mani, "Diverse Markets," 26–27.

115. Bossi et al., *Pensamientos*, 259.

116. Alexander, *Pedagogies of Crossing*, 189–90.

117. Svampa, *Cambio de época*, 44.

118. See Bayer and Campione, *Historia de la crueldad*.

119. Bossi et al., *Pensamientos*, 271.

120. Carolina Golder and Lorena Bossi, interview with author, May 22, 2014.

121. See, for example, Landa, *Apprentice's Sorcerer*; Losurdo, *Liberalism*; Neocleous, *War Power, Police Power*.

122. Neocleous, *Critique of Security*, 30.

123. Neocleous, *Critique of Security*, 32.

124. Badiou, *Ethics*, 8–9.

125. See Williams, *Divided World*.

126. Prensa Asociación Madres de Plaza de Mayo, "Las Madres Contra la Ley Anti-Terrorista: 'La libertad de este país no se negocia,'" Apr. 12, 2005, http://www.madres.org/asp/contenido.asp?clave=724.

127. Asad, *On Suicide Bombing*, 27.

128. Asad, *On Suicide Bombing*, 38.

129. Neocleous, "'Brighter and Nicer New Life,'" 204. As Asad writes, efforts to define terrorism as a "specific legal category," as in antiterrorist laws, involve political decisions to determine "the limits to established state authority and the rights of popular movements that challenge state authority" (*On Suicide Bombing*, 26–27).

130. Boukalas, "Class War-on-Terror," 64.

131. Muzzopappa and Ramos, "Una etnografía itinerante," 129–30.

132. Robinson, *Global Capitalism*, 150.

133. Boukalas, *Homeland Security*, 209–12.

134. Boukalas, *Homeland Security*, 207; on policing in Miami, 198–200.

135. Grandin, *Empire's Workshop*, 214. See also Robinson, *Latin America*, 282.

136. John Lindsay-Poland, "U.S. Military Bases in Latin America and the Caribbean," *Foreign Policy in Focus*, Aug. 2004, https://fpif.org/us_military_bases_in_latin_america_and_the_caribbean, qtd. in Robinson, *Latin America*, 284.

137. Grandin, *Empire's Workshop*, 213–14.

138. Neocleous, "'Brighter and Nicer New Life,'" 204.

139. Robinson, *Global Capitalism*, 149.

140. Robinson, *Global Capitalism*, 150.

141. Robinson, *Global Capitalism*, 149; Neocleous, *War Power, Police Power*, 85–87.

142. Neocleous, "'Brighter and Nicer New Life,'" 204.

143. Robinson, *Latin America*, 282–83.

144. In September 2001, the UN Security Council adopted Resolution 1373, which obliged member states to criminalize terrorism. This prepared the way for global anti-terrorism campaigns, including Argentina's subsequent passage of antiterrorist laws. See Muzzopappa and Ramos, "Etnografía itinerante," 130. The Financial Action Task Force (an international organization developed by G7 countries) threatened to announce that international transactions with Argentina were unsafe unless Argentina ratified an international antiterrorism convention, which was an especially powerful threat given the mass exodus of foreign investment from the country following Argentina's financial crisis in 2001. Eduardo Tagliaferro, "El Senado votó la ley antiterrorista," *Página 12*, June 7, 2007, https://www.pagina12.com.ar/diario/elpais/1-86173-2007-06-07.html.

145. In March 2005 Argentina's National Congress ratified the Interamerican Convention against Terrorism and International Convention for the Repression of the Financing of Terrorism through which Argentina became a party to the twelve United Nations antiterrorism conventions in force. When the Erroristas exhibited *Operación BANG!* in *La Normalidad* at the Palais de Glace in Buenos Aires in 2006, they referenced these laws in the Exhibition Guide to contextualize their installation, writing, "A little history: On March 31st, 2005 the National Congress approved two 'anti-terrorist' laws that, among other things, establish sanctions on images or words that can be interpreted as symbolic weapons and also authorize the detainment of any potentially suspicious person, without judicial order or proof of cause."

146. Nicolas (((frances)))/Etcétera, "Bienvenida a Bush: Erroristas en Buenos Aires (Fotos y Primer Declaración)," *Indymedia Argentina*, Oct. 19, 2005, http://argentina.indymedia.org/news/2005/10/337422.php.

147. Flores Sternad, "Rhythm of Capital," 215.

148. Nelson, *History of the FTAA*, 12–14.

149. Flores Sternad, "Rhythm of Capital," 225.

150. Garín Guzmán, O'Higgins, and Zukerfeld, "Internacional Errorista," part 1.

151. Garín Guzmán, O'Higgins, and Zukerfeld, "Internacional Errorista," part 1. See Flores Sternad, "Rhythm of Capital," 223–24.

152. Halfon, "Etcétera."

153. See Graham, *Cities under Siege*, 45.

154. Zibechi, "Mar del Plata."

155. Nelson, *History of the FTAA*, 5, 102–11.

156. Garín Guzmán, O'Higgins, and Zukerfeld, "Internacional Errorista," part 1.

157. Garín Guzmán and Zukerfeld, *Etcétera . . .* , 261.

158. See Gamboa and Noriega, *Urban Exile*, 12–14, 27–31, 41–49, 131–49.

159. Internacional Errorista/((((Cronopiux Erroristus))), "Erroristas." All translations from the Spanish-language press are my own.

160. Internacional Errorista/(((Cronopiux Erroristus))), "Urgente!!!"

161. Garín Guzmán and Zukerfeld, *Etcétera . . .* , 262.

162. The Internacional Errorista also used stills from *Error Errorista* to produce a black-and-white photonovel with text subtitles that follows the same narrative. This multimedia work was part of the Erroristas' installation *Operación BANG!*, exhibited in *La Normalidad* at the Palais de Glace in Buenos Aires, February 15–March 19, 2006.

163. I provide my own English translations of the video's dialogue, which is in Spanish. *Etcétera . . . Etcétera . . .* (2017) includes a transcription of the dialogue in *Error Errorista*, but there are minor discrepancies from the dialogue in the video.

164. Garín Guzmán and Zukerfeld, *Etcétera . . .* , 262.

165. Crawley, *House Divided*, 347.

166. Seri, *Seguridad*, 22.

167. Althusser, *Lenin and Philosophy,* 118.

168. Boal, *Theater of the Oppressed*, 92.

169. Althusser, *For Marx*, 142.

170. Althusser, *For Marx*, 140.

171. Neocleous, *Critique of Security*, 115.

172. Perelman, "Protesta social," 488.

173. Althusser, *For Marx*, 144.

174. Neocleous, *Critique of Security*, 118.

Ahmad, Eqbal. *The Selected Writings of Eqbal Ahmad*. Edited by Carollee Bengelsdorft, Margaret Cerullo, and Yogesh Chandrani. New York: Columbia University Press, 2006.

Akers Chacón, Justin. "The Anti-Migrant International." *Puntorojo,* Oct. 20, 2019, https://www.puntorojomag.org/2019/10/20/the-anti-migrant-international.

Akers Chacón, Justin, and Mike Davis. *No One Is Illegal: Fighting Racism and State Violence on the U.S.-Mexico Border*. Chicago: Haymarket Books, 2006.

Alexander, M. Jacqui. *Pedagogies of Crossing: Meditations on Feminism, Sexual Politics, Memory, and the Sacred*. Durham, NC: Duke University Press, 2006.

Almaguer, Tomás. *Racial Fault Lines: The Historical Origins of White Supremacy in California*. Berkeley: University of California Press, 2008.

Althusser, Louis. *For Marx*. Translated by Ben Brewster. London: Verso, 1979.

Althusser, Louis. *Lenin and Philosophy and Other Essays*. Translated by Ben Brewster. New York: Monthly Review Press, 2001.

Althusser, Louis. *On the Reproduction of Capitalism: Ideology and Ideological State Apparatuses*. New York: Verso, 2014.

Alvarez, Sonia, Arturo Escobar, and Evelyn Dagnino. "Introduction: The Cultural and the Political in Latin American Social Movements." In *Cultures of Politics, Politics of Cultures: Re-Visioning Latin American Social Movements*, edited by Sonia Alvarez, Arturo Escobar, and Evelyn Dagnino, 1–29. Boulder, CO: Westview Press, 1998.

Amin, Samir. *Capitalism in the Age of Globalization: The Management of Contemporary Society*. New York: ZED Books, 2000.

Amin, Samir. *Eurocentrism*. Translated by Russell Moore and James Membrez. New York: Monthly Review Press, 2009.

Amin, Samir. *Unequal Development: An Essay on the Social Formations of Peripheral Capitalism*. Translated by Brian Pearce. New York: Monthly Review Press, 1976.

Amin, Samir. *The World We Wish to See: Revolutionary Objectives in the Twenty-First Century*. New York: Monthly Review Press, 2008.

Amin, Samir, Giovanni Arrighi, Andre Gunder Frank, and Immanuel Wallerstein. *Transforming the Revolution: Social Movements and the World-System*. New York: Monthly Review Press, 1990.

Arthur, Paige. "How 'Transitions' Reshaped Human Rights: A Conceptual History of Transitional Justice." *Human Rights Quarterly* 31, no. 2 (May 2009): 321–67.

Asad, Talal. *On Suicide Bombing*. New York: Columbia University Press, 2007.

Azamar, Aleida, and José Ignacio Ponce. "Extractivismo y desarollo: Los recursos minerales en México." *Revista Problemas del Desarrollo* 179, no. 45 (Oct.–Dec. 2014): 137–58.

Bacon, David. "Displaced People: NAFTA's Most Important Product." *NACLA Report on the Americas* 41, no. 5 (2008): 23–27.

Badiou, Alain. *Ethics: An Essay on the Understanding of Evil*. London: Verso, 2001.

Balibar, Étienne. *The Philosophy of Marx*. Translated by Chris Turner. London: Verso, 2007.

Barajas, Frank P. "An Invading Army: A Civil Gang Injunction in a Southern California Chicana/o Community." *Latino Studies* 5 (2007): 393–417.

Barker, Colin. "Class Struggle and Social Movements." In *Marxism and Social Movements,* edited by Colin Barker, Laurence Cox, John Krinsky, and Alf Gunvald Nilsen, 41–61. Boston: Brill, 2013.

Bartra, Armando. "Las guerras del ogro." *Chiapas* 16, no. 3 (2004): 63–82.

Basualdo, Eduardo. "The Legacy of the Dictatorship: The New Pattern of Capital Accumulation, Deindustrialization, and the Decline of the Working Class." In *The Economic Accomplices to the Argentine Dictatorship: Outstanding Debts*, edited by Horacio Verbitsky and Juan Pablo Bohoslavsky, 75–89. Cambridge: Cambridge University Press, 2016.

Baugh, Scott L. "*Hecho en Mexico,* @cross 'Digital Divides': Border Graffiti and Narrative-Cinema Codes in *Una Ciudad*'s City." In *Mediating Chicana/o Culture: Multicultural American Vernacular*, edited by Scott L. Baugh, 142–43. Newcastle, UK: Cambridge Scholars Press, 2006.

Bayer, Osvaldo, and Daniel Campione, eds. *Historia de la crueldad Argentina. Tomo I: Julio Argentino Roca*. Buenos Aires: Ediciones del CCC, 2006.

Bayer, Osvaldo, Atilio A. Boron, and Julio C. Gambina. "Apuntes sobre su historia y sus consecuencias." In *El terrorismo de estado en la Argentina*, edited by Bayer et. al. Buenos Aires: Instituto Espacio para la Memoria, 2010.

Benjamin, Walter. "The Author as Producer." *New Left Review* 62 (July–Aug. 1970): 83–96.

Benjamin, Walter. *Illuminations*. Translated by Harry Zohn. New York: Schocken Books, 1969.

Beverley, John. *Latinamericanism after 9/11*. Durham, NC: Duke University Press, 2011.

Bhattacharya, Tithi. "How Not to Skip Class: Social Reproduction of Labor and the Global Working Class." In *Social Reproduction Theory: Remapping Class, Recentering Oppression*, edited by Tithi Bhattacharya, 68–93. London: Pluto Press, 2017.

Blum, William. *Killing Hope: US Military and CIA Interventions since World War II*. London: ZED Books, 2004.

Blum, William. *Rogue State: A Guide to the World's Only Superpower*. London: ZED Books, 2014.

Boal, Augusto. *Theater of the Oppressed*. Translated by Charles A. McBride, Maria-Odilia Leal McBride, and Emily Fryer. London: Pluto, 2008.

Bogad, L. M. *Electoral Guerrilla Theatre: Radical Ridicule and Social Movements*. New York: Routledge, 2016.

Bogad, L. M. *Tactical Performance: The Theory and Practice of Serious Play*. New York: Routledge, 2016.

Bonfil Batalla, Guillermo. *México Profundo: Reclaiming a Civilization*. Translated by Philip A. Dennis. Austin: University of Texas Press, 1996.

Bonner, Michelle. *Policing Protest in Argentina and Chile*. Boulder, CO: First Forum Press, 2014.

Bonnet, Alberto. *La insurrección como restauración*. Buenos Aires: Prometeo Libros, 2015.

Bonnet, Alberto. "El kirchnerismo es la restauración del orden impugnado en esa insurrección." *La Izquierda Diario*, Dec. 20, 2014. http://www.laizquierdadiario .com/Entrevista-a-Alberto-Bonnet?utm_campaign=Newsletter&utm_medium =email&utm_source=newsletter.

Bossi, Lorena Fabrizia, Vanessa Yanil Bossi, Fernanda Carrizo, Mariana Cecilia Corral, and Nadia Carolina Golder. *Pensamientos, prácticas y acciones del GAC*. Buenos Aires: Tinta Limón, 2009.

Boukalas, Christos. "Class War-on-Terror: Counterterrorism, Accumulation, Crisis." *Critical Studies on Terrorism* 8, no. 1 (2015): 55–71.

Boukalas, Christos. *Homeland Security, Its Law and Its State: A Design of Power for the 21st Century*. London: Routledge, 2014.

Brecht, Bertolt. "Against Georg Lukács." In *Aesthetics and Politics*, edited by Fredric Jameson, 68–85. Brooklyn, NY: Verso, 2007.

Brecht, Bertolt. *Brecht on Art and Politics*. Edited by Steve Giles and Tom Kuhn. New York: Bloomsbury, 2003.

Brecht, Bertolt. *Brecht on Film and Radio*. Edited and translated by Marc Silberman. London: Methuen Drama, 2006.

Brecht, Bertolt. *Brecht on Theater: The Development of an Aesthetic*. Translated by John Willet. New York: Hill and Wang, 1977.

Bricmont, Jean. *Humanitarian Imperialism: Using Human Rights to Sell War*. Translated by Diana Johnstone. New York: Monthly Review Press, 2006.

Brodsky, Marcelo, ed. *Memoria en construcción: El debate sobre la* ESMA. Buenos Aires: La marca editora, 2005.

Bürger, Peter. *Theory of the Avant-Garde.* Translated by Michael Shaw. Minneapolis: University of Minnesota Press, 1982.

Cabral, Amilcar. *Return to the Source: Selected Speeches of Amilcar Cabral.* New York: Monthly Review Press, 1973.

Caffentzis, George. "From Capitalist Crisis to Proletarian Slavery: An Introduction to Class Struggle in the US, 1973–1998." Brooklyn: Midnight Notes, 1998. Reproduced on Wildcat. http://www.wildcat-www.de/en/material/gc_slave.htm.

California Housing Partnership. "Los Angeles County Renters in Crisis: A Call for Action." May 2017. http://1po8d91kdoco3rlxhmhtydpr.wpengine.netdna-cdn.com/wp-content/uploads/2017/05/Los-Angeles-County-2017.pdf.

Calveiro, Pilar. *Violencias de estado, la guerra antiterrorista y la guerra contra el crimen como medios de control global.* Buenos Aires: Siglo vientiuno editores, 2012.

Carby, Hazel. "The Multicultural Wars," *Radical History Review, no.* 54 (Fall 1992): 7–18.

Cerdeiras, Raúl. "El regreso de la política. ¿Que política?" *La Fogata,* Nov. 29, 2010. http://www.lafogata.org/cerdeiras/r.3.12.htm.

Cerdeiras, Raúl. "¿El regreso o la re-invención de la política? Algunas reflexiones pensando en la juventud Kirchnerista." *La Fogata,* Mar. 30, 2011. http://www.lafogata.org/cerdeiras/rc.5.1.htm.

Cerdeiras, Raúl. "¿Es el kirchnerismo un acontecimiento político?" *La Fogata,* Oct. 13, 2011. http://www.lafogata.org/cerdeiras/cerd.20.1.htm.

Cerdeiras, Raúl. *Subvertir la política.* Buenos Aires: Editorial Quadrata, 2014.

Césaire, Aimé. *Discourse on Colonialism.* Translated by Joan Pinkham. New York: Monthly Review Press, 1972.

Chabram-Dernersesian, Angie. "Whiteness in Chicana/o Discourse." In *Displacing Whiteness: Essays in Social and Cultural Criticism,* edited by Ruth Frankenburg, 107–54. Durham, NC: Duke University Press, 1997.

Chakrabarty, Dipesh. *Provincializing Europe: Postcolonial Thought and Historical Difference.* Princeton, NJ: Princeton University Press, 2000.

Chakravarty, Paula, and Denise Ferreira da Silva. "Accumulation, Dispossession, and Debt: The Racial Logic of Global Capitalism—An Introduction." *American Quarterly* 64, no. 3 (2012): 368–71.

Chavez, Leo. *Latino Threat: Constructing Immigrants, Citizens, and the Nation.* Stanford, CA: Stanford University Press, 2008.

Chomsky, Noam, and Edward S. Herman. *The Washington Connection and Third World Fascism.* Boston: South End Press, 1979.

Churchill, Ward. *A Little Matter of Genocide: Holocaust and Denial in the Americas 1492 to the Present.* San Francisco: City Lights, 2001.

Churchill, Ward. *Wielding Words Like Weapons: Selected Essays in Indigenism, 1995–2005.* Oakland, CA: PM Press, 1997.

Churchill, Ward, and Jim Vander Wall. COINTELPRO *Papers: Documents from the FBI's Secret Wars against Dissent in the United States.* Boston: South End Press, 1990.

Colectivo Situaciones. "Causes and Happenstance (Dilemmas of Argentina's New Social Protagonism)." Translated by Nate Holden and Sebastian Touza. *Commoner*, no. 8 (Autumn–Winter 2004). https://thecommoner.org/wp-content/uploads/2020/06/Colectivo-Situaciones-Causes-and-Happenstance.pdf.

Colectivo Situaciones. "Politizar la tristeza." 2007. Accessed July 25, 2015. http://194.109.209.222/colectivosituaciones/articulos_29.htm.

Comandancia General del Ejército Zapatista de Liberación Nacional. "Declaración de la Selva Lacandona." 1993. Enlace Zapatista. http://palabra.ezln.org.mx/comunicados/1994/1993.htm.

Comandancia General del Ejército Zapatista de Liberación Nacional. "Primera Declaración de la Selva Lacondona." Jan. 1, 1994. Enlace Zapatista. http://enlacezapatista.ezln.org.mx/1994/01/01/primera-declaracion-de-la-selva-lacandona.

Comaroff, Jean, and John Comaroff. *The Truth about Crime: Sovereignty, Knowledge, Social Order*. Chicago: University of Chicago Press, 2016.

Comisión de la Sexta del EZLN. *El pensamiento crítico frente a la hidra capitalista*. N.p.: n.p., 2015?

Comité Clandestino Revolucionario Indígena–Comandancia General del Ejército Zapatista de Liberación Nacional. "Cuarta Declaración de la Selva Lacondona." Jan. 1, 1996. Enlace Zapatista. http://enlacezapatista.ezln.org.mx/1996/01/01/cuarta-declaracion-de-la-selva-lacandona/.

Comité Clandestino Revolucionario Indígena Comandancia General del Ejército Zapatista de Liberación Nacional. "Sexta Declaración de la Selva Lacondona." June 2005. Enlace Zapatista. http://enlacezapatista.ezln.org.mx/sdsl-es.

Correa, Eugenia, Gregorio Vidal, and Wesley Marshall. "Financialization in Mexico: Trajectory and Limits." *Journal of Post Keynesian Economics* 35, no. 2 (2012): 255–75.

CORREPI. "Boletín informativo no. 779." Feb. 29, 2016. https://correpi.lahaine.org/boletin-informativo-n-779/.

Cortiñas, Nora. "Nora Cortiñas: 'Nunca apoyamos al oficialismo, fuera el gobierno que fuera.'" Interview. *Lavaca*, Jan. 16, 2006. http://www.lavaca.org/notas/entrevista-a-nora-cortinas/.

Coulthard, Glen Sean. *Red Skin, White Masks: Rejecting the Colonial Politics of Recognition*. Minneapolis: University of Minnesota Press, 2014.

Creischer, Alice, Andreas Siekmann, and Gabriela Massuh, eds. *Schritte zur Flucht von der Arbeit zum Tun: Pasos para huir del trabajo al hacer*. Buenos Aires: Interzona Editora, 2004.

Crenzel, Emilio. *Memory of the Argentina Disappearances: The Political History of Nunca Más*. Abingdon, UK: Routledge, 2011.

Dabat, Alejandro, and Luis Lorenzano. *Argentina: The Malvinas and the End of Military Rule*. Translated by Ralph Johnstone. London: Verso, 1984.

da Silva Catela, Ludmila. "Apagón en el ingenio, escrache en el museo: Tensiones y disputas entre memorias locales y memorias oficiales en torno a un episodio de represión de 1976." In *Luchas locales, comunidades e identidades*, edited by Ponciano del Pino and Elizabeth Jelin, 63–106. Buenos Aires: Siglo veintiuno, 2003.

Dávalos, Karen Mary. *Chicana/o Remix: Art and Errata since the Sixties*. New York: New York University Press, 2017.

Dávila, Arlene. *Culture Works: Space, Value and Mobility across the Neoliberal Americas*. New York: NYU Press, 2012.

Davis, Ben. *9.5 Theses on Art and Class*. Chicago: Haymarket Books, 2013.

Davis, Mike. *City of Quartz: Excavating the Future of Los Angeles*. New York: Verso, 2006.

Davis, Mike. *Magical Urbanism: Latinos Reinvent the US Big City*. New York: Verso, 2000.

Davis, Mike. *Planet of Slums*. New York: Verso, 2006.

Davis, Mike. "Uprising and Repression in L.A." In *Reading Rodney King, Reading Urban Uprising*, edited by Robert Gooding-Williams, 142–54. London: Routledge, 1993.

Davis, Mike. "Who Killed LA? A Political Autopsy." *New Left Review* 1, no. 197 (1993): 3–28.

de Certeau, Michel. *The Practice of Everyday Life*. Translated by Steven Rendell. Berkeley: University of California Press, 1984.

De Genova, Nicholas. "The 'Crisis' of the European Border Regime: Towards a Marxist Theory of Borders." *International Socialism* 150 (2016): 31–54.

De La Cruz-Viesca, Melany, Zhenxiang Chen, Paul M. Ong, Darrick Hamilton, and William A. Darity Jr. *The Color of Wealth in Los Angeles*. Los Angeles: Duke University, The New School, University of California, Los Angeles, and the Insight Center for Community Economic Development, 2016. http://www.aasc.ucla.edu/besol/color_of_wealth_report.pdf.

de la Loza, Sandra. Interview by Jennifer Flores Sternad. *Latinart*, Dec. 1, 2004. http://www.latinart.com/transcript.cfm?id=65.

de la Loza, Sandra. *The Pocho Research Society Field Guide to L.A.: Monuments and Murals of Erased and Invisible Histories*. Seattle: University of Washington Press, 2011.

de la Loza, Sandra. "La Raza Cósmica: An Investigation into the Space of Chicana/o Muralism." In *L.A. Xicano,* edited by Chon Noriega, Terezita Romo, and Pilar Tompkins Rivas, 53–62. Los Angeles: UCLA Chicano Studies Research Center Press, 2011.

Denning, Michael. *The Cultural Front: The Laboring of American Culture in the Twentieth Century*. New York: Verso, 2011.

Denning, Michael. *Culture in the Age of Three Worlds*. New York: Verso, 2004.

de Oliveira, Francisco. "Lula in the Labyrinth." *New Left Review*, no. 42 (Nov.–Dec. 2006): 5–23.

Derrida, Jacques. "The Theater of Cruelty and the Closure of Representation." *Theater* 9, no. 3 (Summer 1978): 6–19.

Deutsche, Rosalyn. *Evictions: Art and Spatial Politics*. Cambridge, MA: MIT Press, 1996.

Deutsche, Rosalyn, and Cara Gendel Ryan. "The Fine Art of Gentrification." *October* 31 (Winter 1984): 91–111.

Díaz Polanco, Héctor. *Elogía de la diversidad: Globalización, multiculturalismo, y etnofagia*. Mexico City: Siglo XXI, 2006.

Díaz Polanco, Héctor. *La rebelión Zapatista y la autonomía*. Mexico City: Siglo veintiuno editores, 1998.

Díaz Polanco, Héctor, and Stephen M. Gorman. "Indigenismo, Populism and Marxism." *Latin American Perspectives* 9, no. 2 (Spring 1982): 42–61.

Díaz Polanco, Héctor, Francisco Javier Guerrero, and Victor Bravo. "La teoría indigenista y la integración." In *Indigenismo, modernización y marginalidad: Una revisión crítica*, 9–46. Mexico City: Centro de Investigación para la Integración Social, 1979.

Di Stefano, Eugenio. "From Shopping Malls to Memory Museums: Reconciling the Recent Past in the Uruguayan Neoliberal State." *Dissidences: Hispanic Journal of Theory and Criticism* 4, no. 8 (2012). https://digitalcommons.bowdoin.edu/cgi /viewcontent.cgi?article=1039&context=dissidences.

Draper, Susana. *Afterlives of Confinement: Spatial Transition in Postdictatorship Latin America*. Pittsburgh, PA: University of Pittsburgh Press, 2012.

Draper, Susana. "Against Depolitization: Prison-Museums, Escape Memories, and the Place of Rights." *Memory Studies* 8, no. 1 (Jan. 2015): 62–74.

Durán, Ramona E., and Gabriel Rockhill. "It's Time to Get Violence: Breaking Down the Assault on Antifa." *Counterpunch*, Sept. 7, 2017. https://www.counterpunch .org/2017/09/07/its-time-to-get-violence-breaking-down-the-assault-on-antifa.

Eagleton, Terry. *Literary Theory: An Introduction*. Minneapolis: University of Minnesota Press, 2003.

Echeverría, Bolívar. *Modernidad y blanquitud*. Mexico City: Ediciones Era, 2011.

Echeverría, Bolívar. "Potemkin Republics: Reflections on Latin America's Bicentenary." *New Left Review* 70 (July–Aug. 2011): 53–61.

Engels, Friedrich. *The Condition of the Working Class in England*. Oxford: Oxford University Press, 2009.

Epstein, Edward, and David Pion-Berlin, eds. *Broken Promises? The Argentine Crisis and Argentine Democracy*. Oxford: Lexington Books, 2006.

Escobar, Arturo. *Territories of Difference: Place, Movements, Life, Redes*. Durham, NC: Duke University Press, 2008.

Esteva, Gustavo. "Desarollo del mandar-obedeciendo: Chiapas y Oaxaca." In *Bienvenidos a la selva: Diálogos a partir de la Sexta Declaración del EZLN*, edited by Colectivo Situaciones, 181–94. Buenos Aires: Tinta Limón, 2006.

Estrada, William David. *Los Angeles Plaza: Sacred and Contested Space*. Austin: University of Texas Press, 2008.

Expósito, Marcelo. *Walter Benjamin, Productivist*. Translated by Nuria Rodríguez. Bilbao: Consonni, 2013.

Expósito, Marcelo, Ana Vidal, and Jaime Vindel. "Activismo artístico." In *Perder la forma humana: Una imagen sísmica de los años ochenta en América Latina*, edited by Fernanda Carvajal, André Mesquita, and Jaime Vindel, 43–50. Madrid: Museo Nacional Centro de Arte Reina Sofía, 2012.

Fal, Juan. "Argentina's Model of Accumulation: Twenty Years of Ruptures and Continuities." *Social Justice* 40, no. 4 (2014): 38–51.

Fallon, Paul. "Negotiating a (Border Literary) Community." In *Latin American Cyberculture and Cyberliterature*, edited by Claire Taylor and Thea Pitman, 161–75. Liverpool: Liverpool University Press, 2007.

Fanon, Frantz. *The Wretched of the Earth*. Translated by Constance Farrington. New York: Grove Press, 1968.

Federici, Silvia, and Matthew Carlin. "The Exploitation of Women, Social Reproduction, and the Struggle against Global Capital." *Theory and Event* 17, no. 3 (2014): n.p.

Feldman, Allen. "Memory Theaters, Virtual Witnessing, and the Trauma-Aesthetic." *Biography: An Interdisciplinary Quarterly* 27, no. 1 (Winter 2004): 163–202.

Feldman, Allen. "On Cultural Anesthesia: From Desert Storm to Rodney King." *American Ethnologist* 21, no. 2 (May 1994): 404–18.

Fernandes, Deepa. *Targeted: Homeland Security and the Business of Immigration*. New York: Seven Stories Press, 2007.

Fernández Retamar, Roberto. *Caliban and Other Essays*. Translated by Edward Baker. Minneapolis: University of Minnesota Press, 1989.

Fields, Karen E., and Barbara J. Fields. *Racecraft: The Soul of Inequality in American Life*. New York: Verso, 2014.

Finkelstein, Norman. *The Holocaust Industry: Reflections on the Exploitation of Jewish Suffering*. New York: Verso, 2005.

Flanagan, Mary. *Critical Play: Radical Game Design*. Cambridge, MA: MIT Press, 2009.

Fraile, Lydia. "Lessons from Latin America's Neo-liberal Experiment: An Overview of Labour and Social Policies since the 1980s." *International Labour Review* 148, no. 3 (2009): 215–33.

Flores Sternad, Jennifer. "The Rhythm of Capital and the Theater of Terror." In *Art and Activism in the Age of Globalization: Essays on Disruption*, edited by Karel Vanhaesebrouck, Lieven De Cauter, Paul De Bruyne, and Ruben De Roo, 214–38. Rotterdam: NAi, 2011.

Flores Sternad, Jennifer. *See* Ponce de León, Jennifer.

Fregoso, Rosa Linda, and Angie Chabram. "Chicana/o Cultural Representations: Reframing Alternative Critical Discourses." *Cultural Studies* 4, no. 3 (1990): 203–16. doi: 10.1080/09502389000490171.

Freire, Paolo. *Pedagogy of the Oppressed*. Translated by Myra Bergman Ramos. New York: Continuum, 1993.

Fuentes, Marcela A. *Performance Constellations: Networks of Protest and Activism in Latin America*. Ann Arbor: University of Michigan Press, 2019.

Gago, Verónica, and Diego Sztulwark. "Disidencia: Hacia una topografía inconclusa." *Lobo Suelto,* Oct. 11, 2017, http://lobosuelto.com/disidencia-hacia-una-topografia-inconclusa/. Previously published in *e-misférica* 10, no. 2 (2013).

Galeano, Eduardo. *The Open Veins of Latin America: Five Centuries of the Pillage of a Continent*. New York: Monthly Review Press, 1997.

Galeano, Eduardo. *Upside Down: A Primer for the Looking-Glass World*. Translated by Mark Fried. New York: Metropolitan Books, 2000.

Gamboa, Harry, Jr., *Urban Exile: Collected Writings of Harry Gamboa Jr.* Edited by Chon A. Noriega. Minneapolis: University of Minnesota Press, 1998.

Gandesha, Samir. "Three Logics of the Aesthetic in Marx." In *Aesthetic Marx*, edited by Samir Gandesha and Johan F. Hartle, 5–10. New York: Bloomsbury, 2017.

Gandsman, Ari. "The Limits of Kinship Mobilizations and the (A)politics of Human Rights in Argentina." *Journal of Latin American and Caribbean Anthropology* 17, no. 2 (July 2012): 195–214.

Ganser, Daniel. *NATO's Secret Armies: Operation GLADIO and Terrorism in Western Europe.* New York: Routledge, 2005.

Garcia, David, and Geert Lovink. "The ABC of Tactical Media." *Nettime*, May 16, 1997. www.nettime.org/Lists-Archives/nettime-1-9705/msg00096.html.

García, Ramón. "Against Rasquache: Chicano Camp and the Politics of Identity in Los Angeles." In *The Chicana/o Cultural Studies Reader*, edited by Angie Chabram-Dernersesian, 211–23. New York: Routledge, 2006.

García Canclini, Néstor. *Hybrid Cultures: Strategies for Entering and Leaving Modernity.* Translated by Christopher L. Chiappari and Silvia L. López. Minneapolis: University of Minnesota Press, 2001.

García Linera, Alvaro. "El Zapatismo: Indios insurgentes, alianzas y poder." *OSAL*, no. 12 (Sept.–Dec. 2003): 293–300.

García Navarro, Santiago. "Live and Learn." Translated by Sandra Alboum. *Frieze* 11 (Nov.–Dec. 2007): 166–171.

García Navarro, Santiago, Teresa Riccardi, Valeria Gonzalez, and Santiago García Aramburu, eds. *El pez, la bicicleta y la máquina de escribir: Un libro sobre el encuentro de espacios y grupos de arte independientes de América Latina y el Caribe.* Buenos Aires: Fundación PROA, 2005.

Garín Guzmán, Loreto, and Federico Zukerfeld, eds. *Etcétera . . . Etcétera. . . .* Buenos Aires: Self-published, 2016.

Garín Guzmán, Loreto, Antonio O'Higgins, and Federico Zukerfeld. "International Errorista: The Revolution through Affect." Interview by Santiago García Navarro. Part 1. July 1, 2006. http://www.latinart.com/aiview.cfm?id=353.

Garín Guzmán, Loreto, Antonio O'Higgins, and Federico Zukerfeld. "International Errorista: The Revolution through Affect." Interview by Santiago García Navarro. Part 2. July 2, 2006. www.latinart.com/aiview.cfm?start=2&id=358.

Getino, Octavio, and Fernando Solanas. "Toward a Third Cinema." *Tricontinental* 14 (Oct. 1969): 107–32.

Gibson-Graham, J. K. *A Postcapitalist Politics.* Minneapolis: University of Minnesota Press, 2006.

Gilmore, Ruth Wilson. "Globalisation and US Prison Growth: From Military Keynesianism to post-Keynesian Militarism." *Race & Class* 40, nos. 2–3 (1998–99): 171–88.

Gilmore, Ruth Wilson. *Golden Gulag: Prisons, Surplus, Crisis, and Opposition in Globalizing California.* Los Angeles: University of California Press, 2007.

Gilmore, Ruth Wilson. "Terror Austerity Race Gender Excess Theater." In *Reading Rodney King/Reading Urban Uprising*, edited by Robert Gooding-Williams, 23–37. London: Routledge, 1993.

Giorgi, Gabriel, and Karen Pinkus. "Zones of Exception: Biopolitical Territories in the Neoliberal Era." *Diacritics* 36, no. 2 (2006): 99–108.

Giunta, Andrea. *Pos-crisis: Arte Argentina después del 2001*. Buenos Aires: Siglo XXI Editores, 2009.

Goldman, Shifra. *Dimensions of the Americas: Art and Social Change in Latin America and the United States*. Chicago: University of Chicago Press, 1994.

Gómez, Alan Eladio. *The Revolutionary Imaginations of Greater Mexico: Chicana/o Radicalism, Solidarity Politics, and Latin American Social Movements*. Austin: University of Texas Press, 2016.

Gómez-Barris, Macarena. *Beyond the Pink Tide: Art and Political Undercurrents in the Americas*. Berkeley: University of California Press, 2018.

Gómez-Barris, Macarena. *The Extractive Zone*. Durham, NC: Duke University Press, 2017.

Gómez-Barris, Macarena. "The Plush View: Makeshift Sexualities and Laura Aguilar's Forbidden Archives." In *Axis Mundo: Queer Networks in Chicano L.A.*, edited by C. Ondine Chavoya and David Evans Frantz, 320–33. New York: Prestel, 2018.

Gómez-Barris, Macarena. *Where Memory Dwells: Culture and State Violence in Chile*. Berkeley: University of California Press, 2009.

González Casanova, Pablo. "Internal Colonialism and National Development." *Studies in Comparative International Development* 1, no. 4 (Apr. 1965): 27–37.

Gonzales-Day, Ken. *Lynching in the West: 1850–1935*. Durham, NC: Duke University Press, 2006.

González, Marcial. "Postmodernism, Historical Materialism, and Chicana/o Cultural Studies." *Science and Society: A Journal of Marxist Thought and Analysis* 68, no. 2 (Summer 2004): 161–86.

Gonzalez, Rita, Howard Fox, and Chon Noriega, eds. *Phantom Sightings: Art after the Chicano Movement*. Los Angeles: University of California Press, 2008.

Gordon, Avery F. *Ghostly Matters: Haunting and the Sociological Imagination*. Minneapolis: University of Minnesota Press, 2008.

Gottschalk, Marie. *Caught: The Prison State and the Lockdown of American Politics*. Princeton, NJ: Princeton University Press, 2015.

Graham, Stephen. *Cities under Siege: The New Military Urbanism*. New York: Verso, 2010.

Gramsci, Antonio. *The Antonio Gramsci Reader: Selected Writings 1916–1935*. Edited by David Forgacs. New York: New York University Press, 2000.

Gramsci, Antonio. *Selections from the Prison Notebooks of Antonio Gramsci*. Edited and translated by Quintin Hoare and Geoffrey Nowell Smith. New York: International Publishers, 1974.

Grandin, Greg. *Empire's Workshop: Latin America, the United States, and the Rise of the New Imperialism*. New York: Owl Books, 2007.

Grandin, Greg. "The Instruction of Great Catastrophe: Truth Commissions, National History, and State Formation in Argentina, Chile, and Guatemala." *American Historical Review* 110, no. 1 (2005): 46–67.

Grupo de Arte Callejero. "Grupo de Arte Callejero." *Ramona,* no. 33 (2003): 10.

Grupo de Arte Callejero. *Thoughts, Practices and Actions.* Translated by the Mareada Rosa Translation Collective. Brooklyn: Common Notions, 2019.

Grupo Etcétera. . . . *Etcétera . . . TV.* DVD, 24 min. 2005.

Guattari, Félix, and Suely Rolnik. *Molecular Revolution in Brazil.* Translated by Karel Clapshow and Brian Holmes. Cambridge, MA: MIT Press, 2008.

Guevara, Che, and Fidel Castro. *Socialism and Man in Cuba.* New York: Pathfinder Press, 2009.

Guha, Ranajit. "Prose of Counterinsurgency." In *Subaltern Studies II,* edited by Ranajit Guha, 1–40. Delhi: Oxford University Press, 1983.

Gunder Frank, Andre. *Crisis: In the Third World.* New York: Holmes and Meier, Inc., 1981.

Gunder Frank, Andre. *ReOrient: Global Economy in the Asian Age.* Berkeley: University of California Press, 1998.

Gutiérrez, Laura G. "Rasquachismo." In *Latino/a Keywords*, edited by Deborah R. Vargas, Nancy Raquel Mirabal, and Lawrence La Fountain-Stokes, 184–87. New York: New York University Press, 2017.

Halfon, Mercedes. "Etcétera: Y todo lo demás también." *Página 12*, Nov. 19, 2017. https://www.pagina12.com.ar/76462-y-todo-lo-demas-tambien.

Hall, Stuart. "Notes on Deconstructing 'The Popular.'" In *People's History and Socialist Theory*, edited by Raphael Samuel, 227–40. New York: Routledge, 1981.

Hall, Stuart. "Signification, Representation, Ideology: Althusser and the Post-Structuralist Debates." *Critical Studies in Mass Communication* 2 (June 1985): 91–114.

Hall, Stuart, Chas Critcher, Tony Jefferson, John Clarke, and Brian Roberts. *Policing the Crisis: Mugging, the State and Law and Order.* Hong Kong: Macmillan, 1978.

Harnecker, Marta. *Rebuilding the Left.* Translated by Janet Duckworth. New York: ZED Books, 2007.

Harvey, David. *A Brief History of Neoliberalism.* Oxford: Oxford University Press, 2005.

Harvey, David. *New Imperialism.* Clarendon Lectures in Geography and Environmental Studies. Oxford: Oxford University Press, 2003.

Harvey, Neil. *The Chiapas Rebellion: The Struggle for Land and Democracy.* Durham, NC: Duke University Press, 1998.

Harvey, Neil. *Rebellion in Chiapas: Rural Reforms, Campesino Radicalism, and the Limits to Salinismo.* La Jolla: University of California at San Diego, 1994.

Hayden, Dolores. *The Power of Place: Urban Landscapes as Public History.* Cambridge, MA: MIT Press, 1995.

Hernández, Luis. "The Breaking Wave," introduction to the *Other Campaign/La Otra Campaña* by Subcomandante Insurgente Marcos and the Zapatistas. San Francisco: City Lights Books, 2006.

Híjar, Cristina. "Zapatistas: Lucha en la significación, apuntes." In *De gente común: Prácticas estéticas y rebeldía social*, edited by Lorena Méndez, Brian Whitener, and Fernando Fuentes, 453–65. Mexico City: Universidad Autónoma de la Ciudad de México, 2011.

Hinton, Mercedes. *The State on the Streets: Police and Politics in Argentina and Brazil.* Boulder, CO: Lynne Rienner, 2006.

Hitchcock, Peter. "Accumulating Fictions." *Representations* 126, no. 1 (2014): 135–60.

Hite, Katherine. *Politics and the Art of Commemoration: Memorials to Struggle in Latin America and Spain.* New York: Routledge, 2011.

Holmes, Brian. "Extradisciplinary Investigations: Towards a New Critique of Institutions." *Transversal,* Jan. 2007. http://eipcp.net/transversal/0106/holmes/en.

La hora de los hornos. Directed by Octavio Getino and Fernando Solanas. Argentina: Grupo Cine Liberación, 1968.

Hupert, Pablo. *El estado posnacional: Más allá del Kirchnerismo y anti-Kirchnerismo.* Buenos Aires: El Autor, 2011.

Huyssen, Andreas. *Present Pasts: Urban Palimpsests and the Politics of Memory.* Stanford, CA: Stanford University Press, 2003.

Ilich, Fran. "El Artista como productor en internet." In *Propiedad intelectual, nuevas tecnologías y libre aceso a la cultura,* edited by Alberto López Cuenca and Eduardo Ramírez Pedrajo, 319–42. Puebla: Universidad de las Américas, 2008.

Ilich, Fran. "Barter for Coffee at This Brooklyn Pop-Up." Interview by Gigen Mammoser. *Vice,* Dec. 18, 2016. www.vice.com/en_us/article/bm3n7m/barter-for -coffee-at-this-brooklyn-pop-up-because-brooklyn.

Ilich, Fran. "Existencia y resistencia como práctica cotidiana de otra cultura, otro internet, y otras narrativas posibles." In *De gente común: Prácticas estéticas y rebeldía social,* edited by Lorena Méndez, Brian Whitener, and Fernando Fuentes, 467–88. Mexico City: Universidad Autónoma de la Ciudad de México, 2011.

Ilich, Fran. "Fragmentos: Reporte anual de Diego de la Vega S.A. de C.V., 2010." *Espectro Rojo,* no. 1 (May 2010): 38–41.

Ilich, Fran. Interview. In *En voz propia/In Their Own Voices: Entrevistas con narradores de la frontera México–Estados Unidos,* edited by Edgar Cota Torres and José Salvador Ruiz Méndez, 147–59/387–99. Colorado Springs: University of Colorado Springs, 2014.

Ilich, Fran. "Otra Cultura es posible: No imposible." *Sabot,* no. 1 (May 2007): 2.

Ilich, Fran. *Otra narrativa es posible: Imaginación política en la era del internet.* Buenos Aires: Centro Cultural de España Buenos Aires, 2011.

Ilich, Fran. "Repatriate the Feather Crown of Moctezuma to México-Tenochtitlan." Petition. Change.org, March 2013. https://www.change.org/p/republic-of -austria-repatriate-the-feather-crown-of-moctezuma-to-méxico-tenochtitlan.

"Ingenio Ledesma: Una historia sin éxito y sin gloria." In *La normalidad,* edited by Gabriela Massuh and Sol Arrese, 163–65. Buenos Aires: Interzona Editora, 2006.

Internacional Errorista/((((Cronopiux Erroristus))). "Erroristas continuaron avanzando sobre las costas marplatenses." *Argentina Indymedia,* Nov. 5, 2005. http:// argentina.indymedia.org/news/2005/11/345485.php.

Internacional Errorista/((((Cronopiux Erroristus))). "Urgente!!! Erroristas tomaron un balneario de Mar del Plata." *Argentina Indymedia,* Nov. 5, 2005. http://archivo .argentina.indymedia.org/news/2005/11/345450.php.

Jacobsen, Annie. *Operation Paperclip: The Secret Intelligence Program That Brought Nazi Scientists to America.* New York: Little, Brown, 2014.

Jagoda, Patrick. *Network Aesthetics.* Chicago: University of Chicago Press, 2016.

Jameson, Fredric, ed. *Aesthetics and Politics*. Brooklyn, NY: Verso Books, 2007.

Jelin, Elizabeth. *La lucha por el pasado*. Buenos Aires: Siglo XXI Editores, 2017.

Jelin, Elizabeth. "The Politics of Memory: The Human Rights Movements and the Construction of Democracy in Argentina." *Latin American Perspectives* 21, no. 2 (Spring 1994): 38–58.

Jelin, Elizabeth. *Los trabajos de la memoria*. Madrid: Siglo XXI Editores, 2002.

Johnson, Kaytie. *Leaving Aztlán*. Exhibition catalogue. Santa Monica, CA: ARENA 1/ Santa Monica Art Studios, 2006.

Johnson, Troy R. *The Occupation of Alcatraz Island: Indian Self-Determination and the Rise of Indian Activism*. Chicago: University of Illinois Press, 1996.

Kazanjian, David, and María Josefina Saldaña-Portillo, eds. "The Traffic in History: Papers from the Tepoztlán Institute for the Transnational History of the Americas." Special issue, *Social Text* 92, vol. 25, no. 3 (Fall 2007).

Kelley, Bill, Jr., and Grant Kester, eds. *Collective Situations: Readings in Contemporary Latin American Art*. Durham, NC: Duke University Press, 2017.

Kessler, Gabriel. *El sentimiento de inseguridad: Sociología del temor al delito*. Buenos Aires: Siglo Veintiuno Editores, 2009.

Kester, Grant H. *The One and the Many*. Durham, NC: Duke University Press, 2011.

Kester, Grant, and Mick Wilson, "Autonomy, Agonism, and Activist Art: An Interview with Grant Kester." *Art Journal* 6, no. 3 (2007): 107–18.

Klein, Naomi. *The Shock Doctrine: The Rise of Disaster Capitalism*. New York: Henry Holt, 2007.

Kunzle, David. "Dispossession by Ducks: The Imperialist Treasure Hunt in Southeast Asia." *Art Journal* 49, no. 2 (1990): 159–66.

Landa, Ishay. *The Apprentice's Sorcerer: Liberal Tradition and Fascism*. Chicago: Haymarket Books, 2012.

Larsen, Neil. *Reading North by South: On Latin American Literature, Culture, and Politics*. Minneapolis: University of Minnesota Press, 1995.

Laslett, John. *Shameful Victory: The Los Angeles Dodgers, the Red Scare, and the Hidden History of Chavez Ravine*. Tucson: University of Arizona Press, 2015.

Lefebvre, Henri. *State, Space, World: Selected Essays*. Edited by Neil Brenner and Stuart Elden. Minneapolis: University of Minnesota Press.

Lichtblau, Eric. *The Nazis Next Door: How America Became a Safe Haven for Hitler's Men*. New York: First Mariner Books, 2015.

Light, Michael T., Mark Hugo Lopez, and Ana Gonzalez-Barrera. "The Rise of Federal Immigration Crimes." PEW Research Center, March 18, 2014, https://www.pewresearch.org/hispanic/2014/03/18/the-rise-of-federal-immigration-crimes/.

Lloyd, David. "Representation's Coup." *Interventions: International Journal of Postcolonial Studies* 16, no. 1 (2014): 1–29.

Lloyd, David, and Paul Thomas. *Culture and the State*. New York: Routledge, 1998.

Longoni, Ana. "Encrucijadas del arte activista en Argentina." *Ramona* no. 73 (Aug. 2007): 31–43.

Longoni, Ana. "Fotos y siluetas: Dos estrategias contrastantes en la representación de los desaparecidos." In *Los desaparecidos en la Argentina: Memorias, representaciones e*

ideas (1983–2008), coordinated by Emilio Crenzel, 43–64. Buenos Aires: Biblios, 2010.

Longoni, Ana. "¿Tucumán sigue ardiendo?" *Brumaria*, no. 5 (Summer 2005): 43–51.

Longoni, Ana, and Gustavo Bruzzone, eds. *El Siluetazo*. Buenos Aires: Adriana Hildalgo, 2008.

Longoni, Ana, Fernanda Carvajal, and Jaime Vindel. "Socialización del arte." In *Perder la forma humana: Una imagen sísmica de los años ochenta en América Latina*, edited by Fernanda Carvajal, André Mesquita, and Jaime Vindel, 226–35. Madrid: Museo Nacional Centro de Arte Reina Sofía, 2012.

Lorenzano, Sandra. "Angels among Ruins." In *Telling Ruins in Latin America*, edited by Michael J. Lazzara and Vicky Unruh, 249–59. New York: Palgrave Macmillan, 2009.

Losurdo, Domenico. *Class Struggle: A Political and Philosophical History*. Translated by Gregory Elliott. New York: Palgrave Macmillan, 2016.

Losurdo, Domenico. *Liberalism: A Counter-History*. Translated by Gregory Elliott. Brooklyn, NY: Verso, 2014.

Losurdo, Domenico. *War and Revolution: Rethinking the 20th Century*. Translated by Gregory Elliott. New York: Verso, 2015.

Luxemburg, Rosa. *The Accumulation of Capital*. London: Routledge Classics, 2003.

Mani, Kristina. "Diverse Markets for Force in Latin America: From Argentina to Guatemala." In *The Markets for Force: Privatization of Security across World Regions*, edited by Molly Dunigan and Ulrich Petersohn, 20–37. Philadelphia: University of Pennsylvania Press, 2015.

Mann, Barbara Alice. "'And Then They Build Monuments to You,'" foreword to *Wielding Words Like Weapons: Selected Essays in Indigenism, 1995–2005*, by Ward Churchill, xiii–xviii. Oakland, CA: PM Press, 1997.

Marcuse, Herbert. *An Essay on Liberation*. Boston: Beacon Press, 1969.

Markarian, Vania. *Left in Transformation: Uruguayan Exiles and the Latin American Human Rights Network, 1967–1984*. Latin American Studies: Social Sciences and Law. New York: Routledge, 2005.

Martínez, Maria Elena. "Archives, Bodies, and Imagination." *Radical History Review*, no. 120 (Fall 2014): 159–82.

Martins de Carvalho, Horácio. "The Emancipation of the Movement of Landless Rural Workers within the Movement of Continual Social Emancipation." In *Another Production Is Possible: Beyond the Capitalist Canon*, edited by Boaventura de Sousa Santos, 179–201. New York: Verso Books, 2006.

Marx, Karl. *Capital: A Critique of Political Economy, Volume 1*. Translated by Ben Fowkes. New York: Vintage Books, 1977.

Marx, Karl. *Economic and Philosophic Manuscripts of 1844*. Translated by Martin Milligan. New York: Prometheus Books, 1988.

Marx, Karl. *The Eighteenth Brumaire of Louis Bonaparte*. New York: International Publishers, 1994.

Marx, Karl, and Friedrich Engels. *Collected Works. Volume 5: Marx and Engels: 1845–47*. New York: International Publishers, 1976.

Marx, Karl, and Friedrich Engels. *The Marx-Engels Reader*. Edited by Robert C. Tucker. 2nd ed. New York: W. W. Norton, 1978.

Massuh, Gabriela, and Sol Arrese, eds. *La normalidad*. Buenos Aires: Interzona Editora, 2006.

Mattini, Luis. *El encantamiento político: De revolucionarios de los '70 a rebeldes sociales de hoy*. Buenos Aires: Peña Lillo, 2004.

Mattini, Luis. "Las madres pueden ser memoria, pero no historia." *Kaosenlared*, Oct. 9, 2010. https://kaosenlared.net/las-madres-pueden-ser-memoria-pero-no-historia-por-luis-mattini/.

McCaughan, Edward J. *Art and Social Movements: Cultural Politics in Mexico and Aztlán*. Durham, NC: Duke University Press, 2012.

McGonigal, Jane. "This Is Not a Game: Immersive Aesthetics and Collective Play." Presentation. Digital Arts and Culture Conference, Melbourne, May 2003. www.avantgame.com/writings.htm.

McSherry, J. Patrice. *Incomplete Transition: Military Power and Democracy in Argentina*. New York: St. Martin's Press, 1997.

McWilliams, Carey. *Factories in the Field: The Story of Migratory Farm Labor in California*. Berkeley: University of California Press, 2000.

Meister, Robert. *After Evil: A Politics of Human Rights*. New York: Columbia University Press, 2014.

Melamed, Jodi. *Represent and Destroy: Rationalizing Violence in the New Racial Capitalism*. Minneapolis: University of Minnesota Press, 2011.

Mesa de Escrache Popular and Colectivo Situaciones. *Genocida en el barrio*. Buenos Aires: Ediciones Mano en Mano, 2001.

Mesa-Bains, Amalia. "Domesticana: The Sensibility of Chicana Rasquache." *Aztlán: A Journal of Chicano Studies* 24, no. 2 (Fall 1999): 157–67.

Midnight Notes Collective. "The Hammer and . . . or the Sickle: From the Zapatista Uprising to the Battle of Seattle." In *Auroras of the Zapatistas: Local and Global Struggles of the Fourth World War*, edited by the Midnight Notes Collective, 9–14. Brooklyn, NY: Autonomedia, 2001.

Midnight Notes Collective. "The New Enclosures." In *Midnight Oil: Work, Energy, War, 1973–1992*, edited by the Midnight Notes Collective, 317–33. Brooklyn, NY: Autonomedia, 1992.

Mitchell, W. J. T., ed. *Landscape and Power*. Chicago: University of Chicago Press, 2002.

Moyn, Samuel. *The Last Utopia: Human Rights in History*. Cambridge, MA: Harvard University Press, 2010.

"Multiplicidad/Los 'colectivos.'" *Ramona* no. 33 (2003): 4–23.

Munck, Ronaldo. "Farewell to Socialism? A Comment on Recent Debates." *Latin American Perspectives* 17, no. 2 (Spring 1990): 113–21.

Munck, Ronaldo, with Ricardo Falcón and Bernardo Galitelli. *Argentina: From Anarchism to Peronism*. London: Zed Books, 1987.

Muñoz, Carlos. *Youth, Identity, Power: The Chicano Movement*. Revised ed. London: Verso, 2007.

Muñoz Ramírez, Gloria. *The Fire and the Word: A History of the Zapatista Movement*. Translated by Laura Carlsen with Alejandro Reyes Arias. San Francisco: City Lights Books, 2006.

Muzzopappa, Eva, and Ana Margarita Ramos. "Una etnografía itinerante sobre el terrorismo en Argentina: Paradas, trayectorias y disputas." *Antípoda: Revista de Antropología y Arqueología* 29 (2017): 123–42. https://dx.doi.org/10.7440/antipoda29.2017.06.

Nelson, Marcel. *A History of the FTAA: From Hegemony to Fragmentation in the Americas*. New York: Palgrave Macmillan, 2015.

Neocleous, Mark. "'A Brighter and Nicer New Life': Security as Pacification." *Social and Legal Studies* 20, no. 2 (2011): 191–208.

Neocleous, Mark. *Critique of Security*. Montreal: McGill-Queen's University Press, 2008.

Neocleous, Mark. *War Power, Police Power*. Edinburgh: Edinburgh University Press, 2014.

Ngai, Mai M. *Impossible Subjects: Illegal Aliens and the Making of Modern America*. Princeton, NJ: Princeton University Press, 2004.

Nichols, Robert. "Disaggregating Primitive Accumulation," *Radical Philosophy* 194 (Nov.–Dec. 2015): 18–28.

Noriega, Chon, ed. *Just Another Poster?: Chicano Graphic Arts in California*. Santa Barbara: University Art Museum, University of California Santa Barbara, 2001.

Noriega, Chon, Terezita Romo, and Pilar Tompkins Rivas, eds. *L.A. Xicano*. Los Angeles: UCLA Chicano Studies Research Center Press, 2011.

Oliver, Melvin L., James H. Johnson Jr., and Walter C. Farrell Jr. "Anatomy of a Rebellion: A Political-Economic Analysis." In *Reading Rodney King, Reading Urban Uprising*, edited by Robert Gooding-Williams, 117–41. London: Routledge, 1993.

Olivera, Mercedes, and Carlos Pérez. "From Integrationist 'Indigenismo' to Neoliberal De-Ethnification in Chiapas: Reminiscences." *Latin American Perspectives* 39, no. 5 (2012): 100–110.

Otero, Gerardo, ed. *Mexico in Transition: Neoliberal Globalism, the State and Civil Society*. London: Zed Books, 2004.

Otero, Gerardo. "Neoliberal Globalization, NAFTA, and Migration: Mexico's Loss of Food and Labor Sovereignty." *Journal of Poverty* 15, no. 4 (2011): 384–402.

Overmyer-Velásquez, Rebecca. *Folkloric Poverty: Neoliberal Multiculturalism in Mexico*. University Park: Pennsylvania State University Press, 2010.

Perelman, Marcela. "La protesta social como acción irregular: Vigencia de la figura del partisano en la mirada policial sobre los manifestantes piqueteros en Argentina." *Revista Colombiana de Antropología* 45, no. 2 (2009): 469–503.

Pereyra, Sebastián. *¿La lucha es una sola? La movilización social entre la democratización y el neoliberalismo*. Buenos Aires: Universidad Nacional de General Sarmiento, 2008.

Perugini, Nicola, and Neve Gordon. *The Human Right to Dominate*. New York: Oxford University Press, 2015.

Petras, James. "Popular Struggle in Argentina: Full Circle and Beyond." *Monthly Review* 55, no. 4 (2003): 22–37.

Petras, James. "The Unemployed Workers Movement in Argentina." *Monthly Review* 53, no. 8 (2002): 32–45.

Petras, James, and Henry Veltmeyer. *Social Movements and State Power: Argentina, Brazil, Bolivia, Ecuador*. London: Pluto Press, 2005.

Petras, James, and Henry Veltmeyer. *Social Movements in Latin America: Neoliberalism and Popular Resistance*. New York: Palgrave Macmillan, 2011.

Petras, James, and Steve Vieux. "The Transition to Authoritarian Electoral Regimes in Latin America." *Latin American Perspectives* 81, no. 21 (1994): 5–20.

Ponce de León, Jennifer. "On the Zapatistas' Little School of Freedom (A Student's Notes)." In *Dancing with the Zapatistas: 20 Years Later*, edited by Diana Taylor and Lorie Novak. Durham, NC: Duke University Press, 2015. http://scalar .usc.edu/anvc/dancing-with-the-zapatistas/on-the-zapatistas-little-school-of -freedom-a-students-notes.

Ponce de León, Jennifer. *See also* Flores Sternad, Jennifer.

Ponce de León, Jennifer, and Gabriel Rockhill. "Toward a Compositional Model of Ideology: Materialism, Aesthetics and Cultural Revolution." *Philosophy Today*, 63.1 (Winter 2020): 95–116. https://doi.org/10.5840/philtoday202044322.

Poulantzas, Nicos. *State, Power, Socialism*. New York: Verso, 2014.

Pratt, Mary Louise. *Imperial Eyes: Travel Writing and Transculturation*. New York: Routledge, 2007.

Quijano, Aníbal. "Coloniality of Power, Eurocentrism, and Latin America." In *Coloniality at Large: Latin America and the Postcolonial Debate*, edited by Mabel Moraña, Enrique Dussel, and Carlos A. Jáuregui, 181–224. Durham, NC: Duke University Press, 2008.

Quijano, Aníbal, and Immanuel Wallerstein. "Americanity as a Concept, or the Americas in the Modern World System." *International Journal of Social Sciences*, no. 134 (Nov. 1992): 549–57.

Rajca, Andrew. *Dissensual Subjects: Memory, Human Rights, and Postdictatorship in Argentina, Brazil, and Uruguay*. Evanston, IL: Northwestern University Press, 2018.

Rancière, Jacques. *The Politics of Aesthetics*. Edited and translated by Gabriel Rockhill. New York: Bloomsbury Academic, 2006.

Reed, T. V. *The Art of Protest: Culture and Activism from the Civil Rights Movement to the Streets of Seattle*. Minneapolis: University of Minnesota Press, 2005.

Renard, Marie-Christine, and Mariana Ortega Breña. "The Mexican Coffee Crisis." *Latin American Perspectives* 37, no. 2 (2010): 21–33.

Risler, Julia. *La acción psicológica: Dictadura, Inteligencia y gobierno de las emociones (1955–1981)*. Buenos Aires: Tinta Limón, 2018.

Rivera Cusicanqui, Silvia. "Ch'ixinakax utxiwa: A Reflection on the Practices and Discourses of Decolonization." *South Atlantic Quarterly* 111, no. 1 (Winter 2012): 95–109.

Robinson, William I. "Accumulation Crisis and Global Police State." *Critical Sociology* (2018): 1–14. doi: 10.1177/0896920518757054.

Robinson, William I. *Global Capitalism and the Crisis of Humanity*. New York: Cambridge University Press, 2014.

Robinson, William I. *Into the Tempest: Essays on the New Global Capitalism*. Chicago: Haymarket Books, 2019.

Robinson, William. *Latin America and Global Capitalism: A Critical Globalization Perspective*. Baltimore, MD: Johns Hopkins University Press, 2010.

Robinson, William I. "The New Global Capitalism and the War on Immigrants." *Truthout*, Sept. 13, 2013. https://truthout.org/articles/the-new-global-capitalism-and-the-war-on-immigrants/.

Robinson, William I. *Promoting Polyarchy: Globalization, US Intervention, and Hegemony*. New York: Cambridge University Press, 1996.

Robinson, William I. "Promoting Polyarchy: 20 Years Later." *International Relations* 27, no. 2 (2013): 228–34.

Robinson, William I. "Remapping Development in Light of Globalisation: From a Territorial to a Social Cartography." *Third World Quarterly* 23, no. 6 (2002): 1047–71. doi: 10.1080/0143659022000036658.

Robinson, William I. *Transnational Conflicts: Central America, Social Change and Globalization. New York: Verso Books, 2003*.

Robinson, William I., and Xuan Santos. "Global Capitalism, Immigrant Labor, and the Struggle for Justice." *Class, Race and Corporate Power* 2, no. 3 (2014): 1–16. doi: 10.25148/CRCP.2.3.16092122.

Rockhill, Gabriel. *Counter-History of the Present: Untimely Interrogations into Globalization, Technology, Democracy*. Durham, NC: Duke University Press, 2017.

Rockhill, Gabriel. "Foucault, Genealogy, Counter-History." *Theory & Event* 23, no. 1 (2020): 85–119.

Rockhill, Gabriel. *Interventions in Contemporary Thought: History, Politics, Aesthetics*. Edinburgh: Edinburgh University Press, 2016.

Rockhill, Gabriel. *Radical History and the Politics of Art*. New York: Columbia University Press, 2014.

Rodríguez, Gabriela, and Gabriela Seghezzo, "La problematización de la (in)seguridad en los medios de comunicación: Los imperativos del saber y del hacer." In *A la inseguridad la hacemos entre todos: Prácticas académicas, mediáticas y policiales*, 75–120. Buenos Aires: Hekht Libros, 2010.

Rodríguez, Juana María. *Queer Latinidad: Identity Practices, Discursive Spaces*. New York: New York University Press, 2003.

Rodríguez, Sergio. "Las cooperativas son el pilar económico del Zapatismo." Interview. *La Coperacha*, June 11, 2014. www.lacoperacha.org.mx/sergio-rodriguez-zapatistas.php.

Roht-Arriaza, Naomi. "Why Was the Economic Dimension Missing for So Long in Transitional Justice? An Exploratory Essay." In *The Economic Accomplices to the Argentine Dictatorship: Outstanding Debts*, edited by Horacio Verbitsky and Juan Pablo Bohoslavsky, 19–28. Cambridge: Cambridge University Press, 2016.

Rojas, James T. "The Enacted Environment of East Los Angeles." *Places* 8, no. 3 (1993): 42–53.

Romanin, Enrique Andriotti. "¿Cooptación, oportunidades políticas y sentimientos? Las Madres de Plaza de Mayo y el gobierno de Néstor Kirchner." *Polis* 39 (2014): 1–15.

Romanin, Enrique Andriotti. "De la resistencia a la integración: Las transformaciones de la Asociación Madres Plaza de Mayo en la 'era Kirchner.'" *Estudios Politicos* 41 (2012): 35–54.

Romanin, Enrique Andriotti. "Nosotros los del 73: Memoria y política en la Argentina post-2001." *Nómadas: Critical Journal of Social and Juridicial Sciences* (2012): n.p.

Romero, Luis Alberto. *La larga crisis Argentina*. Buenos Aires: Siglo XXI Editores, 2013.

Ryan, Marie-Laure. Introduction to *Narrative across Media: The Languages of Storytelling*. Lincoln: University of Nebraska Press, 2004.

Sader, Emir. *The New Mole: Paths of the Latin American Left*. Durham, NC: Duke University Press, 2009.

Saldaña-Portillo, María Josefina. "From the Borderlands to the Transnational? Critiquing Empire in the Twenty-First Century." In *A Companion to Latino Studies*, edited by Juan Flores and Renato Rosaldo, 502–4. Hoboken, NJ: Blackwell, 2017.

Saldaña-Portillo, María Josefina. *Indian Given: Racial Geographies across Mexico and the United States*. Durham, NC: Duke University Press, 2016.

Saldaña-Portillo, María Josefina. *The Revolutionary Imagination in the Americas and the Age of Development*. Durham, NC: Duke University Press, 2003.

Saldívar, José David. *The Dialectics of Our America: Genealogy, Cultural Critique, and Literary History*. Durham, NC: Duke University Press, 1991.

Saldívar, José David. *Trans-Americanity: Subaltern Modernities, Global Coloniality, and the Cultures of Greater Mexico*. Durham, NC: Duke University Press, 2012.

Saldívar, Ramón. *The Borderlands of Culture: Américo Paredes and the Transnational Imaginary*. Durham, NC: Duke University Press, 2008.

Saldívar, Ramón. *Chicano Narrative: The Dialectics of Difference*. Madison: University of Wisconsin Press, 1990.

Sánchez, George. *Becoming Mexican American: Ethnicity, Culture and Identity in Chicano Los Angeles, 1990–1945*. New York: Oxford University Press, 1995.

Sánchez, Rosaura. "On a Critical Realist Theory of Identity." In *Identity Politics Reconsidered*, edited by Linda Martín Alcoff, Michael Hames-García, Satya P. Mohanty, and Paula M. L. Moya, 31–52. New York: Palgrave Macmillan, 2006.

Sánchez, Rosaura, and Beatrice Pita. "Theses on the Latino Bloc: A Critical Perspective." *Aztlán: A Journal of Chicano Studies* 31, no. 2 (Fall 2006): 25–53.

Sánchez Vázquez, Adolfo. *Art and Society: Essays in Marxist Aesthetics*. Translated by Maro Riofrancos. New York: Monthly Review Press, 1973.

Sánchez Vázquez, Adolfo. *Las ideas estéticas de Marx*. Mexico City: Ediciones ERA, 1965.

Sandoval Palacios, Juan Manuel. *La frontera México–Estados Unidos: Espacio global para la expansión del capital transnacional*. Mexico City: Secretaría de Cultura, Instituto Nacional de Antropología e Historia, 2017.

Sarlo, Beatriz. *La audacia y el cálculo: Kirchner 2003–2010*. Buenos Aires: Penguin Random House Grupo Editorial Argentina, 2011.

Sartre, Jean-Paul. "A Plea for Intellectuals." In *Between Existentialism and Marxism*, 228–85. London: New Left Books, 1974.

Schrank, Brian. *Avant-garde Videogames*. Cambridge, MA: MIT Press, 2014.

Seghezzo, Gabriela. "Entre los derechos humanos y la (in)seguridad: modos de construcción de la 'violencia policial' en las ciencias sociales." In *A la inseguridad la hacemos entre todos: Prácticas académicas, mediáticas y policiales*, 51–74. Buenos Aires: Hekht Libros, 2010.

Seremetakis, C. Nadia, ed. *The Senses Still: Perception and Memory as Material Culture in Modernity*. Chicago: University of Chicago Press, 1996.

Seri, Guillermina. *Seguridad: Crime, Police Power, and Democracy in Argentina*. New York: Bloomsbury Academic, 2013.

Seri, Guillermina. "Terror, Reconciliation, Redemption: The Politics of Memory." *Radical Philosophy*, no. 147 (2008): 8–13.

Shiva, Vandana. *Protect or Plunder? Understanding Intellectual Property Rights*. New York: Zed Books, 2001.

Sholette, Gregory. *Dark Matter: Art and Politics in the Age of Enterprise Culture*. London: Pluto Press, 2011.

Simpson, Edward, and Stuart Corbridge. "The Geography of Things That May Become Memories: The 2001 Earthquake in Kachchh-Guajarat and the Politics of Rehabilitation in the Prememorial Era." *Annals of the Association of American Geographers* 96, no. 3 (2006): 566–85.

Sims, J. Revel. "More Than Gentrification: Geographies of Capitalist Displacement in Los Angeles 1994–1999." *Urban Geography* 37, no. 1 (2016): 26–56. doi: 10.1080/02723638.2015.1046698.

Smith, Neil. "New Globalism, New Urbanism: Gentrification as Global Urban Strategy." *Antipode* 34, no. 3 (2002): 427–50.

Soja, Edward W. *Seeking Spatial Justice*. Minneapolis: University of Minnesota Press, 2010.

Stevens, Quentin, Karen A. Franck, and Ruth Fazakerley. "Counter-monuments: The Anti-monumental and the Dialogic." *Journal of Architecture* 17, no. 6 (2012): 951–72. doi: 10.1080/13602365.2012.746035.

Streeby, Shelley. *Radical Sensations: World Movements, Violence, and Visual Culture*. Durham, NC: Duke University Press, 2013.

Striffler, Steve. *Solidarity: Latin America and the US Left in the Era of Human Rights*. London: Pluto Press, 2019.

Subcomandante Insurgente Marcos. *The Other Campaign/La Otra Campaña*. San Francisco: City Lights Books, 2006.

Subcomandante Insurgente Marcos and the Comité Clandestino Revolucionario Indigena-Comandancia General. *Zapatistas: Documents of the New Mexican Revolution*. Brooklyn, NY: Autonomedia, 1994.

Subcomandante Marcos. "La Cuarta Guerra Mundial." *In Motion Magazine*, Oct. 26, 2001. https://inmotionmagazine.com/auto/cuarta.html.

Svampa, Maristella. *Cambio de época: Movimientos sociales y poder político*. Buenos Aires: Siglo XXI, 2008.

Svampa, Maristella. "Commodities Consensus: Neoextractivism and Enclosure of the Commons in Latin America." *South Atlantic Quarterly* 114, no. 1 (January 2015): 65–68. doi: 10.1215/00382876-2831290.

Svampa, Maristella. *La sociedad excluyente: Argentina bajo el signo del neoliberalismo*. Buenos Aires: Taurus, 2005.

Sztulwark, Pablo. "Ciudad Memoria." *Foro Alfa*. Accessed May 1, 2015. http://foroalfa .org/es/articulo/18/Ciudad_memoria.

Tandeciarz, Silvia R. "Citizens of Memory: Refiguring the Past in Postdictatorship Argentina." *Modern Language Association* 122, no. 1 (2007): 151–69.

Tapia, Luis. *Política Salvaje*. Buenos Aires: Waldhunter Editores, 2011.

Taylor, Analisa. "The Ends of Indigenismo in Mexico." *Journal of Latin American Cultural Studies* 14, no. 1 (2005): 75–86.

Taylor, Claire, and Thea Pitman, eds. *Latin American Cyberculture and Cyberliterature*. Liverpool: Liverpool University Press, 2007.

Taylor, Claire, and Thea Pitman, eds. *Latin American Identity in Online Cultural Production*. New York: Routledge, 2013.

Taylor, Diana. *The Archive and the Repertoire: Performing Cultural Memory in the Americas*. Durham, NC: Duke University Press, 2003.

Taylor, Diana. *Disappearing Acts: Spectacles of Gender and Nationalism in Argentina's "Dirty War."* Durham, NC: Duke University Press Books, 1997.

Taylor, Julie. "Body Memories: Aide-Memoires and Collective Amnesia in the Wake of the Argentine Terror." In *Body Politics: Disease, Desire, and the Family*, edited by Avery Gordon and Michael Ryan, 192–203. Boulder, CO: Westview Press, 1994.

Therborn, Göran. *The Ideology of Power and the Power of Ideology*. New York: Verso, 1999.

Thiong'o, Ngũgĩ wa. "Enactments of Power: The Politics of Performance Space." *Drama Review* 41, no. 3 (Autumn 1997): 11–30.

Topik, Steve. "Coffee as Social Drug." *Cultural Critique*, no. 71 (Winter 2009): 81–106.

Trouillot, Michel-Rolph. *Silencing the Past: Power and the Production of History*. Boston: Beacon Press, 1997.

Tse-Tung, Mao. "Talks at the Yenan Forum." In *Mao Tse-Tung on Literature and Art*, 75–122. Peking: Foreign Languages Press, 1960.

Valdez, Luis. *Luis Valdez—Early Works: Actos, Bernabé and Pensamiento Serpentino*. Houston, TX: Arte Público Press, 1994.

Van Drunen, Saskia. "Struggling with the Past: The Human Rights Movement and the Politics of Memory in Post-dictatorship Argentina, 1983–2006." PhD dissertation, University of Amsterdam, 2010.

Vargas, Deborah R. "Ruminations on *Lo Sucio* as a Latino Queer Analytic." *American Quarterly* 66, no. 3 (2014): 715–26.

Veltmeyer, Henry. *On the Move: The Politics of Social Change in Latin America*. Toronto: Broadview Press, 2007.

Veltmeyer, Henry, and James Petras, eds. *The New Extractivism: A Post-Neoliberal Development Model or Imperialism of the Twenty-First Century?* London: Zed Books, 2014.

Veltmeyer, Henry, James F. Petras, and Steve Vieux. *Neoliberalism and Class Conflict in Latin America: A Comparative Perspective on the Political Economy of Structural Adjustment.* New York: St. Martin's Press, 1997.

Verbitsky, Horacio, and Juan Pablo Bohoslavsky, eds. *The Economic Accomplices to the Argentine Dictatorship: Outstanding Debts.* Translated by Laura Pérez Carrara. Cambridge, UK: Cambridge University Press, 2016.

Verdú, María del Carmen. *Represión en democracia: De la "primavera alfonsinista" al "gobierno de los derechos humanos."* Buenos Aires: Herramienta Ediciones, 2009.

Viewpoint Magazine. "The Border Crossing Us." Nov. 7, 2018. https://www.viewpointmag.com/2018/11/07/from-what-shore-does-socialism-arrive/.

Villa, Raúl Homero. *Barrio Logos: Space and Place in Urban Chicano Literature and Culture.* Austin: University of Texas Press, 2000.

Villanueva, Pedro Valderrama. *Detonación: Contra-cultura (menor) y el movimiento fanzine en Tijuana (1992–1994).* Tijuana: NortEstación Editorial, 2014.

Wacquant, Loïc. *Punishing the Poor: The Neoliberal Government of Social Insecurity.* Durham, NC: Duke University Press, 2009.

Wallerstein, Immanuel. *World-Systems Analysis: An Introduction.* Durham, NC: Duke University Press, 2004.

Whitener, Brian. *Crisis Cultures: The Rise of Finance in Mexico and Brazil.* Pittsburgh, PA: University of Pittsburgh Press, 2019.

Whitener, Brian. "The Politics of Infrastructure in Contemporary Mexican Writing." In *Mexican Literature in Theory*, edited by Ignacio M. Sánchez Prado, 261–78. New York: Bloomsbury Academic, 2018.

Whitman, James Q. *Hitler's American Model: The United States and the Making of Nazi Race Law.* Princeton, NJ: Princeton University Press, 2017.

Williams, Randall. "'. . . or the Bullet?' Notes on Right and Violence." Paper presented at the annual meeting of the American Studies Association, Washington, DC, Nov. 5–8, 2009.

Williams, Randall. *The Divided World: Human Rights and Its Violence.* Minneapolis: University of Minnesota Press, 2010.

Williams, Randall. "State of Permanent Exception: The Birth of Modern Policing in Colonial Capitalism." *Interventions* 5, no. 3 (June 2010): 322–44.

Williams, Raymond. *Marxism and Literature.* Oxford: Oxford University Press, 1978.

Williams, Raymond. *The Sociology of Culture.* Chicago: University of Chicago, 1995.

Wolff, Janet. *Aesthetics and the Sociology of Art.* Boston: George Allen and Unwin, 1983.

Wolff, Janet. *The Social Production of Art.* New York: New York University Press, 1984.

Woocher, Jacob. "Los Angeles Is Quickly Becoming a Place Exclusively for the White and Rich." *Knock L.A.,* Nov. 7, 2017. https://knock-la.com/los-angeles-is-quickly-becoming-a-place-exclusively-for-the-white-and-rich-c585953e0614?fbclid=IwAR2avFhHlzYMirRK41aaOGGnISZqkur9w112xszCs8DmlSkSQb bMeIMPVzU.

Wright, Stephen. "The Delicate Essence of Artistic Collaboration." *Third Text* 18, no. 6 (2004): 533–45.

Wright, Stephen. "The Future of the Reciprocal Readymade: An Essay on Use-Value and Art-Related Practice." *Networked Performance*, May 13, 2005. http://archive .turbulence.org/blog/archives/000906.html.

Wynter, Sylvia. "The Ceremony Must Be Found: After Humanism." *boundary 2* 12, no. 13 (Spring–Autumn 1984): 19–70.

Wynter, Sylvia. "1492: A New World View." In *Race, Discourse, and the Origin of the Americas: A New World View*, edited by Vera Lawrence Hyatt and Rex Nettleford, 5–57. New York: Smithsonian, 1995.

Wynter, Sylvia. "Rethinking 'Aesthetics': Notes towards a Deciphering Practice." In *Ex-iles: Essays on Caribbean Cinema*, edited by Mbye Cham, 238–79. Trenton, NJ: Africa World Press, 1992.

Ybarra-Frausto, Tomás. "Rasquachismo: A Chicano Sensibility." In *Chicano Aesthetics: Rasquachismo*, 5–8. Phoenix, AZ: Movimiento Artístico del Rio Salado, 1989.

Young, James E. "The Counter-Monument: Memory against Itself in Germany Today." *Critical Inquiry* 18, no. 2 (1992): 271.

Young, James E. "Memory/Monument." In *Critical Terms for Art History*, edited by Robert S. Nelson and Richard Shiff, 234–47. Chicago: University of Chicago Press, 2003.

Zibechi, Raúl. "El estado de excepción como paradigma político del extractivismo." In *Territorios en disputa: Despojo capitalista, luchas en defensa de los bienes comunes naturales y alternativas emancipatorias*, edited by Claudia Composto and Mina Lorena Navarro, 76–88. Mexico City: Bajo Tierra Ediciones, 2014.

Zibechi, Raúl. *Genealogía de la revuelta: Argentina, la sociedad en movimiento*. La Plata: Letra Libre, 2003.

Zibechi, Raúl. "Mar del Plata y el ascenso del libre comercio." *La Jornada*, Nov. 18, 2005, www.jornada.com.mx/2005/11/18/index.php?section=opinion&article =029a2pol.

Zibechi, Raúl. *Movimientos sociales en América Latina: El "mundo otro" en movimiento*. Madrid: Baladre, 2018.

Zibechi, Raúl. *Política y miseria: La relación entre el modelo extractivo, los planes sociales y los gobiernos progresistas*. Buenos Aires: La Vaca, 2011.

Zibechi, Raúl. *Territories in Resistance*. Translated by Ramor Ryan. Oakland, CA: AK Press, 2012.

Air Force One, 237
Akers Chacón, Justin, 98–99
Alcatraz Island, 72–73
Alegría, Claribel, 54
Alemann, Roberto, 146–47
Alexander, M. Jacqui, 36–37
Alfonsín, Raúl, 142–43
Algeria, 133
alternate reality games (ARGs), 31–32, 36,
 53, 256n11
Althusser, Louis, 64, 166, 240–42
American holocaust, 2, 55–56, 59, 61, 67;
 indifference to, 67; references to, 59, 61
Americas, 3, 13–16, 27, 32, 36–41, 57–61,
 68–71, 94, 100, 185; Anglo settler
 colonialism in, 57; anticolonial resis-
 tance in, 36; colonial capital extraction
 from, 69–71; colonial time-space and,
 61; grassroots movements across, 2;
 migrants of, 94, 100; neoliberal states
 in, 16; popular uprisings throughout,
 14, 127, 185
América Tropical, 80, 83
Amin, Samir, 11
Anticolonial Tattoo, 33
antiglobalization movement, 2, 13,
 228–34, 267n78; flashpoints in, 231;
 heterogenous formation of, 13; military
 operation against, 228–29
antisystemic movements, 3, 7–9, 13–18,
 21, 24–27, 42–43, 46, 127, 132, 154–55,
 177, 183–84, 192–94, 201, 212, 227–29,
 247–50, 251n2; anticapitalist horizon
 of, 42–43; artistic experimentalism
 and, 21, 24, 127, 249–50; criminaliza-
 tion of, 228; epicenter of, 13; gen-
 erational formation of, 9, 132; Latin
 Americans and, 13–18, 127; neutraliza-
 tion of, 26–27, 194, 201, 227
antiterrorism, 3, 17, 99, 127, 228, 230, 236,
 238, 243, 276n144, 276n145; discourses
 of, 17, 228, 236; hemispheric politics
 of, 3, 99, 243; international convention
 for, 276n144, 276n145; laws of, 17, 127,
 228, 230, 236, 238; twenty-first century
 and, 99

Apagones de Ledesma (Ledesma Black-
 outs), 178–80, 183
Aquí viven genocidas, 152
Arabs, 232
Ares, Pablo, 135–37
Argentina, 13–14, 26–27, 126–27, 131–33,
 137, 140–41, 150, 165, 173, 179, 186,
 191–94, 200–1, 220–24, 229, 276n144;
 courts of, 179; crisis in, 173, 276n144;
 economy of, 127, 133, 186, 276n144;
 foreign debt of, 133, 276n144; his-
 torical representations of, 26, 140, 201,
 220; military junta of, 133, 140–41,
 150; popular politics in, 27, 127, 137,
 186, 191–94, 198, 229, 243; regimes
 of, 131–33, 140–41, 150. 165; security
 industry of, 149, 213, 221, 224; social
 order of, 131–33, 200–1; uprisings in,
 13–14, 126, 191–94, 229
Argentina vs. Argentina, 159–65, 171,
 174–75; collective subject of, 165; mul-
 tivalent allegory within, 161, 164
Arrieta de Blaquier, Nelly, 179–81
Artaud, Antonin, 167, 188–89
Artifact Piece, 60
Arts and Action, 110
Asco, 235
Asociación Madres de Plaza de Mayo.
 See Madres de Plaza de Mayo
Austria, 2, 24, 29–30, 33, 36, 52, 56, 59,
 61–62, 64–66, 71; audiences in, 66;
 live actions in, 36, 56, 62; president of,
 30, 64
authoritarianism, 26, 152, 208–10;
 critique of, 208; political liberalism
 and, 26
autonomy, 2, 14, 20, 22, 34, 42, 45–46,
 49, 63–64, 111, 116, 142, 156, 168,
 176–77, 181, 201–2, 211, 255n95; art ide-
 ologies of, 20, 22, 111, 116, 176–77, 181,
 255n95; bourgeois myths of, 2; building
 of, 45; economic resistance and, 34;
 material form of, 46, 181; practice of,
 46; pursuit of, 14; regional form of, 42
avant-garde, 20, 31–32, 38; ethos of, 38;
 genealogies of, 31

Balibar, Étienne, 130, 252n10

Barker, Colin, 15

Bartra, Armado, 43

Batalla, Bonfil, 260n139

Baugh, Scott, 41

Benjamin, Walter, 18–19, 41, 199

Bertolazzi, Carlo 241

Beverley, John, 131

Bicentennial Historical Monument (Los Angeles), 91–96

Las bicicletas de Rosario, 270n168

Blaquier, Carlos Pedro, 178, 180

Boal, Augusto, 19, 41, 84, 166–69; theater theories of, 166–69

Bolivarian Revolution, 14

Bonasso, Miguel, 227–28

Bonnet, Alberto, 198–99

Borderhack festivals, 41, 110

Bossi, Lorena, 220, 225, 273n54

Boukalas, Christos, 228–29

Bracho, Ricardo A., 119–20, 149, 219, 265n127

Brecht, Bertolt, 18–22, 41, 54, 166–69, 241, 255n92; bourgeois theater and, 166; materialist theater of 166–67, 241; politics of art and, 21–22; socialist art practice and, 21, 270n168

Brooklyn Stock Exchange, 49

Buenos Aires, 1–3, 26, 66–67, 127, 135, 146–56, 161, 176, 180, 185–87, 190, 197, 201, 204, 216–17, 231, 271n2, 276n145, 277n164; affluent parts of, 149; arts groups of, 26, 127, 146, 152, 187, 190, 197, 216, 271n2, 276n145, 277n164; movements based in, 154, 176, 187, 190, 197; multinational corporations in, 149, 217; popular assemblies held in, 187, 190, 197, 231; subway system of, 148, 217

Bush, George W., 2, 230, 237

Café Penacho, 33–35, 57, 62, 64–65

California, 1, 39, 91, 99, 105–6, 263n70; artists in, 1, 40, 263n70; Mexican culture of, 91; prison expansion in, 106; recessions in, 105; state laws of, 99

Canada, 71

Cananea, 39

capital, 10–12, 14, 21, 36, 39, 43–44, 52, 63–64, 70–72, 75, 77, 90, 97–98, 114, 116, 118, 125, 128–29, 132, 134–36, 154, 173, 180–81, 184, 190, 193, 199, 202–3, 221, 224, 227, 244; flow of, 39, 52; foreign form of, 70–72; globalized form of, 10–11, 72, 77, 129, 134, 227, 244; symbolic form of, 154, 173, 180, 203; transnational form of, 14, 52, 63, 75, 97, 128, 135, 184, 190, 193; violence of, 227; vulnerability to, 125

Caracazo, 14, 127, 185

Carroll, Lewis, 8

Carteles viales, 146

Catholic Church, 29, 71

Central America, 13, 43, 80, 97–98, 250

Cerdeiras, Raúl, 201

Chávez, Hugo, 234

Chiapas, 34, 45, 48, 62; coffee cooperatives in, 34, 62

Chicago, 198

Chicano movement, 19, 101–3, 111–13, 263n67; art of, 101–3, 113, 263n67

Chile, 12, 132, 140, 176, 200, 228; military regimes in, 132; socialist party in, 200; territorial rights in, 228

China, 70–71

Churchill, Ward, 59

Cine Liberación, 19–20, 265n4

Cinematík, 41

Cochabamba Water Wars, 14, 127, 185–86

Cold War, 10, 227

Collective Intelligence Agency, 49

colonialism, 10, 12–13, 25, 36–38, 63, 68, 78; contemporary forms of, 13, 25, 38; effects of, 68; European form of, 10, 78

Colorado, 263n70

conquest, 11–12, 16, 29–30, 33, 43–44, 52, 60, 68, 73–75, 79, 88, 92–93, 96, 114, 133; colonial form of, 11, 16, 68, 73–75, 88, 92, 133, 260n138; imperialist form of, 16; indigenous politics and, 12, 260n138; invasion and, 29; Meso-american culture prior to, 33, 52, 74;

gle in, 37, 45, 51, 75–76, 228; literary scene of, 40; military force in, 47; mining in, 71; movements in, 43–46, 228; neoliberal restructuring in, 44; ruling classes of, 54–55, 75–76; southern region of, 3, 34; urban communities of, 50; U.S. border of, 40, 42, 97–99; U.S. imperialist relationship to, 83, 93, 97

Mexico City, 40, 103–5, 119; artistic communities in, 105; murals in, 103

Miami, 229, 275n134

Mi Casa Es Su Casa, 108

Middle East, 233

Midnight Notes Collective, 12–13

El Mierdazo, 173, 186–91

migration, 1, 44, 97–101; regimes of, 98; transnational history of, 100

Modern Drama, 41

modernity, 31, 37–38, 61, 75–79; ambit of, 37; capitalist form of, 78; colonial form of, 31, 61; European form of, 79; indigeneity counterposed to, 76; tradition and, 37

Monteros, Ezequiel, 237–41, 244

Moraga, Cherríe, 104, 120

Morales, Francisco, 39

Movimiento Patriótico Revolucionario "Quebracho" (Patriotic Revolutionary Movement "Quebracho"), 242–43

Muñoz, Lilia, 39

Museo Nacional de Bellas Artes (National Fine Arts Museum, Argentina), 2, 178–81

Museum of Man, San Diego, 60

Museum of Revolutionary Currency, 33

Nahua, 74, 78

National Congress, Argentina (Congreso de la Nación Argentina), 1, 188, 276n145

National Museum of Anthropology, Mexico, 29

National Security Doctrine, U.S., 98, 133, 225; anticommunist nature of, 225; mandates of, 133

Native Americans, 57, 73, 258n81

Nazi Holocaust, 57–59, 67, 258n88

Negri, Antonio, 106

Neocleous, Mark, 71, 129–30, 213

neoliberalization, 11–13, 43–44, 72–75, 97, 106, 114–15, 127–28, 132–35, 150–54, 192–93, 201, 213, 268n103; conservative policymaking and, 106, 114–15; effects of, 44; history of, 72; inequality and, 44, 127, 192–93; process of, 12–13; resistance to, 43, 201; social struggles and, 128; spatial project of, 150, 268n103; surplus labor and, 154; U.S. promotion of, 11–13, 106

New York, 49, 214, 217

Nicaragua, 54, 107, 119

1960s, 8–9, 43, 119, 157; guerrilla movements in, 43; militancy of, 119; movements of, 8–9

1970s, 2, 9–13, 44, 102, 127, 132–39, 149, 154–55, 164, 201, 235, 238; corporations in, 2; deindustrialization begun in, 135; generation born in, 9, 102, 132; global capitalist production in, 11, 44; history of, 204; memory of, 139; militancy in, 164, 201; mobilizations organized in, 137; political conflicts of, 164; violence in, 2, 127, 137, 154–55, 238

1980s, 9, 13, 43, 63, 84, 94, 98, 106, 119, 134, 136, 185, 235; coffee crisis of, 63; conservative policymaking in, 106; expressive culture in, 84; grassroots politics in, 9; guerrilla movements in, 43; neoliberal reforms implemented in, 43; popular opposition in, 134, 185; transnational movements in, 119

1990s, 9–10, 13–14, 26, 39–44, 63, 70, 98–99, 106–8, 114–15, 119–20, 134–36, 142, 149, 151–58, 184, 201, 213–14, 224, 228; conservative policymaking in, 106, 214; federal laws in, 99; imprisonment and, 106; income inequality in, 106; Latin American states in, 228; markets in, 43, 63, 224; movements of, 14, 26, 119, 142, 154, 184; neighborhoods gentrified in, 114–15; uprisings of 14; urban spatial production in, 151; worker migration in, 44; youth in, 136

Rancière, Jacques, 4–5, 251–52n8
rasquache, 111–13
rasquachismo, 111–13
Red Power movement, 72–73
Right, the, 12, 45, 47, 134, 141, 163, 165,
192, 196, 200–1, 204, 210; apologists
for, 204; corporate media and, 192,
204, 210; disavowal by, 163; drift
toward, 47; extermination by, 141;
forces of, 165; paramilitaries of, 45;
strengthening of, 12, 200–1; violence
of, 163
Robinson, William, 13, 134, 184, 200
Rockhill, Gabriel, 22, 88–89, 153
Rodríguez, Gabriela, 219
Rodriguez, Juana María, 120
Rolnik, Suely, 7
Rovira, Miguel Angel, 148–49
Rubin, Jerry, 198
Ryan, Marie-Laure, 256n9

Saldaña-Portillo, María Josefina, 45, 73, 76
Salinas de Gortari, Carlos, 70
San Andrés Accords on Indigenous
Rights and Culture, 45
San Diego, 40, 60
Sandinistas, 13
Santillán, Darío, 154
Sarlo, Beatriz, 204
Schrank, Brian, 31
Score, The, 120, 122, 124
security, 2–3, 16–17, 27, 42, 90, 98–99, 115,
145, 148–50, 155, 194–95, 200, 203–4,
207, 212–16, 219–21, 224–29, 240–44,
249, 274n103; citizens and, 150, 155,
249; discourses of, 2, 17, 27, 42, 115, 194,
203–4, 207, 213–16, 219–21, 224–25;
ideologies of, 150, 212–14, 225, 220,
226, 228, 242, 274n103; Latin Ameri-
can forces of, 16, 229; national forms
of, 145, 226; order and, 200; private in-
dustry of, 149, 221, 224; state apparatus
of, 195, 213–16, 219–20, 240–42
Seghezzo, Gabriela, 219
Seguri$imo ($uper Secure), 220–21,
224–27

Seremetakis, C. Nadia, 265n129
Seri, Guillermina, 208–9, 213–14, 219,
240
*Sexta Declaración de la Selva Lacandona
(Sixth Declaration of the Lacandon
Jungle)*, 47, 50
silhouettes, 179–80, 232, 270n168; absent
bodies and, 179–80
El Siluetazo, 179–80
Siqueiros, David Alfaro, 80
Sitio de Memoria, 269n132
Situationist International, 56
Smith, Neil, 115
socialism, 9–10, 39, 46
Somoza, Anastasio, 54
Southern Cone, 12, 127, 140, 238
Southern Pacific Railroad, 1, 84
Souvenir of the American Holocaust,
56–57, 60–61
Spacebank, 32–34, 48, 50
Standing Together Advocating for Our
Youth (STAY), 116
statecraft, 27, 140, 195
state terrorism, 2, 12, 16, 26, 98–99,
127–29, 131, 133, 137–39, 141–43,
147–48, 152, 154–55, 178, 182–83, 194,
204, 207–9, 220, 225, 227–28, 230–31,
234, 236–38, 243, 275n129, 276n144;
apologists for, 204; corporate complic-
ity in, 2, 131; discourse of, 99, 227–28,
230–31, 234, 243; economic form of,
129; individuals involved in, 2, 131, 142,
178; militants targeted by, 208; move-
ment condemnation of, 26, 128–29,
143, 178; response to, 139; U.S.–backed
form of, 98, 238
state violence, 2, 130, 133, 137–38, 140–41,
145, 151–52, 154–55, 163, 182–83, 203,
213–14, 220, 224–25; corporate media
and, 214; critique of, 154, 182; histories
of, 145, 154, 220; infrastructure of, 151;
laws dependent upon, 130; logics of,
225; naturalization of, 213, 224; organ-
izations working against, 137; perpetra-
tors of, 145; scale of, 133; specific forms
of, 138; victims of, 141